CATALOGUE
OF

PAINTINGS AT THE THEATRE MUSEUM, LONDON

CATALOGUE
OF

PAINTINGS AT THE THEATRE MUSEUM, LONDON

by
Geoffrey Ashton

edited by James Fowler

Victoria and Albert Museum
in association with
The Society for Theatre Research

Produced by Alan Sutton Publishing Ltd., Stroud, Glos.
Published by the Victoria & Albert Museum 1992 © Trustees of the Victoria & Albert Museum.

ISBN 185177 102 6

Whilst every effort has been made to trace the copyright holders of works reproduced in this catalogue and to clear copyright, the Museum wishes to apologise for any omission that may have occurred.

Photographs of paintings in the catalogue can be ordered from the Victoria and Albert Museum Picture Library, London SW7 2RL. However, the supply of photographs of works by artists still living or who have died less than fifty years ago may require prior permission from the copyright holder.

Front Cover
Portrait of Hester Booth by John Ellys (no. **4**)

Back Cover
Paintings Gallery, Theatre Museum, Covent Garden
Photograph by Graham Brandon

CONTENTS

FOREWORD

This book has gone through the press in the absence of the author Geoffrey Ashton, who died in August 1991 after a devastating illness. Though his death was untimely – he was only 39 – he did leave this important account of paintings at the Theatre Museum along with a catalogue of pictures at the Garrick Club.

This catalogue was commissioned by the Theatre Museum, which is a branch of the Victoria and Albert Museum. As the National Museum of the Performing Arts, the Theatre Museum exists to document, explain and promote through its collections the performing arts in Britain. The V&A has been able to publish the volume with the welcome offer of involvement with the Society for Theatre Research on whose Committee Dr Ashton served for many years. It includes paintings owned by the Museum or loaned by private individuals or by the Department of Prints, Drawings and Paintings at South Kensington. Works such as painted ceramics, 3-dimensional properties, backcloths, watercolours, miniatures, prints, drawings and photographs fall outside its brief.

The catalogue is substantially as Dr Ashton left it at the time of his death, apart from the inclusion of certain corrections, references and other details. Entries have been added for four paintings acquired too late for his attention. In the case of nos. **65** and **67** the entries are based on his previously published work; nos. **95** and **114** are new.

Since illness prevented the author from preparing a list of acknowledgments we wish to thank on his behalf all those who gave him advice and assistance on this project.

We are indebted to all Museum staff who helped produce this book, particularly Lionel Lambourne, Ronald Parkinson, Lesley Burton, Jennifer Blain, Graham Brandon, Sarah Woodcock, Andrew Kirk, Emilie Selbourne and Stacy Denson. Especial thanks are due to Susannah Edmunds who has conserved the paintings with immense skill and dedication and collaborated with Geoffrey Ashton on their physical description.

Jack Reading
Vice-President
The Society for Theatre Research

James Fowler
Deputy Head of the Theatre Museum,
National Museum of the Performing Arts

To
Glynis

INTRODUCTION

The Theatre Museum collection of paintings provides an outstanding visual commentary on the history of the British stage over the past three hundred years. Many of the greatest actors and actresses are represented and there is a diversity of subject matter that reflects the development of the British theatre from the time when London had a solitary permanent playhouse to the present day, with fifty shows a night in the West End.

The variety is unusual and is due to the way the collection has been built up. The nucleus had its origin in the theatrical pictures bequeathed to the South Kensington Museum by the Reverend Alexander Dyce in 1869. After Mrs Gabrielle Enthoven gave her vast theatre collection to the V & A in 1924, these were augmented by important paintings from the collection of the late Harry R. Beard given in 1971, and from the British Theatre Museum Association which became part of the newly-formed Theatre Museum in 1974. Acquisition by gift, bequest and purchase has continued since the Theatre Museum opened in its new Covent Garden premises in 1987.

Most European collections of theatre paintings are based around the work of a particular theatre, the Burgtheater in Vienna for instance, or the Comédie Française in Paris. Grand images suit the grand interiors and the pictures are seen as decorative objects as much as historical documents. There are, of course, more didactic collections and the best of these is at La Scala, Milan, where the history of that theatre is celebrated in a series of portraits and busts of the greatest singers and conductors who appeared there. A similarly distinguished opera house collection, that of the Opéra in Paris, is not particularly well known for its collection of portraits: it is the scene and costume designs and Garnier's designs for his great theatre that claim the attention. Other theatres have collections of portraits, the neo-classical images in the Staatsschauburg in Amsterdam for instance, but the bravest attempt to emulate the collection at La Scala is at the Metropolitan Opera House in New York where the downstairs foyer boasts a bewildering array of portraits of the great singers who have appeared there and at its down-town predecessor.

The Met and the great European national theatres and opera houses have space for display but in London restricted front-of-house areas have always made this difficult. The exception is the Theatre Royal, Drury Lane, where a number of works of art of theatrical interest decorate the Grand Staircase and other areas. Other theatres used to have their pictures: under the management of Arthur Bourchier the Strand Theatre had a series of pictures wending its way up to the circle bar. The magnificent portrait of Tree as King John, now in the Theatre Museum (No. **56**), used to dominate the foyer of Her Majesty's and Tree filled the Dome Room, his private function room at the theatre, with life-size images of himself in performance, painted by his protégé, Charles Buchel. Somerset Maugham left his collection of pictures to the, then unbuilt, National Theatre in the hope that the sparkling images of the past would brighten up the dull concrete of the present. And this they did for some time after the theatre eventually opened in 1977, before being removed for security reasons.

The inspiration for Maugham's collection was not the rather limited displays of portraits in European national theatres but the great collection owned by the Garrick Club. With over a thousand theatrical paintings, drawings and sculptures it is by far the largest collection of theatrical portraiture. The initial collection, about half the present total, was formed by Charles Mathews, a popular comedian in the first thirty years of the nineteenth century. He spent all he had on building up a visual history of the British Theatre from the era of David Garrick to his own. He had a gallery built onto his house in Kentish Town and encouraged visitors. Charles Mathews was best known for his one-man shows which always included a number of imitations of actors of the past. Mathews used his pictures as inspiration for these evocations and on several occasions actually performed in front of a selection of his pictures, working into his script references to the pictures and the performers they represented.

Mathews's erudite use of theatrical portraits perhaps foreshadows one of the hoped-for

functions of the Theatre Museum collection. His own inspiration came from eighteenth-century predecessors with rather more prosaic intentions. David Garrick was the greatest actor of the eighteenth century; he was also its greatest self-publicist. He took great interest in Hogarth's use of visual imagery to promote John Rich's production of *The Beggar's Opera* in half a dozen versions of the painting and a print of a scene from the play. Hogarth also used the theatre as a vehicle for his history painting aspirations with the large portrait of Garrick himself as Richard III. Garrick was unable to direct the efforts of Hogarth – the bad-tempered painter poked out the eyes in his portrait of Garrick and his wife – but he obtained the next best thing with a number of portraits by Francis Hayman. It was Benjamin Wilson who was the first to transpose David Garrick's greatest performances from the stage to the easel; his portraits of Garrick as Hamlet and Lear were reproduced in mezzotint and his picture of Garrick as Romeo with George Anne Bellamy as Juliet was painted and engraved in several versions; one of them is in the collection of the Theatre Museum (No. **8**). Through Wilson Garrick met Johan Zoffany and the future of theatrical portraiture as a major genre of English painting was assured. Zoffany's images of Garrick in such plays as *Macbeth*, *Venice Preserv'd* and *Lethe* are the most satisfying and convincing images of the mid-Georgian theatre and Garrick made sure the images were well known to contemporaries with the proliferation of mezzotints.

It is curious that Garrick's promotion of his own image was not imitated to any large extent by his fellow actors. The next important commissions of theatrical portraits came from a publisher, John Bell, and a theatre manager, Thomas Harris. Bell published four important series of plays in the 1770s and 1780s, two of Shakespeare and two much larger collections of miscellaneous plays. He commissioned first James Roberts and then Samuel De Wilde to draw or paint portraits of actors in costume and then had these engraved as frontispieces to the plays. The engravings were issued separately and helped to start the great deluge of engraved theatrical portraits that only ceased with the advent of effective theatrical photography in the mid-nineteenth century. Thomas Harris was manager of Covent Garden and had a gallery of portraits in his house near Uxbridge. They mostly depicted members of his company and included a series of commissioned half-lengths by Gainsborough Dupont. Most of Harris's pictures and most of Bell's De Wildes, which were exhibited in Bell's British Library in the Strand, ended up in Mathews's collection, bought at sales caused by death in the case of Harris and bankruptcy in the case of Bell. Garrick's pictures were sold after the death of his widow in 1823, but surprisingly Mathews was not one of the buyers. Not only did Mathews buy pictures of the performers of the past, he also commissioned portraits of himself and his contemporaries, usually by De Wilde whose studio was conveniently placed near Drury Lane and Covent Garden in Tavistock Row. Somerset Maugham was clearly attracted by the picturesque aspect of the Garrick Club collection but it is interesting that a theatre portrait in the Theatre Museum collection, Ethel Irving as Lady Frederick (No. **63**) was commissioned by him and presented to the actress at the beginning of his theatrical career. He was following the example of Mathews in more ways than one.

In the later nineteenth century the one quasi-public collection that had a deliberately theatrical aspect was the group of pictures put together to decorate the new theatre at Stratford-upon-Avon from 1879. Obviously, the inspiration was Shakespeare and his works but amongst the fancy pictures, from the Boydell Gallery and elsewhere, there were a few theatrical portraits. This collection was emulated in the early years of this century by Henry Folger for what became the Folger Shakespeare Library in Washington, and which includes a number of theatrical portraits. Pictures were also bought by Lincoln Kirstein to add to those with which he was decorating the American Shakespeare Theatre at Stratford, Connecticut. These were sold in 1976 and most of the important works found their way to the British Art Center at Yale University.

Before Mathews's pictures were sold to the Garrick Club they were exhibited at the Queen's Bazaar, Oxford Street. They were on sale as a job lot but no buyer was found. A few, listed by Mathews in his catalogue of the exhibition but no longer with the pictures in the Garrick Club, may have been sold individually. No. **12** seems to be one of these.

Other actors followed the example of Mathews. For instance, his son Charles James Mathews, commissioned the series of 116 character portraits of himself by James Warren Childe, now in the Garrick Club. Sir Henry Irving was more interested in theatrical memorabilia than theatrical painting but he had a good collection of pictures, many of which decorated the walls of his Beefsteak Room. The finest, Clint's scene of Edmund Kean in *A New Way to Pay Old Debts*, for

which there is a sketch at the Theatre Museum (No. **23**), he bequeathed to the Garrick Club. The rest were sold at Christie's after his death in 1905. No. **46** was in Irving's collection. However, it was Irving's contemporary Herbert Beerbohm Tree who took most interest in contemporary theatrical portraiture. It seems that photography was not a science large enough to capture his flamboyant theatrical personality and, like Garrick, he turned to a talented German-born artist for immortality. Charles Buchel was employed by Tree to illustrate the lavish programmes he provided for performances at Her Majesty's Theatre: Nos. **57**, **58**, **60** and **61** were all used as illustrations in Tree programmes. Tree also employed Buchel as his court portrait painter, not only to create the magnificent image of him as King John (No. **56**) but also in a whole series of roles in the decorations of the Dome Room at Her Majesty's. His later portraits of Tree included a series of small full-lengths, Nos. **70** to **73**, that were presented to RADA by the sitter.

Although Tree was the only actor-manager of the Victorian era to personally continue the tradition started by Garrick, theatrical portraits were seen as eminently suitable gifts to actors and actresses. Nos. **74** and **79** were presented by a group of grateful provincial managers to the money-spinning Fred Terry and Julia Neilson. The Garrick Club was regularly a recipient of paintings presented in memory of dead thespians, John Collier's famous group of Tree as Falstaff with Ellen Terry and Madge Kendal as the Merry Wives being the most notable example.

The development of interest in theatre history in the late nineteenth century and the scholarly pursuit of the subject, especially in the United States, encouraged the accumulation of engraved images of performers. By far the most important group became the basis of the Harvard Theatre Collection whose immense collection was published in four volumes in 1930. Similar collections already existed in England, the most extensive being the Burney Collection in the British Museum which includes many of Roberts's drawings for the first edition of Bell's British Theatre. Because they have been seen purely as sources for theatrical research, the American University collections, such as Harvard and Princeton, and Library collections, the most important being that of the New York Public Library, have concentrated their resources on the acquisition of the documentary evidence of theatre history. This policy is also pursued by the Theatre Museum but as a public exhibition space the visual display of the theatre of the past must also play an important part.

The hundred and twenty three works at the Theatre Museum constitute the most comprehensive visual history of the British stage over the last three hundred years. Indeed they are the largest collection on public display in this country. The Garrick Club has incomparable holdings of Georgian pictures and many fine examples from the Victorian era but the Theatre Museum brings the story up to date. It also has the greatest public collection of paintings by Charles Buchel who, with Zoffany and De Wilde, was the finest artistic observer of theatrical performance. The collection will continue to grow, an attractive and inspiring exordium to the greatest archive of the British Theatre.

G.A.

All measurements are given in centimetres, height preceding width.

The Museum numbers for the paintings appear below each catalogue entry. Those not prefixed by an 'S' are on loan to the Theatre Museum from the Department of Prints, Drawings and Paintings, or from private individuals.

1 Denis Van Alsloot (fl.1599–1628)

The Triumph of the Archduchess Isabella on 31 May 1615

Oil on canvas 117 × 381 cm.

1616

Inscribed: *DENIS VA* (in monogram) *ALSLOOT / Ao 1616* in black oil paint (lower left); *LA CINC-QUIESME* in black oil paint (right of bottom centre); *449.* in cream oil paint (bottom left corner); *IHS* in yellow oil paint (on sides of first car and on banners held at front of carriage); *CLST.. PEU / MILLE LONGV (ES)* in black oil paint (on front of second car); *AETERNELLE MEMOI (RE) / TE CHANTE VNE / GRANDE VICTOIRE* in black paint (on side of second car); *VAINCV DE PLUS FAUTE LOURS / IE VIEN FAIRE MON HOMAGE* in black oil paint (on front of third carriage); *CEDOES / VOSTER / ARC* in black paint (on back of fourth car); *NOUS CHAN / TONS UNE / BELLE VICT / OIRE* in black oil paint (on side of fourth car); *DE LA / STAN.. / EVDA* in black oil paint (on side of fifth car); *AVE MARIA* in black oil paint (on side and back of sixth car); *HEROINA / ISABELLA* in black oil paint (on banner hanging from front of ninth car); *PLUS / ULTRA* in black oil paint (in cartouches attached to verti-cal elements – the Pillars of Hercules – behind the tenth car).

Provenance: Archduchess Isabella; bequeathed to Cardinal Infant, Don Ferdinand, Governor of the Nether-lands; Escorial; Spanish Royal Collec-tion until c.1800 (the companion pictures in the Victoria and Albert Museum 168–1885 & 169–1885 entered the collection of Lord Stafford between 1800 and 1885;; Mr. Farrer; bought from Mr. Farrer for £94 5s, 1859

Exhibited: 1880 Brussels *Exposition historique de l'art Belge;* 1935 Brussels *Exposition universelle de Bruxelles, Cinq siècles d'art,* i, *peintures* (206); 1953–4 Royal Academy *Flemish Art 1300–1700* (213); 1954 Bordeaux *Flandres, Espagne, Portugal, du XVe au XVIIe*

An extravagant procession travels in three parallel lines making a broad S shape with the front of the procession bottom left. The setting is the Grande Place, Brussels, lined on the far side with two and three storey houses, some with gables towards the open space and all with mullion and transomed windows. Ladies with black frocks and white ruffs and bonnets look out from the upstairs windows; the male population, dressed mostly in black gowns and hats with white ruffs, watches the procession from in front of the houses. The content and meaning of the procession itself is explained below. Lit from left.

Ommegangen were originally religious processions in which relics or locally venerated images were carried around a prescribed route on a particular holy day, usually in high summer. In Antwerp there were two processions, celebrating the Circumcision on Trinity Sunday (not the Feast of the Circumcision which falls on 1 January) and the Blessed Virgin on the Sunday in August after the Feast of the Assumption (15 August). The Malines procession was in honour of Our Lady of Hanswyck held during the last fortnight in August and the Louvain *ommegang* celebrated the Nativity of the Virgin on 8 September. The Brussels *ommegang* was the earliest, cele-brating a statue of Our Lady, Notre Dame de Sablon on the Sunday before Whitsun. The church of Notre Dame de Sablon was founded by the Guild of Crossbowmen and they played a prominent part in the procession. There had been an annual procession since at least 1359. During the sixteenth century Renaissance elements were added so that by the early seventeenth century the *ommegang* was a curious mixture of religious and secular.

The 1615 *ommegang* had a particularly topical slant and was dedicated to the Archduchess Isabella, the Governor of the Spanish Netherlands. Two weeks earlier, on 15 May, she had taken part in the annual ceremony of Shooting the Popinjay and with her first shot had brought down the popinjay, which was tied to a long pole on top of a church steeple.

Alsloot's complete depiction of the *ommegang* consisted of six canvases of which **1** is the fifth. The first (Prado, Madrid 1347) shows the opening of the procession with the members of the Handicraft Guilds walking two abreast behind their masters and valets carrying the arms of each Guild. The second (V&A 168/9–1885) shows the senior Guilds, or *Ser-ments en armes,* each accompanied by standard bearers, drums and fifes and an image of their patron saint. In order they are the Fencers (St. Gudula and St. Michael), the Arquebusiers (St. Christopher), the Archers (St. Nicholas) and the lesser

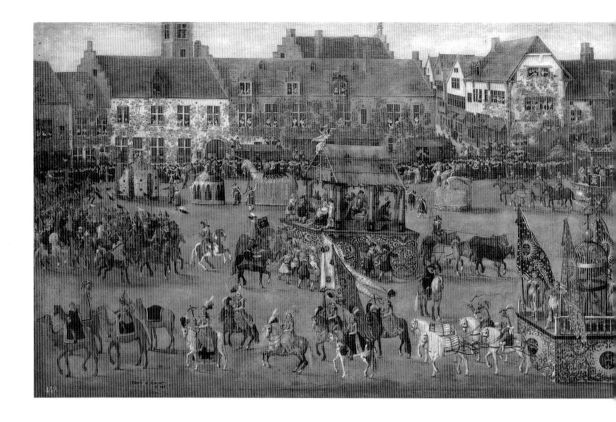

Guild of Crossbow Makers (St. George with his dragon). The third and fourth canvases are lost but probably depicted an historic cavalcade of the Dukes of Brabant and a series of cars with Biblical and Marian scenes. Then came **1** and finally another scene in the Prado (1348) depicting the city fathers and magistrates, followed by the religious orders and the miraculous image of Notre Dame de Sablon.

The picture shown in the Theatre Museum is by far the most interesting of the surviving canvases and, despite its rather late date, is one of the main sources for our scanty knowledge of medieval pageant wagons. This aspect is discussed at length by Meg Twycross in her two exhaustive articles; she places the Brussels *ommegang* in the complete context of the Spanish Netherlands and makes some tentative connections with earlier English pageant wagons. She suggests that there might be a certain element of fantasy in Alsloot's depiction of some of the floats but remains impressed with his attempts at verisimilitude.

The part of the procession shown in **1** begins with four camels followed by several mythical figures on horseback; Apollo, Diana and Queen Semiramis of Babylon. Two Amazons carrying banners with the monograms of the Virgin and St. Anne precede the first car which is pulled by four white horses, the back two each with a groom dressed in red. The car shows King Psapho of Libya, who taught his parrots to say 'Psapho is God', seated at the rear under a red feather parasol. In the gilded cage a boy clad in feather teaches birds (gents standing at the corners) to say 'Isabella is Queen'. The second car is pulled by four brown horses wearing foliage and

siècle (1); 1956 Haarlem, Frans Hals Museum *Renaissance des Rederijkers;* 1982 *Show Business*, Victoria & Albert Museum (and at the Whitworth Art Gallery, Manchester, March 1983) (Apart from the 1880 and 1982 exhibitions the three V&A pictures were shown together).

Literature: Alphonse Wauters *L'Ancien Ommeganck de Bruxelles,* Brussels 1848; Fr. V. Raesten SJ *L'Ommeganck de Bruxelles en 1615 d'après les Tableaux de Denis van Alsloot, Précis Historiques,* Brussels 1889; James Laver *Isabella's Triumph,* 1947; Leo van Puyvelde *De Ommegang te Brussel in 1615 naar de schilderijen van Denis van Alsloot, De Koninklijke Vlaamse Academie voor Taal – en Letterkunde* No. 1–2, Ghent 1958; C.M. Kauffman *Victoria and Albert Museum Catalogue of Foreign Paintings 1. Before 1800,* 1973 pp. 3–7; Lionel Lambourne *Victoria and Albert Museum Masterpieces, Sheet 23 The Triumph of the Archduchess Isabella, 31st May, 1615* (n.d.); Meg Twycross *The Flemish 'Ommegang' and its Pageant Cars, Medieval English Theatre* Vol. 2:1 pp. 15–41 & Vol. 2:2 pp. 80–98 (includes a very full bibliography).

Condition: Lined. There is a certain amount of abrasion of paint and there

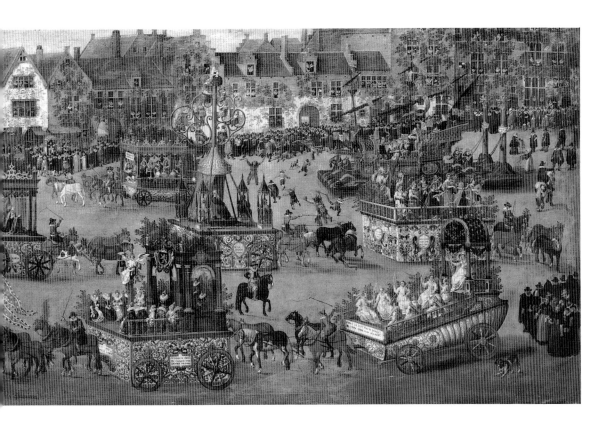

are scattered minor losses. There have been numerous retouchings over old damage along lower edge. Various foreign bodies between lower stretcher bar and canvas have led to distortion and paint loss.

Technique: Cream or grey ground on tabby weave linen.

5928–1859 Neg: JA 1651/CT 505

directed by a single groom. The car represents the Court of the Archduchess with Fame on a column blowing two trumpets. This precedes two cars with Diana and her nymphs and Apollo and the Nine Muses, each pulled by four horses with a single groom. The inscriptions on these three cars refer to Isabella's success with the popinjay and may have been prepared especially for the 1615 procession. The fifth car has a Tree of Jesse, a popular feature of *ommegangen* all over the Netherlands. The corner pavilions presumably house prophets. Jesse sits under a red and gold tent under his tree on which children sway precariously, dressed as the priests and other luminaries of the Old Testament who connect the seed of Jesse with that of the infant Christ at the top of the tree. This car, like the two preceding and the four following, is pulled by two pairs of assorted horses controlled by a single groom. The sixth car depicts the Annunciation and the seventh the Nativity with the Adoration of the Shepherds. A large group of behatted horsemen carrying pennants follows the Nativity and precedes a group of four fantastical animals, two camels, a unicorn and something that looks like a winged camel. They are presumably controlled from within whilst their necks are kept vertical by two figures holding leads. The eighth car shows Christ Disputing with the Doctors in the Temple and the ninth shows the Archduchess again, her virtues glorified in direct emulation of the previous car. The final car was originally made for the funeral procession of Charles V in Brussels, December 1558, and was so admired that it was included in all subsequent *ommegangen*. It shows a very odd looking ship drawn by sea-horses and contains a

Madonna and Child and a group of royal personages. At the rear stand the Pillars of Hercules. The car exhibits no obvious means of locomotion.

The theatrical context of the *ommegangen* is something that Meg Twycross left open for further discussion. Modern scholars tend to assume that the floats had a great deal to do with peripatetic performances but that assumption does not really match the evidence of Van Alsloot's picture. Most of the floats are clearly *tableaux vivants* and are meant to be looked at rather than listened to. There are exceptions and possibly the floats with Christ in the Temple and Apollo with the Muses, for instance, included a spoken element that added an intellectual side to the spectacle.

2 Sir Peter Lely (1618–1680)

Charles Killigrew

There is no other portrait of Charles Killigrew with which to compare **2** but the provenance and the circumstantial evidence of the coat-of-arms suggest that the identity of the sitter is correct. The date of Charles Killigrew's marriage is not known but as his eldest son was born in 1689 he is likely to have married Jemima Bockenham in the late 1680s. This means that the coat-of-arms was added to the picture after the death of the artist. X-ray examination of the coat-of-arms supports this theory although the evidence suggests that it was added no later than the seventeenth century. Charles Killigrew's son Charles bequeathed his mother's house, Thornham Hall, to his godson, the Rev. Charles Tyrell. Tyrell sold the Thornham estate to Sir John Major and seems to have left a collection of fourteen Killigrew family portraits at Thornham, including one of his benefactor, Charles Killigrew the Younger. These were published by Edmund Farrer in 1930 in his catalogue of the portraits at Thornham Hall. The provenance of **2** assumes that Tyrell took that picture with him to Gipping Hall, whence it descended to Commander Browne in the late nineteenth century.

The painting is a good example of Lely's mature work, stylistically datable to c.1672–5 when Charles Killigrew was seventeen to twenty years old. The sitter wears a long curly full-bottomed wig of the 1670s, white shirt and lace cravat, brown leather jerkin under body armour, brown panes attached to the sleeves of a doublet and a brown cloak. The iconography of the portrait suggests a military connection with the body armour over leather jerkin, the military baton and the sleeve lappets reminiscent of the glories of Imperial Rome, and the landscape indicated with the right hand seeming to recall the site of foreign battles fought and won. In fact the costume, pose and even the landscape are duplicated exactly in Lely's portrait of Thomas Thynne of Longleat, engraved in the seventeenth-century mezzotint by A.

Oil on canvas 126 × 103 cm.

c.1673

Inscribed: *Cha.s Killigrew* in black oil paint under coat of arms (lower left) Argent, an eagle displayed with two heads sable, a bordure of the second charged with eight bezants (Killigrew) impaling, Argent, a lion rampant gules (Bokenham of Great Thornham).

Provenance: Charles Killigrew, Thornham Hall, Suffolk; his son, Charles Killigrew; bequeathed to Rev. Charles Tyrell, Gipping Hall, 1756; by descent in Tyrell and Ray families, Plashwood, Haughley; by descent to Commander W.W. Browne R.N. 1905, by 1892; Sir John Walter Harvey; Sotheby's 15 March 1978 Lot 57; Colnaghi; bought by the Theatre Museum 1983

Exhibited: 1892 Reynolds Galleries; 1983 Colnaghi 'English Ancestors' A Survey of British Portraiture 1650–1850 (39)

Literature: R.B. Beckett *Lely* 1951 p. 49 No. 274; C.H. Collins Baker *Lely and the Stuart Portrait Painters* 1921 Vol. II p. 128 No. 155; E. Farrer *Portraits in Suffolk Houses* 1908 p. 316 No. 4; *The V&A Album 3* 1984 p. 16 (repr. in colour).

Condition: Lined. Old restored damages bottom edge, possible tear.

Oval canvas inset 4.5 × 2.5 cm., retouched, lower right corner. Some minor retouchings at bottom.

Technique: Cream ground on tabby weave canvas.

S.540–1983 Neg: HF 4577/CT 16137

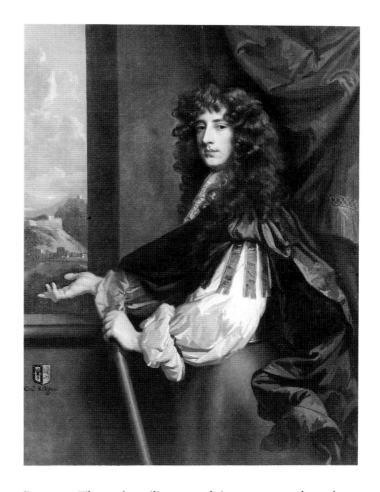

Browne. Thynne's military exploits appear to have been negligible before his putative involvement in Monmouth's Rebellion which took place some years after the picture was painted. Lady Gibson has suggested that the costume worn by both Thynne and Killigrew might be masquerade dress and she instances Count Grammont's references to the antique costumes worn by Prince Rupert and others at masquerade balls. This would seem to be a pertinent garb for the Master of the Revels, and patentee of Drury Lane. The landscape seems too specific to be accidental or decorative and may have a theatrical significance. The point should be made that **2** is a picture of far higher quality than the portrait of Thomas Thynne which can only be attributed to Lely with considerable reservation.

3 After Sir Godfrey Kneller (1646–1723)

Thomas Betterton

Oil on canvas 29 × 23 cm.

c.1690 (original picture)

There are two portrait types of Thomas Betterton attributed to Sir Godfrey Kneller. A picture at Knole inscribed and dated 1708 is the only example of the type showing the sitter with his own hair. (Knole 166 Oil on canvas 77.5 × 63.5 cm. It has

Provenance: Rev. Alexander Dyce; Dyce bequest, 1869

Condition: Lined. Some scuffing, cracking and retouching along left edge. Small hole right of centre in hair.

Technique: Tabby weave canvas. The application of paint is thin and tenuous.

D.65 Neg: HG 685/CT 16473

been suggested by Oliver Miller that this picture is by Charles Jervas.) Bust-length in a painted oval, Betterton looks out of the picture wearing an open-necked shirt. The other type, the most familiar image of Betterton, is the one on which **3** is based. The sitter is shown half-length to right, facing to the front over his left shoulder. He wears a brown full-bottomed wig, and a brown night-gown held at the chest by his left hand. His white cravat is untied. The style of the wig would suggest a date in the late 1680s or early 1690s for the original of this type. The version with the best claim to being Kneller's original is again at Knole (Knole 167 Oil on canvas 77.5 × 63.5 cm.). There are others in the Garrick Club (474 Oil on canvas 74.3 × 61 cm.) and National Portrait Gallery (752 Studio of Kneller Oil on canvas 76.2 × 64.8 cm.). There is a copy by Alexander Pope, the actor, in the collection of the Earl of Mansfield (Oil on canvas 76.2 × 63.5 cm.). Betterton is shown turned to the left although the pose is reversed in R. Williams's mezzotint, published by E. Cooper.

3 is the same size as the mezzotint and is evidently copied from the print rather than from any version of the original picture; it shows the sitter turned to the right as in the print rather than to the left as in the paintings. The fact that the print has been misread – Betterton has been given a side parting rather than the centre parting usual in full-bottomed wigs and the depiction of the cravat is very uncertain –

suggests that **3** was painted when the fashions of the late seventeenth century were no longer understood. There are eleven other prints based on Kneller's bewigged portrait of Betterton, including Michael van der Gucht's line engraved frontispiece to the 1710 biography of Betterton, but there appears to have been a particular interest in engraved copies of the picture in the early nineteenth century.

4 John Ellys (c.1701–1757)

Hester Booth

Oil on canvas 122 × 89 cm.

c.1722–25

Provenance: Sotheby's 15 November 1989 Lot 34 (Property of a Gentleman); purchased for the Theatre Museum by the Trustees of the Victoria & Albert Museum with considerable help from the National Arts Collection Fund and the National Heritage Memorial Fund

Literature: James Fowler 'Hester Booth as a Harlequin Woman' *National Arts Collection Fund Review 1990* pp. 94–6.

Condition: November 1989. Generally sound. Lined, canvas slightly brittle. There is an old repaired tear to the right of the skirt and scattered retouching, especially to the left of the head. The paint has been slightly flattened during lining. December 1989. Dents treated and removed. Losses filled and retouched.

Technique: Tabby weave canvas.

S.668–1989 Neg: JA 923/CT 23377

Hester Booth made her debut at Drury Lane on 28 February 1706. She was about sixteen years of age and had been a pupil of the French dancer René Cherrier for the previous two years. She had a varied repertoire of serious and grotesque dances, amongst the latter she seems to have made a speciality of a 'Harlequin Dance'. Her performance was so popular that, according to the German visitor von Uffenbach, she was portrayed in her Harlequin costume on snuff-box lids. From

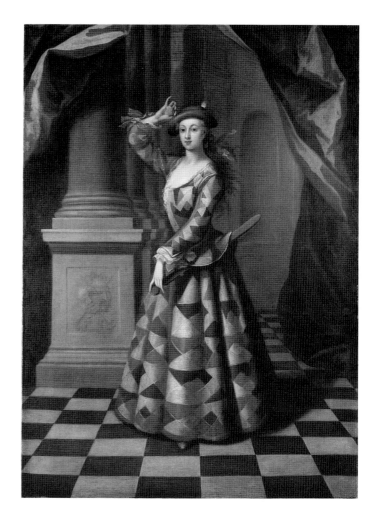

1709 she also developed as an actress, playing both the coy ingenue and the tragic heroine, but continued to dance her Harlequin role between acts. It is not clear whether she cross-dressed for the part but in March 1710 she appeared as a Harlequin Woman to Lewis Layfield's Harlequin Man. **4** may show Hester Booth in one of these dances, which she continued to perform until 1731, two years before her retirement. It is perhaps more likely that she is depicted in John Thurmond's pantomime *The Escapes of Harlequin – a new Dramatick Entertainment of Dancing in Grotesque Character*, which was first performed at Drury Lane on 10 January 1722 and given twenty-three times there before 22 October 1725. She played Harlequin Woman to the Harlequin of John Shaw. There were two Punches, Thurmond himself and Boval, and a Punch Woman, played by Elizabeth Younger. Elizabeth Willis played the part of the Doctor's Wife to complete the curiously mammiferous cast list. If there ever was a text it has been lost but the grand architectural background to the portrait is reminiscent of the anonymous drawing in the British Museum of a scene from Thurmond's Drury Lane pantomime *Harlequin Dr. Faustus* which was first performed on 26 November 1723. On either side of the stage there is a perspective of three pillars on high pedestals, similar to those to the left of Hester Booth.

In *Harlequin Phoenix* (1956 p. 49) Thelma Niklaus describes the female Harlequin costume as a dress made of brightly coloured patches with a low-cut neck with a frill and a bodice fastened with ribbons. The hat and flat sword are identical to those of Harlequin but unlike her male counterpart the female Harlequin does not wear a mask. Mrs. Booth has blue, yellow, red and purple triangular patches arranged in five or six horizontal bands around the skirt of the frock and more irregularly on the bodice and sleeves. There are red ribbons attached to the cuffs rather than fastening the bodice.

There is another version of this picture in the collection of Hester Booth's descendants at Port Eliot in Cornwall, one of three portraits of her by Ellys mentioned in the 1773 inventory of her house. It is much larger (216 × 145 cm.) and somewhat cruder than the Theatre Museum picture. The sitter is shown life-size without a background. Her left foot is prominent below a slightly shorter frock and the triangular patches are organised with more regularity. The positioning of the hands is slightly different and the face is far less attractive. Stylistically it is much closer to John Ellys's usual portraits, described by Ellis Waterhouse as 'Dreary survivors of the Kneller tradition'. It is possible that the Theatre Museum picture is by a rather more talented painter than Ellys who, clearly a favourite with the actress, was commissioned to take a copy for Mrs. Booth's own collection.

5 Attributed to Giuseppe Grisoni (1699–1769)

A Masquerade at the King's Theatre, Haymarket

Oil on canvas 71 × 93 cm.

c.1724

Provenance: Sotheby's 28 July 1948 Lot 12 (anonymous vendor); purchased by the Victoria & Albert Museum for £60

Literature: Edward Croft-Murray & Hugh Phillips 'The Whole Humours of a Masquerade' in Country Life 2 September 1949 pp. 672–5 (fig. 5).

Condition: Lined. Tacking edges brittle and split in several places. There are three old tears in the original canvas. There is loss of ground and retouching associated with these areas. Another area of ground loss 5 cm. from bottom, below the bag of coins being emptied, bottom left. Some of the darker areas seem to have been 'strengthened' and there are retouchings to some of the drying cracks.

Technique: Possibly dark grey ground on tabby weave canvas.

P.22–1948–2 Neg: HG 678/CT 16431

Sir John Vanbrugh built his opera house, the Queen's Theatre (becoming the King's Theatre when George I succeeded in 1714), in 1704–5. It was altered 1707–8 when the ceiling of the auditorium was lowered and four tiers of boxes were constructed all around. On either side of the stage were pairs of larger boxes for the use of the royal family. The boxes visible in the picture looked onto the stage itself and those nearer the auditorium looked over the orchestra. John James Heidegger (1666–1749), who was involved in the management of the theatre as early as 1707, started holding masquerades there in 1711. They were a major supplement to his income and with a profit of £4–500 from each he made £5,000 a year. They were well organised if notorious and were held initially in a large room built for the purpose to the West of the auditorium. The masquerades seem to have been moved to the stage of the theatre in the late 1710s or early 1720s; there were no opera seasons 1717–18 and 1718–19 although a detailed description of a masquerade still taking place in the Assembly Room was published on 15 February 1718. A letter from Montague Bacon to Lady Mary Montagu of 1724 (?) mentions the temporary conversion of the theatre: 'There was a masquerade on Thursday last at the Haymarket Playhouse. By laying planks over the Pit, they made a continued floor as far as the Boxes, which were blocked up with pieces of fine

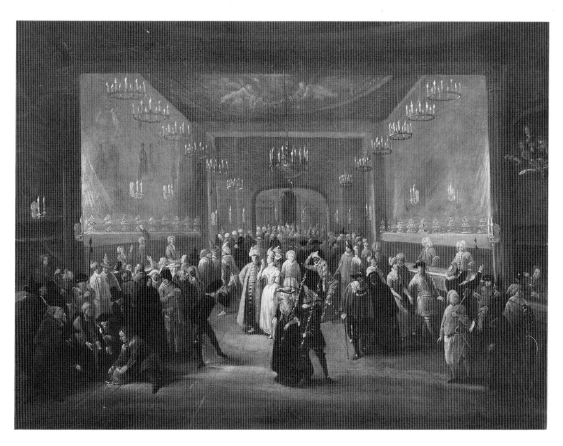

painting, and two or three of the side Boxes left open for wine and other things. 'Twas of Heidegger's projecting; the price of tickets a guinea and a half, and not only so but they that took them were obliged to subscribe too for the next.'

The stage of the King's Theatre was 100 feet deep but when grand perspective effects were required, the room beyond the stage was opened. This can be seen through the arch at the back of the picture along with the Venetian window in the South wall of the theatre. The enormous painted cloths on either side of the stage were temporary features created for the masquerades, as was the allegorical false ceiling. The lighting was also much more brilliant than would have been expected on the early eighteenth century stage.

There are several variants of the composition, one in the collection of Lord Tollemache in 1958, another in the collection of Sir Osbert Sitwell in 1949 and a third sold at Sotheby's 17 July 1985 Lot 69. The Sotheby's picture shows a much more crowded stage, a much deeper and busier forestage and two double rows of chandeliers. One or other of the versions seem to have been known to Hogarth when he produced his satirical *Masquerade Ticket* in 1727. Without a knowledge of the painting it would be impossible to appreciate the fact that Hogarth has set his scene on the stage and forestage of the King's Theatre. On either side of what should be the proscenium Hogarth has placed two 'Lecherometers' and in place of the stage boxes are niches to Priapus and Venus and Cupid. The face of Heidegger appears in a large clock-face over the proscenium; the time is one-thirty.

The picture has been attributed to Grisoni because of a remark by George Vertue (Vertue Note Books Vol. 14 B.M.16; Walpole Society *Vertue III* p. 20): 'Mr. Grisoni painter of Florence . . . he has made a fine picture representing the Masquerade with various habits'. The entry is dated May 1724. However, the picture and its companions look nothing like Grisoni's documented works, usually rather grand, highly finished and smoothly painted portraits on a large scale. Another artist must be responsible, probably with some theatrical connection. The light flickering touch suggests an artist trained in Italy or by an Italian such as Marco Ricci.

6 Jean-Baptiste Van Loo (1684–1745) (?)

Margaret Woffington

There is some doubt as to the identity of the sitter but she resembles the somewhat plainer and possibly more mature lady in Arthur Pond's indubitable portrait of Peg Woffington, engraved by James McArdell at an unknown date, probably in the late 1740s. The narrative interest of the picture is amorous rather than theatrical and the meaning of the allegory of white birds at liberty and darker birds in captivity would have been clear to contemporaries.

Oil on canvas 92 × 71.3 cm.

1740–42 ?

Provenance: Jones bequest, 1882

Exhibited: 1867 *National Portrait Exhibition*

Condition: Lined. Old repaired tears on left forearm and neck; repairs in background possibly covering tears. There is some discoloured retouching.

Technique: Cream-white ground on tabby weave canvas.

P.601–1882 Neg: HG 682/CT 16435

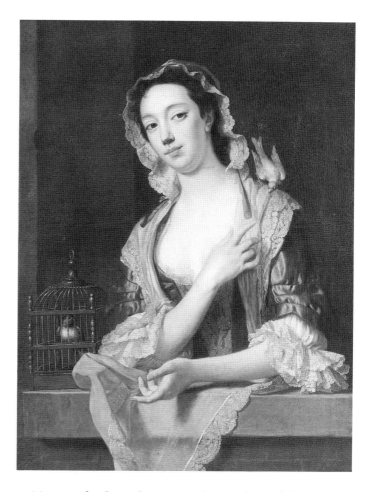

6 is one of at least three surviving versions of the portrait, and is possibly a copy of the lost original. The two other surviving versions (Coll: Sir John Hanbury-Williams, Oil on canvas 88.9 × 69.9 cm.; and Hoe Sale, American Art Association, New York 15 February 1911 Lot 68 Oil on canvas 90.2 × 71.1 cm.) show a sitter with rather more archaized features in the manner of John Giles Eccard (fl. c. 1740–1779), who was Van Loo's assistant. These two pictures show a length of velvet draped over the foreground ledge and it folds in a convincingly velvety way to the right of the cage. In **6** the velvet has been changed to lace-edged linen and the fold, which is retained, looks entirely contrived. Given the date, this anomaly may have been caused by an inattentive drapery painter. Even if it is a copy, **6** seems to be much fresher in concept and much more pleasing and direct as a portrait than the other two surviving versions. The attribution to Van Loo of one or all versions is more convincing than other candidates who have appeared over the years; Hogarth, Highmore, Knapton, Hudson &c.

7 Thomas Worlidge (1700–1766)

David Garrick as Tancred in 'Tancred and Sigismunda' by James Thomson

Garrick created the role of Tancred at Drury Lane on 18 March 1745 and played the part twenty-three times over the next few years. There were several performances in the Spring of 1752 when Worlidge painted the most important version of his portrait of Garrick as Tancred. This is a life-size, full-length version in the Garrick Club, signed and dated 1752. (247 Oil on canvas 221 × 147.3 cm.) A reduced full-length version is in an English private collection (Oil on canvas 101.5 × 72.5 cm.).

Worlidge produced an etching of the large picture, probably in 1752, and various versions showing the figure facing in the same direction as in the painting as well as in reverse had a long life in the print shops. An example in the Harvard Theatre Collection is printed on paper watermarked 1794 and another seems to be one of the several prints of Garrick re-published by T. Purland in the early 1850s. Editions of the play published in the late eighteenth century were given portrait frontispieces adapted from Worlidge's portrait, by Wenman and James Roberts for instance, even though Garrick stopped playing Tancred in 1762.

An oval Liverpool enamel transfer-printed portrait plaque of about 1778 also post-dates Garrick's last appearance in the

Oil on canvas 62.9 × 52 cm.

1752

Provenance: Rev. Alexander Dyce; Dyce bequest, 1869

Literature: Allardyce Nicoll *The Garrick Stage*, 1980, pp. 152–3.

Condition: Lined. Some of the original tacking edges remain and have been lined as part of the face of the painting. There are minor retouchings including an area at the left lower corner near elbow, over scratch mark horizontally across face, below eyes and on the left cheek.

Technique: Red brown or dark grey ground on tabby weave canvas.

D.14 Neg: HF 4510/CT 16067

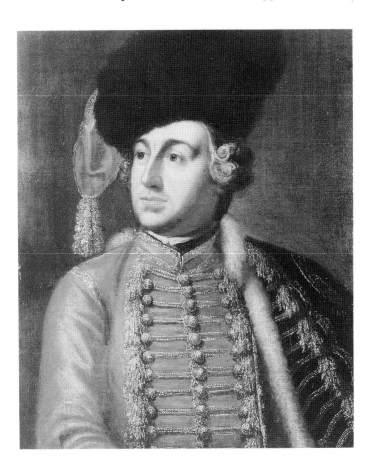

role. An example of the enamel was sold at Christie's in 1983 and another in Wolverhampton Art Gallery, show a half-length figure and reverse Worlidge's picture. However, Garrick was still playing the part when his portrait was translated into a Derby figure, produced by William Duesbury & Co. in about 1760.

Garrick's costume consists of a red hussar's tunic with quantities of silver braid and tassels. Over his left shoulder he wears a dark blue short cloak with silver braid and tassels and a white fur border. The dark fur hat has a red and silver tassel. More obviously resplendent in the full-length versions of the picture, the costume is very close to the mid-eighteenth-century dress for masquerade.

8 Benjamin Wilson (1721–1788)

David Garrick as Romeo, George Anne Bellamy as Juliet and Charles Blakes as Tybalt in 'Romeo and Juliet' adapted by David Garrick from William Shakespeare

Oil on canvas 63.5 × 76.3 cm.

c.1753

Inscribed: *CAPULET* in black paint (over tomb chamber)

Provenance: Christie's 3 August 1978 Lot 34; Iain Mackintosh; bt. 1986

Exhibited: 1979 The Old Vic, London *We shall not look upon his like again* (17); 1981 Buxton *Thirty Different Likenesses. David Garrick in portrait and performance* (28.1)

Literature: Allardyce Nicoll *The Development of the Theatre* 1927 p. 177; Raymond Mander & Joe Mitchenson (unpublished essay c.1952); Carola Oman *David Garrick* 1958 pp. 162 & 187; William Moelwyn Merchant *Shakespeare and the artist* 1959 p. 58; Kalman A. Burnim *David Garrick, Director* Pittsburgh (1961) pp. 127–40; Martin Anglesea *David Garrick and the visual arts* (M.A. thesis Edinburgh University); Lance Bertelsen *David Garrick and English painting* in *Eighteenth Century Studies* Vol. 11 No. 3 (Spring 1978) pp. 308–24; Geoffrey Ashton *Shakespeare and British Art* exh.cat. British Art Center, Yale No. 162 pp. 56–7; Iain Mackintosh *David Garrick and Benjamin Wilson, Apollo* May 1985 pp. 314–20.

The picture illustrates the moment in Act V scene iii of the Garrick adaptation of *Romeo and Juliet* when Juliet awakes: 'Where am I? Defend me, Powers!' Her lover reacts: 'She speaks, she lives, and we shall still be bless'd', and we plunge into the interpolated death scene. Since 1680 the most popular version of Shakespeare's play had been Otway's *Caius Marius* although Theophilus Cibber had also written a version, first performed in 1744. Both Garrick and Cibber followed Otway's alteration, allowing Juliet to wake up before the death of Romeo (Lavinia and Marius in Otway's play). Otherwise, Garrick's play is much closer to the original text than Otway's or Cibber's. He did, however, include a grand funeral procession and added 65 lines to the final scene.

Garrick's adaptation was written for Spranger Barry and Mrs. Cibber and they took the parts for the first time at Drury Lane on 29 November 1748. They both left Drury Lane before the start of the 1750–51 season to join John Rich and his company at Covent Garden. Rich announced his new stars in Garrick's version of *Romeo and Juliet* for 28 September 1750 and Garrick countered by announcing himself as Romeo for the same night with George Anne Bellamy as Juliet. A famous rivalry ensued and both theatres gave the play for twelve consecutive nights, an event unique in the non-musical British theatre of the eighteenth century. Garrick was regarded as the winner when his production lasted a thirteenth night. Garrick and George Anne Bellamy appeared together again as the lovers five times during the 1752–3 season, the first on 13 October 1752. The third, on 25 October 1752, coincided with a performance at Covent Garden with Spranger Barry and Mrs. Cibber as Juliet. It is probable that this performance stirred memories of the

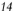

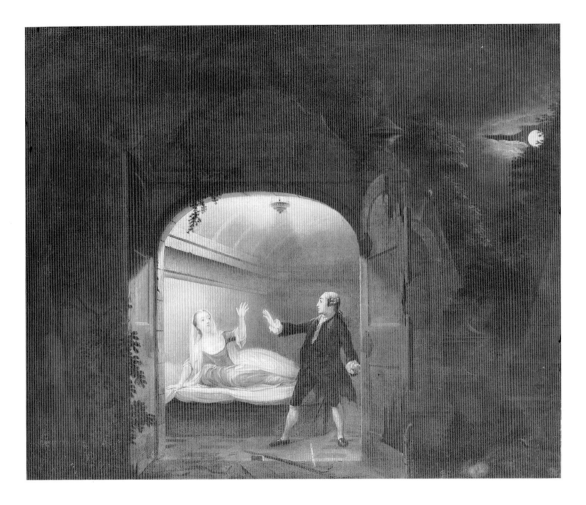

famous 1750 rivalry and possible that Garrick decided to commemorate his victory in retrospect with Wilson's picture. The performance nearest in date to Ravenet's print (see below) was given on 29 March 1753. In the autumn of 1753 George Anne Bellamy joined the Covent Garden company and Mrs. Cibber returned to Drury Lane.

There are at least three versions of this picture, with the large painting (Oil on canvas 137.2 × 190.5 cm.) in the British Art Center at Yale usually regarded as the original and the only version known to most of the authors mentioned in the literature. It is signed and dated 1753. The figure of Garrick is somewhat attenuated and that of Juliet idealised. Apart from the figures the picture is difficult to read but details such as the phial in the foreground appear to be missing. The other version, painted by Wilson for Henry Hoare in 1757 and still at Stourhead, is even more murky. **8** clearly relates very closely to Ravenet's line engraving, published in 1753 with the inscription: *Mr. Garrick and Miss Bellamy in the characters of Romeo and Juliet. Designed, printed and published by Benjamin Wilson. Engraved by S.F. Ravenet. Published according to Act of Parliament, 20th April 1753.* The picture and engraving agree as to every particular in their detail. There is a possibility that **8** was copied from the engraving but it is a picture of some quality and is more likely to have been painted for Ravenet's guidance. The print was

Condition: Lined, no original tacking edges. Good condition generally although there are extensive minor retouchings in the dark background. Some paint losses around the edges.

Technique: White or cream ground on tabby weave canvas.

S.1452–1986 Neg: HG 679/CT 16432

re-issued by Boydell in 1765 and there are undated plates by Stayner and R. Lowrie. The status of the Yale picture remains uncertain; its dawdling, vapid composition may have been rejected by Ravenet when approached by Wilson to make an engraving and the artist may have responded with the much tighter composition of **8**.

9 Philippe Jacques De Loutherbourg (1740–1812)

David Garrick as Don John in 'The Chances' by John Fletcher, adapted by George Villiers

Oil on panel 46 × 68.6 cm.

1774

Signed: 'P.I.de Loutherbourg' in black oil paint (bottom right)

Provenance: Rev. Alexander Dyce; Dyce bequest, 1869

Exhibited: 1774 R.A. (163) '*Mr. Garrick, in the character of Don John, with a view of Naples, by moon-light*'; 1968 R.A. *Bicentenary Exhibition* (1004); 1975 Hayward Gallery *The Georgian Playhouse* (36)

Condition: Minor losses at edges and a small hole on top edge left. Craque-

Garrick's version of *The Chances* was first given at Drury Lane on 7 November 1754 with Garrick as Don John. His last performance of the part in that production took place on 13 April 1758 although the play was revived for a single performance on 22 April 1772 when Cautherley played the part for his Benefit. A new production 'with great Alterations by Mr. Garrick' opened at Drury Lane on 21 April 1773. De Loutherbourg had joined the Drury Lane company at the end of 1772 and may have been involved in the designing of scenery for the play. The emphasis on the view of Naples in the R.A. catalogue entry for his portrait of Garrick as Don John suggests that the scenery was as important a consideration as the actor. The portrait was exhibited with a pendant showing Garrick as Richard III in a similar moon-lit setting (R.A.1774 (166) Oil on panel 43.2 × 64.8 cm. Christie's 20 February 1925 Lot 73).

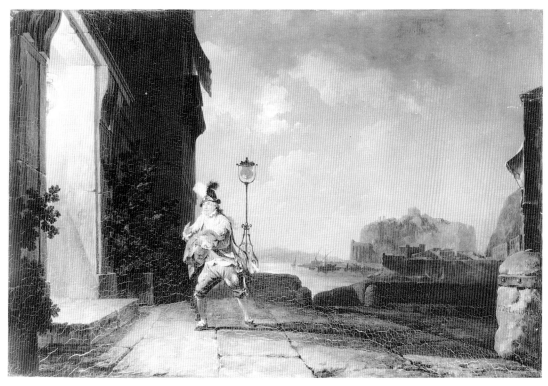

De Loutherbourg produced a number of versions of this exhibited picture. There are two repetitions of the whole composition, one in the Mander and Mitchenson Theatre Collection (1 Oil on canvas 46 × 68.5 cm.) and the other in the Victoria & Albert Museum, inscribed 'P.I.de Loutherbourg 1774' (P.46–1935 Pencil & watercolour on laid paper 29.7 × 40.9 cm.). And there are two versions depicting the left half of the composition showing the figure of Garrick and very little more: a painting in the Garrick Club (236 Oil on canvas 35 × 28 cm.) and a drawing in the British Museum (E.e.3–87 Pencil on laid paper 25.1 × 20 cm.). **9** was etched by Charles Phillip in 1775 although the plate was not published. The single figure of Garrick was engraved by Hall after Edward Edwards for Lowndes's *New English Theatre*, published by T. Lowndes & Partners 16 September 1777. Edwards probably based his drawing on the full composition rather than the smaller single figure in the Garrick Club.

The Lowndes engraving includes the quote from the play, 'What have I got by this now? – a Child!' whilst Charles Mathews, in his 1833 catalogue entry for his own version now in the Garrick Club, suggests, 'Come, good wonder, Let you and I be jogging: your strained treble will waken the rude watch else.'

lure and possible retouchings in dark areas.

Technique: Panel, one member, grain horizontal. White ground.

D.70 Neg: HF 4518/CT 16073

10 John Keyse Sherwin (1751–1790)

Sarah Siddons as Euphrasia in 'The Grecian Daughter' by Arthur Murphy

Sarah Siddons played Euphrasia throughout the provinces during the 1770s. It appeared amongst the list of her roles in a letter sent by Henry Bate to David Garrick on 15 August 1775 when he was pushing her as a prospective leading lady for Garrick. After the subsequent disaster of the 1775–6 Drury Lane season Sarah Siddons developed Euphrasia and a few other unbearably tragic roles as the mainstays of her repertory. It was one of her most triumphant roles during her four years with John Palmer the Younger's company at the Theatre Royal, Bath. She opened there as Lady Townley in *The Provoked Husband* on 24 October 1778 and left Bath only to accept Sheridan's offer to return to Drury Lane where she opened on 10 October 1782 as Isabella in *Isabella: or, The Fatal Marriage*. She played Euphrasia for the first time in London on 30 October 1782 and the role, which she repeated eleven times during the season, was a huge success. Covent Garden tried to pre-empt Sarah Siddons's expected success by presenting *The Grecian Daughter* on 23 October with Mrs. Yates as Euphrasia and John Henderson as Evander but the ruse failed and the 1782–3 Drury Lane season was the most complete success of the great Siddons career.

John Sherwin was one of the first artists to cash in on the new theatrical excitement. He engraved his own picture,

Oil on canvas 26.7 × 22.3 cm. (oval)

1782

Provenance: Rev. Alexander Dyce; Dyce bequest, 1869

Condition: Lined. Paint badly worn. Line following the curve of the oval edge along the bottom where the drawing lines of her arms, fold of material &c. are not present and there in a grey underpaint, ground or filling only. Minor unfilled loss bottom centre and retouched areas on bottom end of neck and on left shoulder, arm and breast.

Technique: Grey ground on tabby weave linen.

D.77 Neg: 59948

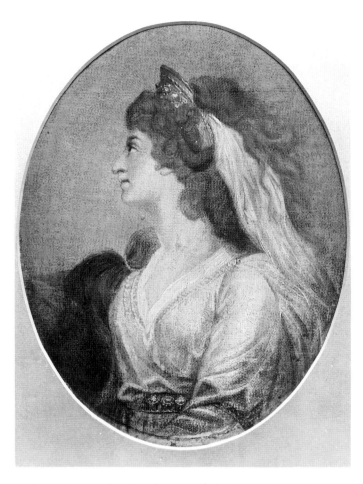

dedicated it to the Gentlemen of the Bar and published it himself, with W. Hinton on 15 December 1782. This line and stipple engraving, 24.2 × 20.3 cm., is almost the same size as the original. A smaller stipple version, 8.3 × 6.7 cm., omitting the tiara was engraved by W. Holl and published by H.D. Symonds in 1800.

11 Attributed to William Hamilton (1750/1–1801)

Sarah Siddons

Oil on canvas 35.75 × 30.75 cm.

c.1784

Provenance: Rev. Alexander Dyce; Dyce bequest, 1869

Condition: Lined. Scattered paint loss in neck and hair. Widespread craquelure in surrounding background. Cleaned and retouched April 1986.

Technique: White ground on twill

There is no doubt as to the identity of the sitter and a comparison with the facially similar portrait by Reynolds of Sarah Siddons as the Tragic Muse (Huntington Library, San Marino 21.02 Oil on canvas 236.2 × 146.1 cm.), which was shown at the 1784 Royal Academy (190), suggests a date of about 1784 for **11**. Both versions of Reynolds's Tragic Muse (the later version is in the Dulwich Picture Gallery 318 Oil on canvas 239.7 × 147.6 cm. and is signed and dated 1789) show Sarah Siddons facing to the left but the angle of turn is almost exactly the same as in **11** and the artist must have been aware of Reynolds's work. In the nineteenth century **11** was

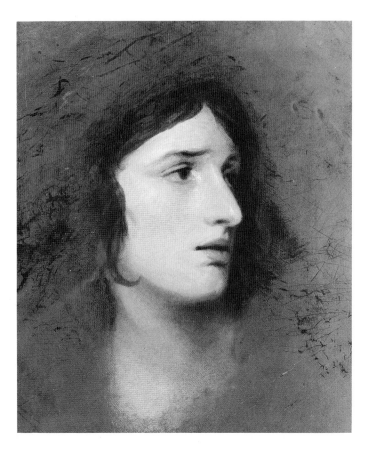

weave canvas. Much of the paint is very thin, especially forehead, both sides of face and neck with twill weave showing through.

D.76 Neg: HG 683/CT 16436

attributed to Reynolds and, despite the fact that this has been dismissed in recent years, the sketch just might have been preparatory to the large Tragic Muse. However, the thin technique and romantic approach to the subject suggest a younger painter, such as William Hamilton. Hamilton painted Sarah Siddons, and her brother John Philip Kemble, a number of times (cf. **13**). His portrait of her playing the title role in Aaron Hill's *Zara* (Sotheby's 5 February 1947 Lot 78) is datable to c.1784 and shows her turned to the right with her head almost in profile. The treatment of the eyebrows is similar to **11**, as is the dimpled chin, the dark shadow under the lower lip and the treatment of the open mouth filled with dark paint rather than teeth. On the other hand, the impressive freedom of handling seen in **11** is not something usually associated with Hamilton.

12 Gilbert Stuart (1755–1828)

John Henderson as Iago in 'Othello' by William Shakespeare

The identification of artist, sitter and part derive from a stipple engraving by Bartolozzi, one state published by John Bell in 1786 and another state published by Baldwyn of Catherine Street. It was later re-engraved in stipple by W.

Oil on canvas 53.6 × 43.2 cm.

1786

Provenance: Charles Mathews; Rev. Alexander Dyce; Dyce bequest, 1869

Exhibited: 1833 Queen's Bazaar, Oxford Street *Catalogue Raisonneé of Mr. Mathews's Gallery of Theatrical Portraits* (144); 1976 Walker Art Gallery, Liverpool *American Artists in Europe 1800–1900* (67)

Condition: Lined. Original stretcher bar marks visible on all sides. Retouched losses along bottom edge and in hair near cheek, in collar and in left centre background. Fine craquelure over whole paint surface with more pronounced cracking in areas of thick impasto such as the face, hair and shoulder. There is an area of craquelure in the background left of head which is more noticeable than the rest, suggesting overheating during lining.

Technique: Cream ground (?) on twill weave canvas.

D.26 Neg: HF 4579

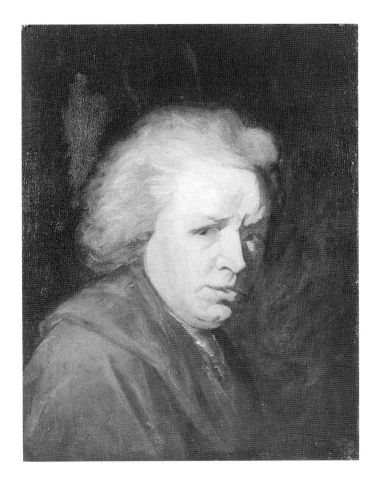

Read and appeared as a plate to *Dramatic Table Talk*. The Baldwyn print is inscribed *Stuart del*, suggesting that the original work was drawn rather than painted. This picture is likely to be No. 144 in the 1833 catalogue of Charles Mathews's pictures. Mathews's collection included four portraits by Stuart. Those of George Frederick Cooke and Alexander Pope passed into the collection of the Garrick Club in 1835 (Mathews 49 & 135, Garrick Club 135 & 681). The portrait of George Joseph Holman has disappeared and that of Henderson appears to have found its way into the collection of Alexander Dyce.

Henderson played Iago only six times in London, all at Covent Garden between 10 November 1780 and 16 May 1785. He played opposite four Othellos, including Alexander Pope and Stephen Kemble and there seems to have been altogether more continuity at Drury Lane where Robert Bensley played Iago to John Philip Kemble's Othello. However, Henderson's Iago was evidently impressive and James Boaden, in his biography of Sarah Siddons, was particularly moved: 'Henderson's Iago was perhaps the crown of all his serious achievements. It was all profoundly intellectual like the character. Any thing near this, I have never seen . . . Other Iagos were to be seen through at once . . . Though a studious man, there was no discipline apparent in the art of Henderson; he moved and looked as humour or passion required . . .'

13 William Hamilton (1750/1–1801)

John Philip Kemble as Richard in 'Richard III' by
William Shakespeare

The scene is Act V scene v; the ghosts of Richard's victims
disappear with the coming dawn:

<div align="center">

(All the Ghosts vanish)

</div>

K. Rich: (*Starts up*) Give me another horse! –
Bind up my wounds! –
Have mercy, heaven! – Ha! – Soft; 't was but a
dream;
But then, so terrible, it shakes my soul:
Cold drops of sweat hang on my trembling
limbs;
My blood grows chilly, and I freeze with
horror.

The text is largely Colley Cibber, and it was Cibber's version
of Shakespeare's play that Kemble used throughout his
career, although he did restore some of the original text and

Oil on canvas 56.5 × 41.6 cm.

1788 (original picture)

Provenance: Rev. Alexander Dyce;
Dyce bequest, 1869

Condition: Lined. Small paint loss top
left corner. There are some minor,
scattered, discoloured retouchings.

Technique: Cream ground on tabby
weave canvas.

D.75 Neg: HF 4517/CT 16072

polish Cibber's verse in the acting editions he published in 1810, 1811 and 1814. A copy of the 1810 edition in the Folger Shakespeare Library, lightly annotated by Kemble, indicates that Act V scene v, *King Richard's Tent*, was discovered behind a landscape scene. The tent was laid out in deliberate imitation of Garrick's tent, familiar to everyone from Hogarth's painting of *Garrick as Richard III* and the engraving after it. The props to be prepared were 'Couch; Table – Papers; Crown &c; Lamp &c; Armour' and the lamps were taken down before the scene opened. The ghosts came and went through downstage traps, at right, left and centre.

Kemble's first London Richard was given at Drury Lane on 6 November 1783. He also gave performances on 10 November and 15 December and, rather curiously, appeared as Richmond at Covent Garden on 29 December. He did not play the part again at Drury Lane until 14 October 1788, when he had become acting manager of Drury Lane and the holder of the part, William Smith, had retired. This means that Kemble was not playing the part when Hamilton painted his picture, shown at the Royal Academy in 1788 (22). *Richard III* was given six times in London during the 1787–88 season, all the performances were at Drury Lane and Smith played Richard in all of them. It seems as though the reference to David Garrick was not just a simple matter of the artist using Hogarth's great Richard III portrait as inspiration for his composition. Kemble, about to take over the practical running of the theatre, wanted an image that would contain a strong reference to his great predecessor at Drury Lane. Hamilton's re-write of Hogarth's composition fitted the bill admirably and the fact that Kemble had not played Richard in London for five years was inconvenient but incidental to the true message of the picture. His costume follows that of Garrick and consists of a paned doublet and hose in dark blue velvet with a red lining and edged with gold braid, over a red tunic and a sleeveless long red jacket edged with ermine. His white hose has a garter around the left leg below knee and he wears cream and pink slippers.

Hamilton's original life-size work is now in the Mander and Mitchenson Theatre Collection (22 Oil on canvas 215 × 160 cm.) and was engraved in stipple by Bartolozzi. It was published by the artist in 1790 and re-issued by the publishers Darling and Thomson in 1794 and 1814. The size, 55.9 × 41 cm., is almost identical to **13** and this suggests that the small picture is copied from the engraving. However, the quality is high and the colours are the same as those in the original version. Another version was sold at Sotheby Parke Bernet, New York 15 January 1976 (Lot 107) and measured 91.5 × 71 cm. and yet another is in the Folger Shakespeare Library, Washington D.C.

14 John Graham (1754–1817)

Richard Suett as Bayes in 'The Rehearsal' by George Villiers, Second Duke of Buckingham

Graham's picture was engraved in line by William Skelton (10.85 × 7.5 cm.) and published by George Cawthorn on 8 October 1796. It appeared as the frontispiece to the text of *The Rehearsal* in Volume 29 of Bell's *British Theatre* which had been taken over by Cawthorn in 1795. Like many of the pictures painted for Bell's *British Theatre*, the vast majority by Samuel De Wilde, the actor portrayed never played the part he is shown performing. The only London performance of *The Rehearsal* in the 1790s was at the Haymarket on 9 August 1792 when the role of Bayes was taken by Richard Wilson, who played it as part of his benefit performance. Suett was a member of the Drury Lane company where the play had last been seen on 16 December 1777 with John Henderson as Bayes. At Covent Garden there had been three performances at the beginning of the 1785–6 season with Henderson again playing Bayes. Of course, since 30 October 1779 Sheridan's *The Critic* had largely replaced the play which had inspired it on the London stage, but Suett never seems to have had a part in this updated version of Buckingham's play.

A half-length version of **14**, engraved in stipple and line by J. Rogers after a drawing by J. Smith (6.8 × 5.05 cm.) was

Oil on canvas 55.9 × 46.9 cm.

1796

Provenance: George Daniel; Rev. Alexander Dyce; Dyce bequest, 1869

Literature: *The Connoisseur* Vol. LXXIX November 1928 p. 149 (repr. in colour)

Condition: Lined. Retouching around old tacking edges, especially where they are crossed by the edges of the oval image, and around the feet of the figure. There are other minor scattered retouchings, particularly in the lower half.

Technique: White or cream ground on tabby weave canvas. The image is painted in an irregular oval, the shape of which has been altered several times, probably by the artist. The spandrels are painted or varnished with cream or pale transparent yellow through which can be seen pencilled numbers and lines that evidently relate to a squaring-up process.

D.81 Neg: HF 4519/CT 16074

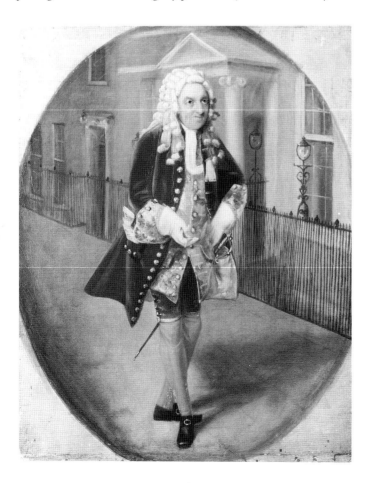

published by G. Virtue on 12 November 1825 as the frontispiece to a short biography of Suett in Oxberry's *Dramatic Biography*.

The costume dates from about 1725 and the matching cuffs and waistcoat must have been quite spectacular. It was evidently not made for Suett as the breeches are far too small; they should end below and not above the knee. The wig is a curiosity and was evidently a select item from Suett's famous collection of hair pieces.

15 After Sir Thomas Lawrence (1769–1830)

John Philip Kemble as Coriolanus in 'Coriolanus' by William Shakespeare

Oil on canvas 76.2 × 47.4 cm.

1798 (original picture)

Provenance: Rev. Alexander Dyce; Dyce bequest, 1869

Condition: Unlined. Horizontal cupping down centre of picture, especially in the drapery where the paint appears potentially unstable. Drying cracks in dark areas and to left of head. Restored tear lower right quadrant approx. centre. Small retouching in dark area lower right side. Lower left and upper right corners retouched February 1986.

Technique: White ground on medium weight twill weave canvas. Canvas stamp on reverse: *MIDDLETON 81 St Martin's.*

D.73 Neg: HF 4583

Coriolanus is shown in the hall of Aufidius's house at the beginning of Act IV scene ii, in Kemble's version of the play, where he answers Aufidius's demand to identify himself:

> *Coriolanus:* My name is Caius Marcius; who hath done
> To thee particularly, and to all the Volscians,
> Great hurt and mischief; thereto witness may
> My surname, Coriolanus.

In the previous scene his stance is described to Aufidius by an officer; 'One of exalted port, his visage hid, / Has plac'd himself beneath the statue of / The mighty Mars, and there majestick stands / In solemn silence.' Three of Kemble's prompt books survive for *Coriolanus*, two in the Folger Library and the other in the Garrick Club Library, in which the 1806 published text is marked up. Act IV scene iii is changed to scene ii and Coriolanus is 'discovered' stage left of the statue of Mars. The statue was an invention of James Thomson whose additions and alterations to the play, particularly in the last two acts were welcomed by Kemble. Thomson redrew the particularly difficult character of Aufidius and added fireworks to Volumnia's great scene in Act V.

Kemble first played Coriolanus at Drury Lane on 7 February 1789. The initial triumph was his sister Sarah Siddons's Volumnia and the play was dropped during her absence from the theatre during the next two seasons. Elizabeth Inchbald suggested that the play reflected too closely events in France and was dropped for that reason. It was played infrequently until 1806 when Kemble revived the play at Covent Garden. Kemble and Siddons played in *Coriolanus* eighteen times during the 1806–7 season and they became particularly associated with their roles in their final years on the stage. Kemble's final appearance on stage was as Coriolanus at Covent Garden on 23 June 1817.

Lawrence exhibited his large picture of Kemble as Coriolanus at the Royal Academy in 1798 (136) (Guildhall Art

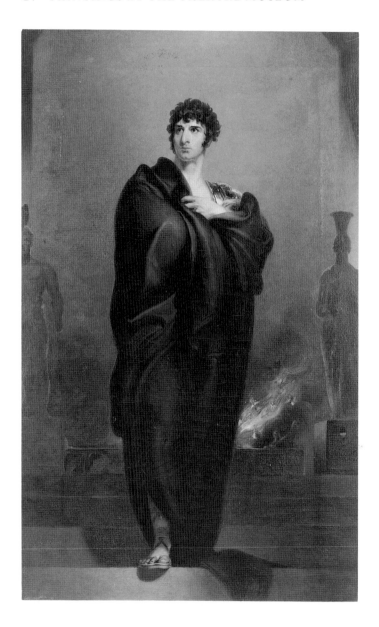

Gallery, Oil on canvas 287 × 179.1 cm.). It was the first of his four heroic images of Kemble described by the artist as 'half-history' pictures; the others followed in 1800 (Rolla in *Pizzaro* Nelson Atkins Museum and Art Gallery, Kansas City), 1801 (Hamlet, Tate Gallery) and 1812 (Cato in Addison's *Cato*, Private Coll., England). Lawrence's Coriolanus was exhibited as *Mr Kemble as Coriolanus at the Hearth of Tullus Aufidius* and the fire behind the figure of Coriolanus shows that Lawrence took his title literally. There was no fire on stage and a picture by Sir Francis Bourgeois shown at the Royal Academy in 1797 (279) and now in the Sir John Soane Museum is a much more literal reproduction of the stage scene. Not only is there no fire but the statue of Mars mentioned in Kemble's text is very large and stands on a high plinth. In Lawrence's picture the statue has been reduced to the small figure of the warrior on the left and is neatly balanced by the other figure on the right. With this arrange-

ment, Kemble has no rival; in Bourgeois's painting he looks rather weedy next to the statue.

The canvas stamp on the reverse of **15** proves that the picture could not have been painted before 1823. Jesse Middleton supplied canvasses at 81, St. Martin's Lane from 1823 to 1830; he later joined J.C. Brodie, the Brushmaker at 69, then 79, Long Acre. Somewhat surprisingly, the original painting was not engraved until 1839, when W.O. Burgess produced a mezzotint that was published by M.M. Holloway. **15** is an excellent copy of Lawrence's picture; better, for instance, than another small version in the Folger Shakespeare Library which for no good reason is attributed to George Henry Harlow.

16 After Sir Thomas Lawrence (1779–1830)

John Philip Kemble as Rolla in 'Pizarro' adapted by Richard Brinsley Sheridan from 'Die Spanier in Peru' by August Friedrich Ferdinand von Kotzebue

Oil on canvas mounted on board 42 × 28 cm.

1800 (original picture)

Provenance: Unknown

Condition: The canvas is stuck to a poor quality wooden panel with a convex warp. Delamination of the canvas from panel has caused some cracking and flaking in bottom left corner. However, the damage is slight considering the degree of canvas deformation. There are signs of cupping in various areas, especially in the extreme foreground under Kemble's left foot. There is some delamination top right edge and damage along all edges showing exposed canvas. Small flecks of gold paint from frame all over surface of painting.

Technique: Pink-beige ground on twill weave canvas.

S.808–1991 Neg: JA 751

The moment depicted takes place in Act V scene ii, described in the text as 'The Out-Post of the Spanish Camp – The back ground wild and rocky, with a Torrent falling down the Precipice, over which a Bridge is formed by a fell'd Tree'. Rolla, the Inca hero, is brought on stage in chains which Pizarro, the Spanish Conquistador, removes. He also gives Rolla a sword as befits an honourable foe. The child seen in the picture is the son of Rolla's fellow commander Alonzo. Pizarro tells his men to toss the child into the sea but Rolla snatches it and starts to rush off stage. The Kemble prompt copy in the Garrick Club and the two acting copies in the Folger Library and the Garrick Club all have the same markings and the relevant speech runs as follows:

> Rolla: Ha! [*Kemble interpolation*] Then was this sword Heaven's gift, not thine! (*Seizes the Child*) – Who dares to follow [*Kemble interpolation – original:* who moves one step to follow me] dies upon the spot. *Exit with the Child.*

Kemble runs off across the wooden bridge. He is shot but pushes the wooden bridge into the cataract and makes his escape. In Act V scene iii he delivers the child to Cora, Alonzo's wife, and expires.

This is one of many smaller versions of Lawrence's heroic canvas shown at the Royal Academy in 1800 (193). Kemble created the role of Rolla at Drury Lane on 24 May 1799 in a somewhat overblown five hour production that was surprisingly popular. The text was published by J. Ridgway who brought out twenty editions and sold 30,000 copies in 1799 alone. The lavish scenery was by Marinari, Greenwood Jnr., Demaria, Banks, Blackmore and possibly De Loutherbourg.

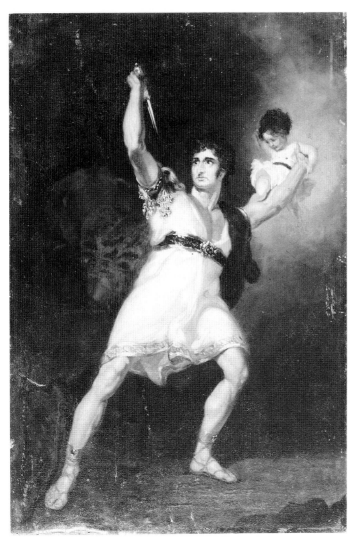

The cast also included Charles Kemble as Alonzo, Barrymore as Pizarro, Dorothea Jordan as Cora and Sarah Siddons as Elvira.

17 After Sir Thomas Lawrence (1779–1830)

John Philip Kemble as Hamlet in 'Hamlet' by William Shakespeare

Kemble made his London debut as Hamlet at Drury Lane on 30 September 1783 and his first appearance, as manager and proprietor at Covent Garden on 24 September 1803, was again as Hamlet, two years after the original version of Lawrence's picture was painted. He played the part frequently and his somewhat lugubrious style of acting was seen to excellent effect in the darker sides of Hamlet's character. It is presumably a darker side that Lawrence chose to paint. The scene is clearly Act V scene i but the exact moment has not been made clear by the painter. Hamlet holds Yorick's skull

Oil on canvas 61 × 45.5 cm.

1801 (Original picture)

Provenance: Given by Mrs. W.E. Kemble in memory of Paul Philip Kemble, 1988

Condition: Unlined. There are four recent patches on the brittle canvas, three in the top left corner and the fourth in the bottom right corner. The

patched areas do not show from the front but there is almost certainly associated loss of ground and paint. The retouching is visible neither to the naked eye nor with UV light.

Technique: Dark cream or brown ground on tabby weave canvas.

S.285–1989 Neg: JA 736/CT 25692

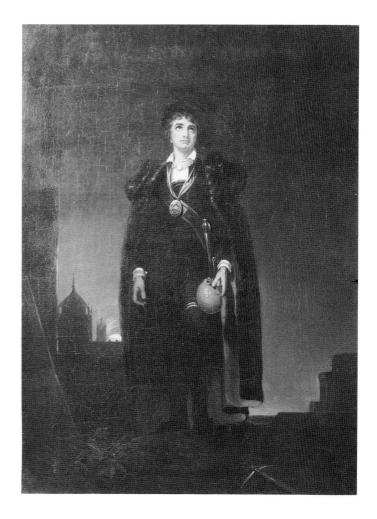

in his left hand and has presumably moved on from 'Alas, poor Yorick . . .' to the moment before the arrival of Ophelia's funeral cortège.

> *Hamlet:* Imperious Caesar, dead, and turned to clay
> Might stop a hole, to keep the wind away;
> O, that that earth, which kept the world in awe,
> Should patch a wall to expel the winter's flow
> (*A Bell tolls.*)

The sound cue is marked as coming from stage right in the Folger Shakespeare Library rehearsal book (in a copy of the play published in 1804). No doubt the spires and belfries in the background are a reference to the bell and the arrival of Ophelia. When the cortège arrives centre stage the rehearsal book includes a diagram showing Hamlet standing stage right, probably the position shown in Lawrence's portrait.

This is one of many smaller versions of Lawrence's large portrait of Kemble as Hamlet (Tate Gallery 142, Oil on canvas 306.1 × 198 cm.) which was shown at the Royal Academy in 1801 (187). Boydell published the first print of the painting in 1805 (engr. Samuel William Reynolds, Mezzotint 83.2 × 54.6 cm.) but others were being published as late as 1855.

18 Samuel De Wilde (1748–1832)

John Philip Kemble in a comic role

This picture belongs to a group of small half-length portraits of actors and actresses in character painted by De Wilde in the first five or so years of the nineteenth century. The sitter has been identified traditionally as John Philip Kemble. The jaunty pose and the vaguely seventeenth-century costume suggest a comic role but the picture is difficult to associate with Kemble's limited comic repertory.

Oil on panel 24.2 × 19 cm.

c.1804

Provenance: Rev. Alexander Dyce; Dyce bequest, 1869

Condition: Paint surface slightly wrinkled, perhaps due to excess use of oil in the medium. An old damage on the left shoulder filled and retouched. Minor scattered abrasions and dents which have been retouched and a band of minor scuffing and loss along the bottom rebate edge.

Technique: Panel, one member, grain vertical. White ground.

Inscription on verso: *Fine Art Collection No. 72* (black stamp)

D.72 Neg: JA 737/CT 25693

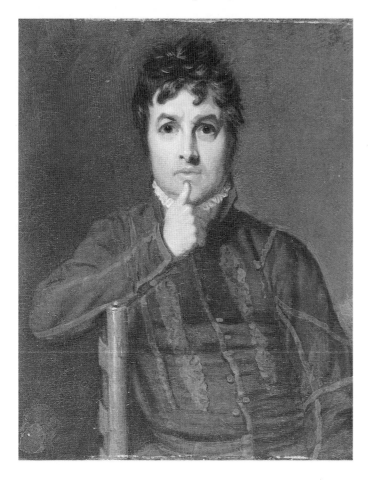

19 British School c.1810

Punch and Judy Show

The costumes suggest a date of about 1810. There are a number of unusual features; the two musicians attached to the puppet show were usually a drummer, not usually dressed in a clown's costume, and a bagpipe or hurdy-gurdy player. The marbling of the booth is also unusual. The main drama of the picture seems to concern the central trio of male figures with the flanking clown and old man and the females in the centre

Oil on panel 62 × 44 cm.

c.1810

Inscription: *MALT AND SPIRIT / STORES* in yellow and black oil paint (on wooden sign over door at right).

Provenance: Tom Kemp, by whom presented to the British Puppet & Model Theatre Guild, by whom presented to the Theatre Museum, 1979

Condition: Generally sound but several large gouges out of the front. There are numerous lesser dents. The paint losses coincide with the gouges. The paint has cracked diagonally into wide shallow approx. straight drying cracks. There is a dark abrasion running from near the top of booth to below the child's waist. Numerous minor abrasions and fairly extensive flake losses along the upper two thirds of the right edge, up to 1 cm. in width.

Technique: Panel, one member, grain vertical. Bevelled edges on all sides of verso. Highlights painted in thick impasto.

Inscriptions on verso: *This was found by Tom Kemp in Brighton. Painted about 1800 by a journeyman or signpainter. Understood to be a London street scene* (typed label on frame); *'18'* in white chalk (verso); *MUSEUM / AC / SEC-TION / P6–611/ The British Puppets: Model Theatre Guild* printed and written on orange paper label (verso); signs of a large label in centre verso but no longer there.

S.823–1991 Neg: JA 738/CT 25694

merely acting as compositional devices. Possibly the boy, having just left the ale-house on the right, is being seduced into joining the troupe of travelling entertainers.

20 Samuel De Wilde (1748–1832)

John Liston as Pompey in 'Measure for Measure' by William Shakespeare

Oil on panel 23.5 × 19.05 cm.

1812

Signed: *S DeWilde. / Pinx^t 1812.* in black oil paint (top left)

Provenance: Rev. Alexander Dyce; Dyce bequest, 1869

Exhibited: 1971 Northampton, Central Art Gallery *The De Wildes* (19)

Condition: Some paint losses around

Pompey has two outdoor scenes in *Measure for Measure* and in the second of these, Act III scene ii, he is being led away to prison. The other, Act I scene ii, in which Pompey converses saucily with Mistress Overdone, was cut in the eighteenth century but largely restored by John Philip Kemble for his production in 1794. It is Pompey's first appearance in the play and **20** seems to record the event, possibly at the lines:

> *Pompey:* Here comes Signior Claudio, led by the provost to prison; and there's Madam Juliet.

Liston played Pompey for the first time at Covent Garden on

edges and small discoloured retouchings on right arm, both hands, left cuff, dark background and sky. Fine rectangular network of craquelure with a more noticeable crack in the impasto of the forehead.

Technique: One panel member with vertical grain. White ground.

D.80 Neg: HF 4546/CT 16108

30 October 1811. Hazlitt saw him in the part in 1816 and wrote; 'We cannot say that the Clown Pompey suffered in the hands of Mr. Liston; on the contrary, he played it inimitably well. His manner of saying "a dish of some three-pence" was worth anything. In the scene of his examination before the Justice, he delayed and dallied, and dangled his answers, in the true spirit of the genius of his author.'

Liston was not noted as a Shakespearean actor and he seems to have treated his audiences to a display of broad comedy when he did attempt such roles as Pompey, the part was always billed as 'Clown', and Polonius. He was a notable Bottom in Frederick Reynolds's adaptation of *A Midsummer Night's Dream* at Covent Garden in 1816 and, in 1819, played one of the two Dromios in a musical version of *The Comedy of Errors*.

There is another version of **20** in the Garrick Club (434 Oil on panel 23 × 19 cm.), signed and dated 'S De Wilde 1812'. One or other was engraved in stipple by Thomas Woolnoth and published in August 1822 by Simpkin and Marshall as a plate to Oxberry's *New English Drama*. An anonymous full-length version of the picture was also engraved in stipple, publisher and date unknown.

The costume worn by Liston is not historically accurate as the doublet is made like a waistcoat. However, there is an evident attempt at sixteenth- or early seventeenth-century fashion and the audience would have appreciated the suggestion of another time. Pompey's servile profession is indicated by the blue apron.

21 John James Halls (1776–1853)

Edmund Kean as Richard in 'Richard III' by William Shakespeare

Oil on canvas 144 × 84 cm.

1814

Provenance: Rev. Alexander Dyce; Dyce bequest, 1869

Exhibited: 1815 R.A. (189); 1816 British Institution (90)

Condition: Stretcher bar marks on all four sides and horizontally at intervals. Canvas incorrectly tensioned upper left corner causing diagonal waves across the corner. Similar distortion upper and lower right corners with ripples over an area approx. 25 × 25 cms. Slight cupping caused by raised lines in an overall fine network craquelure.

Technique: Twill weave canvas. Reverse not inspected.

D.78 Neg: 48254

Richard is shown in Act IV scene iv when, having dispensed with the curses of his mother, the Duchess of York, and the shallow changing blandishments of his sister-in-law, Queen Elizabeth the widow of Edward IV, he first hears the news that portends his own defeat and death:

K. Richard:	Once more, what news?
Stanley:	Richmond is on the seas.
K. Richard:	There let him sink, and be the seas on him! White-liver'd runagate! what doth he there?
Stanley:	I know not, mighty sovereign, but by guess.
K. Richard:	Well, as you guess!
Stanley:	Stirr'd up by Dorset, Buckingham and Morton,

	He makes for England, here to claim the crown.
K. Richard:	Is the chair empty? is the sword unsway'd? Is the king dead? the empire unpossess'd? What heir of York is there alive but we? And who is England's king but great York's heir?

Kean's first mature appearance as Richard in London took place on 12 February 1814 at Drury Lane, shortly after his debut as Shylock on 26 January. It became his most popular part, adored by the public and a goldmine for artists. There are well over a hundred prints of Kean as Richard including Charles Turner's mezzotint after **21** (57.5 × 37.45 cm.), published 21 November 1814 and dedicated to Samuel Whitbread. There are a number of watercolour copies of Turner's mezzotint and the same engraver also produced a stipple engraving of Halls's picture showing Kean three-quarter length. It was also published in 1814.

The costume and wig worn by Edmund Kean in **21** are now in the Museum of London (53.96). The costume is a particularly good example of early nineteenth-century stage dress and consists of a long red sleeveless coat, edged with ermine and decorated with a border of gold braid, pattern of white Yorkist rose in bottom corner. Under this a paned doublet and hose, dark blue edged with gold braid and patterned with gold braid flowers, with white lining, over a long sleeved blue tunic with red cuffs, all decorated with gold braid. Ermine cap with gold crown, the crown with three vertical members at the front all edged with pearls.

22 Samuel De Wilde (1748–1832)

William Farren as Lord Ogleby in 'The Clandestine Marriage' by George Colman the Elder and David Garrick

Lord Ogleby, described in the *dramatis personae* of the play as 'an old peer, ridiculously aping the graces of youth, but kind-hearted and benevolent, withal', is shown in Act II scene ii of *The Clandestine Marriage* which is set in the garden of Sterling's country house. Sterling is showing Lord Ogleby his improvements when his younger daughter, Fanny, presents the aged guest with a nosegay.

Lord Ogleby: I'll wear it next my heart, madam! – I see the young creature dotes on me! (*Apart*)

Miss Sterling: Lord, sister! you've loaded his lordship with a bunch of flowers as big as the cook or the nurse carry to town, on a Monday morning for a beau-pot. – Will your lordship give me leave to present you with this rose and sprig of sweet-briar?

Oil on canvas 29.2 × 24.15 cm.

1818

Signed: *DeWilde Pinx / 1818* in black oil paint (bottom right)

Provenance: Rev. Alexander Dyce; Dyce bequest, 1869

Exhibited: 1971 Northampton, Central Art Gallery *The De Wildes* (22); 1973 British Council travelling exhibition *All the World's a Stage* (49)

Condition: Not lined. Numerous minor splits along tacking edges and tear at bottom right corner. Many raised lines running across paint sur-

face causing some cracking in ground. Pronounced craquelure in face, right shoulder and right arm. Paint very worn in background and around all edges. Cleaned and varnished by F. Haines and Sons, December 1903.

Technique: Cream ground on tabby weave canvas. The original tacking edges are present. They have a ground but no paint layer, indicating that the picture is its original size despite the oddness of the composition.

D.35 Neg: HF 4538/CT 16102

Lord Ogleby: The truest emblems of yourself, madam! all sweetness and poignancy. – A little jealous, poor soul! (*Apart*)

William Farren's look of utter astonishment suggests that in presenting her rose, Miss Sterling has knocked her younger sister's nosegay from his hand.

De Wilde's painting celebrates William Farren's first appearance at Covent Garden on 18 September 1818 when he played Lord Ogleby. He was the finest Ogleby since Thomas King and it became one of his best-known roles. He played the part for his farewell benefit in 1851. A watercolour by De Wilde (there are two versions; Garrick Club 214 and National Theatre 56, the latter dated 5 January 1819) shows Farren as Ogleby, full-length, wearing the same cream coat. It is a fanciful creation and as well as expressing the vanity of the character might have reminded audiences of the costume worn by running footmen, a deliciously inappropriate garb.

De Wilde's picture makes a rather lop-sided composition and when it was engraved by J. Hopwood jnr. in stipple and line, published 1818 by Simpkin & Marshall, it was reduced along the bottom to half way up the left hand and along the right side to a line running vertically from the *D* in the signature. The head alone appeared, in reverse and surrounded by clouds, in an anonymous lithograph published in December 1833 by W. Soffe as the frontispiece to the *Theatrical Orrery* No. 5. The publication is not listed in Arnott

and Robinson *English Theatrical Literature 1559–1900* (1970). The picture was adapted by R. Page in a drawing that was engraved in line by J. Rogers and published on 3 September 1825. Lord Ogleby is shown with Fanny's posy rather than Miss Sterling's rose, he is not wearing a hat and the costume is different.

23 George Clint (1770–1854)

Edmund Kean as Sir Giles Overreach in 'A New Way to Pay Old Debts' by Philip Massinger

This is a sketch for the head of Kean in George Clint's large scene from *A New Way to Pay Old Debts*, exhibited at the Royal Academy in 1820 (311) and now in the Garrick Club (355 Oil on canvas 165 × 235 cm.). Edmund Kean is shown with fourteen other figures including Thomas Attwood, Charles Bass, John Pritt Harley, Kean's Secretary Hughes, Mrs. Edward Knight, Thomas Lupton, Joseph Shepherd Munden, Mrs. Orger, William Oxberry, Sampson Penley, Snelling Powell and George Clint himself.

The moment depicted is the climax of the play in Act V when Sir Giles tries to kill his own daughter because of her disobedience and independent urges:

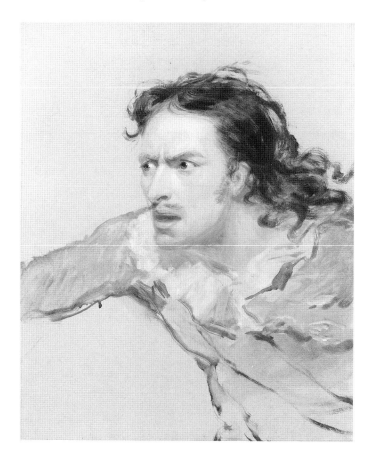

Oil on canvas 29.95 × 22.9 cm.

1820

Provenance: Mr. Blamire (?); Rev. Alexander Dyce; Dyce bequest, 1869

Exhibited: 1973 British Council travelling exhibition *All the World's a Stage* (R.N.14); 1975 Hayward Gallery, Arts Council of Great Britain *The Georgian Playhouse* (204)

Condition: Unlined. Canvas somewhat brittle. Some minor cracking of ground at turnover edge. Slight craquelure over entire surface.

Technique: Tabby weave canvas on strainer with cream ground. Very thinly painted in some areas, especially top half background.

Inscribed on verso: (brush & black ink) *624K* in large letters over *Mr. Blamire's* (?) / *Painting* in small black letters; (black stamp) *BRITISH FINE ART COLLECTIONS NO 79*. On top stretcher member (pen & black ink) 449.

D.79 Neg: HF 4523/CT 16077

Sir Giles: Village Nurses
Revenge their wrongs with curses; I'll
Not waste a syllable; but thus I take
The life which, wretched, I gave to thee
(*Offers to kill Margaret*)

There are other sketches by Clint of Kean as Sir Giles including one reproduced in *The Times* 15 May 1933 and another that used to be in the collection of Bram Stoker.

Kean played Sir Giles Overreach for the first time in London on 12 January 1816. Clint's large painting shows the cast of the revival during the 1819–20 season, with some additions.

24 George Clint (1770–1854)

William Charles Macready as Macbeth in 'Macbeth' by William Shakespeare

Oil on panel 30.5 × 24.5 cm.

1821

Provenance: Rev. Alexander Dyce; Dyce bequest, 1869

Condition: Slight convex bow in panel. Paint in good condition generally with small losses along top and bottom edges.

Technique: Cream ground. Panel, one member, grain vertical, 0.4–0.5 cm. thick. Chamfered inwards from edges approx. 3.5 cm.

Inscription on verso: *R. Davy / 16. Wardour St* (stamp)

D.74 Neg: H 1608/CT 16109

Macready gave his first Macbeth at Covent Garden on 9 June 1820 as part of his benefit; the bill also included Garrick's *Cymon*. The other players included Mrs. Bunn as Lady Macbeth, Terry as Macduff and Egerton as Banquo. The

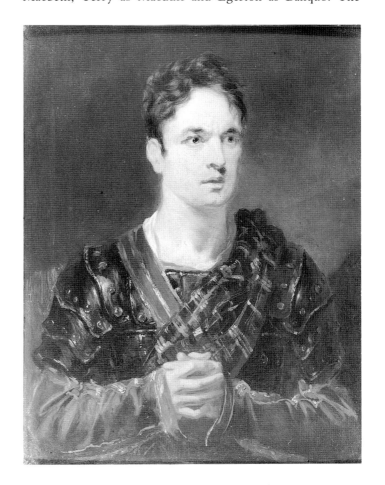

witches were played by Blanchard, Farley and Faucit. The performance was repeated on 13 June with an enthusiastic puff on the playbill: 'The Tragedy of Macbeth was acted last Friday, in which (for the first time) Mr. MACREADY performed the arduous character from which the Play derives its name, with success rarely equalled. The Tragedy will therefore be repeated this evening and Monday next, and will be acted at least once in every week during the remainder of the Season.' The play was given a third performance on 19 June but the others failed to materialise and the season ended on 17 July with *Macbeth* having been seen only three times. It was not played at all the following season at either Covent Garden or Drury Lane, presumably regarded as unsuitable fare for Coronation year.

24 was engraved in stipple, 10.05 × 7.95 cm., by W. Coutts and published by Simpkin & Marshall in 1821 for William Oxberry's *New English Drama*. At the head of the text there is a brief list of costume suggestions. Clint appears to have shown Macready in his third dress which includes 'Kelt, tartan, cap and armour' although, of course, the cap is missing and the kelt swings below the half-length format of the portrait.

25 G. Hancock (fl.1824)

William Robert Grossmith as Richard in 'Richard III'
by William Shakespeare

Richard is shown in front of his tent towards the end of Act V scene iii. Hancock was clearly aware of Halls's portrait of Kean as Richard (**21**), or more probably Charles Turner's mezzotint of the portrait, when he produced this portrait of the great actor's minute emulator. Master Grossmith holds a sword rather than a baton and he looks bad-tempered rather than balefully philosophical. The costume is similar to and probably based on Kean's although the long jacket is blue rather than red and the doublet and hose red rather than blue.

The picture is crudely reproduced in wood-cut, along with thirty-three other portraits of Master Grossmith on the frontispiece of his biography by E.C.B., *The Life of the celebrated infant Roscius, Master Grossmith of Reading, Berkshire, only seven years and a quarter old* published in Reading in 1825. The second edition with the same frontispiece increases the infant Roscius's age to 'not yet nine years of age'. It is one of the two principal portraits, to the left of the central bust of Shakespeare. The part being played on the other side of the bust appears to be Othello with the juvenile actor again emulating Kean's costume. There is no known source for any of the other figures although the Othello figure is similar to Dighton's caricature of John Philip Kemble as Rolla.

Hancock is otherwise completely unknown although this picture was engraved in aquatint by P. Roberts and published

Oil on panel 30.7 × 25 cm.

1824

Provenance: Presented to the British Theatre Museum (1969/A/108) by Andrew Faulds M.P., 1969

Inscribed: *G. Hancock Pinxt / 1825* in black oil paint (bottom right)

Condition: The panel is slightly chipped around the edges. There are touches of repaint, especially to the damaged edges.

Technique: Panel, one member, grain vertical.

S.851–1991 Neg: JA 750/CT 25706

by D. Greene. Roberts specialised, to some extent, in theatrical portraits. He engraved plates for *The British Stage* in 1821 after his own portraits of Catherine Stephens and John Liston, and his engraved work after other artists is quite extensive. The most relevant prints are the series of six character plates depicting a much more famous Infant Roscius, Master Joseph Burke who, like Master Grossmith, was born in 1818. His career began as a six year old in 1824 and he speedily collected a considerable inconography; there are thirty-one images of him in the Harvard Theatre Collection, several of them in multiple parts. Roberts's six plates were engraved with Robert Cruikshank after drawings by Thomas Charles Wageman and published by William Kenneth. They show Master Burke playing six characters in *March of the Intellect*. Clearly P. Roberts was the man to come to when a picture of an Infant Roscius was to be engraved. The two infantile careers seem to have progressed neck and neck although Master Grossmith's father was wise enough to restrict his son's career to the provinces and it is not possible to tell which image came first. The earliest dated engraved portrait of Master Burke came out in February 1825 and was lithographed by M. Gauci from Masquerier's portrait.

Master Grossmith's career began in Reading on 9 November 1824 and his performance included scenes from *Macbeth, Douglas* and *Richard III*. His repertoire was expanded over the next ten years to include numerous characters in melodramas

and comic songs. He also played the glass harmonica. His father made him a miniature portable stage with thirty changes of scenery, one of which is presumably shown in Hancock's picture. The costumes were on show to the public during the interval along with a Grand Diorama with views of Italy. In 1835 William Robert Grossmith, long in the tooth at the age of seventeen, had to give up top billing to his seven-year-old brother, Master B. Grossmith. The careers of the infant Grossmiths have been studied by Derek Forbes in an unpublished paper, inspired by the discovery of an illustrated Hertford playbill for a Master B. Grossmith performance.

26 Michael W. Sharp (fl. 1801–1840)

Maria Rebecca Davison as Juliana in 'The Honey Moon' by John Tobin

Tobin's comedy was first performed at Drury Lane on 31 January 1805 as the mainpiece of the evening followed by

Oil on panel 31.5 × 21.8 cm.

1827

Provenance: Rev. Alexander Dyce; Dyce bequest, 1869

Condition: Slight abrasions to the paint of the rebate covered edges. There are two 'score marks' with paint loss in the sky to the right of her head. A general fine network craquelure and in the sky to the right of her head a small area of drying cracks.

Technique: Panel, oak, one member, grain vertical. White ground.

Inscriptions on verso: *BRITISH FINE ART COLLECTIONS No 36* (black stamp); *39* (ink on paper label); *R.DAVY / 16 WARDOUR ST* (stamp impressed into the wood); *nan 8* (?) / *W COMPTON / LONDON W.C.; Dyce No 36* (ink); *B P. S 36* (crayon); *V&A* (biro on paper); *13* (biro on paper)

D.36 Neg: JA 752

Allingham's *Fortune's a Frolic*. It was seen 29 times during the season with Miss Duncan (Mrs. Davison) as the original Juliana. It remained popular for ten years with Mrs. Davison the usual Juliana. It was her best-known role but the part was taken by Miss Lawrence when the play was revived at Drury Lane on 30 June 1827, the first performance for ten years according to the playbill.

Sharp's painting was engraved in stipple and line, 19.5 × 14.6 cm., by Robert Cooper and published by W. McDowall on 1 March 1827. The same engraving was printed by E. Brain without the identifying letter-press.

The plot of the play is based on *The Taming of the Shrew* with Katherine, alias Juliana, eventually tamed by her husband, the Duke. Sharp has shown a moment in Act III scene iv, the interior of a rustic cottage, where the Duke drinks with his friend Lopez and is exceedingly cruel-to-be-kind and abrupt with Juliana. He asks for wine and she brings it in a horn. The Duke demands a jug which Juliana fetches. He tells her to find a better bottle and she goes out to return a third time with her jug and mug on a tray.

27 George Clint (1770–1854)

John Liston as Paul Pry, Madame Vestris as Phebe (?), Phyllis Glover as Eliza (?) and Mr. Williams (or William Farren) as Colonel Hardy in 'Paul Pry' by John Poole

Oil on canvas 127.4 × 101.7 cm.

1827

Provenance: T. Griffiths, 1828; John Sheepshanks; Sheepshanks bequest, 1857

Exhibited: 1827 R.A. (222); 1868 South Kensington *Third National Portrait Exhibition* (566)

Literature: *Art Journal* 1854 pp. 212–3 (obituary by R.W. Buss which mentions *Paul Pry* as one of Clint's principal works)

Condition: Unlined. Small paint loss middle right edge. Drying cracks in dark areas.

Technique: Buff ground on tabby weave canvas.

Inscription on verso: *LINENS* 256 under symbols of Crown & Feathers? Canvas stamp in black; *BRITISH FINE ART COLLECTIONS* No 21 (black stamp); *B/124* (in chalk); $\frac{126}{1}$ G. *Clint No 4* (in chalk).

F.A. 21 Neg: HF 4515

Paul Pry, on the right, is shown making one of his many unwelcome intrusions, this one in Act II scene ii.

Phebe: . . . (places herself at the door) No one shall enter this room; we stand upon our honour; and if you suspect my young lady's what is to become of mine, I should like to know?

Pry: Can't possibly say; but I would advise you to look after it, for I protest he is there.

Hardy: (endeavouring to suppress his anger) Sir, you are impertinent.

The lady with her back to the door is, in fact, Eliza, Hardy's demure daughter and the person concealed behind the door, unknown to Hardy, is her sweetheart Harry Stanley. The lady in pink is Phebe, the somewhat overdressed lady's maid. Paul Pry has just entered in pursuit of Stanley and has been savaged by Colonel Hardy's dogs whilst climbing his garden wall. His disarray is not evident in Clint's picture nor are Hardy's pistols called for in the text. The bag on the table is the reticule that Phebe has just snatched from Eliza and given to Paul Pry urging him to look inside for his disappearing prey.

Paul Pry was one of the great comic creations of the late Georgian period and the play one of the most popular and amusing of the nineteenth century. It was first performed at the Haymarket on 13 September 1825 when John Liston introduced what quickly became his best known character to an ecstatic public. The costume was inseparable from the part, especially the lorgnette and the green umbrella which was forever being left behind to give Paul Pry an excuse to return and have a further pry into everybody else's business.

On the last night of the 1825 Haymarket season Liston made a curtain speech saying that Paul Pry would be back the following season, bowed and left only to return a few seconds later to collect his umbrella.

The slightly stooped posture and large behind of Paul Pry became the most familiar of all theatrical icons and he was reproduced in all sorts of materials, from Rockingham porcelain to gingerbread. A 'drollery' written for Liston as Paul Pry and published in 1827 mentions some of the transformations the character endured:

> They shew me off, in every form and way;
> In paper, pewter, plaster, brass and clay;
> In tea pot, milk pot, *other* pot and jug,
> They even make me out *an ugly mug*.
> When Christmas comes, I dare say for my sake,
> They'll set me dancing on an iced twelfth cake;
> And little boys and girls, no doubt, will eat me
> Like cannibals – This is the way they treat me.

Madame Vestris was the orignal Phebe and Phyllis Glover the original Eliza. William Farren created the part of Colonel Hardy but was replaced by the less well-known Mr. Williams on 25 September 1825. Mr. Williams has no known iconography and it may be he who is represented; if Clint has portrayed Farren then the actor is very well padded.

Clint has made a practicable, and rather grandly furnished room, out of the simple set he would have seen on stage at the Haymarket. The published text gives the setting as 'A Room at Hardy's' with an open window third exit stage left and a door second exit stage right. The sturdy but imaginary doorcase is matched by the furniture which Clint has copied from two designs by Juste Aurèle Meissonier, published and engraved in Paris by Huquier c.1745. The chair and extremely *rocaille* console table are taken from a *Projet d'un Trumeau de glace pour un grand cabinet fait pour le Portugal* and the wall bracket from a *Projet de Porte d'Appartement fait pour Me la Baronne de Bezenval*. The rather silly portrait no doubt reflects the valour of the brave Colonel's ancestors and the dragonfly caught on the side of the blue vase not only adds incident and colour to the wall but also acts as a comment on the relationship between Eliza and her father.

Infra-red examination revealed evidence of a changed composition; a male head appeared above that of Eliza around whose head *pentimenti* are also visible. It seems likely that Colonel Hardy was originally placed further to the left in the composition. However, the overpainted face does appear to be rather more youthful than the one enjoyed by the Colonel in the final work.

Robert William Buss copied the figure of Mme. Vestris in a half-length portrait (Garrick Club 825 Oil on panel 32 × 24.5 cm.) and the whole composition was engraved in mezzotint by Thomas Lupton and published by Moon, Boys & Graves 1 July 1828.

28 Alexander Keith (fl. 1828–1862)

John Langford Pritchard as Duke Aranza in 'The Honey Moon' by John Tobin

Engravings of Pritchard show the distinctive mutton-chop whiskers, hooked nose and pointed chin. The head in a line engraving by C. Thomson after W.S. Watson (38.75 × 27.3 cm.) is particularly close to **28**. Pritchard is shown full-length as Rob Roy with a feather in his hat and a costume with a belt over the right shoulder and cloak over the left shoulder. The costume in **28** is similar to an embroidered tunic worn by Pritchard as Romeo in an anonymous etching, showing him full-length, standing with right arm extended.

An X-ray examination did not help in reading the underlying painting and the canvas seems to have been used to experiment with a number of ideas rather than for a specific composition.

28 is Alexander Keith's earliest known work. Otherwise, there are no indications of his career before 1846.

Oil on canvas 62.2 × 48.7 cm.

1828

Provenance: Presented to the British Theatre Museum (1969/A/108) by Andrew Faulds M.P., 1969

Condition: (22 January 1986) 'Lined. The ground is lifting along craquelure lines which extend over the whole picture surface. Tear top right corner with loss of original canvas. An old repaired tear top of forehead is lifting. There are numerous minor losses of both ground and paint at the edges and there are a number of old repaired and retouched damages particularly above and below right shoulder and along top edge. The retouchings have discoloured'. Treatment October 1986: The painting cleaned and relined. Damages filled and retouched. Revarnished.

Technique: Cream ground on tabby weave canvas.

Inscription on verso: 'Portrait of / John Langford Pritchard / as the Duke Aranza / Honey Moon' / Late of the Theatre Royal Covent Garden / Edinbro / From 1823 to 33 / Dublin from 1833 / to 1835 / TR Covent Garden 1835 / to – 1838 / returned to / Edinbro Sepr 1838 / Painted by Alex Keith Edinbro – 1828' (pen and ink very blurred and indistinct, read with the aid of an Ultra Violet photograph).

S.84–1986 Neg: HF 4635

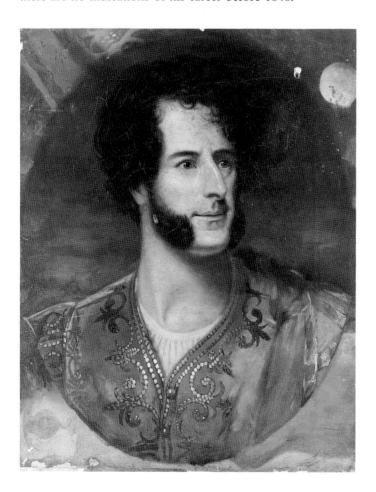

29 Attributed to Thomas Charles Wageman (1787–1863)

Ira Aldridge as Mungo in 'The Padlock' by Isaac Bickerstaffe

Oil on canvas 44.5 × 34.5 cm.

c.1833

Provenance: Given by Professor Herbert Marshall, 1958

Literature: Herbert Marshall & Mildred Stock *Ira Aldridge The Negro Tragedian* 1958 (pl. 10)

Condition: Lined. Small paint losses top left and bottom right. Retouchings on arms and background. Foreground overpainted, possibly by the artist.

Technique: Cream/white ground on tabby weave canvas.

S.1130–1986 Neg: HF 4638/CT 16184

Aldridge gave his first certain London performance at the Royal Coburg Theatre on 10 October 1825. He was billed as *Mr. Keene, Tragedian of Colour* and played Oroonoko in *The Revolt of Surinam or A Slave's Revenge*, an adaptation of Southerne's *Oroonoko*. Being a minor theatre, there was a strong emphasis on music at the Royal Coburg. Marshall and Stock suggest that in looking for a suitable singing part Aldridge came across Mungo in *The Padlock* and he gave his first London performances in the role towards the end of 1825. During the next few years it is assumed that Aldridge performed exclusively in provincial theatres although he may have appeared in one or more of the minor theatres. His patent theatre debut was as Othello at Covent Garden on 10 April 1833, only two weeks after Kean's farewell performance in the same part. He repeated his Othello on 12 April but all his other scheduled performances were cancelled, including *The Padlock* on 16 April 1833. He immediately transferred to the Surrey Theatre where he opened with *Othello* on 17 April and gave a full repertory that included *The Padlock*.

Marshall and Stock date this picture to c.1840 without

giving any sort of reason. It relates in feel and format to much earlier pictures by De Wilde and the later interpretations by Clint, Boaden and Wageman amongst others. A date somewhere between the Coburg performances of *The Padlock* in 1825–6 and those at the Surrey in 1833 makes more sense art-historically and the suggestion that Wageman is the artist is based on the doll-like characteristics of the figure, his somewhat tentative pose and the affection lavished on details of costume and decor.

Mungo in *The Padlock*, a singing role created by Charles Dibdin at Drury Lane on 3 October 1768, was Aldridge's only comic part. He was particularly admired for being able to accompany himself on the guitar. Mungo is employed by Don Diego, an old man who plans to marry the young and lovely Leonora. He keeps her locked up just in case but Mungo lets in Leander, her secret lover, lulled by a serenade and tempted by the bottle of wine he grasps in **29**. He points to the window, presumably Leander's point of access.

30 George Clint (1770–1854)

Charles Mayne Young as Hamlet and Mary Glover as Ophelia in 'Hamlet' by William Shakespeare

Hamlet and Ophelia are shown in Act III scene i. Claudius and Polonius are concealed and Hamlet has just completed his 'To be, or not to be' soliloquy when he is approached by Ophelia:

> *Ophelia:* My lord, I have remembrances of yours,
> That I have longed long to re-deliver;
> I pray you, now receive them.
> *Hamlet:* No, not I;
> I never gave you ought.

In Clint's picture it appears to be Hamlet who is doing the approaching as Ophelia has carefully positioned herself near the rosary on the table to absolve her duplicity.

Hamlet was a play particularly associated with Charles Mayne Young in the early nineteenth century. He made his London debut as Hamlet, at the Haymarket on 22 June 1807, and played it for his first appearance at Drury Lane on 17 October 1822. He also played Hamlet at Covent Garden where he took his farewell to the stage in the part on 30 May 1832. Mary Glover's first Ophelia was played opposite Young on 16 October 1826. This casting was seen six times during the season, and the last performance on 7 May 1827 was the last time they appeared together in the play. However, on 14 June 1827 Mary Glover and Young played a vignette from *Hamlet* in a revival from David Garrick's *The Jubilee* for Mr. Warde's benefit. Young's last performances as Hamlet before Clint painted his picture were at Drury Lane on 1 & 5 October 1829 with Miss Faucit as Ophelia. The

Oil on canvas 128.9 × 96.5 cm.

1831

Provenance: John Sheepshanks; Sheepshanks Gift, 1857

Exhibited: 1831 R.A. (281); 1868 South Kensington *Third National Portrait Exhibition* (571); 1982 R.A. *Royal Opera House Retrospective 1732–1982* (152)

Condition: Drying cracks in dark areas. Surface cleaned with sponge and lightly varnished by F. Haines and Sons June 1896.

Technique: Cream ground on tabby weave canvas. Unlined.

Inscriptions on verso: BRITISH FINE ART COLLECTIONS No 20 (stamp in black) 259r55/r15 ----82 RATH-BONE PLACE / BRITISH LINEN (Canvas stamp in black); $\frac{123}{1}$ in chalk); G. Clint No 2 (in chalk).

F.A.20 Neg: HF 4516

picture was exhibited as *Mr. Young in Hamlet* with no mention of Ophelia. The young lady in **30** has always been identified as Mary Glover but Miss Faucit seems to be just as good a bet. Unfortunately, she is at least as obscure as Mary Glover, being neither the Mrs. Faucit famous for matronly parts by 1831 nor her daughter, the well-known Helena Faucit who did not make her stage debut until 1836.

31 William Daniels (1813–1880)

Charles Kean as Hamlet in 'Hamlet' by William Shakespeare

Oil on canvas 60.5 × 43.3 cm.

1835

Provenance: Sir Joshua Walmsley; presented 1872

Exhibited: 1835 Liverpool Academy (101); 1960 Liverpool, Walker Art Gallery *The Liverpool Academy 1810–1867* (41)

Condition: Lined. Minor losses of ground along upper and lower edges

Charles Kean played Hamlet in Liverpool in October 1833 and also appeared there in 1835, when he probably posed for Daniels's portrait. After his success as Hamlet at Drury Lane early in 1838 Kean toured the provinces, appearing at Liverpool in November of the same year.

Shortly after Daniels painted his portrait Lord Meadowbank wrote to William Murray, the manager of the Edinburgh Theatre, in praise of Charles Kean's Hamlet. The letter is dated 31 March 1836: 'I have never seen anything on the stage so perfect as Mr. Kean's Hamlet. We may rise from reading the criticisms of Johnson and Malone, without fully

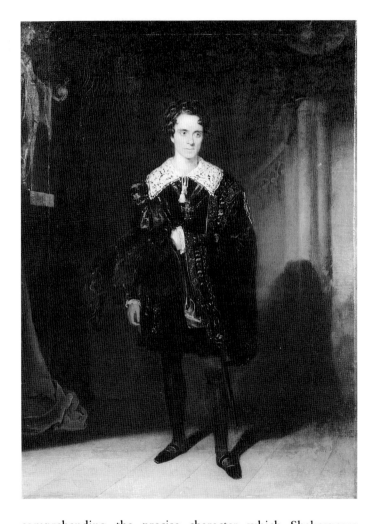

and numerous scattered retouched losses of paint; some retouchings discoloured, noticeably along the stretcher bar marks and some craquelure lines. Craquelure particularly noticeable in pale floor area. The painting does not reach the edge of the stretcher and the lining canvas has been painted (without filling) to extend the original design to the stretcher edge.

Technique: White ground with dark grey underpainting (?) on tabby weave canvas.

369–1872 Neg: HF 4522/CT 16076

comprehending the precise character which Shakespeare intended to delineate. But no one can have seen the representation of Mr. Kean, without having all his difficulties removed, and his doubts cleared away. From the beginning to the end, Hamlet is a gentleman and a prince; but a gentleman the equilibrium of whose brain has been deranged, and who, for the purpose of revenge, feigns that madness in greater degree. But he is not sensible himself of this derangement. I could not detect a single emphasis improperly placed. The recitation of all the speeches was exquisitely fine. Nothing was lost to the sense which was the most finished study could convey, and yet the audience were, to all that appeared, entirely lost sight of. In short, the identification was complete'

Kean's costume is particularly distinguished and consists of a very dark blue paned doublet and hose with paler blue lining, a dark blue cloak over his left shoulder and arm with silver braid decoration along edges and order on upper arm. Cross on red ribbon around neck, wide lace collar tied at neck with tassels.

32 Samuel John Stump (1790–1863)

Charles Kean as Hamlet in 'Hamlet' by William Shakespeare

Oil on canvas 92.3 × 72.6 cm.

1838

Signed: *S J Stump RA / 1838* in cream oil paint (top right corner)

Provenance: J.H. Leigh; A.L. Whitwam, Huddersfield, 1923; Christie's 21 November 1952 (157); James Atkinson Gallery, Sandwich; bought for the Theatre Museum, 1983

Exhibited: 1838 R.A. (727)

Condition: Lined. There is some wearing of the paint noticeable in the dark tunic. There are discoloured retouchings on forehead and other parts of the face and extensive areas of retouching around edges.

Technique: White ground on tabby weave canvas.

S.1057–1983 Neg: HF 4512/CT 16069

Charles Kean first played Hamlet on his early American tour of 1830 to 1833 and developed his interpretation during the years of provincial touring. For his mature London debut at Drury Lane on 8 January 1838 he chose to play Hamlet and was received with ecstasy by the audience and somewhat guarded pleasure by the critics. The *Morning Post* saw his performance as a combination of the Romantic qualities of his father and the Classical ones of Charles Mayne Young, with a bias towards the Romantic. Michael Nugent, in the *Times*, called Kean's Hamlet 'elegant and finished' but thought that, 'It may, however, be rendered even better. His pauses are in many instances so long that he fails to make the point at which he is aiming.'

Kean's debut inspired several portraits including **32**. E. Morton lithographed a portrait of Kean as Hamlet by Alfred Edward Chalon, published by J. Mitchell in 1838 and Richard James Lane produced a lithograph of his own drawing of Kean as Hamlet also published by J. Mitchell, in 1839. Two other, anonymous, portraits of Kean as Hamlet were lithographed by C.F. Reichert, published by Thomas McLean in

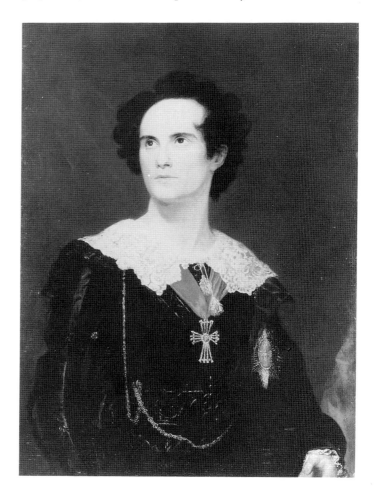

1838, and engraved in stipple by A.H. Brown for issue 325 of *Figaro in London*.

Stump exhibited five portraits of Charles Kean. The earliest and best is the Richard III in the National Portrait Gallery (1249) which was shown at the Royal Academy in 1831 (701). The costume is the same as that shown in Daniels's slightly earlier picture.

33 British School c.1840

Behind the Scenes at Astley's

The picture was given with the sitters identified as 'Twist, John Cartlich, John Widdicome and Andrew Ducrow', presumably from left to right. The ring master figure is probably John Esdaile Widdicombe, ring-master at Astley's in the second quarter of the nineteenth century; a wood-engraving published in the *Illustrated London News* on 20 May 1843 seems to show the same figure. The other figures await documented identification.

Oil on canvas mounted on board 24 × 32.5 cm.

c.1840

Inscription: *ASTLEY'S / BARR* in blue and red oil paint (poster top left); *ADOOR* (?) in red oil paint (poster top centre); *ASTLEY'S* in red oil paint (poster, top right of centre); *ASTLEY'S* in red oil paint (poster upper right).

Provenance: Presented by Dr. David Mayer III, 1989

Exhibited: 1988–89 Theatre Museum *Circus! Circus!* (10)

Condition: There are very noticeable craquelure lines along the tops of ridges in the paint which at first sight look like the severe wrinkling due to excess oil medium. The effect is caused by deeply cupped paint between extremely raised craquelure lines. However, while it appears that the paint could be unstable there is only one minute flake loss and no other signs of incipient flaking. There are cracks in both paint and ground relating to the split in the panel towards the right edge. There are some strong linear cracks mainly in the upper right corner. The small flake loss is from Harlequin's right leg.

Technique: Probably no preparation. Thick paint applied in a swirling amateurish way.

Inscription on verso: *Behind the scene's / at Astley's* (pencil on piece of canvas attached to verso); *Behind the scene's / at Astley's* (pen and ink on paper label); various illegible pencillings including *Behind* inscribed several times on the canvas.

S.474–1989

34 David Scott (1806–1849)

Queen Elizabeth Viewing the Performance of 'The Merry Wives of Windsor' at the Globe Theatre

Oil on canvas 185 × 275 cm.

1840

Exhibited: 1840 R.A. (410); 1841 Edinburgh, R.S.A. (249); 1849 Edinburgh, Posthumous exhibition of Scott's work (24); 1880 Edinburgh, R.S.A. (505); 1882 Stratford-upon-Avon, Inaugural exhibition at Shakespeare Memorial Theatre Picture Gallery (8).

Provenance: The Artist: Artist's studio, 1849; George Young; by descent; Dowell's Ltd., Edinburgh, c.1970; Tom Fidelo; bought by the Theatre Museum, 1985

Literature: James Fowler *David Scott's 'Queen Elizabeth Viewing the Performance of "The Merry Wives of Windsor" in the Globe Theatre (1840)'* in R. Foulkes (ed.) *Shakespeare and the Victorian Stage* 1986 pp. 23–38 (Illus. of ptg., engr. of ptg. and a prep. drawing).

Condition: Lined with a wax adhesive, apparently with excessive pressure and possibly also with

A view across the crowded gallery of the Globe Theatre. Falstaff and the Merry Wives are in the middle of their reconciliation at the end of the play on the stage at the right. The audience includes many of the luminaries of late Elizabethan and Jacobean England. There is much bright local colour, especially reds, yellows and blues, but drastic repainting has undoubtedly altered much of the artist's original chromatic composition. Lit from top centre whilst many of the principal figures, Queen Elizabeth, Ben Jonson and Shakespeare for instance, glow with their own inner fire.

Dr. Fowler deals exhaustively with all the points that might be raised by David Scott's Elizabethan *machine* and this catalogue entry is based entirely on his discussion of the picture. W.B. Scott published a biography of his short-lived brother in 1850 in which he described *Queen Elizabeth at the Globe Theatre* as 'the most laborious and extended exhibition of character ever accomplished' by David Scott. It was not a success at the 1840 Royal Academy, ostensibly because of bad hanging but even in 1840 the promiscuous mixture of literary figures from Sir Philip Sidney to Beaumont and Fletcher must have seemed more than faintly ridiculous. It had been widely known since the late eighteenth century that Queen Elizabeth never attended a public playhouse although Scott's main concern is, of course, the tradition that Shakespeare wrote *The Merry Wives of Windsor* so that the Queen

could see Falstaff 'in love'. Queen Elizabeth attends a performance of the play at the Globe in Robert Folkstone Williams's *Shakespeare and his Friends*, published in 1838, and the loving description of the interior of the Globe is likely to have been the immediate inspiration for the details of Scott's picture. Both Williams's novel and Scott's picture were part of the early nineteenth century fictionalisation of much British history, British heroes in general and Shakespeare in particular.

The 1840 R.A. catalogue included a descriptive passage under the entry for Scott's picture, presumably supplied by the artist:

> The tradition recorded by Rowe, that Queen Elizabeth commanded to show Falstaff in love, furnishes the historical foundation for the picture. The first rude wooden building of the Globe, the public theatre, exclusively belonging to Shakespeare's company, is supposed to be represented. Those of the characters which belong to history are introduced without strict adherence to their relative ages. In the royal box, in attendance on the Queen, are the Earl of Leicester, in armour, the Earl of Essex, and Walsingham. Towards the foreground is Sir Walter Raleigh, in a light-red dress; between whom and Shakespeare, who stands upon the landing place at the end of the seats, are Spencer, his hands on his breast, the Earl of Southampton, Fletcher and Beaumont. To the other side of Shakespeare are Ben Jonson, in a black doublet, Thomas Sackville, Earl of Dorset, and Dr. Dee, who addresses a youth. The group behind the figure of Shakespeare represents Cecil, Lord Burleigh, Mildred, his wife, and a son and daughter. In the line of seats before these, but farther from the spectator, stand Sir Philip Sidney; and higher, towards the left, Francis Bacon and Drake, Massinger, Harrington etc., are meant to be represented by other figures.

A revised description appeared in a posthumous exhibition catalogue of 1849. Dr Fowler traces a number of the sources for the figures in the picture as well as their costumes. However, in 1840 original works were not easily available even to a painter obsessed with his subject and secondary sources were almost non-existent. Scott's reconstruction of the Globe is perhaps the most interesting aspect of the picture. He shows a circular wooden auditorium, the centre open to the sky and the rest thatched. There are three levels of audience, mostly standing but with some seated in boxes in the socially elevated middle section. The stage is railed off at both front and sides and, underneath a curious fret-work pelmet at the front of the stage house, there appear to be means to work a curtain of sorts. It is a mixture of elements familiar to Scott from the contemporary theatre and the enthusiastic application of imaginative logic. The result is an auditorium that is similar in many respects to our current understanding of the Elizabethan theatre.

34 was etched by William Bell Scott 1866–7 and published

excessive heat. There are many damages but the retouching is so extensive that it is not possible to locate them all concisely. There are two particularly large tears in upper right and left corners. Large circular area bottom right, which may be a canvas inset. Detachment of lining canvas at all corners and tent-like bulge top centre where the canvas is leaving the lining. The painting has extensive drying cracks. A very hard dark varnish has been patchily removed leaving many areas of dark varnish although the ground is clearly visible through worn paint in other areas. Tears badly aligned, showing as raised lines. Damages unevenly filled. Extensive retouching of original paint although some of the fillings have only been partially retouched and show clearly.

Technique: White ground on tabby weave canvas.

S.511–1985 Neg: HG 680/CT 16433

by the Art Union of Glasgow. Much of the detail lost through decay in the original painting is perfectly legible in the print.

35 G. A. Turner (fl. 1831–1843)

Fanny Cerrito as Ondine in 'Ondine, ou La Naïade' by Jules Perrot

Oil on canvas 59.7 × 49 cm.

1843

Inscribed & signed: *Cerito / as Ondine / Shadow Dance / G A Turner / 1843* in brown oil paint (bottom left)

Provenance: Cyril W. Beaumont; bequeathed to the Theatre Museum, 1976

Condition: Lined. Wrinkles in paint in upper half of picture. Dent caused by blow centre of bottom stretcher mark. Cleaned and revarnished February 1987.

Technique: White ground on tabby weave canvas.

S.101–1986 Neg: HF 4571

35 is similar in concept to J.H. Lynch's lithograph after his own drawing of Cerrito as Ondine. Published by William Spooner on 15 August 1843 it shows her dancing with her shadow in a rather more elevated position, standing on her right *pointe*, left leg raised in fourth position back, *en l'air (demi-position)*, left arm arched above her head and right arm extended in fourth position front.

Fanny Cerrito arrived in London early in May for the 1843 season after her exhausting engagement at La Scala, Milan in which she and Marie Taglioni has been pitted against each other. Adèle Dumilâtre and Fanny Elssler were already dancing at Her Majesty's theatre but Cerrito received the ecstatic reception expected by Romantic prime ballerine when she opened her season on 9 May with a Turkish divertiss-

ement, *Les Houris*, after the first act of *Il Barbiere di Siviglia*. After the opera she appeared in the *pas de quatre* from *Le Lac des fées* and finally danced the *Pas Styrien*.

Ondine, ou la Naïade was Fanny Cerrito's first new full-length ballet of the 1843 season in London. A grand ballet in six scenes by Jules Perrot with music by Pugni, it was first performed on 22 June 1843. Set in Sicily, the story follows the fated love of the naiad Ondine for the simple peasant Matteo. She changes places with his bride-to-be, Giannina, who is temporarily lured to the bottom of the sea, but finds that being a human being is simply too difficult for a young fairy. The naiad queen reverses the swap and Matteo and Giannina live happily ever after. The ballet contained a number of mechanical triumphs such as the first appearance of Ondine, rising from the stage on a large shell, then flying through the air and disappearing into the waves. However, both these mechanical effects and the dances fitted perfectly into the action of the ballet. The most striking examples of Perrot's ability to coalesce choreography and narrative were the *pas de la rose flétrie*, a tarantella for Matteo and the fading Ondine near the end of the ballet and the *pas de l'ombre*, shown in **35**.

The *pas de l'ombre* is danced by Ondine the moment she transmogrifies into a human and discovers that she has a shadow. On a moon-lit seashore Giannina has just been lured into the sea by a group of naiads and Matteo has gone off to unmoor his boat. Miss Cerrito is shown standing on left *pointe*, right leg apparently crossed at back of supporting knee, arm to left, preparing a third arabesque.

36 After J.H. Lynch (fl.1844)

Marie Guy-Stephan dancing 'Las Boleras de Cadiz'

36 is a copy of a lithograph by C.G. Lynch, published by William Spooner 12 March 1844, after a drawing by J.H. Lynch. The artist of **36** has omitted the left background of the lithograph, the main feature of which is an accurate depiction of the Scuola di San Marco in the Campo San Giovanni e Paulo, Venice. The building has been reversed in the print indicating that in the original watercolour Mme. Stephan would have been facing the other way with the right foot front. Perhaps the figure too lost something in the translation as the dancer's position with her left arm in *demi-seconde* position looks even more uncomfortable when seen in the mirror image. The picture has been examined with X-rays, infra-red and ultra-violet but there is no sign of the Scuola di San Marco under the present paint layer.

Oil on canvas 48.2 × 39.9 cm.

1844

Provenance: Cyril W. Beaumont; bequeathed to the Theatre Museum, 1976

Literature: Beaumont & Sitwell *Romantic Ballet* p. 130 No. 86 pl. 60

Condition: Lined. There is an irregular pattern of age cracks particularly noticeable in skirt and sky. Relined, cleaned and revarnished 1986.

Technique: Cream (?) ground on twill weave canvas.

S.103–1986 Neg: HF 4581

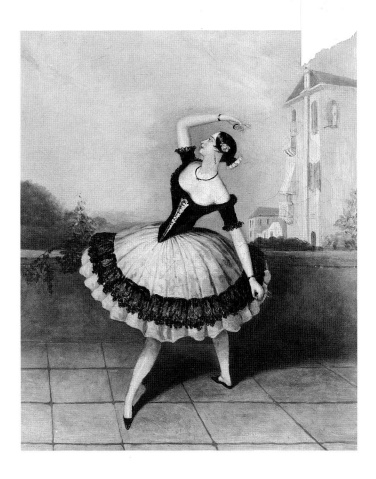

37 Possibly British School c.1848

Ira Aldridge as Othello in 'Othello' by William Shakespeare

Oil on canvas 42.8 × 34.4 cm.

c.1848

Provenance: Given by Professor Herbert Marshall, 1958

Condition: Lined. Minor losses along top edge, bottom right corner and hem of cloak. Minor flaking on upper left arm. Slight wrinkling flattened during lining.

Technique: Cream ground on tabby weave canvas.

S.1129–1986 Neg: HF 4630/CT 16178

Othello is shown addressing the Duke of Venice and his Senators in the Council Chamber, Act I scene iii:

> *Othello:* Most potent, grave, and reverend signiors,
> My very noble and approved good masters,
> That I have ta'en away this old man's daughter,
> It is most true; true, I have married her:

His principal speech in the scene, 'Her father loved me; oft invited me', in which he describes Desdemona's love and her father's admiration for him, was the most popular inspiration for painters of scenes from *Othello* in the early nineteenth century. **37** is unusually theatrical in showing Othello as he might have appeared on stage rather than treating the text in a purely literary way and transposing the scene to Brabantio's house.

Aldridge played Othello for the first time in England at the Theatre Royal, Brighton, on 17 December 1825. The portrait of him as Othello by Henry Perronet Briggs in the American

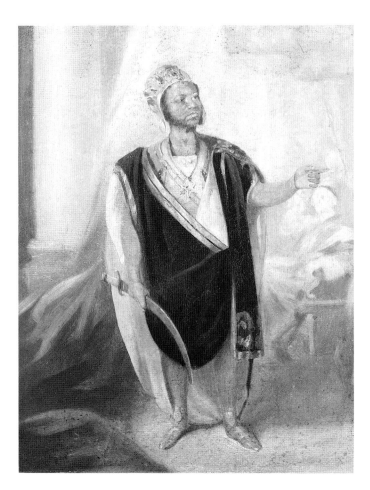

National Portrait Gallery (NPG.72.73) is usually dated
c.1826, presumably because of the Brighton performances
and also because Briggs exhibited a scene from *Othello* at the
Royal Academy in 1826 (31). However, it was almost
certainly inspired by Aldridge's two performances as Othello
at Covent Garden on 10 & 12 April 1833. Briggs shows
Aldridge wearing a green cassock-like garment, tied at the
waist with a length of rope, a red cloak over his shoulders and
a gold chain around his neck. The costume in **37** is much
more peculiar with a cloak that appears to be unique in shape,
and was evidently made up to give Aldridge an exotic and
even more African appearance. This costume reappears in a
lithograph by S. Bühler showing Aldridge playing Othello in
Frankfurt in 1852, although there the head-dress splays out
from the top of the head and does not cover the ears. A
similar costume and the Bühler head-dress can be seen in a
woodcut of Aldridge as Othello in *The Theatrical Times* for 15
April 1848. The Bühler lithograph reproduces the pose of **37**
in reverse and this, the odd way of holding the sword and the
peculiar costume, conspire to suggest a common source.

38 Daniel Maclise (1806–1870)

William Charles Macready as Werner in 'Werner: or, The Inheritance' by George, Lord Byron

Oil on canvas 174 × 100.3 cm.

1849–50

Provenance: John Forster; Forster bequest, 1876

Exhibited: 1850 Hogarth's Print Shop; Provincial tour; 1851 Royal Academy (644); 1875 R.A. *Old Masters*; 1970 V&A *Charles Dickens* (g69); 1972 National Portrait Gallery and Dublin, National Gallery *Daniel Maclise 1806–1870* (85); 1982 R.A. *Royal Opera House Retrospective* (158)

Literature: *The Times*, 3 May 1851; *Art Journal*, 1851 p.160; O'Driscoll *Maclise* pp. 100, 106; Toynbee (ed.) *Diaries*, 1912 vol. ii, pp. 440–1

Engr: C.W. Sharpe pub: J. Hogarth 1852 Line 47.2 × 31.75 cm.

Condition: Unlined. losses at extreme edges, possibly caused by the picture being framed originally whilst still wet. Minor flaking in bottom right corner and retouching in bottom left corner. Tenting caused by old water-stain on back of canvas but paint adhesion sound. General craquelure.

Technique: Cream ground on tabby weave canvas.

F.21 Neg: HF 4521/CT 16075

Werner is shown with Josephine, his wife, in Act I scene i. The scene is 'The Hall of a decayed Palace near a small Town on the northern Frontier of Silesia – the Night tempestuous' and Werner mentions the disarrayed wall-hanging with almost his first words: 'Tis chill; the tapestry lets through / The wind to which it waves: my blood is frozen.' They are both morose about the rigours of life in general and the loss of their son, Ulric, twelve years previously in particular. The picture evokes the mood of the scene without representing a particular moment but Werner's curious gesture to his chest may refer to his reaction on hearing a loud knocking:

Josephine: Who can it be at this lone hour? We have
Few visitors.
Werner: And poverty hath none,
Save those who come to make it poorer still.
Well, I am prepared.

(*Werner puts his hand into his bosom as if to search for some weapon*)
Josephine: Oh! do not look so. I
Will to the door, it cannot be of import
In this lone spot of wintry desolation –

The 1851 Royal Academy catalogue takes a more general approach to the subject and quotes Josephine in Act I scene i with:

'Who would read in this form
The high soul of the son of a long line?
Who, in this garb, the heir of princely lands?
Who, in this sunken, sickly eye, the pride
Of rank and ancestry? In this worn cheek,
And famine hollow'd brow, the Lord of halls
Which daily feast a thousand vassels' &c.

Macready gave his first performance as Werner in Bristol on 25 January 1830 and it was seen in London during his next engagement at Drury Lane which began on 18 October 1830. He had been playing the part at the Haymarket in the autumn of 1849, just before being painted by Maclise. The season at the Haymarket had ended with a performance of Macbeth on 8 December ('– the last night of my first series of perform-ances previous to my retirement.') and Macready went on a brief tour of the provinces before sitting to Maclise on 27 December ('Went to Maclise and gave him a long sitting') and 29 December ('Went in carriage to Maclise, sat to him. . . . Returned to Maclise and sat or stood in the dress of Werner for him. He showed me his study – most beautiful – of the Great Picture he designs, "The Marriage of Strongbow and Eva." Forster stopped me going away and after returning to see the study went with me home.')

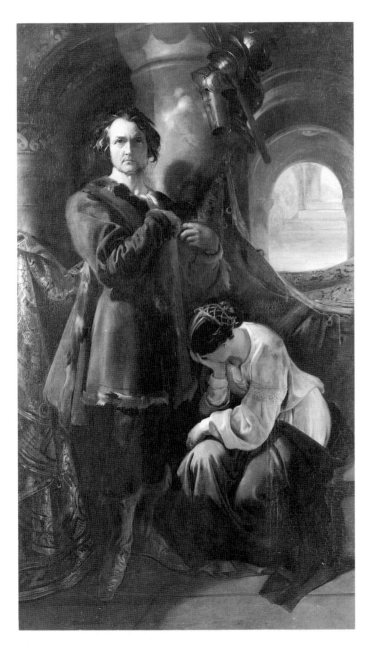

The portrait was painted for Forster in exchange for an earlier picture by Maclise, *Macbeth and the Weird Sisters; Macready as Macbeth* which was shown at the Royal Academy in 1836 (22). This picture, never a favourite with the sitter, was recalled by Maclise after a letter from him to Forster dated 1 August 1849 (Forster Mss.44) indicated that the artist was also unhappy with the work. *Werner* was finished by March 1850 and followed Macready around the country on the first of his farewell tours, attracting subscriptions for an engraving. This was eventually produced by C.W. Sharpe and published in 1852 by J. Hogarth at whose print shop the picture had been exhibited initially in 1850. The picture was a commemorative tribute on a grand scale, recalling the earlier portraits of Kemble by Lawrence.

39 Attributed to Thomas Chambers (c.1808–1868)

'The Penny Show'

Oil on board 19 × 30.7 cm.

c.1850

Inscribed: *ADMISSION ONE PENNY* in black oil paint on white (centre left).

Provenance: Dealer in Bradford; Private Collection, Yorkshire (?); Christopher Wood Gallery; bought by the Theatre Museum, 1984

Condition: Diagonal crease top left corner.

Technique: Cream ground on prepared cardboard.

Inscription on verso: *J Tonks & Sons Ltd / Depository – Scarboro' No 27911 / oil painting in / Gilt Frame / 'The Penny Show'* (label)

S.271–1984 Neg: HF 4572/CT 16132

The picture shows fourteen figures and a dog on the outside parade of a Penny Theatre, a wooden platform with a ramp or steps up from bottom centre. The facade of the theatre itself is tripartite with four roughly carved columns, supporting segmental arches either side. The Showman stands centre with a switch in his right hand and gesturing to the theatre with left hand. The group of four performers on the left consists of an Acrobat sitting on the edge of the platform, a Clown holding a banner inscribed *ADMISSION ONE PENNY* with a stage Hero who is splendidly dressed in a silver and plumed helmet, a blue cloak lined in white, gold chain-mail doublet with purple skirt edged in white fur, brown gauntlet and large boots. The fourth performer in the group is a Dancer with flowers in her dark hair and wearing a blue short-sleeved off-the-shoulder frock. Five spectators push into the theatre beyond the figure of a young Acrobat who dances balanced on his right foot. To the right of platform a Dancer sits putting on her shoes next to a large drum with a coat of arms and a mysterious bearded man with a top-knot. He stands behind a table or chest decorated with metal plaques and a green top on which he rests his left hand and to which he gestures with right hand. To the left another bearded man with white turban and Arab dress. Painted show-cloths line the avenue seen on the right.

Thomas Chambers was, according to Christopher Wood whence derives the attribution, a painter of rustic subjects and coastal scenes. He exhibited at the Royal Society of British Artists from 1849 to 1858 from addresses in Scarborough and

London. He later became a male-milliner. The label on the verso supports the Scarborough connection but is hardly conclusive. In her 'Victorian Portable Theatres' Josephine Harrop lists the northern venues of several travelling theatre companies but none of them seem to have visited Scarborough between 1832 and 1857.

However, the companies she mentions – Sam Wild, William Thorne, Matthew Wardhaugh and Billy Purvis – were all rather grander than that shown in Chambers's picture. The venues for these travelling theatres nearest to Scarborough were Leeds, Bradford, Knottingley and Halifax.

40 Alfred W. Elmore (1815–1881)

Scene from 'Macbeth' by William Shakespeare

Charles Kean's lavish production of *Macbeth* opened at the Princess's Theatre on 14 February 1853 after a royal preview at Windsor Castle on 4 February. Inspired by the success of his 1852 *King John* Charles Kean spent a great deal of time and money convincing himself and his audience that he was creating an 'historically accurate' production of the play, and the preface to the published text is full of his usual fatuous references to irrelevant source material. For instance, his justification for the use of tartan: 'Party-coloured woollens and cloths appear to have been commonly worn among the Celtic tribes from a very early period. Diodorus Siculus and Pliny allude to this peculiarity in their account of the dress of the Belgic Gauls; Strabo, Pliny, Xiphilin, record the dress of Boadicea, Queen of the Iceni, as being woven chequer-wise, of many colours, comprising purple, light and dark red, violet, and blue.'

Elmore shows *Macbeth* Act III scene iv, 'A Banqueting Hall in the Palace'. The initial stage direction in Kean's text specifically mentions 'BARDS, with harps, in gallery, C. at back'. After Macbeth has discussed Banquo's death with the Murderer and is looking forward to the banquet the stage direction reads, 'The GHOST of BANQUO rises, C.'. Elmore depicts the scene just before the ghost disappears for the first time:

> Macbeth: Pr'ythee, see there! behold! look! lo! how say you?
> Why, what care I? If thou can'st nod, speak too. . . .

The Ghost disappears by sinking into the stage and reappears stage right, in the middle of the pillar by which the Macbeths are standing in **40** for the second taunting of Macbeth. Eventually, 'The Scene Dissolves into a Mist'.

The production had extremely lavish scenery 'Painted under the Direction of Mr. Grieve' and stage machinery by Mr. G. Hodsdon. Apart from the Keans the cast included Mr.

Oil on panel 15.3 × 21 cm.

1853

Signed and Inscribed: *A.ELMORE – 53* in brown oil paint (bottom right – the *A* could be read as an *H* and the date is far from clear)

Provenance: Given by Professor Carel Weight, 1978

Condition: The surface coating is perished and discoloured which rendered the subject almost unreadable. Varnished to improve legibility 1990.

Technique: White ground? The panel appears to be the lid of a box with a small niche on the verso to facilitate movement between grooves.

Inscription on verso: *To my esteemed friends / Mr. & Mrs. Charles Kean* (pen and ink on label); *£12* (blue biro); *J20SJ15* (red biro); *S62 CE* (stamped on frame); *Works . . . 46 HANOVER STREET / J. DAVEY & SONS / Print Sellers and Pictures / Dealers, Carvers, Gilders / and / Picture Frame Makers / CHURCH HOUSE / 7 SOUTH STREET / LIVERPOOL* (printed label, partly illegible).

S.290–1978 Neg: JA 739/CT 25965

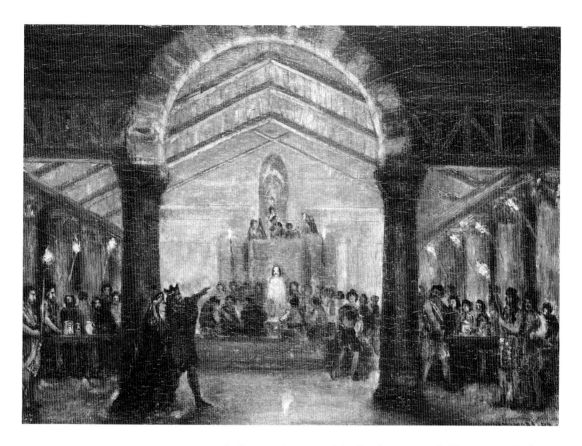

Graham as Banquo, Mr. Ryder as Macduff, Mr. J.F. Cathcart as Malcolm and Mr. F. Cooke as Duncan. Kate Terry played Fleance and the witches were Messrs. Addison, Meadows and Saker.

There is a photograph by Martin Laroche (Theatre Museum & the Garrick Club Library) of Charles and Ellen Kean as the Macbeths in the Dagger Scene, probably taken at the time of the 1 November 1858 revival. Kean has a striped short cloak over his left shoulder, chain mail over his kilt, and cross-garters. Mrs. Kean has striped decoration across the front of her dark frock and on her wide sleeves. Her veil appears to be white.

The dedication on the verso of the picture is interesting; a rare example of hard evidence of a connection between an important actor and an important Pre-Raphaelite painter. Elmore also produced a series of drawings of Charles Kean's 1858 production of *Richard II*.

The portentous nature of Kean's *Macbeth* was the inspiration for a burlesque production of the play at the Olympic with Frederick Robson as Macbeth, the text a revised schoolboy prank by Thomas Talfourd and very amusing programme notes by the manager William Farren based on those of Kean. The music was largely inspired by nigger minstrel tunes and included 'Who's dat knocking on de door?' and 'Such a gittin' upstairs'.

41 R. Emery (fl.1856)

*Frederick Robson as Gam-Bogie, the Yellow Dwarf in
'The Yellow Dwarf' by James Robinson Planché*

The dwarf appears at the beginning of the eighth scene:

> Scene Eighth. – Another part of the Enchanted Groves
> (Dwarf's Castle) – Moonlight.
> Enter Dwarf.

> Dwarf: Of ugly news there is a pretty batch,
> By submarine electric eel dispatch,
> From our own correspondent to receive!
> King Meliodorus absent without leave, . . .

The dwarf has tricked Queen Indulgenta into promising him
the hand of her daughter, Princess Allfair, in exchange for
deliverance from sundry monsters. To his surprise the
princess turns him down and quickly marries one of her
previously rejected suitors, Meliodorus, King of the Gold
Mines. The dwarf then kidnaps the princess and Haridan, the
desert fairy, kidnaps Meliodorus. The dwarf's electric eel

Oil on board 30.2 × 21.7 cm.

1856

Signed: *R Emery / 1856* in brown oil
paint (bottom right)

Provenance: Given by the family of
Harry R. Beard, 1971

Literature: Sands *Robson* p. 68, pl. 11

Condition: Damaged lower corners
repaired. Minor scattered losses
around edges and at corners filled and
retouched 1986.

Technique: White ground on prepared
composition board, 0.2 cm. deep.

S.220–1987 Neg: HF 4525/CT 16079

dispatch is correct and later, in scene eight, Meliodorus arrives to save the princess. He is killed by the dwarf but then the princess kills herself and the lovers are turned into palm-trees by Haridan. Syrena, a mermaid, arrives to turn them back into whatever they were to begin with and scene nine is set in the Throne Room in the Palace of Meliodorus in the Royal Gold Mine. The play ends with a song from the dwarf set to the music of *Villikins and his Dinah*, a song from Henry Mayhew's *The Wandering Minstrel* which Robson had made immensely popular.

The Yellow Dwarf was adapted from *Le Nain Jaune*, a fairy story by Mme. d'Aulnoye. Planché wrote his piece in rhyming couplets and called it a Fairy Extravaganza, the songs being set to music from operas such as *Der Freischütz, Norma, Oberon* and *Robert le Diable*. It was written as the 1854 Boxing Day entertainment at the Royal Olympic Theatre and was such a great success that it remained in the evening bill for 122 performances. Robson was presented with an inscribed silver cigar case on the 122nd. night, 26 May 1855, by Alfred Wigan, the manager of the Olympic. Queen Victoria is said to have seen the piece five times. Robson was particularly suited to the part as he was only five foot high with an unnaturally large head and it became one of his best known roles.

G.A. Sala, writing in *The Train* 1857, described Robson playing Gam-Bogie as the 'jaundiced embodiment of the spirit of oriental evil: crafty, malevolent, greedy . . . you laughed and yet you shuddered. He spoke in mere doggerel and slang. He danced the Lancashire hornpipe, he rattled out puns and conundrums. Yet he did manage to infuse . . . an unmistakably tragic element'. According to Mollie Sands, such was the terror engendered that the audience often became hysterical. The costume was clearly designed to emphasise the ghoulish aspects of Robson's dwarfish figure. The yellow body-paint added to the effect.

42 Albert Joseph Moore (1841–1893)

An Ancient Greek Audience watching a performance of 'Antigone' by Sophocles

Tempera on canvas 203.2 × 881.5 cm.

1867

Provenance: Commissioned by Lionel Lawson 1867; apparently passed with the lease of the theatre to Henry Labouchere, 1867; given to A.L. Baldry 1901; presented to the Victoria & Albert Museum 1902

Literature: *The Builder* 5 October 1867 pp. 728–9; *Building News* 18 October

Moore's large classical frieze was painted to go above the proscenium of the Queen's Theatre, Long Acre. The theatre, the largest in London after Drury Lane and the two opera houses when it opened in 1867, was designed by C.J. Phipps and constructed within the shell of an earlier building, the St. Martin's Hall. The second St. Martin Hall, Long Acre opened on 6 January 1862 and replaced the earlier hall which had been badly damaged by fire in 1860. The building contained two performance spaces and in 1864 there was an attempt to turn the small hall into a theatre.

This fit-up was advertised for hire and eventually it was

decided to convert the entire building into a larger theatre, a decision announced in *The Era* on 19 May 1867. With typical mid-nineteenth century efficiency the building was gutted and Phipps's circular auditorium opened on 24 October 1867 with Felix Dale's one-act farce *He's a Lunatic* followed by *The Double Marriage* by Charles Reade. The theatre is described in some detail in the sources listed in the literature but the point to remember when visualising the position of the Moore frieze is that it was contained within the drum that supported the shallow dome of the ceiling, and that it was separated from the rectangular proscenium by the very deep, curved entablature which was supported in part by the giant order pilasters on either side of the stage. The entablature, which continued in a circle around the whole theatre to form the gallery front, seems to have had something of an overhang and the frieze must have been difficult to view from the pit. However, it would have been perfectly visible from the expensive seats in the dress circle and the upper box tier and much more visible than the activities on stage to the inhabitants of the amphitheatre. Moore's frieze was complemented by William Telbin's drop curtain which showed, '. . . a Greek temple, very beautifully painted in a medallion, set in a frame of lace and fringed with amber drapery.'

Moore's picture shows sixteen full-length figures all, apart from one naked boy, swathed in classical drapes. Three players perform standing at far left, back view of male at left gesturing to two females with his right hand. A vase of flowers on a stand separates the players from the thirteen figures in the audience all facing to the left. Three figures are seated, one lounges on a couch and the rest are standing. Moore's sketch for the frieze is in the Victoria & Albert Museum. Above the performing figures on the left of the composition are inscribed the names *Chorus, Antigone* and *Oedipus*, suggesting that the play depicted is Sophocles's *Oedipus at Colonus*. However, both figures on the right of the

1867 pp. 719–20; *The Morning Advertiser* 25 October 1867; *The Illustrated London News* 26 October 1867 p. 457; *The Illustrated London News* 8 February 1879; A.L. Baldry *Albert Moore, His Life and Works* 1894 p. 36; Raymond Mander & Joe Mitchenson *Lost Theatres of London* 1976 (revised ed.) pp. 146–7

Condition: Lined November 1986. Badly damaged with extensive paint loss at the end of the nineteenth century and restored between 1902 and 1905. Overpaint was applied indiscriminately on top of original paint and bare canvas. The overpaint has darkened. The picture appears to have been rolled up from the left where the greatest proportion of original paint remains although there were scratches and a circular tear in the base of the canvas. The worst paint loss is on the right of the canvas where at least 75% of the original paint has disappeared.

Technique: Chalk ground on coarse tabby weave canvas. Samples taken showed white, pale blue or flesh coloured underpaint. Analysis found the paint medium to be egg with a small amount of an animal glue. There is a very thin transparent surface layer which may be glair.

249–1902 Neg: 27380

group are clearly female and, as the reporter in *The Morning Advertiser* for 25 October 1867 noted, Moore has painted '. . . a fine scene from the "Antigone"'. The figure on the left is Creon, the central figure Antigone and the bowed figure on the right her sister Ismene. Creon is venting his anger at the women because they have disobeyed his decree and have buried their brother Polynices.

Moore's reliance on the sculpted classical frieze is obvious. There may be no specific source but Moore had made a study of the Elgin Marbles during the 1860s and the principal influence must be the East frieze of the Parthenon. The central grouping on the East frieze shows twelve seated gods and it may have been Moore's intention to show a group of immortals watching the play at the left of his frieze. Some of Moore's typical poses, such as the hand to the side of the head, do not appear in classical sculpture, either on or off the Parthenon frieze. However, there are one or two specific references such as the naked boy who must have been inspired by the famous figure at the West corner of the North frieze.

Lionel Lawson, the proprietor of *The Daily Telegraph*, bought St. Martin's Hall and financed the building of the Queen's Theatre in 1867. He was presumably the source of the £200 that Moore received for painting the frieze. Lawson seems to have leased the theatre almost immediately to Henry Labouchere, the editor of *Truth*, who then went on to buy the theatre in 1871 in order to give his wife, the actress Henrietta Hodson, a permanent field of display. After a disastrous production of *The Last Days of Pompeii* Labouchere let the theatre to a number of dramatic and musical managements but none was really successful. The last performance was given on 13 July 1878; Labouchere must have removed the frieze before he sold the theatre at the end of the year as the auditorium was demolished early in 1879 and the building converted into the stores of the Universities Co-operative Association. In 1901 A.L. Baldry, Moore's biographer, found

the frieze rolled up and in the possession of Labouchere. Labouchere gave the picture to Baldry who passed it on the Victoria & Albert Museum where its precarious state caused alarm; removal from the theatre had evidently caused heavy paint loss. The picture was restored and repainted in part by W.H. Allen and/or E.J. Lambert before 1905 when it was photographed and appeared to be in good condition. At some point the frieze disappeared into a museum store whence it was rescued, dirty and degraded, in 1981.

43 R. S. C. (fl. 1876)

Edward Compton as Hamlet in 'Hamlet' by William Shakespeare

There is no doubt that the actor depicted is playing Hamlet and comparison with photographs suggests that the sitter is Edward Compton. Unfortunately, there seems to be no evidence that Compton, one of the best known comedians of the late nineteenth century, ever played Hamlet in London although he might have taken the part elsewhere. Before he founded the Compton Comedy Company in 1881 he was best known as a Shakespearean actor and played most of the lighter juvenile parts such as Cassio, Malcolm, Posthumous and Romeo. He had a season as 'leading gentleman' at the Theatre Royal, Birmingham, starting September 1876 and Hamlet could have been included in the repertory of a 'leading gentleman'. Before he started performing in London, his first appearance was at a benefit for his father Henry Compton at Drury Lane on 1 March 1877.

The picture has a photographic appearance and tests have shown that the portrait may be painted over photographic emulsion. However, no photographic source has been found.

Oil on canvas 128 × 76.5 cm.

c.1876

Signed: *RSC* (monogram) in black oil paint (bottom left)

Provenance: Compton family; presented to the British Theatre Museum Association (1970/A/87) by Anthony Pelissier, 1970

Condition: Unlined. The support is slack and wavy on left side. There is a water stain on verso from left to right across centre of bottom half of canvas and a small paper patch by the centre of the bottom bar of the stretcher. There are tiny holes lower half centre. The surface coat is patchy and somewhat blanched in some areas.

Technique: The ground appears to be dark ochre, but may have been white, on tabby weave canvas.

Label on frame: *Mr. Edward Compton*

S.812–1991 Neg: JA 956/CT 25710

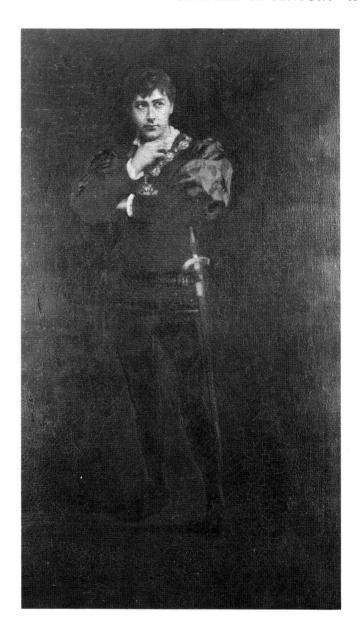

44 Stanley Lathbury (fl. 1878?)★

Sir Henry Irving as The Flying Dutchman in 'Vander-decken' dramatised by Percy Fitzgerald and William Gorman Wills

Oil on canvas 66 × 45.5 cm.

c.1878

Provenance: Given by the artist to Murray Carrington; given to the

Vanderdecken was advertised as 'A New Romantic Poetic Play' and opened at the Lyceum, under the management of Mrs. H.L. Bateman, on 8 June 1878. Irving played the Dutchman with Mrs. Fernandez as Nils, the Pilot and Isabel Bateman as his daughter Thekla. The cast also included Arthur Wing Pinero as Alden Jargas. The 'New Characteristic Scenery' was

★ A later date is more likely if the artist is the actor Stanley Lathbury (as the inscription on the back of the painting suggests). Born in 1873 he was still performing in 1949. (Ed.)

by Hawes Craven with the music arranged by Robert Stoepel. Wagner's opera, with his own libretto based on Heinrich Heine's *Memoirs of Herr von Schnabelewopski*, was first performed at the Dresden Hofoper on 2 January 1843 but was not seen in London until 1870 when it was given in Italian at Drury Lane. It was the first opera by Wagner to be heard in England and in 1876 was given in English by the Carl Rosa Company at the Lyceum. Presumably these performances in English persuaded Irving that a spoken version would give him a success. In the event, without Wagner's sublime music

British Theatre Museum Association (1959/W/17), 1959

Condition: The canvas is slightly embrittled. There is a small tear in the hat, top of brim upper left quadrant. There is a protruberance due to a foreign body between the stretcher and canvas close to bottom edge approx. 7 cm. from lower left centre. This has produced a distortion and a small hole. There is loss of paint and

ground associated with these two damages and there are stretcher bar marks on all four sides. Numerous spots and runs on the surface have caused blanching of the paint in some places.

Technique: White ground on tabby weave canvas.

Inscription on verso: *Presented to / MURRAY CARRINGTON / BY ACTOR artist / who painted it himself / Stanley Lathbury / BENSONIAN CO.* (black ink); pasted onto the verso is a newspaper cutting with photographs of *Three of IRVINGS Most famous roles; Wolsey in 'Henry VIII', Mathias in 'The Bells', Vanderdecken in 'The Flying Dutchman'.*

S.813–1991 Neg: JA 740/CT 25696

to emphasise the drama and obscure the plot the play was thought altogether too sombre and silly and the part of the Dutchman entirely unworthy of Irving. His next part, the title role in *Jingle* which opened on 8 July 1878, was more of a success and at the end of the year he took control of the management of the Lyceum. His reign began with *Hamlet* on 30 December 1878.

44 is a highly coloured copy of a photographic original. There are several examples of the photograph in the Percy Fitzgerald Collection in the Garrick Club. Vol. v, p. 144 and in the Theatre Museum. A drawing of Irving as Vanderdecken by R. Blun, signed and dated 1880, is reproduced in Walter Calvert's *Souvenir of Sir Henry Irving*, 1895. It is similar to **44**.

45 John Dawson Watson (1832–1892)

Rosalind Preparing to Leave Duke Frederick's Palace 'As You Like It' Act I scene iii by William Shakespeare

Oil on canvas 45.8 × 21.5 cm.

1881

Signed: *J.D.W. 1881* in black oil paint (bottom left)

Provenance: Harry R. Beard; given by the family of Harry R. Beard, 1971

Acquired by Harry Beard and given to the Theatre Museum as an unidentified theatrical portrait. In fact, **45** is one of the many idealised portraits of Shakespeare heroines so beloved of late nineteenth-century British artists. Although the iconography of this picture does not immediately suggest Rosalind – Viola in 'Twelfth Night' seems more likely at first sight – a picture sold recently at Christie's firmly identifies the character.

This picture, which appears to be a pendant to **45**, was sold on 13 October 1978 Lot 192 as 'The Message'. It is signed with Watson's initials and dated 1881 in exactly the same manner as **45** and is exactly the same size as the Theatre Museum picture. The model appears to be the same and she wears the same costume. She is shown full-length to the right, standing under a tree, leaning on a spear held in her right hand and reading a message on a sheet of paper held in her left. The red hat of **45** has been replaced by a wreath of leaves and the belt is fastened more tightly but the rest of the costume appears to be the same down to the rather complicated strapping of the boots. The Christie's picture evidently shows Rosalind in the Forest of Arden, *As You Like It* Act III scene ii, reading one of the poems with which Orlando had been festooning the forest earlier in the scene. There is no moment in the play when Rosalind wears male attire indoors but Watson takes Rosalind's words at the end of the first act of the play as read and shows her about to go find her father in the Forest of Arden.

> Were it not better,
> Because that I am more than common tall,
> That I did suit me all points like a man?
> A gallant curtal-axe upon my thigh,
> A boar-spear in my hand; . . .

Watson, a prolific illustrator and painter of genre scenes in both oil and watercolour, was not especially known for his interest in Shakespeare or the theatre. However, he did design furniture and costumes for a production of *Henry V* in Manchester in 1872, and an amusing scene from *Twelfth Night* was sold at Christie's 14 May 1976 Lot 64. Called by the cataloguer *The Plague of her Life*, it shows Maria with a bed-pan scolding Sir Toby, Sir Andrew and Feste in Act II scene iii at: 'Maria: What a caterwauling do you keep here!'

Condition: January 1986: Unlined. Brittle canvas and weak tacking edges. Small loss bottom centre caused by trapped debris pushing forward. Slight cracking and small losses along rebate edges. Conservation, March 1986: Distortion ameliorated. Loss retouched.

Technique: Cream ground on tabby weave canvas.

S.850–1991 Neg: HF 4531/CT 16095

46 William Henry Margetson (1861–1940)

Henry Irving as Mephistopheles and George Alexander as Faust in 'Faust' by W.G. Wills, adapted from Goethe

Margetson's picture depicts the second scene of the Prologue in Wills's adaptation of Goethe's *Faust* and shows the Witch's Kitchen with the monkeys skimming the witch's brew which Faust presently drinks to regain his youth. Irving's production of *Faust* opened at the Lyceum on 19 December 1885 but the scene of the Witch's Kitchen, with scenery painted by Hawes Craven, was not added until the 244th performance on 15 November 1886, by which time the play was well into its second season at the Lyceum. It was one of Irving's greatest successes and it was played 792 times before its final performance in Bristol on 10 December 1902. The part of Faust was originally played by H.B. Conway but George Alexander

Oil on canvas 30.2 × 75 cm.

1885

Signed: *W.H. MARGETSON* in fine black ink (bottom left)

Provenance: Sir Henry Irving; Irving Sale, Christie's 16 December 1905 (95); given to the British Theatre Museum Association by Mr. W.B. & Miss J.B. Shaw, 1957

Condition: Lined. Minor abrasions along edges. Wide drying cracks in

dark areas. Paint flattened by pressure during lining.

Technique: Cream ground on tabby weave canvas.

E.23072–1957 (now transferred to Theatre Museum)
Neg: HF 4576/CT 16136

took over the part on 9 January 1886 and played it for the rest of the run.

The souvenir booklet, written by Joseph Hatton for the Lyceum *Faust*, was revised following the introduction of the Witch's Kitchen scene and five pages of text added, illustrated with three drawings by Margetson. The major drawing, *Mephistopheles introducing Faust to the Witch's Kitchen*, agrees in almost every detail with **46**. The exceptions are the broom lower right which is in a different position, the sieve which is missing in the drawing, and the three owls sitting above the monkeys and one to the right of Faust which are all fairly prominent in the drawing. It is tempting to suggest that **46** is the original of the work reproduced in the souvenir booklet. However, the caption is quite specific that the original work was drawn and not painted and the picture might easily be a refinement painted by the artist for Irving after the publication of the drawing.

Irving's Mephistopheles costume is in the Museum of London (38.19/1).

47 Hal Mansfield Murray (fl.1887)

Alma Murray as Beatrice Cenci in 'The Cenci' by Percy Bysshe Shelley

Oil on canvas 62.4 × 46.1 cm.

1887

Signed and inscribed: *Miss Alma Murray / as 'Beatrice Cenci' / a study from Life, / Hal Mansfield Murray 1887* in red and black oil paint (bottom left); *IHS* (? Monogram) *1887* in red and black oil paint (bottom right)

Provenance: Presented to the British Theatre Museum Association (1963/W/7) by Miss Elsa Forman, the niece of the sitter, 1963

Condition: (March 1986) Canvas split along whole length of top edge, brittle and buckling. Widespread fine wrinkles and associated incipient flaking and very minor paint loss especially in background. Some areas of bloom. Conservation October 1986: Paint and ground layer consolidated. Split edges repaired.

Technique: White ground on tabby weave canvas. XRF examination showed no evidence of a photographic emulsion present beneath the paint layer.

S.161–1986 Neg: HF 4139

Shelley's *The Cenci* was given a single performance by the Shelley Society at the Grand Theatre, Islington on 7 May 1886 with Alma Murray as Beatrice. The cast also included Hermann Vezin as her father, Count Francesco Cenci, Maude Brennan as Lucretia, Countess Cenci, William Farren Jnr. as Cardinal Camillo and Philip Ben Greet as Savella, the Pope's Legate. It was an extremely successful performance of the entire text and it must have been an expensive one-off production as the six acts included eleven changes of scenery. Alma Murray's frock was made by Miss Fisher.

Beatrice is shown at a particularly striking moment in Act V scene iii where, upbraiding the murderers she has hired to kill her appalling father she seizes the dagger, intent on doing the deed herself if need be.

Alma Murray's performance clearly had an overwhelming impact on the members of the Shelley Society in the audience and at least six ecstatic descriptive pamphlets were published (Arnott & Robinson Nos. 3353–7, 3360). The most considered was B.L. Mosely's *Miss Alma Murray as Beatrice Cenci*, a paper read to the Shelley Society on 9 March 1887 and published in the same year. It was possibly this pamphlet that encouraged Hal Mansfield Murray to paint his picture in the year following the original performance. However, the most sublimely purple prose appeared in the anonymous *Shelley's Beatrice Cenci and Her First Interpreter Alma Murray*, published privately in 1886:

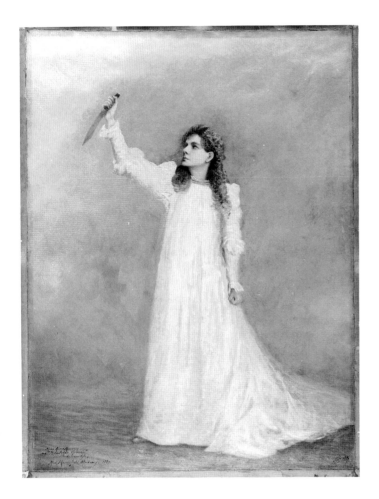

Her face, in which the perpendicular and shapely brow appeared to be almost as instinct with expression as the mouth and eyes themselves, was a continual mirror both of the outward action and of the inward soul. Ablaze with horror, poignant with supplication, or blank and blinded with despair, it offered to the spectator an unintermitting study of the only beauty *essential* to an actress, the beauty of perfectly controlled, appropriate, and affluent expression. The eyes are especially noteworthy, being of a rich, liquid, aerial brown which, in moments of culminating passion, assumes a slightly reddish tinge, and lends to the whole countenance a supernatural and almost terrifying glow, the tragic effect of which is indescribable.

48 Christine M. Demain Hammond (1862–c.1952)

Alma Murray

48 shows Alma Murray looking not unlike a photograph of her as Beatrice Cenci by A. Lorne, presumably dating from 1886. However, she appears slightly more mature, less

Oil on canvas 61 × 45.8 cm.

c.1887

Signed: *C DEMAIN HAMMOND* in pale blue oil paint (top left)

Provenance: Presented to the British Theatre Museum Association (1963/W/7) by Miss Elsa Forman, the sitter's niece, 1963

Condition: Original tacking edge reduced top and left; the *C* of the signature is partially turned over. Conservation April 1986. Strip lined. Small tears in forehead and along upper left and middle right tacking edges, repaired and retouched. Major paint losses behind the ear and in the hair (caused by glue previously on reverse of canvas) filled and retouched.

Technique: Off-white ground on tabby weave canvas.

Inscriptions on reverse: Chris: 17. Demain Hammond Clapham 33 Lansdowne Gardens S £15

S.86–1986 Neg: HF 4541/CT 16105

piggy-like and with an emphasis on her slightly upturned nose. Christine M. Demain Hammond exhibited from 1886 to 1895.

49 Walter Richard Sickert (1860–1942)

W.S. Penley as Lord Fancourt Babberley in 'Charley's Aunt' by Brandon Thomas (verso: *Harbour Scene with Fishing Boats*)

Oil on panel 36.9 × 2.3. cm.

c.1892

Signed and inscribed: (recto.) *Sickert.S.Pancras* in black oil paint (top right); (verso) *ALBION / OTEL* in green oil paint (on building upper left); *LBION / OTEL* in green oil paint (on building left of centre)

Provenance: On loan from Donald Price, 1987

Charley's Aunt was first performed at the Theatre Royal, Bury St. Edmunds, on 29 February 1892 with W.S. Penley as Lord Fancourt Babberley, Brandon Thomas as Col. Sir Francis Chesney and Ada Branson as Donna Lucia d'Alvadorez. The play opened in London at the Royalty Theatre on 21 December 1892, following the Independent Stage Society's production of G.B. Shaw's first play *Widowers' Houses*. It ran at the Royalty until 30 January 1893 and then moved to the Globe where it completed a run of 1,469 performances, a record for non-musical production until Noël Coward's *Blithe Spirit* began a run of 1,997 performances at the Piccadilly Theatre on 2 July 1941.

Condition: The portrait is in good condition. The harbour scene has suffered damage, probably from knocks and abrasion and there are scattered losses of ground and paint particularly around the edges and in the bottom corners. There is widespread drying craquelure.

Technique: Panel; one member, both recto and verso painted and with white cream ground. Painted on recto, with grain vertical; on verso, with grain horizontal.

Neg: HG 686/CT 16474

On the back of the picture there is a harbour scene showing a group of flat-ended small sailing boats sitting on the calm water of a harbour, beyond the quay a row of buildings including, on the left, the large bulk of the Albion Hotel. This scene is painted largely in subdued tones of blue and green.

50 Walford Graham Robertson (1867–1948)

Sir Arthur Wing Pinero

In his volume of reminiscences, *Time Was*, W. Graham Robertson mentions the house on the 'North Coast' that he and his mother took in the summer of 1892 with George Alexander, the manager of the St. James's Theatre. Alexander was then casting and rehearsing Pinero's *The Second Mrs.*

Oil on canvas 77.9 × 62.9 cm.

c.1892

Provenance: Kerrison Preston; given to the Mermaid Theatre, 1965; given

by Sir Bernard Miles to Theatre Museum, 1976

Condition: Unlined. Four patches on the back of the canvas associated with old tears and holes are now causing distortion. The ground is tenuously attached to the canvas and there has been extensive loss. There are large areas of retouching on the bare canvas and over paint. Conservation 1987: Ground and paint layers consolidated.

Technique: White ground on tabby weave canvas.

S.37–1976 Neg: HF 4520

Tanqueray and through him Graham Robertson met the author. Photographs of Pinero of c.1892 show him with the shiny bald pate and fresh face seen in **50** and Graham Robertson might have produced his undistinguished portrait soon after being introduced to the author.

51 Walter Richard Sickert (1860–1942)

Winifred Emery as Rosamund, Cyril Maude as Mr. Watkin and Brandon Thomas as Mr. Brabazon in 'Sowing the Wind' by Sydney Grundy

Oil on canvas 30.5 × 76.6 cm.

1893

Signed: *Sickert.* in black oil paint (bottom right)

Provenance: Brandon Thomas; by descent to Sylvia Brandon Thomas; Browse & Darby: bought by the Theatre Museum, 1984

Sickert depicts the Act III curtain. Brabazon, who is pointing so dramatically, has just discovered that Rosamund is his daughter. She has not yet realised this but has just discovered that her mother, Helen Gray, was a loose woman and because of the shame is trying to sacrifice her love for Brabazon's adopted son, Ned Annesley. Watkin, who supports Brabazon, has been trying to end the relationship just as he ended Brabazon's affair with Rosamund's mother. The setting is Rosamund's cottage at Fulham.

Brab: . . . Outcast of outcasts, by-word of the town! Baby Brabant!! (*gasps – much exhausted*)
Rosa: Don't call her that! Call things by their true names!
Brab: I know her by no other!
Rosa: Call her Helen Gray!
Brab: (*gasping – inarticulately*) Gray! Gray! (*holding his finger pointed at her – chokes*)
Rosa: (*rushing to him*) What have I done?
Brab: (*backing from her*) Bob, Bob! (*re-enter Watkin r.*) I'm choking! Bob! (*Watkin runs to him and supports him in his arms with infinite tenderness – Brab. goes into a fit, with his outstretched finger still pointed at Rosa*).

Sowing the Wind opened under J. Comyns Carr's new management at the Comedy Theatre on 30 September 1893 with the cast shown in Sickert's picture and Sydney Brough as Ned Annesley, the other leading part. The play was set in the 1830s and the three sets were designed by William Telbin the Younger (Act 1), Walter Johnson (Act 2) and W. Hann (Acts 3 and 4). The costumes were designed by Karl. Winifred Emery's Act 3 dress is seen in more detail in Aubrey Beardsley's portrait of her, published in the *Yellow Book* Vol. IV, 1894, pl. XVI. The play was revived at the Comedy on 9 March 1895 with the same leading men but with Evelyn Millard as Rosamund. It is not a good play but it has its dramatic moments, the one shown in **51** for instance, and Sickert has caught perfectly the theatrical excitement of the glow from the footlights.

Sickert painted another version of the scene which was sold by Cyril Maude's daughter at Sotheby's on 15 December 1971 (Lot 22A) and is now in an English private collection.

Exhibition: 1953, Scottish Arts Council *Sickert 1860–1942* (79)

Literature: D. Sutton *Sickert* 1976 pp. 90–1

Condition: Lined. Pronounced irregular craquelure in the blue river in the background.

Technique: Tabby weave canvas. The artist appears to have painted directly onto the sized canvas without a ground layer.

S.270–1984 Neg: HF 4639

52 Sarah Bernhardt (?)

Sarah Bernhardt

Oil on panel 35.7 × 25.7 cm.

1896

Inscribed: *a ma charmante / Maria Bernard / Souvenirs affectiants / de son ami / Sarah Bernhardt / 1896* in black ink (bottom right)

Provenance: Given by the sitter to Maria Bernard; Courtney Thorpe; given to the Old Vic; acquired by the Theatre Museum

Condition: There is a vertical split in the panel 12 cm. long downwards from top edge 9.5 cm. from top left.

Technique: Panel, one member, grain vertical. The ground has been rubbed down until it only fills the wood grain. Paint thin.

Inscription on verso: *Given to the Old Vic by Courtney Thorpe* in pencil on brown paper strip (top): *GIRC* (erased) / *VIC ROOM* in pencil (vertically across centre of panel)

S.809–1991 Neg: JA 748/CT 25704

52 may be a self portrait. Whoever it is by it appears to have been copied from a portrait photograph, the divine Sarah showing her preferred left profile.

If, as seems unlikely, Maria Bernard was an English friend of Sarah Bernhardt she would have been given the portrait during the two-week Bernhardt season at the Comedy Theatre in June 1896 under Charles Hawtrey's management. Bernhardt played Adrienne Lecouvreur, Magda, Tosca, Princesse Fédora and Marguerite Gautier. Maria Bernard has not been traced but Courtney Thorpe, the subsequent owner is an interesting minor theatrical figure. He was an early Ibsen specialist, playing Alfred Allmers in *Little Eyolf* to Mrs. Patrick Campbell's Rat Wife in Elizabeth Robins's production at the Avenue Theatre in 1896, Torwald Helmer in *A Doll's House* and Gregers Werle in *The Wild Duck* both at the Globe the following year and Daniel Heire in *The League of Youth* at the Vaudeville in 1900. Most of these productions were given in a limited number of matinee performances. He was a member of Mrs. Patrick Campbell's company around the

turn of the century and played Lucas Cleeve in a memorable revival of Pinero's *The Notorious Mrs. Ebbsmith* with George Du Maurier, George Arliss and Mrs. Campbell. His own adaptation from Kipling, *The Light that Failed*, was given nineteen performances at the Royalty Theatre in 1898. His greatest moment was his performance in the title role of Byron's *Manfred* for two matinees at Drury Lane in July 1918. The production had Schumann's incidental music with an orchestra conducted by Sir Thomas Beecham. Edith Evans played Nemesis. Thorpe's appearances on the London stage were choice and few, but he seems to have had a penchant for the role of the Ghost in *Hamlet*. He gave it at the Olympic in 1897 opposite Nutcombe Gould and his stand-in, the young Edward Gordon Craig, at the Lyric with Johnson Forbes-Robertson in 1902, at the Haymarket with John Barrymore in 1925, and with Russell Thorndike at the Lyceum in 1926.

Sarah Bernhardt's work as a sculptress is well-known. She was taught by Mathieu-Meusnier and produced quite impressive Beaux-Arts allegorical pieces such as the Figure of Music in the casino at Monte Carlo. Her relief of the dying Ophelia has a fin-de-siècle abandon that appealed to buyers in Paris and London, where she had an exhibition during her first visit in 1879. In 1876 she was given an honourable mention at the Salon for her group of 'Après la Tempête', depicting a Brittany woman holding the body of a drowned boy. Her busts were particularly good and the best include Victorien Sardou, the artist Louise Abbema and a self-portrait. Her career as an artist is less well documented. According to Cornelia Otis Skinner she showed some of her watercolours to Alfred Stevens and he advised her to take up painting. She briefly took to landscape and went on sketching trips with Georges Clairin and Gustave Doré, both rather better known for work in other genres. There is a photograph by Nadar of Sarah in studio garb, a white silk gent's suit that she designed with Worth which caused a scandal when the image was reproduced as a postcard. She stands in front of a large allegorical portrait of Rachel holding a sheaf of corn. The subject, although clearly biblical, is perhaps a coy reference to Sarah's great predecessor. Other paintings included *La Jeune Fille et la Mort*, which was engraved for the Salon Folio, and *Kiss of the Sea*, showing a girl in the clutches of a giant crab. She painted a self-portrait which was exhibited at the Nouveau Journal and also modelled an ink-well with her portrait as a sphinx with bat's wings. Another self-portrait, based on a drawing by Clairon, was a bronze relief showing her crowning Shakespeare and Molière. **52** is a fragile portrait, unlike the full-blooded images preferred by the actress but the inscription strongly sugests that the divine Sarah painted the portrait herself, adapting her style to the intimate nature of the gift.

53 Sir William Rothenstein (1872–1945)

Edward Gordon Craig as Hamlet in 'Hamlet' by William Shakespeare

Oil on canvas 93.3 × 61.3 cm.

1896

Provenance: The artist; John Rothenstein; bequeathed to the Theatre Museum by Sir John Rothenstein, 1984

Exhibited: 1949, Lady Lever Art Gallery, Port Sunlight *Theatrical Exhibition* (153); 1964 Guildhall Art Gallery *Shakespeare and the Theatre* (34); 1972 Bradford City Art Gallery and Museums *Sir William Rothenstein 1872–1945 A Centenary Exhibition* (13); 1982, Heslington Hall, University of York *Edward Gordon Craig. An exhibition of wood engravings and woodcuts* (72)

Literature: Sir William Rothenstein *Men and Memories* 1931–39 Vol. 1. p. 276; Craig 1957 pp. 179, 182 repr. facing p. 160

Condition: Sound. Unlined.

Technique: White ground with red/brown upper coat on tabby weave canvas. The picture is very thinly painted, forms indicated with strokes of dark green/grey paint. The brown ground shows through all round the figure and also in the face.

S.1056–1984 Neg: HF 4513/CT 16070

Craig played Hamlet a number of times from 1894 to 1897 but his association with the play began at the age of thirteen when he walked on in Irving's touring production in Chicago in February 1885. When the first four volumes of the Irving *Shakespeare* appeared in April 1888 the great actor gave the young Craig a set inscribed 'To the young Lord Hamlet from Henry'. However, his first speaking part in *Hamlet* was the second gravedigger in Sarah Thorne's company in a tour that started in Tunbridge Wells on 27 July 1891. Three years later he played Hamlet for the first time, while touring with the W.S. Hardy Shakespeare Company, based at Hereford. He was billed as coming straight 'From the Lyceum Theatre' where his parts had included Cromwell and Oswald to Irving's Wolsey and Lear. It was for this 1894 production that the Beggarstaff Brothers, William Nicholson and James

Pryde, produced their famous poster of Craig as Hamlet. Craig claims that rehearsals for *Hamlet* were completed in three days and that the company then went on to rehearse *Romeo and Juliet* in which he played Romeo; this only required two days of rehearsal. The Hereford first night was 4 September 1894 when Craig wore Irving's 'oldest Hamlet dress, with belt (craped) and sword' which was given for the occasion. The tour lasted until mid–December 1894 with *Hamlet* usually the first play given at each new date.

Craig's next Hamlet seems to have been a single performance, given on his own benefit night, 26 July 1895, during a season with the Paisley repertory company but on 10 February 1896 he rejoined Sarah Thorne's company at Chatham and played the part six times before his benefit night on 5 May when he played either Hamlet or Macbeth. Gradually getting closer to central London, Craig gave four performances of *Hamlet* for Gilbert Tate at the Parkhurst Theatre, Holloway Road in July 1896. His mother, Ellen Terry, brought a party to the theatre on 25 July.

Rothenstein, a friend of both Ellen Terry and Craig, may have been one of the party and it was certainly one of the Parkhurst performances that inspired Rothenstein's picture; 'I saw him once act as Hamlet, somewhere in Islington, and never had I seen such a touching and beautiful figure. I made him sit for a painting in his Hamlet dress, a small full-length, which was never finished; for he came, or stayed away, as the spirit moved him.' Rothenstein also produced an unfinished half-length portrait of Craig as Hamlet which is reproduced in the first volume of *Men and Memories* facing page 276. Evidently Craig had stopped wearing the Irving costume which was of black velvet and had a wide open neck and had developed the Regency dandy look seen in Rothenstein's pictures. Craig's memories conflict with those of Rothenstein and he remembers him coming to one of the eight performances of his last Hamlet. He finally played the part in the West End, just around the corner from the Lyceum at the Olympic Theatre in the Strand, on 17 May 1897 when he stood in for Nutcombe Gould at very short notice. The manager, Ben Greet, kept him on for a total of six evening and two matinee performances. Not only was this Craig's last Hamlet it was also one of his last parts as he decided to devote his enormous talents to direction, design and publishing.

The first issue of Craig's periodical *The Page* was published in January 1898 and included a caricature of Max Beerbohm by William Rothenstein, an artist Craig professed particular admiration for as one of 'the moderns'. Rothenstein drew Craig several times and drawings dated 1903, 1904 and 1922 were reproduced in John Rothenstein's *The Portrait Drawings of William Rothenstein 1889–1925* 1926 (Nos. 188–191 and 628). In 1904 they were both members of the new 'The Society of Twelve', a group of draughtsmen and illustrators that also included Muirhead Bone, William Nicholson, Augustus John and Ricketts and Shannon. Rothenstein had also introduced Craig to Count Kessler of Weimar in 1903 and the two men kept in touch throughout Craig's resultant

European career. Rothenstein's son John continued the friendship after his father's death in 1945.

Rothenstein's picture was probably at the back of Craig's mind when, in 1904, he produced a costume design for Hamlet as an English gentleman, a drawing that is now in the Österreichisches Nationalbibliothek. Although there are differences in the position of the body, feet and head, the pose of the figure is similar to the Rothenstein and shows Hamlet in an approximation of modern dress with bags, cardigan and muffler. He has his hands in his pockets which Craig satirically ascribes to his position as a perfect gentleman.

54 P. Shaken (?) (fl. 1897)

Sir Johnston Forbes-Robertson as Hamlet in 'Hamlet' by William Shakespeare

Oil on canvas 46 × 36 cm.

c. 1897

Signed and inscribed: *P Shaken* (?) in red oil paint (bottom left); *Yours very truly / J. Forbes-Robertson* in brown oil paint (lower right)

Provenance: Unknown

Condition: Unlined. Slight distortion of canvas on throat with some flaking and minor paint loss. Conservation March 1986: Distortion ameliorated and flaking consolidated.

Technique: White/cream ground on tabby weave canvas. XRF examination to detect possible silver photographic emulsion proved negative.

Inscription on verso: *REEVES & SONS / PREPARED CANVAS / LONDON* (stamp)

S.91–1986 Neg: HF 4542/CT 16106

The artist is unknown and the signature might also read *Shaker* or *Thakery*. **54** is copied from a photograph by W.&D. Downey of London SW which was distributed in the United States by the Rotograph Company of New York in their *Rotograph series*.

Forbes–Robertson played Hamlet for the first time at the age of forty-four, in September 1897 at the Lyceum. He was an enormous success and was recognised as the greatest Hamlet of the era, more sympathetic, romantic and natural than any of his contemporaries. The part became the main-stay of his career as an actor manager and 'over and over again both in England and America, when the production of a new play had spelt failure, a revival of *Hamlet* . . . always set me on my feet again'. His last Hamlet in England was given at Drury Lane on 6 June 1913 and his final professional appear-ance was as Hamlet on 26 April 1916 in a performance given at Harvard University. The Sheldon Lecture Theatre was converted into the Fortune Theatre for the occasion by the great Shakespearean, Professor George Baker. Forbes–Robertson made a film of *Hamlet* in 1912.

55 Henry Lawrence ? (fl.late 19th century)

Sir Henry Irving

Henry Lawrence, if he is indeed the artist of **55**, has copied a photograph of Irving by Window & Grove of London. It was published in the American *Vanity Fair* Vol. VII, No. 3 p. 181, New York, 1899 and was used as the basis for a caricature by B. Kronstrand, *The Well-beloved Head of the Profession*, published in *The Bystander* of 17 May 1905, p. 323.

Oil on canvas 25.3 × 20.2 cm.

c.1899

Provenance: British Theatre Museum Association

Condition: Unlined. Minor losses at edges where stretching tacks have pierced the support and due to abrasion from rebate.

Technique: Greyish ground on tabby weave canvas. Canvas stamp on reverse. There are traces of paint on the bottom tacking edge.

Inscription on verso: *Sir Henry Irving / Henry Lawrence / 4. Parsons Green Lane, London S.W.* (pen and ink on label on stretcher); *WINDSOR & NEWTON'S / No 8 QUALITY PRE-PARED CANVAS / RATHBONE PLACE / LONDON W.* (stamp)

S.1132–1986 Neg: HF 4527/CT 16091

56 Charles A. Buchel (1872–1950)

Herbert Beerbohm Tree as King John in 'King John' by William Shakespeare

Oil on canvas 218.4 × 147.3 cm.

1900

Signed: *CHARLES BUCHEL 1900* in black oil paint on bronze (in panel in red cloth on step bottom right).

Provenance: Herbert Beerbohm Tree; Denys Grayson; David Tree Parsons; purchased by the Theatre Museum, 1989

Exhibited: 1900–c.1977 Foyer of Her Majesty's Theatre; c.1985–9 Theatre Royal, Drury Lane

Literature: Charles Buchel 'Some Famous People I Have Painted' 193– p. 341, article from unidentified source in Theatre Museum.

Condition: Lined. Some raised craquelure overall. Slight stretcher bar marks across centre.

Technique: Tabby weave canvas. Ground not visible.

Inscription on verso: *..ALL..L, . . .SIT / CARLTON S. . .T REG. . . TREE / Mrs Dorys Grayson* (printed and typed on paper label on back of frame)

S.332–1989 Neg: JA 756

Tree's production of *King John* opened at Her Majesty's Theatre on 20 September 1899 and had a run of 114 performances until 6 January 1900. Apart from Tree the cast included J. Fisher White as Faulconbridge, Franklin McLeary as Hubert and Lewis Waller, who received most praise for his acting, as the Bastard. Julia Neilson played Constance and Kate Bateman Queen Elinor. The elaborate scenery was by Joseph Harker, Hawes Craven and Walter Hann and the even more elaborate costumes were designed by Percy Anderson. Tree had given the play rather less lavish treatment when he produced it for a series of matinees at the Crystal Palace Theatre 1889–90.

56 was Buchel's third portrait of Tree, following a Hamlet painted in 1898 and D'Artagnan inspired by the 1898 production of *The Three Musketeers*. Tree commissioned a poster from Buchel for the 1899 production of *King John* and then decided to sit for **56**, by far the grandest of Buchel's many portraits of him. In his article, 'Some Famous People . . .' Buchel describes one of his sessions with Tree: 'Tree was a bad sitter and yet a good one. He was good because he was sympathetic. He himself drew well and knew about painting, but he was bad as a sitter because he was impatient and seemed to want to do the work himself! One midday I was at work in my studio on the eight-foot canvas of him as King John. Tree's dresser had come with him to make him up and Tree had then got on the throne, magnificent in grease paint and robes, crown and sceptre. After five minutes he descended to see how I was getting on. I had done little but a few charcoal lines. Tree started to declaim his part and suggested that it might help if he got the Hubert of the play and they both acted. I replied that the best help he could give me was to get back on the throne and forget he was being painted. He had hardly resumed his place when his heavy metal crown fell off and clattered across the studio. Tree was still making one of his speeches and in one breath gave vent to: "I have not murdered him. – Where's my bloody crown"; and as the dresser (hidden behind the canvas) giggled at the mishap, added "List to the prattling babe. I had a mighty cause to wish him dead!"'

Tree is shown in *King John* Act IV scene ii, 'A Room of State in the Palace' which he starts with the words 'Here once again we sit, once again crown'd / And look'd upon with cheerful eyes.' During the rest of the scene things go from bad to worse from his point of view; he hears that his mother is dead and that Prince Arthur is not. Tree's anguished pose reflects the king's growing anger and despair.

Buchel emphasises Tree's famous flaming hair and pale blue eyes. The costume is impressive and ostentatiously expensive consisting of a long loose garment of cloth of gold studded with occasional gems, lined in red, and along the hem an embroidered

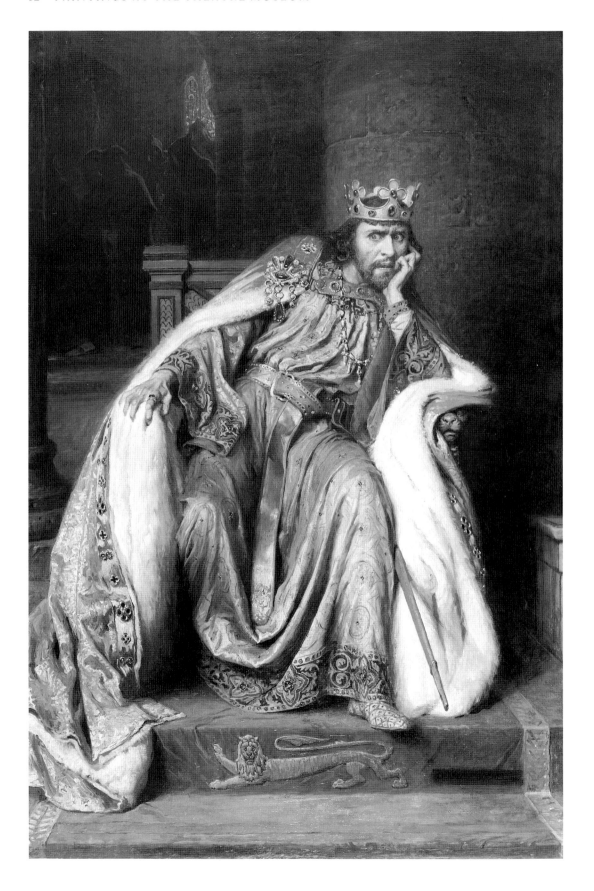

58 Charles A. Buchel (1872–1950)

Stage Setting for 'Twelfth Night' by William Shakespeare

Long grassy staircase rising gradually from foreground to distance between banks of shrubs. Garden seat bottom right with griffin arm rests, shrubs and tree beyond. Small garden at left, sundial in centre surrounded with topiary, beyond a raised path over two arches, approached by steps and flanked by urns on a balustrade. Letter with red seal on grass bottom right. Small full-length figure of Malvolio near top of grassy steps.

Herbert Beerbohm Tree's production of *Twelfth Night* opened at Her Majesty's on 5 February 1901. It was one of the most popular of all his Shakespeare revivals and ran for 128 performances. Tree, who reorganised the action into three acts and eight scenes, played Malvolio and the cast also included Gerald Lawrence as Orsino, Lionel Brough as Sir Toby, Norman Forbes as Sir Andrew, Courtice Pounds as Feste, Maud Jeffries as Olivia and Lily Brayton as Viola. Joseph Harker and Hawes Craven designed the sets and Percy Anderson the costumes. **57** shows Harker's set for Act I scene ii, *The Terrace of Olivia's House* and **58** Hawes Craven's *Olivia's Garden* which was used in Act II scene ii and Act III scenes i and iii. This garden scene was the scenic triumph of the production and was inspired by a photograph that Tree had found in the issue of *Country Life* for 8 December 1900, p. 748. The full-page photograph shows 'The Grass Stairway at St. Catherine's Court' but is shown as a curiosity rather than as part of the usual gardening article. Other aspects of the production straight out of the pages of *Country Life* include the sun-dial garden in **58**, examples at Hatfield House (11 August 1900 p. 181) and Gunnersbury Park (24 November 1900 p. 658), and the whole feel of **57** is surely inspired by the photographs of the glorious garden at Powis Castle, illustrated in *Country Life* 5 January 1901 pp. 16–24.

The scenery managed to capture most of the reviews. The New York *Morning Telegraph* of 15 February 1901 included a typical eulogy: 'Mr. Tree's production of *Twelfth Night* is, pictorially speaking, one of the most perfect that possibly has ever been presented. The stage pictures are lovely, and one set that is shown several times, "Olivia's Garden" is quite unique in its beauty. It shows a terraced garden that slopes from a high grassy mound by deep shallow steps of grass to the flat green sward hedged with quaintly cut box-trees. The effect of distance and the remarkable beauty of the grassy flights of steps that seem to lead up and up until they reach the blue heavens and the waving trees, is a veritable masterpiece. It would be pleasant to be able to speak with such unstinted praise of the acting.'

The grassy steps of Olivia's garden captured the artistic imagination and most artists, drawing the production for publication in journals, included them in their work. Artists who illustrated the set, usually as a back-drop to Malvolio's

Oil on prepared paper 30.5 × 40.6 cm.

1901

Signed: *CHAS.A.BUCHEL* in pale green oil paint (bottom left)

Provenance: Harry R. Beard; given by the family of Harry R. Beard, 1971

Condition: 'Canvassed' paper and cotton detached from card support in a series of large blisters. Loss of support in top corners. Paint lifting in many areas, especially along top edge and above two arches left centre where there is a small flake loss. Several losses associated with loss of paper and lifting paint near top edge, some losses retouched without fillings. Small loss left edge below centre.

Technique: c.f.**57**.

Inscription on verso: *GEORGE ROWNEY & Co. / BI. . .RE / . . .D / LONDON ENGLAND / SIZE 10 × 12* (Label)

S.807–1991 Neg: HF 606

flower pattern with gems between two rows of red gems. He has a heavy gold collar with red and green gems and a heavy and enormous cloth of gold cloak edged with patterns of jewels and lined with ermine. A huge jewel on his right shoulder is made of gold with red, blue and orange gems and pearls.

Oil on prepared paper 30.5 × 40.6 cm.

1901

Signed: *CHAS.A.BUCHEL* in brown oil paint (bottom right)

Provenance: Harry R. Beard; given by the family of Harry R. Beard, 1971

Condition: The surface of the painting is wavy, as the paper, cotton, board support layers are delaminating. Minor paint losses along top edge, particularly centre and top corner.

Technique: The support is paper with a cream ground and imitation canvas weave, stuck to cotton and stretched over a pulp board. No label on reverse but the board is identical to the support of **58**

S.806–1991 Neg: HF 4526/CT 16090

57 Charles A. Buchel (1872–1950)

Stage Setting for 'Twelfth Night' by William Shakespeare

Terrace overlooking a bay, stone stair on left with sculpted male figure at end of balustrade, the stair rises to a flat eminence above a gothic arch and descends on the other side, the arch is partly hidden by tall flowers behind a low box hedge, stone seats on right in front of flowering trees, grander trees behind either side of central scene, flowering bushes beyond the terrace, indicating a hill-side that descends to the coast, in the centre of the scene a distant view of sea with mountains and a cloudy sky beyond, lit from a clouded sun top right.

appearance to Olivia cross-gartered, Act III scene i in Tree's production and Act III scene iv in the text, included John Jellicoe (*Lady's Pictorial*), Cyrus Cumcoff (*Black & White*), Balliol Salmon (*Illustrated Sporting and Dramatic News*), Samuel Begg (*Illustrated London News*) and Frederick Henry Linton Jehne Townshend (*The Queen*), all published on 16 February 1901. Bernard Partridge published a picture of Malvolio reading Maria's letter in *The Sphere* on 2 March 1901.

The steps were provided, of course, to enable Tree as Malvolio to make the grandest and longest of possible entrances onto the stage and George Bernard Shaw reported him having fun with various bits of hilarious business: 'As Malvolio, Tree was inspired to provide himself with four smaller Malvolios, who ape the great chamberlain in dress, in manners, in deportment. He had a magnificent flight of stairs on the stage; and when he was descending it majestically, he slipped and fell with a crash . . . Tree, without betraying the smallest discomfort, raised his eyeglass and surveyed the landscape as if he had sat down on purpose . . .' One assumes that the four little Malvolios all tumbled over too.

Both **57** and **58** were produced by Buchel for the *Twelfth Night* souvenir booklet which also included portraits of nine of the characters in the play and a view of Harker's kitchen set for Act I scene iii. Four of the portraits were reproduced in *Madame* on 13 April 1901. The original of the portrait of Norman Forbes as Sir Andrew Aguecheek is in the Folger

Shakespeare Library, Washington (Oil on board 30.4 × 40.7 cm.) where there are two further *Twelfth Night* subjects by Buchel, possibly prepared for the souvenir booklet but not used.

59 F. P. Wightman (fl. 1902)

Renée Kelly

59 is part of a large bequest of material relating to Renée Kelly and her husband Hylton Allen. The bequest also included a pastel portrait of Renée Kelly by Harold Smith, 1912, and a Dorothy Wilding photo-portrait in chalks and watercolours. Jean Macnab seems to have assumed that **59** showed her mother in character but it was painted several years before she became a professional actress. She may be shown playing in an amateur production.

Oil on canvas 43.2 × 35.5 cm.

1902

Signed: *F.P. Wightman / 1902* in blue oil paint (top left).

Provenance: The sitter; the sitter's daughter Mrs. Jean Macnab by whom bequeathed to the Theatre Museum, 1983

Condition: There are stretcher bar marks and losses of ground and paint around edges. There is general abrasion and retouching with an area of flaking and paint loss to the right of the neck. There is a discoloured retouching on the cheek.

Technique: White ground on tabby weave canvas

Inscription on verso: *F.P.W.* (pencil on left stretcher); *Kelly (?)* (pencil, centre of canvas); *Renee Kelly by / F.P. Wightman 1902 / 81/788* (pen & ink on sticker upper stretcher)

S.53–1983 Neg: JA 741/CT 25697

60 Charles A. Buchel (1872–1950)

Nancy Price as Calypso in 'Ulysses' by Stephen Phillips

Oil on prepared paper 45.5 × 29.2 cm.

1902

Signed: *CHAS.A.BUCHEL / 1902* in brown oil paint (bottom right)

Provenance: Nancy Price; presented to the British Theatre Museum Association (1971/A/50) by the sitter's daughter, Miss Elizabeth Maude, as part of the Nancy Price Collection, 1971

Condition: Tear in paper at top left corner and slight distortion of board at top right corner. Some minor retouched losses on figure.

Technique: Cream ground. The support, an 'Oil sketching tablet' made by Reeves & Sons, is paper with a canvas grain. The paper appears to be stuck to a thin tabby weave cotton and stretched over a board.

S.94–1986 Neg: HF 4545/CT 16107

Nancy Price is shown in Act I Scene iii of Stephen Phillips's *Ulysses* which is set on Calypso's Island (Act I scene ii in the published text. On stage the Prologue was treated as Act I scene i). Although it is unlikely that the artist intended to show Calypso at any particular moment in her scene, the curtain falls on her lonely figure watching the departure of Ulysses's ship:

> *Calypso:* I breathe a breeze to waft thee over sea!
> Ah, could I waft thee back again to me!

Ulysses was the second of four plays in verse by Stephen Phillips produced by Tree at His Majesty's. The others were *Herod* (1900), *Nero* (1906) and *Faust* (1908). They were all extremely successful and all played for over one hundred performances. *Ulysses* opened on 1 February 1902 in the sort of lavish production expected of Tree. There were seven scenes, by William Telbin, Joseph Harker and Hawes Craven with, according to the published text, architecture and architectural decoration by Prof. W.R. Lethaby 'based on recent discoveries of the Mycenaean age.' The *Sea-cave on Calypso's Island* was the work of Hawes Craven and he presumably attempted to create the scene described lovingly in the text: 'The shore of Ogygia with the sea-cave of Calypso. A vine full of fruit trails over one side of the cave, and round about it grow whispering poplars and alders, from under which rillets of water run to the sea. Beyond, a verdant shore, with thickets of oleander, etc., and the ship of Ulysses lying beached. Within the cave a fire burning gives out the smell of sawn cedar and sandal-wood. The sun behind is sinking, and the water is golden, while over all broods a magic light. A chorus of Ocean-Nymphs is discovered dancing and singing on the sands.' The costumes were by Percy Anderson and were based on 'the very earliest Greek sculpture, and . . . vases of the sixth and seventh centuries B.C.'

Tree played Ulysses, Gerald Lawrence his son Telemachus and the wicked suitors included Henry Kemble as Ctesippus and Oscar Ashe as Antinous, in other words the strongest casting available in Tree's company. However, the casting of the female parts produced one of the biggest headaches of Tree's management. The part of Penelope was given to Lily Hanbury, the current leading lady at His Majesty's but the important role of Pallas Athene was given to the comparatively unknown Constance Collier. Mrs. Brown-Potter was cast as Calypso and Nancy Price was given the small role of Anticleia. The *Pelican* announced the news on 18 January 1902: 'Miss Nancy Price, of the singularly graceful carriage, has been selected by Mr. Tree to play the shade of Ulysses's mother. Miss Price moves so regally that here at last will be a Ghost whom we shall all be glad to see walk.' Shortly before the first night Mrs. Brown-Potter was relieved of her role. It

was gleefully announced in the press that the author had found her interpretation of the role of Calypso 'too passionate'. She was replaced by Nancy Price and the incident attracted a great deal of press comment, most of it in verse. Many writers attempted a heavy-handed imitation of Phillips's own style but the most amusing was the limerick in the *World* for 29 January 1902:

The Lady they cast for Calypso
Considered the part needed 'grip' so
She thought her own way
Was best for the play,
And she told Mr. Stephen Phillips so.

The poet looked up from his blotter
And saw the love-making grow hotter,
And he said, 'All these Kisses
Will ruin *Ulysses* – '
'Then, good morning!' said Mrs. Brown-Potter.

After the play had been running for six weeks Constance Collier and Nancy Price exchanged roles. A commitment to appear in *Ben Hur* at Drury Lane at the same time meant that Constance Collier could only spend a part of her evening at His Majesty's. This arrangement was evidently not satisfactory as she soon disappeared from the cast altogether and the passionate Mrs. Brown-Potter returned to finish the run of the play as Calypso.

Buchel's picture was painted for a *Ulysses* souvenir, published by Carl Hentschel in late March 1902. It consisted of ten portraits of the principal characters in the play. A portrait of Mrs. Brown-Potter as Calypso was included in later editions of the souvenir.

61 Charles A. Buchel (1872–1950)

The setting for the last scene of 'The Tempest' by William Shakespeare

Oil on prepared paper 25.4 × 35.7 cm.

1904

Signed: *CHAS.A.BUCHEL.* in brown oil paint (bottom left)

Provenance: Harry R. Beard; given by the family of Harry R. Beard, 1971

Condition: Four corners scuffed, wearing at extreme edges. Top left corner bent forward causing a crease.

Technique: Cream ground. The support appears to be paper with an imitation canvas surface, probably attached to cotton and stretched over cardboard. The paint is applied very sparingly and sketchily. There is a pencil line, partly obscured by paint, parallel with top and bottom edges, approx 1 cm. from edges.

S.221-1987 Neg: HF 4530/CT 16094

Rocks and cliffs on either side frame a distant ship sailing out to sea. Full-length figure sitting on rocks at left looks out to sea, his right hand to his brow. He has long hair and a rude garment. Below him green sea-weed is attached to the brown rocks. The bright blue sea stretches to a pink sky. Lit from the left.

The scene is the final curtain of Tree's production of *The Tempest* which opened at His Majesty's on 15 September 1904. Tree chose to play Caliban rather than Prospero and he rearranged the ending of the play so that he could have the final curtain. In fact he cut all of Prospero's great epilogue, 'Now my charms are all o'erthrown, . . .' and ended the text of the play with a marriage of Prospero's 'Ye elves of hills . . .' from earlier in the last act with his various speeches before the epilogue, ending with 'Be free, and fare thou/well!' addressed to Ariel. Prospero then breaks his staff and sets in motion the final moments of Tree's vision. Tree's production copy of the play gives a remarkably complete picture of his ending and is worth quoting in full (the numbers indicate sound cues):

(Black out as he breaks his staff – BLUE)
As Pros. breaks his staff across knee LIGHTENING (D.S.R.) then THUNDER, DARKNESS, TAKE UP BACK 6 CUT CLOTH, LOWER GAUZE, AND AS THE SINGING IS HEARD – BRING LIGHTS UP SLOWLY.
'Yellow Sands' 53A is heard off L – out of that comes the sound of boatmen and the ship is seen moving behind row No.2 from L to R. Meantime Caliban has entered from his cell, climbs rocks and watches the ship disappearing in the distance. At this moment Ariel is heard singing (54 Bee Sucks) 'Where the Bee sucks', and is lowered by a wire from L.U.E. to centre of stage, where she continues her

singing until cue 'Merrily Merrily shall I live now' when she is taken up again to platform to L.U.E., her voice still heard getting higher and higher, and gradually is transformed into a Lark! At this moment Caliban, who has been watching the departing ship; hearing the voice of the Lark, points in the direction from which the sound is coming. Thus forming picture – at which the curtain descends.
1st PICTURE Moonlight – Caliban discovered crouching on rock with arms lifted, bidding farewell to the ship which is dimly seen in the distance.
2nd PICTURE Caliban is still seen on the rocks in an attitude of despair – The ship having disappeared.

Tree's daughter Viola played Ariel and the unfortunate Prospero was William Haviland. The critical reception was surprisingly enthusiastic despite, or perhaps because of, Caliban's absolute domination of the play.

Buchel's picture was painted for a *Tempest* souvenir programme which also included his portrait of Tree as Caliban. Buchel also published a head and shoulders portrait of Tree as Caliban in the *Tatler* on 21 September 1904. The original, charcoal on wove paper 38.2 × 27.4 cm. signed and dated 1904, is in the Folger Shakespeare Library, Washington. Another *Tempest* subject by Buchel is also in the Folger Library, charcoal and grey wash on board 54.5 × 38.7 cm. signed and dated 1904. It shows Tree as Caliban, Lionel Brough as Trinculo and Louis Calvert as Stephano in Act II scene ii, and was published in the *Sphere* on 24 September 1904.

62 After Cyrus Cincinnato Cuneo (1879–1916)

Sir Henry Irving as Matthias in 'The Bells' by Leopold Lewis

Oil on canvas 41 × 30.5 cm.

c. 1905?

Provenance: Presented to the British Theatre Museum Association (1968/A/18) by Miss H. Gerhard, 1968

Literature: David Mayer (ed.) and Eric Jones-Evans *Henry Irving and the Bells*, 1980 illus. p. 31 and dust-jacket. (Cuneo's original)

Condition: The canvas has suffered water damage in a flood and has shrunk. Since it was already somewhat embrittled it has split along most of the top edge. Due to the resultant lack of tension the whole surface (seen from the front) is now concave and wavy. The surface edge of the split is curling upwards. Due to the wetting and canvas shrinkage the paint has been forced into long tent shaped blisters. The blisters run horizontally across most of the painting except the centre. The blistered paint appears to be detached from the canvas, there are some minor losses close to the upper edge. There appears to be some blanching.

Technique: Grey ground on tabby weave canvas. The bottom tacking edge is a selvedge and the gound does not fully cover this. However, the ground does go right to the edge on each of the other three sides where the edges are cut. Evidently the canvas was cut from a large sheet of pre-stretched and primed canvas and then put onto the stretcher.

Inscription on verso: *G ROWNEY & Co / LONDON W / QUALITY F* (Stamp)

S.70–1988 Neg: JA 753

62 is copied from a drawing by Cyrus Cuneo in the collection of Richard Briers, reproduced in colour on the dust-jacket of *Henry Irving and the Bells*. There are minor differences such as the fact that Irving wears a purple rather than a brown fur hat. However, apart from a rather baleful failure to reproduce Irving's physiognomy the picture is a remarkably accurate copy down to the meticulous placing of the snowflakes. Cuneo arrived in England in 1902 and quickly made a name for himself as an illustrator. He was not known especially for his theatrical work and the single reason for a portrait of Henry Irving must have been the actor's death in 1905. He may have seen one of Irving's final performances in the role, the last only two days before he died, but as these were all in the provinces this seems unlikely and Cuneo probably relied on a second-hand description. The original drawing does not appear in any of the magazines in which Cuneo's work is known to have appeared and it is possible that the drawing was never published. There are minor colour differences, for instance the hat mentioned above, but it does appear that **62** is

copied from the coloured original rather than a black and white print of it.

Matthias was the role that established Irving as the leading British tragedian. He played it for the first time at the Lyceum on 25 November 1871 and for a further 150 consecutive performances. It remained in his repertory for the rest of his life, a typical melodrama raised to a higher psychological and theatrical plane by Irving's great performance.

Cuneo's picture shows Irving's entrance in Act I through the door in the back wall of the principal room of an Alsatian inn, the dwelling of the Burgomaster. The door leads on to the village street and, at least in earlier productions, opened to stage right rather than stage left as shown in Cuneo's picture.

MUSIC 2
(*Mathias passes the window.*)
Walter: At last! At last!
(*Mathias enters, takes off cap, throws it with whip R. and embraces CATH.*) Stop MUSIC
Math: It is I! – it is I! At last! At last!

One of a series of photographs of the original production taken by the London Stereoscopic Company in 1872 shows Irving wearing a rather odd floppy fur hat with a life of its own for his entrance in Act I. This had been replaced by a round hat similar to that seen in **62** by 1880. Irving's entrance was regularly delayed for several minutes by enthusiastic applause and he stuttered rather than swept in. Cuneo may have had this necessary hesitation in mind when he produced his picture of Irving peeping around the door but there is also a chance that Irving is shown closing rather than opening the door, a moving visual farewell to the stage.

63 Frederick Howard Michael (fl.1892–1929)

Ethel Irving as Lady Frederick Berolles in 'Lady Frederick' by William Somerset Maugham

The illustration in *The Stage Year Book* shows that the painting has been cut down from a full-length portrait. There are a number of *pentimenti*, to the left of the sitter's neck for instance and down her left arm, suggesting that the artist found her difficult to position on the canvas. The picture was not exhibited, surprisingly for a portrait of a well known actress in a popular role.

Lady Frederick was Maugham's first big theatrical success and tells the rather silly story of a seriously foolish young man, Lord Mereston, who falls desperately in love with an older woman, Lady Frederick Berolles, until he sees her in her boudoir without make-up and hair-pieces. Lady Frederick is a wise and mature Marschallin-like figure and Maugham's play may have inspired Hugo von Hofmannsthal when writing the

Oil on canvas 87.5 × 78 cm.

c.1907

Provenance: Commissioned by William Somerset Maugham and given to the sitter in gratitude for playing Lady Frederick; Ethel Irving; Mrs McQueen, the sitter's niece; presented by Mrs. McQueen to the British Theatre Museum Association (1964/G/103), 1964

Literature: *The Stage Year Book* 1909 rep. opp. p. 24

Condition: The tacking edges are

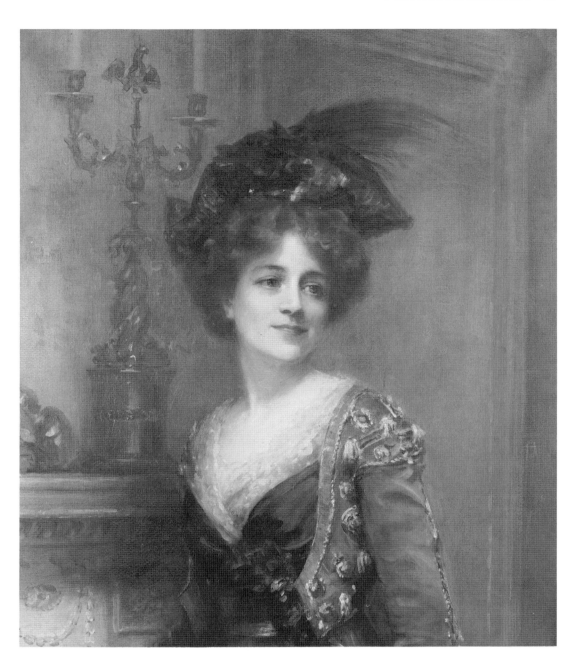

painted indicating that the painting has been cut down. The edges have been abraded by recent framing. Three scratches in upper left corner. Discoloured spots on and around the head and breast, probably caused by mould under the paint surface. Pin-hole sized losses over the face.

Technique: Dark grey ground on tabby weave canvas. Some areas of heavy impasto on the sitter's frock and jacket. Thin wash of paint covers most of the background.

Inscription on verso: *ETHEL IRVING* in pencil (on tape over upper stretcher); *1964 / G/103* (sticker in

libretto to *Der Rosenkavalier*, first performed in Dresden on 26 January 1911. Maugham's play opened at the Court Theatre on 26 October 1907, produced by W. Graham Browne, who also played Lord Mereston, with sets by Joseph Harker. The production ran for 422 performances although it moved from the Court to the Garrick on 10 March 1908 to the Criterion on 27 April to the New on 8 June and ended with a season at the Haymarket that opened on 1 August 1908. Because of the success of *Lady Frederick* Maugham was able to empty his bottom drawer and by June 1908 he had four plays running in the West End; *Jack Straw* which opened in March, *Mrs. Dot* in April and *The Explorer* in June.

Lady Frederick was Ethel Irving's most successful part and in 1913 her husband Gilbert Porteous revived it for her. The production was designed by W.T. Hemsley and opened at the

Globe on 26 April for a run of 57 performances. The play was filmed by Metro Pictures Corp. in 1919 as *The Divorcee* with Ethel Barrymore taking Ethel Irving's role.

The Theatre Museum owns a hair switch worn by Ethel Irving as Lady Frederick. In 1964 Mrs. McQueen presented five costumes worn by Ethel Irving. In F.H. Michael's picture her Lady Frederick costume consists of a pale blue velvet jacket heavily decorated with silver fringe and braid and a purple frock crossed right over left at breast and edged in frothy lace over shoulders to cleavage, held tight at the waist by a broad silver belt. She also wears a dark hat with orange and blue decoration and spray of osprey feathers.

upper left corner); ...*HAEL F.H.* (scratched into cross-bar); *JOHN B. SMITH / 117 HAMPSTEAD RD, N.W. / LONDON* (stamped in two places – artists' suppliers stamp)

S.67–1988 Neg: HH 1266/CT 18530

64 Clare Atwood (1866–1972)

Sir Herbert Beerbohm Tree rehearsing 'Henry VIII' by William Shakespeare at His Majesty's Theatre

Interior of theatre, stage seen from the front row of the gallery. Multi-figured scene on stage. Seated figure on podium downstage right in yellow and green. Standing figure upstage centre also in yellow and green with rows of figures behind. Downstage left a standing figure in a long crimson garment stands slightly upstage of seated figure in dark red. Red tabs and pelmet to the proscenium, overall tawny tinge to the whole picture. Gallery rail across picture foreground.

The scene depicted on stage is *Henry VIII* Act II scene iv, *A Hall in Blackfriars*, the Trial scene, with King Henry seated downstage right, Queen Katherine upstage centre and Campeius and Wolsey on their dais downstage left. Behind the Queen are three tiers of lords, ladies and prelates. After the various processional entrances Wolsey has risen to open the proceedings:

> *Wolsey:* Whilst our commission from Rome is read,
> Let silence be commanded.

Tree's spectacular production of *Henry VIII* opened at His Majesty's on 1 September 1910 and ran for 252 performances. Tree played Wolsey, Arthur Bourchier was Henry, S.A. Cookson Campeius, Henry Ainley Buckingham and Violet Vanbrugh Queen Katherine. The props and costumes, about 380 of them, were designed by Percy Macquoid and the sets were painted by Joseph Harker. In the programme Tree thanks Louis N. Parker 'for his invaluable help in the production and pageantry of the play' and Macquoid 'for his inspiring archaeological advice'. The programme also announced that Tree had been inspired to write 'a little volume entitled *Henry VIII and his Court*' which could be 'procured at the Box Office of the Theatre and from the attendants, price 1/- net.' The play was staged with an apron stage over the orchestra pit which had been installed for

Oil on canvas 76.1 × 63.3 cm.

1910

Signed: *Clare Atwood 1910* in black oil paint (bottom left)

Provenance: Gabrielle Enthoven Collection

Exhibited: 1949 Port Sunlight, Lady Lever Art Gallery *Art and the Theatre* (3)

Condition: (15 January 1986): Long split in canvas, at fold over stretcher, bottom edge, has caused canvas to become buckled and slack generally and belly at the split edge. Small tear bottom right corner. Paint dry and embrittled. July 1986: Strip lined. Tear repaired, filled and retouched. Varnished.

Technique: The ground does not extend on to the tacking edge. Tabby weave canvas. Indiscriminate use of somewhat messy impasto.

S.100–1986 Neg: HF 4578

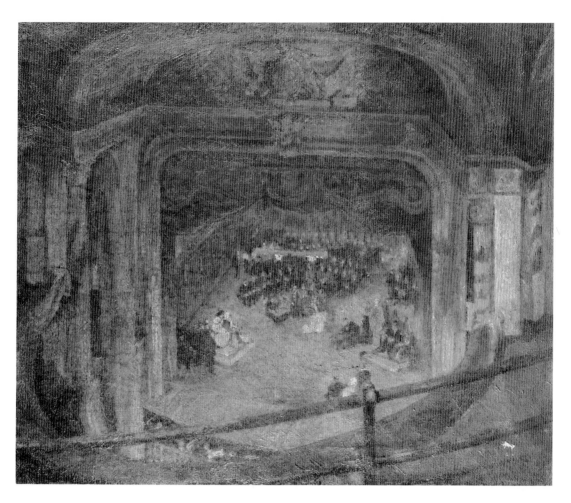

William Poel's production of *The Two Gentlemen of Verona*, given during the Shakespeare Festival of the previous April. This is visible in Clare Atwood's picture although the orchestra does not appear to be entirely covered.

The set for the Trial Scene consisted of a large hall with a beamed roof, a large stained glass window at the back of the stage above the crowds of onlookers, and tapestries around the lower halves of the other walls. The scene was lit with 21 limes with dark amber gelatines. The action is described in detail by Michael Booth in his chapter on the production in *Victorian Spectacular Theatre 1850–1910* using the prompt copy, the three preparation books, the rehearsal copy, the scene plot, lighting plot, property plot, costume plot and acting plot, all in the Bristol University Theatre Collection.

Despite the enormous production and running costs of *Henry VIII*, £7,204 and £41,097 respectively, Tree made a profit of £20,000 on his most lavish production and he may have felt justified in cutting 1,323 of the play's 2,810 lines. The cast appreciated their continued employment and on 1 January 1911 presented Tree with eight silver plates, engraved with Wolsey's Cardinal's Hat.

Clare Atwood evidently plied her heavy hand in a number of London's theatres in the early years of the century. A scene showing a rehearsal at Drury Lane, signed and dated 1917, was sold at Sotheby's on 13 January 1971 (83).

65 Jacques-Émile Blanche (1861–1942)

Vaslav Nijinsky in Michel Fokine's 'Danse Siamoise' from the divertissement 'Les Orientales'

Jacques-Émile Blanche's portrait of Nijinsky in *Les Orientales* was painted in Paris in 1910. Nijinsky took his Siamese costume and Tamara Karsavina her Firebird costume to the artist's studio in Passy where they were sketched by Blanche and photographed by Druet. Blanche worked from Druet's photographs as well as painting during the live sessions with the dancer. *Les Orientales* was the last new offering of the 1910 Paris season but it was never part of Nijinsky's repertoire in London.

Oil on canvas 224 × 120 cm.

1910

Signed: *J E Blanche* in black oil paint (bottom right)

Provenance: Princess Edmond de Polignac, by descent to The Honourable Mrs Reginald Fellowes and thence by family descent. Christie's 28 November 1986 where bought by present owner. Anonymous loan.

Exhibited: 1914 Fine Art Society *Portraits of Nijinsky by various artists* (30); 1954 Edinburgh *Diaghilev* (501); 1982 Royal Academy *Royal Opera House Retrospective 1732–1982* (88); 1989–90 Paris, Musée-Galerie de la Seita.

Literature: F. Reiss *Nijinsky*, 1960 p. 77; R. Buckle *Nijinsky*, 1971 pp. 130 & 151; R. Buckle *Diaghilev*, 1979 p. 273; B. Nijinsky *Early Memoirs*, New York 1981, p. 305.

Condition: Minor scuffing and surface loss along left rebate edge and upper right corner.

Technique: White ground on tabby weave canvas. Considerable impasto on highlights particularly.

Neg: JA 746/CT 25702

66 Adrian Paul Allinson (1890–1959)

'1830' by Maurice Volny, Scene 3 'Jardin des Amoureux'

Oil on canvas 101.5 × 127 cm.

1911

Signed: *ALLINSON* in black oil paint (bottom right)

Provenance: Purchased from the artist by Cyril W. Beaumont; Beaumont bequest, 1976

Literature: Cyril Beaumont *Bookseller at the Ballet* 1975 p. 146

Condition: Drying cracks on tree trunk at left edge, foreground figures lower left and lower right and tree foliage on right edge. Paint brighter where protected by the edge of the frame.

Technique: White ground on tabby weave canvas.

S.71–1988 Neg: HH 1264/CT 18527

1830 was given at the latter end of a programme that opened at the Alhambra on 23 October 1911. It was a ballet in three scenes with a scenario by Maurice Volny and choreography by Emile Agoust and Elise Clerc. The music was arranged by George W. Byng having been 'selected from the Works of Famous Composers'. The production was supervised by Dion Clayton Calthrop, the costumes were by Alias, the scenery by E.H. Ryan and the 'Electrical Effects', presumably the lighting, by J. Weber. The star of the evening was Fraulein Poldi Müller from the Lustspielhaus, Berlin, who played a Parisian Grisette. The other featured artists were Emile Agoust as a painter, Miss Greville Moore as a Danseuse and Charles Raymond as a Patron of Art. The first scene took place in the artist's studio, the second in a 'Restaurant de Nuit' and the third in the 'Jardin des Amoureux'. Allinson depicts the garden with possibly the last dance of the evening, Misses Purzini and Annie Clarke with Messrs. R. Vallis and Victor Andre in the Quadrille Eccentrique. The two spot-lights pick out the four dancers in the foreground, slightly left of centre.

Cyril Beaumont admired Allinson's sense of colour and this was the first picture that Beaumont bought. In *Bookseller at the Ballet* he describes it as a scene in Vauxhall Gardens.

67 Sir John Lavery (1856–1941)

Anna Pavlova as 'The Dying Swan'

This half-length portrait relates closely to Lavery's large picture of Pavlova in the same role in the Tate Gallery (3000). The latter, inspired by Pavlova's first London season, was painted in 1911 and shown at the Royal Academy (415) the following year. Pavlova's husband Victor Dandre did not feel that the Royal Academy portrait was a good likeness and preferred the same artist's head of Pavlova in *The Bacchanale*, which had been the great success at the first night of her first London season.

Cyril Beaumont, in his 1932 biography of Pavlova, described the poignancy of the most famous ballet solo of the twentieth century: 'The arms extend like wings and flutter feebly; but the effort to rise is too much and she sinks to the ground. Gathering all her strength she rises, her head thrown backwards and her body quivering from the effort. Her body becomes more erect. Again the wing-like arms rise slowly, higher and higher. But her strength fails, her head droops, to peer despairingly from under one outstretched arm. Now she moves slowly in a circle. Suddenly one arm leaps upwards towards the sky in a supreme effort to escape from the invisible force that bears her down, but the figure falls helplessly to the ground. One leg bends beneath her, the other glides forward, taut. The arms quiver pitifully, the body is shaken by a few faint tremors. The arms close stiffly above her head and fall forward on the outstretched leg. Her head drops on her breast. Then all is still. The swan is dead.'

Oil on canvas 82.5 × 66 cm. (oval)

c.1911

Signed *J Lavery* in brown oil paint (below centre, right)

Provenance: Bequest of Mrs Leonore Lena Graham, 1989

Literature: G. Ashton *Royal Opera House Retrospective 1732–1982* 1982 pp. 51 & 53.

Condition: Varnish discolouration, moderate.

Technique: Ground, probably dark grey, on tabby weave canvas.

Inscription on verso: On top bar: 125 (in white chalk upside down); *Mrs L L Graham Dec. / (19 items) R.S.P.P. / Tour / 1941 / [line] / OFFICIAL AGENTS / JAMES BOURLET & SONS, Ltd. / 17–18 Nassau St., London W.1. / Tel. Nos. MUSEUM 1871 & 7588* (on paper label). On middle cross bar: *SIR JOHN LAVERY, R.A. / PAVLOVA AS "THE DYING SWAN" / oval 32 in × 25 in* (printed on paper cut-out). On side bar: JAMES BOURLET & SONS LTD / . . . Art Packers (printed paper label, largely missing). On bottom bar: *Frame damaged and / reported when / collected.* / BRADLEY & CO. (printed label); 128 (in black crayon).

E.329–1990 (now transferred to Theatre Museum) Neg: JA 749/CT 25705

68 Norman Wilkinson (1878–1971)

The 'Revenge' Leaving Plymouth to Meet the Armada

A three-masted ship of the Elizabethan era is shown sailing out with the wind very broad on the starboard quarter. She carries a full complement of sail and flies the Royal standard from the main mast. There are pennants flying from the main top mast yard (St. George), main yard (St. George with white and blue stripes – in fact a later commissioning pennant) and lateen mizzen (St. George with a blue border). There is a St. George's flag flying from the stern above the middle poop lantern. There are archery (?) turrets on the forecastle and stern, a main lower tier of guns and guns on the quarter deck. The Royal Arms in gold on a red ground are prominent on the stern. Seamen wave from the rigging. The ship is conceived on far too large a scale. A similar ship is seen sailing further out, lower left. A smaller vessel lower left has a St. George's flag flying from the stern and men waving from the rigging. Five small boats right and left foreground are full of men rowing or waving. The *Revenge* is painted brown with red details. There are pink clouds in a pale blue sky and brown and purple hills at right.

Norman Wilkinson painted three pictures for Sir Herbert Beerbohm Tree's production of *Drake* by Louis N. Parker. Two of them were reproduced in colour in a publicity leaflet on either side of a scene from the play painted by Albert Morrow, **68** on the left and a distant view of the *Revenge* on the high seas on the right. A wood engraving based on **68** was used as advertising for the play in the *Evening News* on 28 November 1912. The publicity leaflet gave details of the cast

Charcoal and oil on paper laid on thin 3-ply panel 99 × 98.1 cm.

1912

Signed: *NORMAN WILKINSON* in white oil paint (bottom right)

Provenance: George Edward Ward; bequeathed to the Theatre Museum, 1981

Condition: Plywood has severe convex warp. Slight detachment of paper, lower left corner. Minor small dents and paint losses upper left and right corners. The purple, blue and brown areas have a speckled appearance, possibly mould.

Technique: Some charcoal underdrawing is visible. Examination with IR reflectography reveals a complete charcoal underdrawing.

S.22–1982 Neg: HF 4642/CT 16186

and performance times on the reverse and was one of six different publications produced to puff the play. A similar leaflet had three illustrations after works by Charles Buchel, *The Game of Bowls*, *The Armada Burning* and *Queen Elizabeth on the Steps of St. Pauls*. The third pictured by Wilkinson was used on a throw-away and depicted an Elizabethan soldier looking out to sea with the beacons lit on the coast behind him. All seven pictures seem to have been used as posters and Wilkinson's distant view of the *Revenge* won first prize in the Theatre and Exhibition class of the *Advertising World* poster competition in January 1913.

Drake, A Pageant Play in Three Acts, by Louis N. Parker was dedicated to Sir Herbert Beerbohm Tree and opened at His Majesty's on 3 September 1912 with Lyn Harding in the title role (Frederick Ross from 5 October) and Phyllis Neilson-Terry as Queen Elizabeth. The part of the dastardly John Doughty was played by Herbert Merivale and his brother Thomas by Philip Merivale. The simpering heroine, Elizabeth Sydenham, was played by Amy Brandon-Thomas. It was a rousing patriotic play with a huge cast and an almost cinematic production with scenery by Joseph Harker and Alfred E. Craven and 'many of the principal dresses' designed by Seymour Lucas. The publicity it received was out of all proportion to its dramatic importance and although it was advertised towards the end of 1912 as 'A Merrie England Play for the Merry Season' Tree's evident aim was to rouse what he felt was a flagging patriotic spirit. It is absolutely clear from all the contemporary comment on the play that the patriotic message, ostensibly celebrating a famous victory over Spain, was directed, in reality, at Germany and Tree's message touched a prolific nerve in the British press. In 1914 *Drake* was Tree's response to the declaration of war and the revival opened on 19 August 1914 with Tree in the title role.

69 Harold Speed (1872–1957)

Lillah McCarthy as Jocasta in 'Oedipus Rex' by Sophocles

Oil on canvas 156.5 × 92 cm.

1913

Signed: *HAROLD SPEED* in off-white oil paint (bottom right)

Provenance: Presented to the British Theatre Museum Association (1966/A/205) by the Royal Borough of Kensington and Chelsea, 1966

Exhibited: 1913 R.A. (602)

Condition: Bottom tacking edge extends 6 cms. from the stretcher edge on the reverse and is painted, con-

Jocasta is shown at her first entry from the palace:

> *Jocasta:* What is the meaning of this loud argument,
> You quarrelsome men? I wonder you are not ashamed,
> In this time of distress, to air your private troubles.

The spectacular production of *Oedipus Rex*, directed by Max Reinhardt and presented by John Martin Harvey at Covent Garden, opened on 15 January 1912. The initial run was for two weeks but it appears to have been extended for a week, to 3 February. The production was seen in Glasgow on 31 March, for five performances, and returned to Covent

tinuing the pictorial design. The edge
is cut and the original tacking edge is
not present on this side suggesting that
the portrait may originally have been
full length. Small damage lower left
corner with retouching and with paper
patch on reverse.

Technique: Grey ground on tabby
weave canvas.

Inscription on verso: *. . . / . . .T /
WIEN / 29* (stamp in diamond)

S.89–1986 Neg: HF 4532/CT 16096

Garden for two weeks of farewell performances from 28
September. Advertised as the first performance of the play in
England since the seventeenth century, the cast included John
Martin Harvey as Oedipus, Lillah McCarthy as Jocasta, Louis
Calvert as Creon, H.A. Saintsbury as Tiresias and Franklin
Dyall as the Messenger. Gilbert Murray's translation was
used, adapted by W.L. Courtney. The sets and costumes
were designed by Reinhardt and were based on the designs
for his original Berlin production at the Schumann Circus.
Details of the costumes, especialy the ornaments worn by
Jocasta, were based on Schliemann's Trojan discoveries then
on display in Berlin. However, it seems that Lillah McCarthy
would not wear the costumes designed for Berlin and Charles
Ricketts was brought in to design something more pleasing.
In *Myself and My Friends* Lillah McCarthy includes a rather
pettish paragraph about the problem of her own making:

'Charles Ricketts must of course design my costume and head-dress. His fastidious sense was for once caught napping. He sent me sketches of costumes worn by German actresses who played the part. No, no. I sent them back telling him I could neither bear nor wear them. Then he became the true Ricketts, the great creative artist, first among all theatrical designers. Lovely things came, Greek robes, barbaric tiara, long ear-rings, chains of heavy beads, plaited hair, exquisite head-dress. He added to the triumph of the play.' Lillah McCarthy's costume is now in the Museum of London and can be studied in Harold Speed's portrait. She is wearing a long, loose orange garment, tied at waist and with folded strip hanging down from her left shoulder. Her barbaric jewels consist of five round white objects decorating the chest of the garment, a large copper and gold Mycenaean-style chain around her neck, and large dangling ear-rings. She also wears an extravagant gold head-dress.

In January 1912 Reinhardt was fresh from his Christmas triumph; C.B. Cochran's production of *The Miracle* at Olympia in which Reinhardt somehow controlled a cast of thousands. The mob scenes were also an important feature of *Oedipus Rex* and to approximate the great open spaces of the Schumann Circus part of the Covent Garden auditorium was taken over, as is explained by the rather shocked reviewer in the *Play Pictorial* for January 1912: 'The fine proscenium arch has been used as the background of the stage, and within its graceful lines has been erected the exterior of the palace of Thebes. Black marble pillars against a massive background of black, relieved by bronze doors and the altar fires on each side prepare the mind for the grim tragedy that is to be enacted. A part of the auditorium has been requisitioned for the use of Thebans, and the customary Chorus, with steps leading to the platform on which the chief events of the tragedy are depicted, while a broad gangway down the centre of the stalls provides means of ingress and egress for those who are supposed to have come from distant parts. This is a favourite device of Professor Reinhart's and against such a great authority I am loath to raise my voice in protest as to a method which seems to me to bring the actors into a too intimate association with the audience. It distracts the attention and to me, I say it with all diffidence, it robbed the drama of some of its weird intensity.'

Oil on board 28 × 38 cm.

c. 1913

Provenance: Bequeathed by C.W. Beaumont, 1976

Condition: 1.9.88. Severe blanching covered the entire surface except for areas of viridian green (Chromium Oxide) and yellow (a chrome yellow). Analysis showed that the paint film

70 ? Cyril William Beaumont (1891–1976)

Scene from 'Le Dieu Bleu' (?) by Michel Fokine

An ice-blue interior with large phantom masks floating about. Although inscribed '*Petrushka*' on the verso this scene bears more relation to Bakst's design for *Le Dieu Bleu*.

was unaffected and the blanching seemed to be the result of a breakdown of the surface wax coat. 28.8.90. The blanching was removed generally some being left in the interstices of the paint from which it proved unsafe to remove it.

Technique: Tabby weave canvas with translucent chalk ground covered by a lead white underpaint. Analysis shows the medium of the coloured paint layer to be egg with small amount of casein and the surface coating to be an organic waxy substance. The wax appeared to have been applied to some colours only, probably to adjust surface gloss.

Inscription on verso: *Established 60 Years* / *WILLIAM JAMES SPILLER* / *Picture Frame Maker, Carver and Gilder* / *WORK DONE FOR THE TRADE* / *MOUNTS & FRAMES OF EVERY DESCRIPTION* / *MADE TO ORDER AT THE SHORTEST NOTICE* / *28 Lichfield St, Charing Cross Road,* / *LONDON W.C.* / *(Near the Palace Theatre)* (paper label); *REEVES & SONS* / *LONDON* / *B* (black stamp); *PETROUCHKA* (black paint on front of frame)

S.804–1991

71 Cyril William Beaumont (1891–1976)

Scene from 'Petrushka' by Michel Fokine

Oil on board 28 × 38 cm.

c.1913

Signed: *C.W. BEAUMONT* in oil paint (lower right)

Provenance: Bequeathed by C.W. Beaumont, 1976

Condition and Technique: As for (**70**). Conservation: 1990. The blanching was found to be more deepseated and unsafe to remove from the ultramarine pigmented areas such as the stage curtains. Some blanching was therefore left and retouched with water colour.

Inscription on verso: (REEVE)S & SO(NS) / *LONDON* (black stamp); Illegible inscription on front of frame.

S.805–1991

Blue curtains framing a garish interior, the wall painted with green trees with large blue and red flowers against a paler red background, a moor seated at left, a dancer balancing on right foot centre stage, Petrushka propped up against door at right.

Cyril Beaumont saw Diaghilev's production of *Petrushka* for the first time at Covent Garden on 4 February 1913 in a triple bill that also included *Thamar* and *Les Sylphides*. The cast included Nijinsky as Petrushka, Karsavina as the Dancer, Kotchetovsky as the Moor and Enrico Cecchetti as the Showman. Like everyone who saw this original production, first seen in Paris at the Théâtre de Châtelet on 13 June 1911, he was stunned by the combination of Stravinsky's music, Fokine's choreography and Benois's designs as well as the interpretations of the leading dancers. This oil sketch attempts to retain the strong impression created by the third scene of the ballet, particularly the garish self-confidence of the Moor's cell.

In *Bookseller at the Ballet* Beaumont describes Karsavina as the Dancer in the Moor's cell: 'Karsavina looked charming as the Dancer in her lace-fringed pantalettes, striped dull red and maroon, her pale mauve skirt, and her crimson velvet bodice with white sleeves trimmed with gold bands. Her hair,

dressed in the short ringlets which became her so well, was crowned with a crimson velvet toque, trimmed with white fur. Her make-up was flesh-pink with a bright dab of red on each cheek. Her eyes were given an air of exaggerated surprise by short black lines painted ray-like about them.'

In 1919 Cyril Beaumont published a small book describing the plot of *Petrushka* in his series, *Impressions of the Russian Ballet*. It was illustrated with hand-coloured wood-cuts by Michel Sevier. None of the illustrations relate to **70** and **71**.

72 Charles A. Buchel (1872–1950)

Sir Herbert Beerbohm Tree as Mark Antony in 'Julius Caesar' by William Shakespeare

Antony is shown with Caesar's corpse haranguing the crowd in the forum in *Julius Caesar* Act III scene ii at the words:

> If you have tears, prepare to shed them now.
> You all do know this mantle: I remember
> The first time ever Caesar put it on;
> 'T was on a summer's evening, in his tent,
> That day he overcame the Nervii.
> Look! in this place ran Cassius' dagger through:
> See what a rent the envious Casca made:
> Through this the well-beloved Brutus stabb'd;
> And as he pluck'd his cursed steel away,
> Mark how the blood of Caesar follow'd it
> As rushing out of doors, to be resolved
> If Brutus so unkindly knock'd or no;

Tree first played Mark Antony on 22 January 1898. It was his first large scale Shakespeare production at his new theatre, Her Majesty's, which had opened the previous April. According to Hesketh Pearson, '. . . it was generally agreed that no play of Shakespeare's within living memory had been so skilfully and realistically handled. For the first time the majority of the critics and playgoing public recognized that Sir Henry Irving's successor as pageant master, if not as actor, had arrived. . . .' The play was not usually popular with actor managers because of the quartet of leading players and Tree's production was the first in the West End since James Anderson's unsuccessful production at Drury Lane in 1850 apart from the Saxe-Meiningen Company's visiting production at the same theatre in 1880.

The speciality of the German company was their stage-management of crowd scenes but the memory of their spectacular forum scene in *Julius Caesar* was eclipsed by Tree's, a point noted in *The Times* for 24 January 1898: 'If the

Oil on millboard 60.9 × 48.1 cm.

1914

Signed: *CHAS.A.BUCHEL* in white oil paint (lower right)

Provenance: Given by the sitter to the Royal Academy of Dramatic Art; sold to John Hall, late 1950s; Harry R. Beard; given by the family of Harry R. Beard, 1971

Condition: Small piece of board missing left edge just above centre. Several minor scratches.

Technique: White ground. Paint applied thickly, especially on the figures. Folds of drapery indicated with the end of the brush bottom left.

Inscription on verso: *ACADEMY / BOARD / OIL PAINTING / PREPARED BY / CHAS.H.WEST / 117 FINCHLEY ROAD LONDON N.W.* (printed label)

S.216–1987 Neg: HF 4628/CT 16139

Saxe-Meiningen company had something to teach us . . .
they may now themselves come to London for a lesson . . .
This is an impressively real crowd that first Mr. Lewis Waller
as Brutus and then Mr. Tree as Antony, harangues. Their
excitement is contagious to the house; their execrations thrill;
one feels the irresistible force of this seething and surging
mass of humanity. And always the picture – the elements, the
groupings, the colouring, in a word the composition – is that
of an artist. In this . . . one feels the plastic hand of Mr.
Alma-Tadema. The now unchained passions of the mob,
clamouring for vengeance upon the conspirators and bran-
dishing their avenging torches lighted at the pyre that has
been prepared for the dictator's remains, combine to produce
a scene which, for its moving effect upon the house, has
probably never been surpassed upon the stage. . .'. The
scenery for the forum scene was in fact painted by Walter
Hann who had worked previously for Irving and Wilson
Barrett and was later to work again for Alma-Tadema when
he directed and designed Irving's last Shakespeare revival, the
Coriolanus of 1901.

Tree reorganised the text of the play into three acts,
devoting the whole of the second act to the forum scene. This
gave him the curtain at the end of the act just as he had taken it

in Act I, a condensation of the first two and a half acts of the original text, with his discovery of the murdering conspirators in the Senate House. The production was immensely successful, ran for five months and made a profit of £11,000. It was taken on tour several times and was revived in London in 1900 and 1904 and for the Shakespeare Festivals of 1905, 1906, 1907, 1912 and 1913, and the forum scene was given in a Gala performance on 27 June 1911. A detailed description of the direction of this scene was published on 16 June 1911. Harley Granville-Barker was in charge and he divided his huge crowd into eleven categories, including Lictors, Trumpeters and Caesarians. The largest section, the Common People, included 106 extras. The organisation finally proved too much for Granville-Barker and it seems that Tree helped him out with rather more emotive directions.

Buchel presumably sketched from one of the 1913 performances when Julius Caesar was played by A.E. George. In the original production Tree had insisted that Charles Fulton, playing Caesar, appeared as the corpse in the forum scene rather than a dummy. According to Pearson, Fulton was anxious about the draughts on stage: 'What will people say if the corpse sneezes?' he said. Tree replied, 'They will call you Julius Cnaesar.'

Buchel's four sketches of Tree in various Shakespearean roles (**72–75**) appear to have been painted in 1914, the date inscribed on the Othello sketch. Buchel's work in this medium was invariably prepared for photographic reproduction in various publications such as theatrical souvenir booklets (cf. Nos. **57–8** and **61**) and publicity pamphlets (cf. portraits of Tree as Wolsey, Arthur Bourchier as Henry VIII and Violet Vanbrugh as Queen Katharine at R.A.D.A.). However, there is no surviving publication that includes reproductions of any of these four portraits and they may have been prepared for an aborted booklet planned for a 1914 Shakespeare season, although the diaries produced by Tree for the 1912 and 1913 seasons are not illustrated. Tree initiated annual Shakespeare seasons in 1905 but if it was ever planned, the 1914 season was abandoned; the new production of *Pygmalion* was extremely popular and the imminence of war probably dampened Tree's usual aversion to financial security and the long run.

There is also a possibility that the four small portraits were preparatory sketches for large portraits of Tree painted to hang in Tree's private suite at His Majesty's theatre, which included the Dome Room or Baronial Hall situated high above the main entrance to the theatre. Two photographs of this room in *The Sketch* for 12 September 1906 show the lower part of the walls covered with large pictures by Buchel, illustrating scenes from plays in which Tree had appeared. The history of the decoration of his extraordinary room is uncertain but at a later date the upper part of the walls was said to be covered with large portraits of Tree in character. The portrait of Tree as King John (**56**) seems to be the only surviving life-size portrait of the actor by Buchel. He may have intended to paint life-size versions of **72–75** but there is no indication that such works were completed.

73 Charles A. Buchel (1872–1950)

Sir Herbert Beerbohm Tree as Macbeth in 'Macbeth' by William Shakespeare

Oil on millboard 61 × 48.2 cm.

1914

Signed: *CHAS.A.BUCHEL* in black oil paint (lower left)

Provenance: As for **72**

Exhibited: 1949 Port Sunlight, Lady Lever Art Gallery *Art and the Theatre* (11)

Condition: Slight loss and damage to board along top right edge. Small chip and several scratches in lower right area.

Technique: White ground.

Inscription on verso: *ACADEMY / BOARD / OIL PAINTING / PRE-PARED BY / CHAS.A.WEST / 117 FINCHLEY ROAD LONDON N.W.* (printed label)

S.217–1987 Neg: HF 4636/CT 16182

Macbeth is shown entering, just having murdered Duncan in Act II scene ii:

> *Lady M:* . . . My husband!
> > *Enter Macbeth*
> *Macbeth:* I have done the deed. Didst thou not hear a noise?
> *Lady M:* I heard the owl scream and the crickets cry.

Tree did not play Macbeth until 5 September 1911 when he opened in his own production at His Majesty's. Violet Vanbrugh played Lady Macbeth, Arthur Bourchier was Macduff, J.H. Barnes Banquo and Basil Gill Malcolm. In an inspired moment Tree had asked Edward Gordon Craig to design the production but the two men disagreed and Tree finally employed McCleery, Craven and Harker. Tree evidently destroyed Craig's drawings and models as a case for damages brought by Craig was settled out of court. It seems likely that the great staircase on which the sleep-walking Lady Macbeth descended and reascended the entire height of the back-scene was a remnant of Craig's vision but the rest of the

scenery was stolidly representational. As usual Tree took a great interest in every aspect of the production and wrote to his daughter, Viola, in Italy about his experiments with back lighting. The critical reception was mixed but there was admiration for Tree's interpretation of the role of Macbeth. His wife, Maud, expressed some surprise at his success in her piece written for Max Beerbohm's book *Herbert Beerbohm Tree* [n.d.], 'I confess that I did not think the part of Macbeth would suit Herbert . . . But he could not be satisfied until he had essayed it, having a great love and reverence for the play. Accordingly he gave it, and gave one of his most wonderful productions. I did not tell him how astounded I was at his Macbeth in the first three acts (The last demands a soldier and that Herbert never succeeded in portraying). But the scenes with the Witches, the Murder scene, the Banquo's ghost scene – these were rendered with a wild, tragic intensity, a very fury of the driven mind that made one's blood run cold . . . And the wistful, distraught face, the wistful, distraught voice in those immortal soliloquies: these were great acting, if ever acting was great' (p. 150).

A photograph by F.W. Burford of Tree clutching the daggers was published in several daily newspapers, including the *Graphic, Express, Sketch* and *News*, on 6 September 1911. The pose, especially of the head, is similar to Buchel's picture although in the photograph Tree holds the daggers to his waist. Buchel published a drawing of Macbeth meeting the witches in the *Sphere* of 9 September 1911. The figures are unusually romanticised for the artist and bear a surprisingly close resemblance to the figures in an oil sketch of the same subject by Buchel signed and dated 1906. This sketch, which is in the Folger Shakespeare Library (ART Box B919 No. 5) does not appear to relate to a specific production and is inscribed 'Please don't engrave'.

In 1916 Tree went to Hollywood to play Macbeth in a film version of the play. The part of Lady Macbeth was taken by Constance Collier.

74 Charles A. Buchel (1872–1950)

Sir Herbert Beerbohm Tree as Shylock in 'The Merchant of Venice' by William Shakespeare

It is difficult to assign a specific moment in the play but photographs of the production show that the striped costume was worn in the early scenes such as the meeting with Antonio and Bassanio in which Antonio foolishly agrees to Shylock's loan of three thousand ducats for three months.

Tree produced *The Merchant of Venice* at His Majesty's and played Shylock for the first time on 4 April 1908. In the light of his great sucess in other similar parts such as Fagin in *Oliver Twist* it is surprising that he did not play the role earlier but as he told the *Daily Mail* on 28 March 1908, 'I had long

Oil on millboard 60.9 × 46.8 cm.

1914

Signed: *CHARLES BUCHEL* in black oil paint (lower left)

Provenance: As for **72**

Condition: Board has bent corner bottom left and delaminated strip at top right edge. Minor paint losses

around edges and associated with damage to board. Some minor scratches.

Technique: White ground.

Inscription on verso: *ACADEMY / BOARD / OIL PAINTING / PRE-PARED BY / CHAS.H.WEST / 117 FINCHLEY ROAD LONDON N.W.* (printed label)

S.219–1987 Neg: HF 4629/CT 16177

contemplated producing *The Merchant of Venice* at His Majesty's but you can understand that I preferred to allow some years to elapse before presenting a play that, through association, belonged to Sir Henry Irving.' Having taken the decision to produce the play he gave it the complete Her Majesty's treatment and some critics felt that the means did not completely justify the end. For instance, the reviewer in *Public Opinion* on 17 April 1908 was not at all impressed; 'Last Saturday hardly a quotation came across the footlights. It was all Mr. Tree, Venetian colouring, gondolas and Ghetto scenes. Let Mr. Tree carry his cynical triumph just one step further. Let him give us say *Romeo and Juliet* by Mr. Tree in a series of tableaux, arranged in a new order, after designs by Mr. Frank Dicksee, without words but with four and a half hours of Mr. Tree's attitudes in the foreground.'

Tree's new order for *The Merchant of Venice* arranged itself in three acts with eight scenes. The designer was not Dicksee, a well-known painter of Shakespearean scenes and heroines, but Percy Macquoid who discussed his thoughts on Tree's Shylock and the production in general in the *Evening Standard and St. James's Gazette* on 4 April 1908; 'At the time chosen for the present setting of the play, about the middle of the sixteenth century, there were over 5,000 Jews in Venice, with at least five synagogues . . . Shylock, as impersonated by Mr. Tree is dignified in type, and his features are of high racial

distinction. Miserly in his avarice, his clothes originally of fine material, are consequently old and shabby, he wears the yellow gaberdine and yellow head-covering of state ord-inance, but the show and glitter of colour dear to the Oriental are dispensed with.' In fact, Buchel shows Tree wearing a striped cotton or silk of a type that must date from the late nineteenth century. The garment, although worn by men in the middle ages, was worn only by women in the Middle-East in the nineteenth century.

The production was dominated by Tree's Shylock even if his performance was occasionally somewhat self-indulgent. Part of the success was due to his appearance, caught so much better in Buchel's portrait than in any of the production photographs and admiringly described in the *Daily Chronicle* of 6 April 1908: 'In a magnificent make-up of curly grey beard and beetling brow Mr. Tree has managed to embody in this cringing, keen, passionate, subtle, strong old man, with his gleaming teeth, rich lips and piercing eye, every racial characteristic that might have been supposed to fan the flame of hatred between mediaeval Jew and Christian.'

75 Charles A. Buchel (1872–1950)

Sir Herbert Beerbohm Tree as Othello in 'Othello' by William Shakespeare

Othello is shown in his costume for his arrival in Cyprus at the beginning of Act II; a full suit of black armour dama-scened in gold and painted with flashes of bright blue, a helmet with gold and green plumes and, hanging from shoulders down back, a green cloak with gold spots and edging. It is likely that both Buchel and Tree were more interested in the magnificent suit of armour than in capturing a particular moment of the drama.

Othello was Tree's last new major Shakespearean role, if one discounts a flirtation with Mercutio in June 1913. His production opened at Her Majesty's on 9 April 1912 and whilst Laurence Irving's Iago was generally preferred to Tree's Othello, whose pale skin colour provoked endless discussion in the press, the best notices were reserved for the sets and costumes. The *Times* reviewer on 10 April 1912, for instance, after yawning over Tree's extremely slow delivery of his lines, took a distinctly art-historical turn; '. . . there was a Carpaccio air about the whole of the costumes and decor, and Carpaccio must have been in the mind of Mr. Percy Macquoid. Why not? The result is beautiful, is roman-tically Venetian (and Venetian-Cypriote) and is a way of presenting Shakespeare that, whatever the Puritan and Pro-fessor may say, is a way that the patrons of His Majesty's are used to and greatly like. At every moment there is a feast for the eye: Roderigo's dress, Othello's inlaid armour, the robes of the Doge . . .'

Percy Macquoid, the designer of *Othello*, gave his usual

Oil on millboard 60.9 × 46.8 cm.

1914

Signed: *CHARLES BUCHEL / 1914* in black oil paint (lower right)

Provenance: As for **72**

Condition: Board has small repaired tear bottom left edge and minor losses and abrasions around edges. Long curved scratch centre left and some rough retouchings, i.e. over tear bottom left.

Technique: White ground.

Inscription on verso: *ACADEMY / BOARD / OIL PAINTING / PRE-PARED BY / CHAS. H.WEST / 117 FINCHLEY ROAD LONDON N.W.* (printed label)

S.218–1987 Neg: HF 4637/CT 16153

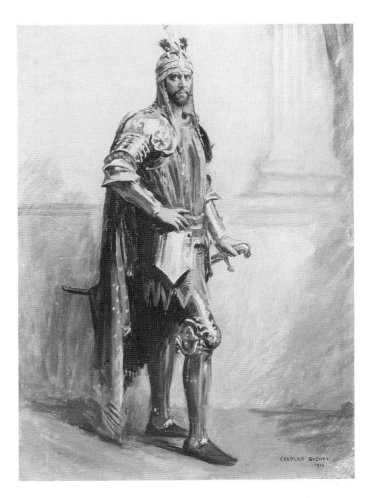

disquisition on his attitudes and aims in the *Evening Standard* on 9 April 1912 and included a paragraph on the Act II armour; 'The dresses worn by Othello, with the exception of the armour, are distinctly oriental. In the second act, when landing at Cyprus in his official capacity he wears a cap-a-pie suit of blued and steel armour richly damascened in gold, which is of the fashion shown in the paintings of Raphael and Perugino, and probably, in a pictorial manner, follows the simple lines of the human form better than any other style of armour that has ever been introduced, the spirit of Orientalism being still apparent in the adoption of the headpiece with the nose-guard and mail hood, in place of the European salade, or armet, of the time.'

76 Frank Daniell (fl. 1889–1921)

Fred Terry as Sir Percy Blakeney in 'The Scarlet Pimpernel' by Baroness Orczy and Montague Barstow

Oil on canvas 132.5 × 102 cm.

1918

Fred Terry played Sir Percy Blakeney for the first time at the Theatre Royal, Nottingham on 15 October 1903. The first London performance was at the New Theatre on 5 January

Signed: *FRANK DANIEL / 1918* in black oil paint (bottom right)

Provenance: Commissioned by 60 provincial theatre managers and given to the sitter, 15 August 1918; Julia Neilson;; Given to the National Theatre, 1963; Indefinite loan to the British Theatre Museum Association (1965/A/107), 1965

Exhibited: 1918 R.S.P.P. (88) (*Fred Terry as 'The Scarlet Pimpernel'*)

Literature: Neilson *This for Remembrance* 1940 p. 213

Condition: Scattered retouchings over areas of drying craquelure in the background. Scattered superficial scratches.

Technique: Cream-white ground on coarse tabby weave canvas. Thin application of paint in some areas, especially the background, but considerable impasto elsewhere, mostly on the lighter highlights of the costume. Printed label on verso: '*DRAWING MATERIALS / . . . / From / C.ROBERSON & Co Ltd / 99, Long Acre, London*'

Label on frame: *PRESENTED TO / FRED TERRY / BY THE / MANAGERS OF THE UNITED KINGDOM / WHOSE THEATRES HE VISITS. / Painted by Frank Daniell. / August 15th 1918*

S.87–1986 Neg: HG 681/CT 16434

1905 with Julia Neilson as Lady Blakeney. It ran for 122 performances and was revived at the same theatre on 26 December 1905 when it achieved a further 119 performances. There were six more revivals in London before the First World War, all of them at the New Theatre. The play was taken to America and performed at the Knickerbocker Theatre, New York, in October 1910. The last London revival before Daniell painted his portrait was at the Strand Theatre on 11 September 1915 when it ran for 128 performances. However, the reason for Daniell being commissioned to paint the picture was the immense success the play enjoyed outside London, making lots and lots of money for both Fred Terry and the grateful provincial managers. Terry's last appearances as Sir Percy seem to have been at the Palace Theatre on 14 May 1928, for the King George's Pension Fund, and in two subsequent revivals at the Strand Theatre, on 26 December 1928 and 30 March 1929 for a total of 97 performances.

The costume is a good example of early twentieth-century stage romanticism, flattery rather than accuracy. The effect of this sort of thing on Hollywood costume dramas was devastating. Terry wears a white curly wig of doubtful historic inspiration, a gold spy-glass hanging by a black band from around neck, bright orange silk jacket with high stiff turned-down collar and wide lapels, and breeches with gold buttons at knees, cream waistcoat with wide lapels open over jacket, white frills at cuffs and neck, white stock pinned with two round jewels, blue and white.

77 Adrian Paul Allinson (1890–1959)

Tamara Karsavina as Columbine in 'Le Carnaval' by Michel Fokine

Oil on millboard 64.3 × 52.3 cm.

c.1918

Signed: *Allinson* in dark blue oil paint (bottom left)

Provenance: Cyril W. Beaumont; bequeathed to the Theatre Museum, 1976

Exhibited: 1954 Forbes House *The Diaghilev Exhibition* (464)

Condition: Board acidic and somewhat embrittled with dents around edges caused by nails which fixed picture into frame. Paint losses around edges and other minor scattered losses. The paint covered by the rebate is markedly lighter than the rest of the picture surface although XRF analysis showed that the same pigments had been used throughout. The removal of surface dirt did not affect the extreme discolouration; solvent tests were also ineffective.

Technique: Probably white ground on millboard.

S.102–1986 Neg: HF 4573/CT 16133

Fokine composed his ballet *Le Carnaval* for a charity performance in the Zal Pavlovoi in St. Petersburg. He used Schumann's suite *Le Carnaval* and persuaded Bakst to design the costumes. Karsavina created the role of Columbine with Leontiev as Harlequin, Cecchetti as Pantalon, Nijinska as Papillon, Fokina as Chiarina, Schollar as Estrella, Meyerhold as Pierrot and, according to Vitale Fokine, Nijinsky took the role of Florestan. The ballet was first seen in the West in Berlin on 20 May 1910.

The following year Karsavina returned to her original role of Columbine and on 6 June 1911 she was accompanied by Nijinsky as Harlequin at the Théâtre du Châtelet. The ballet was given in London for the first time later in the same month. Cyril Beaumont did not see any of the performances during the first two seasons of the Diaghilev ballet in London but made up for lost time by seeing his first *Le Carnaval* on 20 June 1912. The cast was dazzling; Karsavina as Columbine, Piltz as Chiarina, Baranovich as Estrella, Nijinska as Papillon, Bolm as Pierrot, Nijinsky as Arlequin, Cecchetti as Pantalon, Sergeyev as Eusebius and Semenov as Florestan. Beaumont felt that the piece was dominated by Pierrot but in *The*

Diaghilev Ballet in London, 1940 (pp. 23–4) he described his delight with Karsavina:

'Karsavina's Columbine has remained for me the best interpretation of that role. She made Columbine a beautiful young woman, well aware of her beauty, and determined to exploit it to the utmost. Karsavina's Columbine was as dainty as a Dresden china figure, but she had very human failings. She was a heartless coquette who inspired admiration and then snubbed the fool who thought his affection would be returned. She let Pantaloon make advances to her, even accorded him a rendezvous, and then, just when the old beau was in the seventh heaven of anticipation, enlisted the aid of Harlequin and made him the butt for their mockery.'

In Allinson's picture Karsavina wears her original costume of a frothy cream dress with touches of blue and pink with red cherries along a scalloped edge evident bottom left.

In 1918 Beaumont prepared a series entitled *Impressions of the Russian Ballet*, consisting of illustrated booklets telling the story of the ballet. The first four to be planned were *Cléopâtre, The Good Humoured Ladies, Schéhérazade* and *Le Carnaval* and they each contained four small and one large drawing, all by Adrian Allinson. Allinson's drawings for *Papillons, Sadko, Prince Igor* and *The Midnight Sun* were not used. It is likely that Beaumont commissioned his portrait of Karsavina from Allinson at this time. He seems to have become acquainted with Karsavina in 1914 although his close relationship with the Diaghilev *Ballets Russes* really dated from 1918 when he was permitted to attend all rehearsals and watch performances from behind the scenes.

78 Adrian Paul Allinson (1890–1959)

Tamara Karsavina as the Firebird in 'L'Oiseau de feu' by Michel Fokine

Karsavina danced the Firebird at the first performance of *L'Oiseau de feu*, given by Diaghilev's Ballets Russes at the Paris Opéra on 25 June 1910. She danced the part when Diaghilev brought the ballet to London in 1914 but not in the 1919 revival when Lydia Lopokova replaced her. **78** is possibly painted as a pendant to **77** and may date from the same period. *L'Oiseau de feu* was not a favourite ballet with Beaumont and it is curious that he should have wanted a perpetual reminder of it. Jacques-Émile Blanche painted his well-known portrait of Karsavina as the Firebird in June 1913 and possibly both Allinson and Beaumont were inspired by that picture. In both paintings Karsavina is wearing her original costume and head-dress designed by Leon Bakst; a high feather head-dress in green and red feathers, two strands

Oil on hardboard 64 × 52.5 cm.

c.1918

Signed: *Allinson* in black oil paint (bottom left)

Provenance: Cyril W. Beaumont; bequeathed to the Theatre Museum, 1976

Condition: Some small paint losses especially around edges and some minor scratches.

Technique: Ground not visible. The impasto is thick in some areas, with

the artist's fingerprints visible and marks made in the wet paint with the end of the brush. Hairs and brush bristles have dried into the paint.

Inscription on verso: *Allinson / 1686 mk close up* (?) in pencil (bottom); *C.W. BEAUMONT COLLECTION / V.A.M.* (circular sticker)

S.59–1988 Neg: HH 1262/CT 17454

of pearls hanging from ear to ear and a costume with a tight green bodice decorated with hanging red decorative strips, red shoulder pads, orange and beige skirt with green, red and orange feathers swirling about the knees. Bakst also designed the costumes for the Prince and the Beautiful Tsarevna. The remainder and the setting were by A. Golovine.

79 Sacha Guitry (1885–1957)

Lucien Guitry as Talleyrand in 'Béranger' by Sacha Guitry

Oil on canvas 73 × 60 cm.

1920

Signed and inscribed: *SachGuitry* in black oil paint (top left); *a Charles B. Cochran amical souvenir SachGuitry* in pencil (bottom)

Exhibited: 1920 R.S.P.P. (270)

Provenance: Charles B. Cochran; given to the Theatre Museum by John Hall, 1974

Lucien Guitry played the Prince de Talleyrand in his son's play *Béranger* at the Théâtre Porte Saint-Martin in 1920. Sacha Guitry played the part himself in 1948. The picture had been catalogued as a self-portrait by Sacha Guitry until Jacques Crepineau, the director of the Théâtre de la Michodière, made the correct identification.

Cochran introduced Sacha Guitry to the London stage when he presented a season of five plays at the Aldwych, opening on 11 May 1920 with Guitry playing Robert Chapelle in his own *Nono*. Guitry appeared with his father Lucien and with Yvonne Printemps to enormous acclaim and

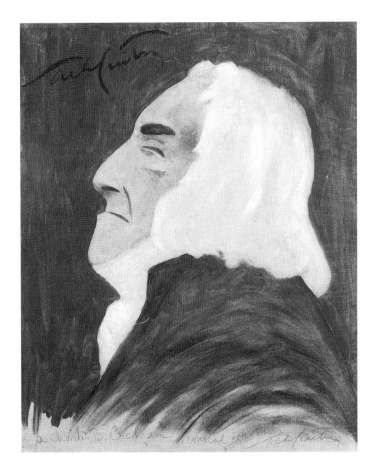

Condition: Conserved: April 1987. Three tears repaired. Lined. Losses along the tears and a scratch next to the cravat retouched. Face and cravat appear spotted, probably by mould in the past.

Technique: White ground on tabby weave canvas. Very thin and sketchy paint. Ground visible all over and no paint layer at all at bottom. Some pencil underdrawing visible.

S.1128–1983 Neg: HF 4634/CT 16181

returned to London for further Cochran seasons in 1922 (three plays at the Prince's) and 1923 (three plays at the New Oxford starring Duse). In June 1926 he appeared for Cochran at the Gaiety as Baron de Grimm in *Mozart* and in June 1929 in *Mariette* at His Majesty's. C.B. Cochran's most prolific year as an impressario was 1932 and his six productions included a Sacha Guitry season at the Cambridge. Guitry played Albert Blondel in *La Jalousie*, Philippe in *La Pélerine Ecossaise* and the title role in *Désiré*. All the plays were by Guitry and the season ran from 7 to 26 November. He also appeared in a special performance of snippets from a number of his other plays on 9 November.

Guitry returned to London yet again in 1935 for another three play season, this time at Daly's, and wrote and appeared in a sketch entitled *You're Telling Me* given at a Royal Command Performance at the India Office on 23 March 1939 and at the Coliseum with Sir Seymour Hicks. His last London appearance was as He in his own *Écoutez Bien, Messieurs* at the Winter Garden in June 1953.

79 was loaned to the 1920 Royal Society of Portrait Painters exhibition by C.B. Cochran along with a portrait of Yvonne Printemps (266), also by Sacha Guitry.

80 Arthur John Foster (fl.1880–1920)

Robert Michaelis

Oil on canvas 92 × 61 cm.

1920

Signed: *19 AJF 20* (AJF in monogram) in grey oil paint (top right)

Provenance: Presented by Mrs. Robert Michaelis to the British Theatre Museum Association (1973/A/48), 1973

Condition: Generally sound. Bulge by right ear caused by a blow from behind. Two slight approximately horizontal scratches running from his face to the left edge with minor paint loss. Garlanding half way down left edge. Water stains on back of canvas. Slight pentimento to sitter's left collar. Minor paint losses and very slight incipient flaking associated with the protruberance and dent.

Technique: White ground on tabby weave canvas.

Inscription on verso: *Artist / Arthur John Foster / 25 Park Hill Rd. NW3 / Title / R.Michaelis Esq.* in crayon or charcoal or dry paint; *FROM JAMES LANHAM / Artist Colourman / St Ives, Cornwall* printed paper label (left stretcher bar); *1973/A/48 / Robert Michaelis / OIL PAINTING, by A.J. FOSTER* (paper label on top bar of frame); *FOSTER* (white chalk on top left corner of frame); *A FFOSTER* (white chalk on top bar of frame)

S.814–1991 Neg: JA 957/CT 25711

The inscription on the verso suggests that the picture was at least entered for an exhibition. There is no trace of it having been shown at any London exhibition. In September 1919 Robert Michaelis returned to the stage as James in *Who's Hooper* at the Adelphi. He had been with the British Expeditionary Force since 1915. In April 1920 he played J.P. Beaudon in *Irene* by Pinero at the Empire. It seems that Foster's portrait celebrates the sitter's return to the stage although it is unlikely that he is shown in character.

He is depicted wearing a grey morning suit with three buttons at cuffs, white handkerchief in left breast pocket, blue and white striped shirt with white collar, gold cuff-links, purple silk tie with black stripes, gold pin.

81 Frank Daniell (fl. 1889–1921)

Julia Neilson as Nell Gwyn in 'Sweet Nell of Old Drury' by Paul Kester

Nell Gwyn is shown in her 'very beautifully and richly furnished' Drawing Room, the set for Act II. King Charles has entered and as Nell strums at her spinet he takes her hand and kisses it.

> *Nell:* Would that these hands could lift all care and sorrow from your brow. (*Playing with right hand*).
> *Charles:* No hands have ever lifted half so much. Ah, Nell, your hand is very beautiful. (*Kisses hand again – drops hand*)

They exchange a little gay badinage and Nell sings *How happy the Lover.* The song was a particularly popular moment in the play and the words, by Dryden, and music, by Raymond Roze, are printed in Julia Neilson's autobiography. The plot of *Sweet Nell of Old Drury* is complicated and silly and has nothing to do with historical fact but it was a popular piece and introduced a large audience to the furtive joys of costume drama. Nell adores Sir Roger Fairfax for saving her father from debtor's prison but he then has to flee the country on a charge of suspected treason. He returns and is hiding in Nell's room during the exchange with King Charles at the spinet.

Oil on canvas 126.8 × 101.3 cm.

1920

Provenance: Commissioned by 60 provincial theatre managers and given to the sitter. Given to the National Theatre 1963; Indefinite loan to the British Theatre Museum Association (1965/A/107), 1965

Exhibited: 1920 R.A. (654)

Literature: Neilson *This for Remembrance* 1940 pp. 213–4

Condition: Lined. Overall shrinkage, cracking only visibly disturbing down back of dress and in background behind her. Canvas shows through the paint in places. Conservation 1987. Varnish removed. Minor retouching carried out on worst shrinkage cracks and on small losses top edge and bottom left corner. Revarnished.

Technique: Tabby weave canvas. White ground.

S.88–1986 Neg: HF 4539/CT 16103

Judge Jeffries appears to look for Fairfax but initially only finds the King – in a cupboard. Fairfax reveals himself too soon and the rest of the play follows Nell's successful attempts to save him from execution.

When Daniell painted **81** Julia Neilson was over fifty and had been playing Nell Gwyn for twenty years. With *The Scarlet Pimpernel* the play was the main stay of Julia Neilson and Fred Terry's management which began with the first performance of *Sweet Nell of Old Drury* at the Haymarket on 30 August 1900 and continued until 1930. Neilson and Terry bought an option on the play from Louis Calvert, acting on behalf of the American author of the play, from under the nose of Kate Rorke. The text turned out to be rather less appealing than they had at first thought and both Julia Neilson and Constance Collier, who was the original Lady Castlemaine, give the credit for most of the final script to Hartley Manners who later became well known as the author of *Peg O' My Heart*. The title was the inspiration of Fred Terry and Louis Calvert. The play opened shortly after another Nell Gwyn play, a vehicle for Marie Tempest called *English Nell*, but it was a great success and the initial six-week run was sold out. After a tour it returned to London, the last production at the old Globe Theatre in Wych Street, and then became a perennial feature of the touring circuit.

Julia Neilson may be wearing the original costume designed by Edith Craig but it is more likely to be the replacement costume designed by Mrs Gordon Craig that can be seen in the production photographs by Ellis & Walery which appear to date from the late 1920s. One of these shows Nell Gwyn seated at her spinet with King Charles seated to the left. The earlier costume had much more frothy lace and was also graced with a huge many-stoned pendant which covered Miss Neilson's generous cleavage. The later one, seen in **81** consists of a heavy blue dress with hanging tabs and full lace sleeves and a lace bodice, which is cut very low and leaves her shoulders strikingly bare. A jewel hangs from a chain around her neck and there are two large rings on her left hand. The costume, both the original version and the replacement seen in **81**, attempts to borrow seventeenth century details but the result is a confused mish-mash of historical ideas and the real feel of the costume is c.1900.

The instrument being played by Julia Neilson appears to be a Dolmetsch single manual harpsicord of about 1890, built as a recreation of a seventeenth-century Flemish harpsicord.

82 Reginald Grenville Eves (1876–1941)

Julia Neilson

Oil on canvas 41 × 31.7 cm.

c.1920

This sketch, only the face is finished in any detail, seems to be preparatory to a larger picture, either lost or never completed. A date of c.1920 would put the sitter in her mid-fifties.

Provenance: Grenville Eves's bequest to the British Theatre Museum Association (1973/A/47), 1973

Condition: Blackish spots on reverse, possibly caused by mould. Small indentation with loss of ground and paint top edge centre.

Technique: Cream gound on tabby weave canvas. The paint extends on to the tacking edges at bottom and both sides, suggesting that the support was stretched after execution.

Inscribed on verso: *REEVES & SONS / PREP.. / LONDON* (black ink stamp); *CHAS.H.WEST / Artist's Colourman, Picture Frame / Maker and Exhibition Agent / 117. Finchley Road. / Swiss Cottage. NW3 / Telephone. Primrose 0465* (printed label)

S.98–1986 Neg: HF 4536/CT 16100

Charles West also provided Charles Buchel with his prepared boards, including **72–75**. **75** is dated 1914 by the artist.

83 Reginald Grenville Eves (1876–1941)

Fred Terry

Despite the affectionate message this is not Eves at his best. No doubt the condition of the picture adds to its lugubrious quality. **83** was presented to the Theatre Museum as *Portrait of Fred Terry by Reginald Eves*. Terry wears a dark jacket, stiff white collar and cuffs, dark green cravat with white spots, white edged waistcoat.

Oil on canvas 95 × 64.5 cm.

c.1920

Inscribed: *To my friend Fred Terry* in red oil paint (top right)

Provenance: Presented to the British Theatre Museum Association (1965/A/25), by Miss Hazel Terry through Phyllis Neilson-Terry, 1965

Condition: Lined. The original canvas appears to have become detached from the lining canvas bottom right corner and has caught on the edge of the slip which is distorting it. There is raised craquelure in some areas, notably above the head in background and in a

wide band roughly level with the hands and parallel with the bottom edge. Below this area there is considerable old loss which may have been retouched without filling as it appears dark and corresponds to staining on the verso. There is a similar 'retouched' loss in the background above the head. Several small areas of white may have been caused by minor blows from behind. There are two new losses associated with the distorted bottom right corner and there are some other minor flake losses on the right edge.

Technique: White ground on tabby weave canvas.

S.815–1991 Neg: JA 742/CT 25698

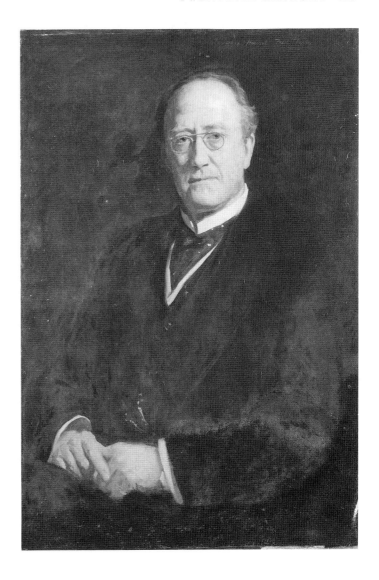

84 Adrian Paul Allinson (1890–1959)

Sir Henry Wood in the Queen's Hall

Oil on millboard 64.7 × 52.7 cm.

c.1920

Provenance: Cyril W. Beaumont; Beaumont bequest, 1986

Condition: Severe convex bow in the board which is delaminating slightly at corners and edges. Minor abrasion losses around rebate edges and small scratches top right, centre bottom and left edge centre.

Technique: The ground is not visible. The board is 0.2 cm. thick.

S.1133–1986 Neg: HF 4528/CT 16092

Henry Wood conducted in the Queen's Hall for the first time in 1894 when he was appointed musical adviser to a series of Wagner concerts organised by Schulz Curtius. The following year he was engaged to conduct a series of Promenade Concerts there by Robert Newman and a life-long connection was created. In 1897 he conducted a command performance of the Queen's Hall Orchestra to celebrate the Queen's Diamond Jubilee. The Proms made Wood the most familiar figure in the musical life of London; he conducted almost all the concerts himself although he encouraged composers to present their own works. Robert Newman died in 1926 and the B.B.C. took over the management of the Proms from Chappell & Co. the following year. The Queen's Hall Orchestra was superseded by the B.B.C. Symphony Orchestra which, however, Wood continued to conduct.

The Queen's Hall was destroyed by bombing in 1941 and the Proms were moved to the Albert Hall. Wood had continued with the concerts under a private management when the B.B.C. left London in 1939 but the Corporation resumed control in 1942. The Proms were chased from the Albert Hall by flying bombs on 30 June 1944 but from 1 July were replaced by broadcasts from Bedford. Wood conducted his last concert in Bedford on 28 July 1944.

The picture shows the interior of the concert hall, seen from stalls looking up to orchestra platform. Conductor standing on podium left centre, full-length; to right, arms raised, baton in right hand. Violinist bottom right, full-length, seated. Three other violinists bottom left. Open grand piano in centre beyond conductor, head of pianist visible. A large suspended lamp with an orange-pink shade hangs over the orchestra, top centre right, part of another top right. The picture is brightly coloured, background wall green with purple and blue spectators.

85 Hugh Goldwin Riviere (1869–1956)

Walter Johnstone-Douglas as Eochaidh in 'The Immortal Hour' by Rutland Boughton, adapted from Fiona Macleod

Oil on canvas 51 × 40.9 cm.

1923

Signed: *HGR (monogram) / 1923* in black oil paint (top left)

Provenance: Bequeathed to the British Theatre Museum Association (1972/A/133) by W. Johnstone-Douglas, 1972

Condition: Repaired tear with retouched abrasion halfway down right side 7.5 cm. from edge. The sides and bottom have been cut down so that the original tacking edges are not present. Part of the painted canvas is folded round the stretcher and used as tacking edges. These folded edges are badly scratched and abraided. Varnish discolouration, moderate. The general appearance is either of a dirt layer under the varnish or a toned varnish. Cross sections showed no dirt layer and did not clarify whether the varnish is toned.

Technique: White ground on tabby weave canvas.

S.96–1986 Neg: HF 4582

The Immortal Hour by Fiona Macleod (William Sharp) was first performed on 26 August 1914 at the Summer Festival, Glastonbury Festival School. It is a Celtic twilight play in verse based on the legend of Midir and Etain in which Midir woos to the Otherworld the beautiful woman Etain, wife of King Eochaidh. The original cast included Frederic Austin as Eochaidh, Irene Lemon as Etain, Arthur Jordan as Midir and Rutland Boughton as Dalua, the messenger of death. Boughton adapted the play into a music-drama which was first given in London at the Old Vic for five performances from 31 May 1920. The first successful run was at the Regent Theatre on 13 October 1922 with W. Johnstone-Douglas as Eochaidh, Gwen Ffrangcon-Davies as Etain, William Heseltine as Midir and Arthur Cranmer as Dalua. It was produced by Barry Jackson and Reginald Gatty and ran for 216 performances. It was revived at the same theatre on 14 November 1923 and 20 January 1924. Barry Jackson revived the play again with the same leading characters at the Kingsway Theatre on 29 January 1926 and again at the Queen's Theatre on 9 February 1932, with Bruce Flegg as

Midir. Paul Shelving designed spectacular costumes for the revival at the Queen's. Despite the extremely unpromising nature of the libretto the music-drama was received with extreme enthusiasm in some quarters. Hannen Swaffer, for instance, thought that it was the most beautiful English Opera ever written.

86 M. Gluck (1895–1978)

Leonide Massine waiting for his cue to go on stage in 'On With the Dance'

Massine is waiting to go on stage as The Beau in his ballet of *The Rake*. Scene 8 in Cochran's revue, *On With the Dance* wearing green jacket and red knee-breeches with brown tie-wig. The revue opened at the London Pavilion on 30 April 1925 after a short try-out in Manchester. The book and lyrics of the review were by Noël Coward and the music by Coward and Philip Braham. The star of the show was Alice Delysia but the cast also included Douglas Byng, Ernest Thesiger, Nigel Bruce, and Hermione Baddeley. Massine, Cochran's favourite male dancer, choreographed two ballets

Oil on canvas 60 × 50 cm.

1925

Provenance: Presented to the British Theatre Museum Association (1968/A/101) by Mrs. Prince Littler, 1968

Exhibited: 1973 Fine Arts Society *'Gluck' Exhibition of Paintings* (25)

Condition: Sound.

Technique: White or cream ground on tabby weave canvas. The frame is a 'Gluck Frame' made for the picture by the artist. It is white and consists of three stepped rectangles made of wood covered with paper.

S.83–1986 Neg: HG 684/CT 16437

for the revue, *The Rake* and *Crescendo*, as well as the grand finale, *A Hungarian Wedding*.

The music for *The Rake* was written by Roger Quilter and the idea taken from Hogarth's moral series, *The Rake's Progress*. The costumes were designed and the scene painted by William Nicholson and the masks were by Betty Muntz. The programme briefly sums up the action and describes the scene: 'Massine has taken a number of Hogarth's characters – symbolic and realistic. William Nicholson has given them a characteristic environment for a Hogarthian Orgy. "The Rake" lolls drunkenly in a chair while his wanton companions disport around him. The negro Cupid is busy with bow and arrows, plumbing the hearts of his victims; and the worship of women and wine whips itself up into a passionate whirl. And while the revellers seek their pleasure, the sages are wrapt in contemplation of their globe, and a window frames the faces of a curious crowd, who see, and are silent.'

Gluck seems to have been a sort of artist in residence for *On With the Dance* and she painted at least three other pictures of the Revue; *Ernest Thesiger on Stage* (F.A.S. 1973 (32)), *Ernest Thesiger Awaiting his Turn* (12) and *The Three Nifty Nats* (22). The Nifty Nats were Richard Dolman, Terry Kendall and Kenneth Henry and danced a *pas-de-trois* in Massine's ballet *Crescendo*.

87 Reginald Grenville Eves (1876–1941)

Elsa Lanchester

Oil on canvas 51.5 × 41.3 cm.

1926

Signed: *R. G. Eves* (top right); *1926* (top left) both in dark brown oil paint

Provenance: Grenville Eves's bequest to the British Theatre Museum Association (1973/A/47), 1973

Condition: Sound.

Technique: Tabby weave canvas with grey/cream ground. The paint layer extends on to the tacking edges. These are of uneven width. Seen from the reverse: the side edges are approx. the width of the stretcher bars, less at the top, and the bottom edge extends approx. one third of the way up the painting. There are old tack holes on the side and bottom turnovers parallel to the edges, suggesting that the picture was planned on a larger scale and was stretched, possibly flat, before being put on to its present stretcher. The picture is evidently a sketch and is thinly painted.

S.97–1986 Neg: HF 4535/CT 16099

It is evident that in her youth Elsa Lanchester had a magnetic attraction for artists. Rodin sketched her (and the other pupils) when she attended Isadora Duncan's school in Paris and when her lecture tour with Rose Benton fizzled out in 1915 she earned a shilling an hour sitting for artists. By 1924, when she was appearing at the *Cave of Harmony* she 'did lots of things to earn a living' including sitting for painters, sculptors and photographers. Not only is it true that she 'mostly posed in the nude for art photographers', she also acted as co-respondent in various divorce cases. She was admired by John Armstrong and sat for Jacob Epstein until Epstein's daughter Peggy shoved her hat down the lavatory.

Reginald Eves painted Elsa Lanchester several times. He showed a portrait of her at the Royal Society of British Portrait Painters in 1928 (95) and two portraits were included in the studio sale at Phillips on 30 October 1973 (*The Years of Reginald Grenville Eves*). Lot P96 was a portrait head only slightly smaller than **87** but lot P95 was a larger three-quarter length portrait, signed and dated 1926, showing Elsa Lanchester sitting provocatively on a stool wearing the laced bodice and frilly underskirt of a can-can dancer. A head and shoulders portrait reproduced as plate 60 in Adrian Bury's *The Art of Reginald G. Eves R.A.* shows the sitter with the same hair decoration she wears in **87**. They were evidently

painted at about the same time, April–May 1926, when Elsa Lanchester was appearing in the revue *Riverside Nights* at the Lyric, Hammersmith, and also in *The Midnight Follies* at the Metropole Hotel. The latter included a number by A.P. Herbert, *Spare a Copper for the Lucky Baby*, in which she was 'a very glamorous gypsy on Derby Day wearing a rather grand satin patchwork shawl and holding a baby in my arms.' This may be the inspiration for **87** with the curious gesture of the right hand a substitute for the baby. The sketch included the lines:

> Who sent the kind stork
> To the Duchess of York
> And cured our dear Prince of his pain?
> Well, you ask the Prince
> If he's had the croup since –
> He was good to Elizabeth Jane!

The Prince of Wales, attending one performance, walked out at this point and Miss Lanchester was sacked.

88 Reginald Grenville Eves (1876–1941)

Sir Frank Robert Benson

Oil on canvas 39.2 × 33 cm.

1927

Provenance: The artist; Grenville Eves's bequest to the British Theatre Association (1973/A/47) 1973

Condition: Minor paint loss on left and right edges, upper left and right corners.

Technique: White ground on tabby weave canvas. The painting appears to have been reduced in size. The original top tacking edge is still present but now lies on the verso of the stretcher and tacks go through what was originally part of the background paint layer. On the other three sides the original tacking-edges have been cut off and the existing tacking-edges have a paint layer on them.

Inscribed on verso: *REEVES & SONS / PREPARED CANVAS / LONDON / C / MADE IN ENGLAND / REEVES & SONS LTD / ASHWIN ST / DALSTON / E.13* (stencil stamp); *1973/A/47 / Grenville Eves Bequest / Sir Frank Benson. Oil Painting / by Reginald Eves* (typed paper label on top bar of frame); *CHAS. A. WEST / Artists' Colourman, Picture Frame / Maker and Exhibition Agent. / 117, FINCHLEY ROAD, / SWISS COTTAGE, N.W.3 / Telephone: Primrose 0465* (printed label on top bar of frame)

S.816–1991 Neg: JA 958/CT 25712

88 relates to a similar portrait in the Garrick Club (60), Oil on canvas 55.9 × 50.8 cm., which is signed and dated *R G Eves / 1927*. It was probably shown at the 1928 R.A. (62). A black chalk drawing, signed and dated *R G Eves 1927* 53.2 × 40 cm., was sold at Sotheby's 23–30 April 1986 Lot 465 (11 in lot) and shows Benson as he appears in **88**. Eves produced at least two other portraits of Benson; that in the National Portrait Gallery (3777), Oil on canvas 74.3 × 62.2 cm., is signed and dated *R G Eves / 1924*, and the other, Oil on canvas 75 × 62.2 cm., is not dated and was sold at Phillips 30 November 1973 Lot 39.

89 John Balloch Souter (fl.1914–1950)

Fay Compton as [?] Crawford in 'This Woman Business' by Benn W. Levy

Oil on canvas 128 × 102.5 cm.

1927

This picture was shown at the Royal Academy as *Miss Fay Compton*, suggesting that the sitter is not shown in character. However, she appeared as Crawford in Benn W. Levy's *This*

Signed: *J B SOUTER / 1927* in red oil paint (bottom right)

Provenance: Compton Family; presented to the British Theatre Museum Association (1970/A/87) by Anthony Pelissier (Fay Compton's son), 1970 (One of a group of 4 paintings)

Exhibited: 1927 R.A. (379)

Literature: *Royal Academy Illustrated* 1927 illus. p. 94

Condition: 9/1988. There are stains of water runs on the canvas reverse and there may be some canvas shrinkage in these areas. The largest stain seems to have been impregnated with wax and runs horizontally across the centre of the bottom half of the painting. The painting was standing on its right edge when the water damage occured. There is severe flaking down the right side with a loss and a line of blind blistering and incipient flaking along the bottom edge. There is other minor loss in the flaking areas. The flaking is clearly a result of the water damage. Conservation 1991: Blisters laid. Flaking consolidated. Losses filled and retouched.

Technique: Cream ground on tabby weave canvas.

S.817–1991 Neg: JA 724/CT 25743

Woman Business at the Haymarket on 1 May 1926. In one scene she wears a pair of mole-skin jodhpurs and in these very jodhpurs she may have been depicted by Souter. On the other hand, Fay Compton spent her Sundays as a member of the landed gentry and may have preferred to be seen in this guise on the walls of the Royal Academy. Other aspects of gentle living included in the picture are the riding crop, the grey hacking jacket, the pink silk tie, the seat in Chippendale taste and the sixteenth-century hunting tapestry with deer and rabbits.

90 Anton Harta (1884–fl.1930)

Unknown Lady

Oil on canvas 110 × 90.2 cm.

c.1930

Signed: *HARTA* in black oil paint (top right)

Provenance: Unknown

Condition: Canvas extremely embrittled and frail and only temporarily attached to stretcher along bottom and right edges. Some distortion along bottom edge. There is a tear approx. 2 cm. long 36 cm. from right and 43 cm. from bottom edge. The ground and paint layers are generally sound although there is some incipient flaking and loss on left breast. The picture has not been varnished and there is considerable ingrained surface dirt.

Technique: White ground on tabby weave canvas. Very deep impasto in some places.

S.810–1991 Neg: JA 743/CT 25699

The sitter with her dramatic red hair is unknown. The dating is approximate and relies entirely on the costume worn by the sitter and the similarity of the portrait to others of this date by Anton Harta. The sitter wears a green-blue shawl with decorations over right shoulder and left arm just below shoulder, slinky silver frock with straps over shoulders. The vague view of Venice with the Campanile on the left and S. Maria Maggiore on the right is probably the key to the identity of sitter and subject.

91 Reginald Grenville Eves (1876–1941)

Lucille Lisle

The inscription on the verso might be a mis-reading of 1936. Lucille Lisle left her native Australia for the United States in 1930 and moved to London at the end of 1932.

Oil on canvas 91.5 × 61 cm.

1931

Signed: *R G Eves* in green oil paint (top right)

Provenance: The artist; Grenville Eves Bequest to the British Theatre Museum Association (1973/A/47), 1973

Exhibited: 1936 R.S.P.P. (175)

Condition: There are run stains, spotting and traces of mould on verso, which suggest that the canvas had been wet at some time.

Technique: White ground on tabby weave canvas.

Inscription on verso: *June 1931* in pencil (right tacking edge); *REEVES & SONS / LONDON / MADE IN ENGLAND / G.REEVES & SONS LTD / UNWIN ST / DALSTON* stencil stamp (verso); *C662* (black ink on label); *EXHIBITION / TitleARNMA. . .. / 16 Price 75 gns* (pen & ink and printed label); *C.H.WEST / ..NCHLEY ROAD, LONDON N.W. / PHONE: HAMPSTEAD 465* (printed label on stretcher); *11* in white chalk.

S.818–1991 Neg: JA 959/CT 25713

92 Margaret Dorothy Nicholson (fl.1920–1972)

Joan Littlewood

Oil on canvas 36.3 × 31.3 cm.

1931

Provenance: Presented by the artist to the British Theatre Museum Association (1972/A/63), 1972

Exhibited: 1960 Royal Society of Portrait Painters (290); 1972 New English Art Club.

Condition: Sound.

Technique: Tabby weave canvas with white ground. Sketchily painted with heavy impasto on forehead and cheeks.

Inscription on verso: *26.9.1931 / M.D.NICHOLSON* (brown oil paint); *NEW ENGLISH ART CLUB / NAME: Margaret Dorothy Nicholson / ADDRESS: High Street,Wimbledon, SW9 / Title of Picture: JOAN LITTLEWOOD / Price in Guineas £52.10.0* (pen & ink on printed label)

S.95–1986 Neg: HF 4587/CT 16101

92 was exhibited in 1960 as *Joan Littlewood when a Schoolgirl.*

93 Hedwig Esther Pillitz (fl.1924–50)

Dorothy Black as Emily Brontë in 'The Brontës' by Alfred Sangster

Oil on canvas 76.9 × 63.8 cm.

1933

Signed: *Pillitz* in red oil paint (bottom right)

Provenance: The sitter; bequeathed to the Theatre Museum, 1985

Condition: Losses from nail holes down left side retouched, possibly by artist.

Technique: White (?) ground on tabby weave canvas.

S.1–1986 Neg: HF 4580/CT 16138

The Brontës opened at the Royalty Theatre on 20 April 1933 and ran for 238 performances. The part of the Rev. Patrick Brontë was taken by the author and his children were played by Lydia Sherwood (Charlotte), Helena Pickard (Anne), Dorothy Black (Emily) and Denys Blakelock. The cast also included Robert Eddison as George Smith and Brian Oulton as G.H. Lewes. The play was directed by Henry Oscar with scenery by Francis H. Bull and costumes by W. Clarkson. The book held by Dorothy Black was provided by Foyles. The very first production of the play was given at the Sheffield Repertory Theatre in May 1932. The play was divided into three acts and nine scenes but as none of them were set out-of-doors Hedwig Esther Pillitz's portrait must be an attempt to reflect the state of mind of Dorothy Black's Emily Brontë rather than a depiction of a particular moment

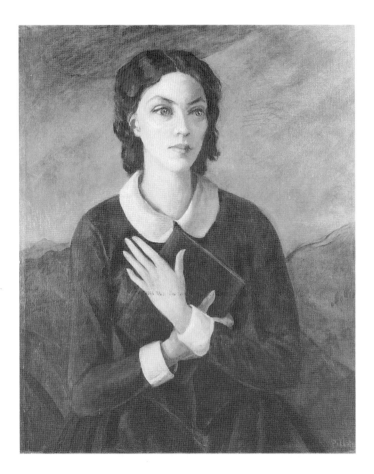

in the play. In fact, in Act II scene ii Charlotte accuses Emily of keeping too much to herself and says, "You live out on the moors alone."

Sangster gives Emily most of the dramatic fireworks in his play, she is the only one of the children to stand up to their dreadful father and the one who dies tragically on stage, breathing in a gust of wind from the moors as Charlotte throws open the window. She is described in the stage directions at the start of the play, when the curtain rises on the Parlour of Haworth Parsonage: "Of the group at the table, Emily, seated facing the audience, is the only one with real beauty. She is tall and pale, her small head finely poised on a slender neck. A mass of dark hair, close cropped. Her manner is direct and fearless, brusque and challenging; but it can soften at times to disarming tenderness. She is twenty-three years old."

Another Brontë play, Clemence Dane's *Wild Decembers*, opened at the Apollo in May 1933. Despite Charles Cochran's lavish production and the glittering cast that included Diana Wynyard as Charlotte, Beatrix Lehman as Emily, Thea Holme as Anne, Emlyn Williams as Branwell and Ralph Richardson as the Rev. Arthur Bell Nichols, the play was not a success and had a very short run. The time span, 1840–60, was the same as Sangster's play and even the settings were the same.

94 Nigel Ramsey Newton (b.1903)

'Hamlet' at the New Theatre

Oil on millboard 53.3 × 64.8 cm.

1934

Provenance: Presented to the British Theatre Museum Association (1966/A/217) by Sir John Gielgud, 1966

Condition: Sound. Small holes around edges from previous attachments and a few scattered losses exposing yellow board.

Technique: The board is tacked onto the front of a stretcher with small nails.

Inscription on verso: *Hamlet / New Theatre 1934 / by Nigel Newton / (Robert Newton's Brother)* (black ink); *G* (in circle) (pencil on stretcher); *and No 43 46 (46* in circle) (biro on stretcher)

S.90–1986 Neg: HF 4533/CT 16097

Looking at stage from dress-circle box, stage left four full-length figures are seen standing on stage. The Ghost is at the top of a flight of stairs upstage right, sword in hand extended towards the wings stage right. Two figures at the bottom of the stair attempt to restrain a third who, sword in hand, is attempting to follow the ghost. The scene depicted on stage is *Hamlet* Act I scene iv. Marcellus and Horatio attempt to stop Hamlet following his father's ghost:

> *Hamlet:* My fate cries out,
> And makes each petty artery in this body
> As hardy as the Nemean lion's nerve.
> (*Ghost beckons.*
> Still am I call'd. Unhand me, gentlemen,
> (*Breaking from them.*
> By heaven! I'll make a ghost of him that lets me:

John Gielgud's production of *Hamlet* at the New Theatre opened on 14 November 1934 and ran for 155 performances until 30 March 1935. Gielgud played Hamlet, William Devlin played the Ghost, Howison Culff was Marcellus and Jack

Hawkins Horatio. Other parts included Frank Vosper as
Claudius, Glen Byam Shaw as Laertes, George Howe as
Polonius, Laura Cowie as Gertrude, Jessica Tandy as
Ophelia, Anthony Quayle as Guildenstern and Alec Guinness
as Osric. The set and costumes, by Motley, are described by
Gielgud in *Early Stages*:

> For the scenery a large rostrum was constructed, revolving
> on its own axis and moved by hand. It was quite easily
> pushed round by four or five stage hands. This rostrum
> (which looked by daylight rather like the body of a
> denuded battleship) provided slopes and levels, seen at
> different angles when the position of the rostrum changed,
> on which I could vary the groupings at different moments
> in the play. A cyclorama was used at the back for the
> exteriors – the platform, the graveyard, and the final scene,
> and painted canvas curtains, covered with a rich florid
> design in blue and silver, enclosed the stage or draped the
> rostrum for other parts of the play. It was easy to raise or
> drop these curtains with only a few moments' pause
> between the scenes.
>
> All the dresses were made of canvas, but trimmed with
> silk and velvet, and with rich autumnal colours patterned
> on to them with a paint spray. The cost of these clothes was
> amazingly little, and the result looked magnificent, thanks
> to the Motleys' labour and ingenuity. The finished
> costumes had the rich, worn look so difficult to obtain on
> stage, where period dresses always appear to be either
> brand-new from the costumier or else shabby and second-
> hand. We wore great chains round our necks, which
> appeared imposing and massive from the front. Actually
> they were made of rubber, painted with silver and gold,
> and were as light as a feather.

Gielgud's performance is recorded in loving detail by
Rosamond Gilder in her book *John Gielgud's Hamlet* and she
has this to say about the moment shown in Nigel Newton's
picture:

> The two men close in on him and the spell is broken. He
> struggles in their hands, his body bent towards the Ghost as
> though it dragged him by an invisible cord. 'My fate cries
> out!' is hard and high. The violence of his voice is matched
> by the swift strength of his gesture as he throws off the two
> men. A swirl of black folds, the flash of a sword, and
> Hamlet stands alone on the platform.

Gielgud repeated his performance in New York in a produc-
tion that opened at the Empire Theatre, transferring to the
St. James's and running for 132 performances, a record for
the New York stage.

95 Roger Fry (1866–1934)

Geoffrey Whitworth

Oil on canvas 76.2 × 61.4 cm.

1934

Signed: *Roger Fry 1934* in black oil paint (towards lower right corner)

Provenance: Geoffrey Whitworth, by family descent to Anna Whitworth. On loan to the Theatre Museum.

Exhibited: at various premises of British Drama League/British Theatre Association.

Literature: *Drama* (December MCMXXXIV) p. 43; BBC Radio 4 script '"We Danced Upon His Strings": The Story of Geoffrey Whitworth (1883–1951)' broadcast on 20 November 1983.

Condition: Sound. Lined.

Technique: White ground on tabby weave canvas.

Inscription on tablet: *PRESENTED TO / GEOFFREY WHITWORTH. / FOUNDER AND DIRECTOR OF THE BRITISH DRAMA LEAGUE. / By GEORGE BERNARD SHAW. / ON BEHALF OF THE LEAGUE, NOVEMBER 1ST 1934.* On verso: On top bar of frame *GEOFFREY WHITWORTH by Roger Fry/Property of Robin Whitworth* [with address etc.] (typed on paper label); *1780 Brit Theatre/Assoc.* (in biro on paper label). On top bar of stretcher *Fine Art Packers Fra . . . / B31939 / 17 & 18 Nassau Street / Mortimer St. W. / Phones: Museum 1871 & 7588.* (printed paper label); *1780 / Frame* (in biro on paper label).

This portrait was given to the sitter, who was founding-director of the British Drama League, at the Royal Society of Arts on 1 November 1934. George Bernard Shaw presented it paying tribute as follows: 'Who is this man named Geoffrey Whitworth? What is he? He is not a great actor. So far as I know he has never acted in a play. If he has written any plays, I have not seen them. And yet, wherever I go I hear the name: Geoffrey Whitworth. He is one of the most important people in the theatre today.' Approximately 100 organisations and 300 individuals subscribed to the gift. Distinguished donors included Lords Howard de Walden and Leverhulme, playwrights (Arthur Pinero and James Barrie), managers (Nigel Playfair and Barry Jackson), stage designers (Albert Rutherston and Gordon Craig), and critics (St John Ervine and Ivor Brown).

95 was one of the last works of the artist who did not live to attend the ceremony. Fry had presided over the very first Committee meeting of the newly-formed British Drama League in 1919 and served on its Plays and Publications Committee. The British Drama League was renamed the British Theatre Association in 1972 and finally closed down in 1990. Its invaluable reference library and indexes were transferred to the Theatre Museum and became publicly available the following year.

96 Colin Colahan (b.1897)

Marie Ney as [?] Portia in 'The Merchant of Venice' by William Shakespeare

Marie Ney played Portia at the Alhambra Theatre in March 1934. Dorothy Moore, a close friend of Marie Ney, suggested that Portia is the part being played in **96**.

A chalk drawing by Colin Colahan of Marie Ney as Marthe in *The Other Heart*, Old Vic 1952, was also bequeathed to the Theatre Museum by the sitter in 1981 (1965/A/89). It was clearly produced at a much later date than **96**.

Oil on canvas 77.8 × 59.9 cm.

1934 (?)

Signed: *Colahan* in bright blue oil paint (bottom left)

Provenance: Bequeathed to the Theatre Museum by the sitter, 1981

Condition: Sound. Slight wearing along rebate edges. Fine shrinkage cracking in hairline.

Technique: Cream ground on tabby weave canvas.

Inscription on verso: *Winsor & Newton / . . . / (UNICOTE) / . . . / 14* stencil stamp (verso)

S.56–1982 Neg: HF 4575/CT 16135

97 Grace Rosher (fl.1926–1938)

Mrs. Edward Compton (née Virginia Frances Bateman)

In January 1915 Mrs. Edward Compton had been the moving spirit in founding the Soho Theatre Girls Club at 59, Greek Street as a residential home for theatre girls who were in need through unemployment. She remained the leading light as well as President and Chairman until her death in May 1940 at

Oil on canvas 81.5 × 93.5 cm.

1935

Signed: *Grace Rosher 1935* in brown-red paint (bottom right)

Provenance: Given by the artist to the Theatre Girls Club, Soho, 1936; Compton Family ?; presented to the British Theatre Museum Association (1970/A/87) by Anthony Pelissier, 1970 (One of a group of 4 paintings)

Literature: Lou Warwick *The Macken-zies Called Compton* published by the author 1977, p. 222

Condition: Unlined. Canvas surface somewhat uneven with stretcher bar marks at all sides and following the central vertical bar. Widespread retouched flake loss, especially in the upper right quadrant.

Technique: Cream white ground on tabby weave canvas.

Inscription on verso: *WITH CARE / Miss Grace Rosher / 20 Blomfield Rd W.9 / Title Mrs. Edward Compton / (Virginia Bateman) / No.1* (blue ink and print on label on top bar of frame)

S.819–1991 Neg: JA 744/CT 25700

the age of 85. The archive of the Theatre Girls Club is now in the Theatre Museum and includes five volumes of Minutes. The Club was an institution fraught with Female Trouble and the Minutes are frequently peppered with references to the pitfalls of life in London. The spiritual and physical welfare of the girls staying in the Club, usually about thirty at any one time, is given detailed monthly consideration although other matters are referred to from time to time. The portrait of Mrs. Edward Compton is mentioned for the first time in an addendum to the Minutes for 20 December 1934: 'Mrs. Compton told the Committee that her portrait was being painted by Grace Rosher. Mrs. Glover proposed that we should buy the portrait for the Club. Miss Eastwood seconded this and it was carried unanimously. It was also agreed that we should not offer her less than £25. The picture would be exhibited at Mrs. Compton's birthday party on Friday 4th' (January 1935). Unfortunately, the portrait does not seem to have been ready for the party as there is no mention of it in the next set of Minutes: 'Owing to Mrs. Compton's illness her birthday party was postponed from the 4th to 11th of this month. The party was a great success – there were about 120 present and Mrs. Compton and the youngest guest – a small boy of 3 cut the cake which had 82 candles on it'.

When the Theatre Girls Club met as an Incorporated

Society for the first time on 24 January 1936 Grace Rosher was one of the twenty-one Members of Council. It seems as though her picture was finished later that year as the Minutes for 3 July 1936 mention a gift that must have been the portrait: 'Our "Coming of Age" Party was really a great success and everybody enjoyed it, . . . Grace Rosher's birthday gift to the Club was displayed and much admired'.

98 Reginald Grenville Eves (1876–1941)

James Campbell Gullan

98 is difficult to date and the Bristol reference on the back of the canvas is only a *post ante quem*. The two references on the back of the canvas to 'Old Jamie' suggest an affectionate nick-name rather than an indication of the sitter's age; he was probably well under sixty when he died in 1939. It is tempting to assign a part to **98** but with the date of the picture being so uncertain and the lack of production photographs of Campbell Gullan being so absolute there is not really much point.

Oil on canvas 51 × 41 cm.

c.1936

Provenance: The artist; Grenville Eves; the Grenville Eves bequest to the British Theatre Museum Association (1973/A/47), 1973

Exhibition: 1936 Bristol?; 19– Doncaster

Condition: Sound. Small hole middle left edge. Canvas stained by mould on reverse. Very small losses top and bottom middle edge.

Technique: Light grey ground on tabby weave canvas. Sketchily and thinly painted.

Inscription on verso: *BRISTOL / 1936 / DICKSEE & CO* (black printed label); *Old Jamie* (typed label); *Title of Picture – / 'Old Jamie' Price £200 / R.G.Eves.A.R.A. / 149, Adelaide Road / London NW3* (typed label); *Lent by R.G. Eves A.R.A. / 149, Adelaide Road, / London NW3* (typed label); *DONCASTER / SPECIAL INVI-TATION / LONDON AGENT / CHAS.H.WEST / 117, Finchley Road, London NW3* (black stamp on verso); *WINSOR & NEWTON'S / MOKEN / . . .RESS / LONDON ENGLAND* (stamp).

S.99–1986 Neg: HF 4540/CT 16104

99 Alexander Christie (b.1901)

Ernest Thesiger

Oil on canvas 91 × 77.5 cm.

1937

Signed: *Alex Christie 1937* in red oil paint (top right)

Provenance: Presented to the British Theatre Museum Association

Alex Christie seems to have painted this portrait as Ernest Thesiger rested after his performance of Mr. Sparkish in *The Country Wife* at the Old Vic in late 1936 and before he left for New York to play L'heureux in *Madame Bovary*. It seems unlikely that any character is represented by Thesiger's elegant attire; his most recent contemporary role had been Henry Higgins in Shaw's *Pygmalion* at the Malvern Festival in August 1936. In **99** he wears a grey velvet jacket and trousers,

V-necked bright yellow jumper and a blue scarf with white decoration which is wrapped several times around his neck. On the little finger of his left hand is a ring with a large blue stone.

Embroidery was Thesiger's best-known activity away from the stage; in 1945 his enticingly entitled *Adventures in Embroidery* was published, but he was also an amateur artist. He was a popular sitter and was portrayed by many distinguished artists including John Singer Sargent (1856–1925) (a chalk drawing used as the frontispiece to Thesiger's 1924 volume of memoirs *Practically True*), Sir Gerald Festus Kelly (1879–1972) (1920 National Portrait Gallery 5571 Oil on canvas 76.8 × 60.6 cm.), William Russell Flint (1880–1969) (Royal Academy 1945 [1076]) and William Bruce Ellis Ranken (1881–1941) (two portraits; the first Royal Society of Portrait Painters 1903 [50] and the second Manchester City Art Gallery 1918 [1942.22] Oil on canvas 128 × 102.4 cm.). A bronze bust by Eric Schilsky of 1925 is in the collection of the Theatre Museum (1963/G/112).

Herbert Furst, the editor of *Apollo* in 1937, gave mixed praise to **99** in his review of the R.S.P.P. exhibition in his column, *Round the Galleries*: 'A similar restrained strength is to be seen in Alexander Christie's excellent likeness of "Ernest Thesiger" – the only pity is that the right hand of the sitter is not a little better drawn.'

(1964/G/32) by Mrs E. Thesiger, 1964

Exhibited: 1937 R.S.P.P. (93); 1938 London Portrait Society (136) ?

Literature: *Apollo* XXVI December 1937 p. 358 (illus.)

Condition: Dent made from verso is visible on sitter's left wrist. Conservation 1991: Minor paint loss associated with tear and minor abrasions at top and bottom of right edge retouched.

Technique: White ground on tabby weave canvas.

Inscription on verso: *WITH CARE / ALEXANDER CHRISTIE / 37 HOLLAND PARK RD / W14 / ERNEST THESIGER Esq.* (blue ink on printed label); *269* (pencil); *563* (blue crayon); *L H* (white chalk); *BOURLET & SONS LTD / Art Packers, Frame Makers / . . .* (fragmentary printed paper label on top bar of stretcher); *JAMES BOURLET & SONS Ltd.. / Fine Art packers, Frame Makers / 17 & 18 Nassau Street, Mortimer Street, W. /Phone: Museum 1871 & 7588* (printed paper label on left bar of stretcher)

S.811–1991 Neg: JA 960/CT 25714

100 Reginald Grenville Eves (1876–1941)

Leslie Howard

This is a sketch for the portrait shown at the Royal Society of Portrait Painters in 1938 (26), present whereabouts unknown. There is another sketch for this picture in the Garrick Club (309). Eves exhibited three other portraits of Leslie Howard. The earliest was exhibited at the R.S.P.P. in 1937 (197) and showed Howard seated half-length with his fingers folded together and wearing a suit. It was reproduced in *The Times* 19 November 1937 and in 1982 was in the collection of Mrs. Dale-Harris. The portrait in the Huddersfield Art Gallery was shown at the Royal Academy in 1938 (100) and shows Howard again half-length and seated but this time with a cigar in his right hand and his arms on the arms of the chair. The fourth exhibited portrait was shown posthumously at the R.S.P.P. in 1941 (92). An oil sketch of Howard was sold at Phillips' on 30 October 1973 (92) and several drawings of Howard in the same sale included one signed and dated 1940.

Oil on canvas 50.5 × 40.5 cm.

1938

Signed: *R G Eves* in black oil paint (top right)

Provenance: The artist; Grenville Eves's bequest to the British Theatre Museum Association (1973/A/47), 1973

Condition: Sound. Some slight flake loss at right centre, lower right and upper left edges. Small scratch above sitter's right shoulder.

Technique: White ground on tabby weave canvas. Liquid brush strokes with some impasto on face and hand. Large areas of the ground visible.

Inscription on verso: *'Leslie Howard' 4 (in circle) LESLIE Howard* (pencil on upper stretcher); *1973/A/47 Leslie*

Howard oil painting study for a portrait, by Reginald Eves Grenville Eves Bequest (black ink on two stickers on stretcher)

S.69–1988 Neg: HH 1261/CT 18524

101 Robert John Swan (1888–1980)

Milton Rosmer

Oil on canvas 44.5 × 34.8 cm.

1938

Signed: *MILTON ROSMER. . MCMXXXVIII* in ochre oil paint along top of canvas; *R.J.SWAN* in red oil paint bottom left

Provenance: The artist; gift of the Residuary Legatees of the estate of Robert Swan 1980

Exhibited: 1938 R.S.P.P. (36)

Condition: Some paint loss at edges caused by rubbing of frame.

Technique: White ground on tabby weave canvas.

Inscription on verso: *1* in black ink

Robert Swan exhibited three portraits of Milton Rosmer at the Royal Society of Portrait Painters. The first was shown in 1934 (202) and the third in 1955 (356). The Theatre Museum owns a red chalk drawing of Milton Rosmer by Robert Swan. It is signed and dated 1934 and is presumably preparatory to the 1934 Royal Society of Portrait Painters portrait. There are close similarities to the 1938 portrait; the drawing depicts the head and shoulders of the sitter in profile to the right wearing an open-necked shirt. The gaze is directed at a slightly lower angle than in the picture. The drawing was also bequeathed by the artist (S.432–1980). In 1955 Muriel Wheeler showed a plaster bust of Rosmer at the Society of Portrait Sculptors (28).

(label on frame top left centre); *306* (printing ink on label on frame top left centre); *MILTON ROSMER (18″ × 14″ / by Robert Swan / (Exhibt. R.S. PORTRAIT PAINTERS (1938)* (black ink on label on frame top centre); *5468* (blue crayon on frame top centre); *Royal Society of Portrait Painters / Name of Artist / Address / Title of Work* printed label in red ink filled in with *ROBERT SWAN / 44 REDCLIFFE ROAD / CHELSEA S.W.10 / 'MILTON ROSMER'* (black ink on frame top right)

S.431–1980 Neg: HH 1267/CT 18529

102 Oliver Messel (1904–1978)

Interior of the Old Vic

Painted from the back of the dress circle looking towards the stage, view framed by two supporting pillars and the fringed edge to the balcony top. Light rays from either side directed at stage, batten of seven lights hanging in front of proscenium arch. On stage right a column and base, indeterminate urban scene framed by quantitites of dark red drapery. Overall pinkish tonality.

Oliver Messel's first designs for the Old Vic were for Tyrone Guthrie's production of Wycherley's *The Country Wife* which opened on 6 October 1936. The following year he designed the sets and costumes for Guthrie's production of *A Midsummer Night's Dream*, 27 December 1937. The cast included Vivien Leigh as Titania, Robert Helpman as Oberon, Gyles Isham as Theseus, Stephen Murray as Lysander, Anthony Quayle as Demetrius and Ralph Richardson as Bottom. The scene set on stage in **102** is Messel's 'Palace of Theseus' for Act I scene i and Act V.

Oil on canvas 53.9 × 76.4 cm.

1938

Provenance: Leicester Galleries; Mrs. Simon Marks, 1938; presented to the British Theatre Museum Association (1963/W/3), 1963

Exhibited: 1938 Leicester Galleries *First Exhibition of Paintings by Oliver Messel* (8)

Condition: Some drying cracks in thicker paint.

Technique: White ground on tabby weave canvas. Ground shows through in many areas. Extra tack holes along side and top suggest that the painting has been placed onto a new stretcher. The paint layer continues round the bottom edge of the stretcher.

S.85–1986 Neg: HF 4631

103 Elizabeth Montgomery (b.1902)

Peggy Ashcroft as Irina and Gwen Ffrangcon-Davies as Olga in 'The Three Sisters' by Anton Chekov

Oil on canvas 61 × 50.7 cm.

c.1938

Signed: *EMW* in blue oil paint (bottom right)

Provenance: Bought from the artist, 1980

Condition: Varnish is uneven and there are runs, especially top right corner.

Technique: Cream ground on tabby weave canvas.

Inscription on verso: *C / Prepared by / C.Roberson & Co Ltd / 101–104, Park Street, LONDON N.W.* (stamp)

S.430–1980 Neg: HF 4529/CT 16093

Olga and Irina are shown in their bedroom in Act III of *The Three Sisters* yearning for Moscow, Irina sitting on the sofa and Olga standing behind her:

Irina: Oh, to go to Moscow, to Moscow!

Michel Saint-Denis's famous production of *The Three Sisters* opened at the Queen's Theatre on 28 January 1938. It was the third play in John Gielgud's season at the theatre following Gielgud's own production of *Richard II* and Tyrone Guthrie's production of *The School for Scandal*. There was an exceptional cast that included Gwen Ffrangcon-Davies, Carol Goodner and Peggy Ashcroft as the sisters, Michael Redgrave as Tusenbach, Glen Byan Shaw as Solyony, George Devine as Prozorov, Leon Quatermaine as Kuligin, Angela Baddeley as Natasha, Alec Guinness as Fedotik, Harry Andrews as Roddey and Gielgud as Vershinin. The sets and costume were designed by Motley, the firm of designers closely associated with John Gielgud in the 1930s and which was originally run by Audrey Sophia Harris, Margaret F. Harris and Elizabeth Montgomery.

Although Elizabeth Montgomery's close connection with the production would suggest that **103** is a contemporary work it is probable that it was painted at a later date. It is almost certainly copied from a photograph by Houston Rogers published in *Theatre World* March 1938 p. 123, in a special photographic feature on the production. The figures are brought closer together in the painting and details are obviously less crisp but the composition is identical and the blue-grey tonality of **103** suggests the inspiration of a monochrome photograph.

104 Robert John Swan (1888–1980)

Beatrix Fielden-Kaye

The formidable sitter in **104**, who occasionally stood in for Edith Evans, is shown wearing a red collarless cloak with gold clasp either side over a dark garment. A white scarf with a silver brooch is tied around the neck and hangs down her chest.

Robert Swan also exhibited a portrait of Peter Bull at the Royal Society of Portrait Painters in 1939. There is a chalk sketch for this portrait, signed and dated 1939, in the Theatre Museum (S.436–1980).

Oil on canvas 61 × 51 cm.

1939

Signed: *R.SWAN* in black oil paint (bottom left)

Provenance: British Theatre Museum Association (?)

Exhibited: 1939 Royal Society of Portrait Painters (105)

Condition: Some abrasion along vertical edges.

Technique: White ground on tabby weave canvas.

Inscription on verso: *BEATRIX FIELDEN-KAYE / (ACTRESS 19)* (wax pencil lower centre); *Reeves & Sons Ltd., Ashwin St., Dalston, E.8. London* (stamp; centre)

S.68–1988 Neg: HH 1265/CT 18528

105 Charles A. Buchel (1872–1950)

Sir John Martin-Harvey as Sidney Carton and Nina de Silva as Mimi in 'The Only Way' by Freeman Wills and Frederick Langbridge

Mimi and Carton take a farewell curtain call. Buchel's picture was reproduced on the cover of a souvenir booklet produced for the farewell tour of Sir John Martin-Harvey and Nina de Silva in 1939. Inside was an essay on Martin-Harvey's career illustrated with twelve photographs of Martin-Harvey and his wife. A rather less lavish souvenir booklet was also produced without the Buchel cover and illustrated with only four photographs. **105** is one of Buchel's last theatrical works and is an attempt to revive the genre of illustrated theatrical souvenirs, a genre that he dominated in the years before the Great War. Buchel produced a pair of charcoal portraits of the Martin-Harveys in 1918 which are now in the National Portrait Gallery (4694 & 4694A).

Sir John Martin-Harvey created the role of Sidney Carton at the Lyceum on 16 February 1899. It was his greatest success by far and when he retired from the stage in 1939 he had played the part over 4,000 times. *The Only Way*, based on *A Tale of Two Cities*, was the most successful of the many nineteenth-century adaptations from Dickens.

Probably an aqueous medium paint on plywood 34.2 × 25 cm.

1939

Signed and Inscribed: *C.BUCHEL* in mauve oil paint (bottom left); *FARE-WELL* in grey oil paint (top); *1899 / 1939* in black ink or watercolour (bottom right)

Provenance: Presented by Mrs. Brooke-Booth to the British Theatre Museum Association (1965/A/29), 1965

Condition: Minor losses at extreme edge of black surround. Slight twist in panel which is cut unevenly along left edge.

Technique: One member panel. Grain vertical. The ground only appears to cover the panel beneath the actual image. The black surround seems to be painted directly onto the wood; tests show that this area is water soluble. On the reverse there are pencil sketches, mostly indecipherable but including the head of a dog.

S.1131–1986 Neg: HF 4524/CT 16078

106 Father Cardew (fl.1939)

A Cleric

Oil on canvas 92 × 73 cm.

1939

Signed: *CARDEW / 1939* in white oil paint (bottom right)

Provenance: Compton Family ? (One of a group of 4 paintings, the others depict members of the Compton family); presented by Anthony Pelissier to the British Theatre Museum Association (1970/A/87), 1970

Exhibited: 1939 Paris, Grand Palais Société des Artistes Independants (506?)

Condition: Canvas slightly slack. Some minor scratches. Old repaired damage which appears to have been a tear upper right corner. A few small scattered spots of white paint on surface.

Technique: White ground on tabby weave canvas on strainer.

Inscription on verso: *506* (printed label on bottom of frame); *SOCIETE DES ARTISTES* (around) *SALON DE 1939* (printed label); *A / C 1197* (blue ink ?); *Chapman Bros. of Chelsea* (printed label on stretcher)

S.820–1991 Neg: JA 961/CT 25715

Father Cardew appears to have run a Club in Paris similar to the Soho Girls Theatre Club (cf.**97**). He was a friend of the deeply religious Mrs. Edward Compton and kept up active contact with her and the girls in London. The Minutes of the Soho Club for 1 May 1936 mention a Cardew visitation: 'The Rev. Prebendary and Mr. Cardew who are over from Paris paid us a visit last Friday. He made a delightful little speech telling us how glad he would be to welcome any of the girls to the Paris Club and telling them about it.' By 1938 Cardew had taken to the cloth and according to the Soho Club Minutes of 31 March 1938 was asking Mrs. Edward to assist one of her girls in Paris who had got herself involved in a *crime passionnel*: "Mrs. Compton said she had heard from Fr. Cardew in Paris asking her to write to Eve Meakin (then in a French prison awaiting trial for ("trying to" crossed out) shooting at her husband) testifying to her general good character.' The letter seems to have done the trick as Eve Meakin was back in London at the end of April 1938.

107 Duncan Grant (1885–1978)

William Squire

Philip Clement Gibbons, a solicitor working for the Coal Commission and later the National Coal Board, was interested in Amateur Dramatics. He took a particular interest in an East End Drama Club where William Squire was a young member. He later assisted William Squire in his passage through R.A.D.A. Although Squire did spend a period in the Royal Navy, by 1949 he was in his second season with the Shakespeare Memorial Theatre Company at Stratford-upon-Avon. The sailor costume in Duncan Grant's picture may be pure nostalgia or the date may be wrong.

Oil on paper with a canvas grain surface attached to cardboard 46 × 36 cm.

1949

Signed: *D GRANT '49* in blue oil paint (top right)

Provenance: Commissioned from the artist by P.C. Gibbons, 1949; bequeathed by P.C. Gibbons, 1989

Condition: Jan 1991. The support has a pronounced convex warp. The paint is sound but the varnish is perished and opaque in many areas and has flaked off completely from others. Conservation 1991. Varnish removed. Revarnished.

Technique: Freely painted with a wide brush and with some impasto particularly in the face and on shirt front.

S.847–1991 Neg: JA 754

108 Alfred Kingsley Lawrence (1893–1970)

Vivien Leigh as Blanche Dubois in 'A Streetcar Named Desire' by Tennessee Williams

Oil on canvas 102 × 91.7 cm.

1950

Signed: *Lawrence* in black oil paint (bottom left)

Provenance: Bequeathed to the British Theatre Museum Association (1968/A/8) by the sitter, 1967

Exhibited: 1951 R.A. (517)

Condition: Sound.

Technique: White ground on tabby weave canvas. The bottom tacking edge has been used to extend the area of the painting, possibly to fit a frame. Inpainted section and tack holes crudely painted with thick black/brown oil paint.

Inscription on verso: *ROBERSON & Co Ltd / (78* (fragmented stamp)

S.92–1986 Neg: HF 4574/CT 16134

Blanche Dubois is shown in scene ten of *A Streetcar Named Desire* in a 'somewhat soiled and crumpled white satin evening gown and a pair of scuffed silver slippers with brilliants set in their heels' in the moments before her supposed rape by her brother-in-law, Stanley Kowalski.

The first London production of *Streetcar* opened at the Aldwych Theatre on 12 October 1949 and ran for 326 performances. Blanche Dubois was perhaps Vivien Leigh's most distinguished stage role and she was supported by Renée Asherson as her sister Stella, Bonar Colleano as Stanley and Bernard Braden as Mitch. The play was produced by Tennents in association with The Arts Council and Irene Mayer Selznick and directed by Laurence Olivier who acknowledged the influence of Elia Kazan's New York production, which had opened at the Ethel Barrymore Theatre on 3 December 1947. The sets for the Aldwych production were designed by Jo Mielziner, painted by Alick Johnstone and built by Brunskill & Loveday, and the costumes were designed by Beatrice Dawson. Vivien Leigh's costumes were made by Elizabeth Curzon.

Despite Jessica Tandy's great success as Blanche Dubois in New York, Vivien Leigh was given the part in Elia Kazan's film of the play in 1950. Although A.K. Lawrence's picture

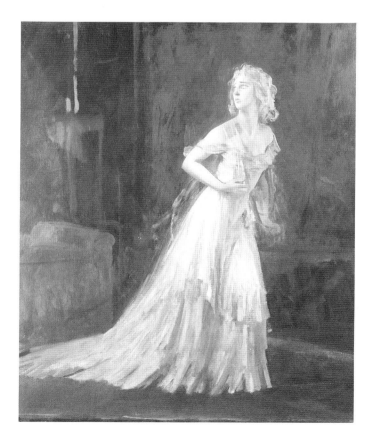

has a somewhat cinematic appearance, the costume worn by Vivien Leigh is the Beatrice Dawson creation of the Aldwych production rather than the costume designed by Lucinda Ballard for the film. The London production was photographed by Angus McBean. His archive, now in the Harvard Theatre Collection, contains several photographs of scene ten including one, J283:22, which is extremely close to the pose of **108**. A.K. Lawrence has failed to catch any sort of likeness but he continued to paint Vivien Leigh and exhibited a portrait of her as Cleopatra at the Royal Academy in 1952 (192).

109 Elizabeth Montgomery (b.1902)

Martita Hunt as Countess Aurelia, the Madwoman of Chaillot in 'The Madwoman of Chaillot' by Jean Giraudoux

Martita Hunt made her debut on the American stage at the Belasco Theatre, New York on 27 December 1948 playing the Countess Aurelia in *The Madwoman of Chaillot*. The play was produced and directed by Alfred de Liagre Jr. and the cast included John Carradine as the Ragpicker, Estelle Winwood

Oil on canvas 50.8 × 40.7 cm.

1951 (?)

Provenance: The sitter; bequeathed to her sister, Catherine Hunt, 1969; presented to the British Theatre Museum Association (1969/A/70), 1969

Condition: Split along turning edge top right corner. There is some corrosion of the wire stretcher.

Technique: White ground on tabby weave canvas. The stretcher consists of a rectangle of rounded metal wire approx. 8 mm. diameter. The canvas is stretched over the wire and the turned over edges are stuck down on to a thin card which fits within the wire frame and backs the canvas. The back of the canvas may also be stuck to the card. The technique is sketchy with the ground showing through in places but there are areas of thick and rather messy impasto, especially in the hat.

S.93–1986 Neg: HF 4534/CT 16098

as Mme. Constance, the Madwoman of Passy, and Clarence Derwent as the President. The play was revived in New York at the Royale in August 1949 and toured the following year. The London production opened at the St. James's Theatre on 15 February 1951. The director was Robert Speaight and apart from Martita Hunt in the leading role the cast included Marius Goring as the Ragpicker and Angela Baddeley as the Madwoman of Passy. The sets and costumes by Christian Bérard used in the productions in both England and America were adapted from his designs for the original Paris production directed by Louis Jouvet with Marguerite Moreno as Aurelia.

Elizabeth Montgomery had some connection with the production at the St. James's Theatre as her firm, Motley, was responsible for supervising the additional costumes which were supplied by M. Berman. However, **109** appears not to be a study from life but rather a copy of an anonymous production photograph (copy in the Mander & Mitchenson Theatre Collection) which shows Martita Hunt seated in a wicker chair in Act I, 'The Café Terrace of Chez Francis, at the corner of the Place d'Alma, Paris'. The painter has omitted the right hand shown in the photograph and the tilt of the head towards the left has been reduced but the rest of the detail is precisely the same, down to the disarray of the fringe and the peculiar positioning of the fingers of the left hand.

Oil on canvas marouflaged to thin 3-ply panel 119.5 × 62.8 cm.

1952

110 Oliver Messel (1904–1978)

Stage property painting for 'Letter from Paris' by Dodie Smith

Dodie Smith's *Letter from Paris* was adapted from Henry James's novel *The Reverberator* and opened at the Aldwych Theatre on 10 October 1952. The play, set in Paris over a Spring and a Summer in the 1880s, is about the differences between two American families, the sophisticated Proberts, who have married into the French aristocracy and live in Paris, and the Dossons from Buffalo who are just visiting. The plot concerns the problematic relationship between Gaston Probert and Francie Dosson. They meet in the studio of Charles Waterlow, another American living in Paris. **110** is one of the works in his studio, mentioned in passing in the stage directions for Act I scene i: 'The studio is obviously that of a hard-working painter in oils, several examples of whose work are to be seen on the walls. He considers himself an Impressionist, but also considers Sargent to be one and has more in common with him than with the great French Impressionists.' It may be the work Waterlow refers to when showing Francie his pictures, 'That landscape's very early work. I mainly do portraits now.' The main influence on Messel, if not Waterlow, is evidently Vuillard rather than the 'great French Impressionists'.

The Aldwych production, which only ran for three weeks, was directed by Peter Glenville with sets and costumes by Oliver Messel and incidental music by Ronny Emanuel. Peter Barkworth played Gaston Probert and Brenda Bruce, Francie Dosson. Charles Waterlow was played by Nicholas Phipps.

Provenance: The artist; bequeathed to The Earl of Snowdon, 1978. On loan to the Theatre Museum.

Condition: Canvas slightly detached from ply top right and bottom left corners. Slight buckle top right corner.

Technique: Cream ground on tabby weave canvas. Ground shows through in some areas as does pencil and charcoal underdrawing.

Neg: HF 4569/CT 16130

111 James Bateman (1893–1959)

Vivien Van Damm

This undistinguished portrait was commissioned and presented to the sitter by the staff of the Windmill Theatre to celebrate the twenty-first anniversary of *Revudeville* in 1953.

Oil on canvas 61.2 × 51 cm.

1953

Signed: *J.BATEMAN* in light brown oil paint (bottom right)

Provenance: The sitter; bequeathed to the Windmill Theatre, 1960; given to Mrs. Harry Roy on the closing night of the theatre, 31 October 1964; presented to the Theatre Museum by Mrs. Harry Roy 1978

Exhibited: 1977 Theatre Museum, *Revudeville* (Unnumbered)

Condition: Sound.

Technique: White ground on tabby weave canvas.

Inscription on verso: *WINTON prepared by / WINSOR & NEWTON* (stamp)

S.203–1978 Neg: HF 4567/CT 16128

112 Ronald Ossory Dunlop (1894–1973)

Sally Gilmour

Oil on canvas 76 × 63.5 cm.

c. 1953 ?

Signed: *Dunlop* in black oil paint (bottom right)

Provenance: Dame Marie Rambert; Rambert bequest 1983

Condition: The corners have been reinforced. There are two repaired tears, the first 20.3 cm. from left 5 cm. from bottom edge and the other 44.5 cm. from left 5 cm. from top edge. Cracking in a 20.3 cm. line starting 25.4 cm. top edge 10.2 cm. from right. There are minor paint losses from the edges and corners and associated with the tears.

Technique: White ground on tabby weave canvas. Thick impasto applied with a palette knife.

Inscription on verso: *Sally Gilmour* in black ink (top centre); *Marie Rambert 4* in black ink (top right).

S.869–1983 Neg: HH 1263/CT 18526

Sally Gilmour retired as leading dancer with the Ballet Rambert in 1953. This portrait might have been a leaving present for Marie Rambert who had moulded Sally Gilmour's entire career.

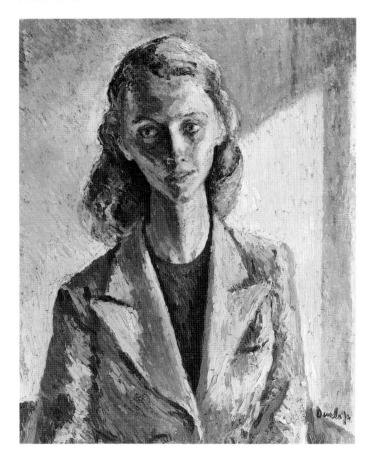

113 Gerard de Rose (fl. 1947–1968)

Herbert Lom as the King in 'The King and I' by Richard Rodgers and Oscar Hammerstein 2nd

Oil on canvas 60 × 50.7 cm.

1955

Signed: *Gerard de Rose '55* in red oil paint (bottom left)

Provenance: Presented by the sitter, 1984

Condition: Sound.

The King and I opened at the St. James Theatre, New York on 29 March 1951 and ran for 1246 performances. Gertrude Lawrence created the role of Anna Leonowens and Yul Brynner that of the King of Siam. The London production, at Drury Lane, opened on 8 October 1953 and was slightly less successful with 946 performances running through to 1955. Valerie Hobson played Anna and Herbert Lom the King. The Drury Lane production was a carbon copy of the New York original with John van Druten directing, Jo Mielziner desig-

Technique: White ground on tabby weave canvas. The ground shows through the paint in many areas.

S.1501–1984 Neg: HF 4641/CT 16185

ning the sets and lighting, Irene Sharaff designing the costumes and the choreography by Jerome Robbins.

Angus McBean photographed the London production and from the photographs it becomes evident that the curious bobbles on Herbert Lom's tunic are circular lumps of glass. He also wore a watch-chain across his chest, an item omitted in the portrait. The ear-ring is a large diamond hanging from a smaller diamond. The rest of the costume consisted of an embroidered belt with a jewelled clasp, loose knee-breeches the same colour as the tunic, and embroidered slip-on shoes with very high built-up soles.

On the reverse of the picture there is a half painted-out bowl of apples.

114 Ruskin Spear (1911–1990)

Sir Laurence Olivier as Macbeth in 'Macbeth' by William Shakespeare

This sketch is for the large portrait of Laurence Olivier as Macbeth which hangs in the RSC Collection at Stratford-upon-Avon. Commissioned by the Governors of the Shakespeare Memorial Theatre in 1955, the Stratford portrait

Oil on ply panel 46 × 25.5 cm.

c.1956

Signed: *Ruskin Spear* in yellow oil paint (towards lower right corner)

Provenance: Dr. med. Anna Schönholzer; given to the Honourable Tarquin Olivier. On loan to the Theatre Museum.

Literature: Mervyn Levy *Ruskin Spear* 1985 pp. 27–8

Condition: When not restrained within the frame the panel tends to warp and deform slightly with an irregular twist. It regains a straight plane when within the frame.

Technique: Off white ground on three ply panel. There is a monochrome painting on the reverse: very sketchy, of a horse and a fallen 'warrior'; possibly representing a Bullfight.

Inscription on verso: *Sketch for portrait of Sir Lawrence Olivier / as Macbeth / 1955 Production at Stratford-upon-Avon* (in pencil on backboard). *MS Dr. med. A Schönholzer /* [with details of address] (on sticker). *Ruskin Spear / Sketch for Lawrence Olivier* (in pencil on upper bar).

Neg: JA 747/CT 25703

shows Macbeth in Act V scene v beginning his soliloquy 'Out, out, brief candle'. Olivier first appeared in the 1955 season as Malvolio in John Gielgud's production of *Twelfth Night*; then came *Macbeth* in June directed by Glen Byam Shaw, followed by Peter Brook's production of *Titus Andronicus* with Olivier in the title role. Vivien Leigh's Lady Macbeth brilliantly matched his performance. While he began quietly, building up to the full heights in the denouement, she was most forceful in the early scenes.

Ruskin Spear worked from life and from photographs taken specially at Stratford by John Underwood. He later recounted to Mervyn Levy how Sir Laurence 'was always late, and always charming. When he first stood in front of me with his Macbeth kit over a pin-stripe suit – glimpses of which I could see – the whole thing worried me. He looked like a whisky advert! He loved smearing his hands with red greasepaint, and even asked if he could use a tube of vermilion for the process, until I warned him that it would be far more difficult to remove than greasepaint! He would stand marvellously for hours until, in the fading light, he would start dropping off, to sleep. I knew then the session was over for the day!'

115 Peter Sheil (fl.1962)

Portrait of Tallulah Bankhead

Tallulah is shown at the end of her career in this highly coloured portrait. The circumstances in which the painting was painted are not known but she thought highly enough of it to bequeath it to one of her oldest English friends, Kenneth Carten who was only ten when he met Tallulah in 1923. His sister Audrey was appearing with the nineteen year old American (and Sir Gerald Du Maurier) in *The Dancers* and the little boy sailed through an appendicitis operation, inspired by his love for Tallulah. Tallulah bequeathed another portrait of herself, by Ambrose McEvoy, to George Cukor but the well-known portrait by Augustus John was sold at auction in New York by Parke-Bernet on 17 April 1969 along with three other pictures from her estate; a Chagall, a Renoir and a portrait of Sir Gerald Du Maurier also by Augustus John. The portrait of Tallulah was bought by John Hay Whitney for $19,000 and given to the American National Portrait Galery. Painted in 1930, it shows Tallulah dressed in the pink negligee that she wore as Wanda Myro in *He's Mine*, a play by Louis Verneuil adapted by Arthur Wimperis which opened in October 1929. The colour and pose of Peter Sheil's portrait are borrowed from Augustus John's portrait but not, alas, its theatrical presence and quality.

Oil (or possibly Acrylic) on canvas
86.5 × 69 cm.

1962

Signed and inscribed: *Peter / Sheil / 1962 / Tallulah* in purple oil paint (bottom right)

Provenance: Bequeathed by the sitter to Kenneth Carten, 1968; Murray MacDonald, bequeathed by him to the Theatre Museum, 1981

Literature: *Variety* 18 December 1968

Condition: The paint layer extends on to the tacking edges which suggests that the painting was originally on a larger stretcher but probably cut down by the artist.

Technique: Cream ground on tabby weave canvas. There is an uneven yellow surface layer which appears to be water soluble. UV examination of this layer suggests that it is an original 'glaze'.

S.457–1981 Neg: HF 4568/CT 16129

116 Robert John Swan (1888–1980)

Lindsay Kemp, 'Between the Acts'

Oil on canvas 76 × 63.5 cm.

1962

Signed: *Robert Swan 1962* in red oil paint (bottom right)

Provenance: The artist; gift of the Residuary Legatees of the estate of Robert Swan 1980

Condition: Minor ground and paint loss at corner edges. Some abrasion near right edge.

Technique: White ground on tabby weave canvas.

Inscription on verso: *Lindsay Kemp* (black ink, top left of stretcher); *BETWEEN THE ACTS* (blue ballpoint top centre of stretcher); *S 435– 1980 R.SWAN* (black ink top right of stretcher)

S.435–1980 Neg: HH 1260/CT 18525

Lindsay Kemp was still a student at the Rambert Ballet School when Robert Swan painted his portrait. His professional career began two years later at the Edinburgh Festival.

Kemp is dressed for vigorous studio exercise. He wears a blue and white striped shirt and black waistcoat with gold buttons.

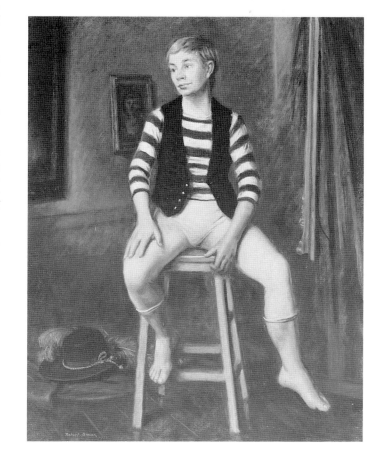

117 Brenda Bury (fl.1964)

Cecil Madden

Oil on canvas 76 × 61 cm.

c.1964 ?

Signed: *Brenda Bury* in dark green oil paint (lower left)

Provenance: Given by the sitter to the Theatre Museum, 1986

Condition: A small square in lower right corner may be an accretion.

Technique: Cream ground on tabby weave canvas. An umber/ochre 'glaze' covers the entire surface of the portrait under the paint and is visible around the portrait

S.848–1991 Neg: JA 745/CT 25701

118 Leonard Boden (b.1911)

Boris Christoff as Boris Godunov in 'Boris Godunov' by Modest Mussorgsky

Christoff is shown in his costume for the coronation scene, Prologue, scene two, designed for the 1958 Covent Garden production by Georges Wakhevitch. It consists of a splendid floor-length robe of gold thread brocade, lined with red and decorated with an ogival lattice design in pearls and further embellished with red and green gems, and a Russian crown with fur rim, gold encrusted with pearls, rubies and emeralds and surmounted with a cross, the points each with a single pearl. He wears large rings on all his fingers. The costume is now in the Theatre Museum.

Herbert Graf's Covent Garden production held the stage until Andrei Tarkovsky's 1983 revolutionary interpretation of the opera. Christoff sang the role in the Graf production in 1958, 1959, 1961, 1965, 1970, 1971, 1974 and 1979, having

Oil on canvas 193.8 × 120.8 cm.

1965

Signed: *Leonard / Boden* in red oil paint (bottom left)

Provenance: Given to the sitter by the artist; given by the sitter to the Theatre Museum, 1979

Exhibited: 1979 Royal Opera House, Covent Garden (Part of the celebrations for Christoff's thirtieth anniversary performances at Covent Garden.)

Condition: Large stain on reverse, upper third.

Technique: White ground on tabby weave canvas. The painted surface extends on to the tacking edges.

Inscription on verso: *To – / the GREAT ARTIST / BORIS CHRISTOFF – / with the most profound admiration / and affection – from / Leonard Boden / London* (black ink); *VARNISHED WITH / MASTIC VARNISH / 1965* (black marker); *B2223 (1)* (blue crayon)

S.306–1979 Neg: HF 4570/CT 16131

sung the role for the first time in 1949 in Peter Brook's 1948 Covent Garden production; which was also revived with Christoff in 1951. The score used in the 1958 production was a conflation of Mussorgsky's 1869 and 1874 versions of the opera but for the revival of 1965 Rimsky-Korsakov's revised score of 1908 was used. The first night of the revival, rehearsed by Ande Anderson, was 15 December 1965 and was the fiftieth performance of the opera at Covent Garden.

119 John Corvin (fl.1966)

Ian Holm as Henry V in 'Henry V' by William Shakespeare

The king is shown alone on stage in Act IV scene i holding a sword in his right hand with the point down. He wears a Royal red, blue and gold tabard over his armour and under a heavy metal belt. He is musing on kingship on the eve of Agincourt in the great soliloquy:

> Upon the king! let us our lives, our souls,
> Our debts, our careful wives,
> Our children, and our sins lay on the king!

In his notes for the Stratford programme Peter Hall emphasised the importance of this speech: 'The play's tension is between two extremes: it's a red and golden land of hope and glory at Agincourt, but also a place of hacked limbs and putrid corpses. Equally, it is hard between extremes to govern men. "Upon the king," on the night before Agincourt, is the crux of the play.'

The 1964 Royal Shakespeare Company production of *Henry V* opened in Stratford-upon-Avon on 3 June, the first

Oil on hardboard Ground white/cream 84.6 × 99.1 cm.

1966

Signed: *John Corvin / 1966* in red oil paint (bottom left)

Provenance: Given to John Bruce by the artist, 1966; presented by John Bruce to the Theatre Museum, 1984

Condition: Slight losses along edges, top corners and bottom left corner.

Technique: Oil on hardboard.

Inscription on verso: *Henry V Stratford / Aldwych R.S.C. / 'Those were the days' / With every good wish for the future / to John Bruce who was there! / John Corvin / Stratford-upon-Avon,* (blue

ink); *John Corvin / 8, Warwick Road / Stratford-on-Avon / 'Ian Holm, "Henry V"'* (black ink on cream paper label)

S.452–1984 Neg: HF 4632/CT 16179

production of the play there since 1951. It was the fourth in the sequence of seven histories that the R.S.C. produced to celebrate the 400th anniversary of Shakespeare's birth. Ian Holm was also Prince Hal in the two parts of *Henry IV* and on 12 August 1964 gave the first performance of what was to become a famous Richard III. Like all the 1964 histories, *Henry V* was directed by Peter Hall and John Barton and designed by John Bury. The cast also included Eric Porter as Chorus, Charles Kay as the Archbishop of Canterbury and the Dauphin, Paul Hardwick as Ancient Pistol and, as the Governor of Harfleur, John Corvin, the painter of **119**. The play eventually transferred to London and opened at the Aldwych on 28 May 1966, with Ian Holm but without John Corvin. The picture evidently shows the London revival even though John Corvin was based in Stratford and the inscription on the reverse suggests that the picture was painted there.

On the verso of the picture there is a landscape.

120 Laurence Irving (1897–1988)

Alick Johnstone's Scenic Studios with Charles Ricketts and Rex Whistler in attendance supervising the realisation of their designs for 'Henry VIII' and 'Victoria Regina'

Oil on canvas 61.5 × 45.9 cm.

1970

Signed: *LHI* (in monogram) *70* in yellow oil paint (bottom left)

Provenance: Given to the Theatre Museum by the artist, 1983

Condition: Some very minor losses of ground and paint at edges. Minor flaking in white impasto of ceiling lights.

Technique: White ground on tabby weave canvas.

Inscription on verso: *WINTON / Prepared by / WINSOR & NEWTON Ltd. / LONDON ENGLAND* (stamp)

S.1115–1983 Neg: HF 4640

Laurence Irving has painted a confabulation of his memories of Alick Johnstone's scenery painting studio and combines work on two productions that took place more than a decade apart. The academic figure in the centre is Charles Ricketts discussing with Alick Johnstone the cloth on the frame on the left which is for Lewis Casson's production of *Henry VIII*. This opened at the Empire Theatre on 22 December 1925 with Sybil Thorndike as Queen Katherine, E. Lyall Sweete as Cardinal Wolsey, Norman V. Norman as Henry, Angela Baddeley as Anne Bullen and Casson himself as Griffith. The cloth seen in **120** was used as the backdrop to the final Palace scene, Act V scene v, in which the king is introduced to his new baby daughter, Elizabeth. In a letter to Sydney Cockerell of 25 October 1925 Ricketts wrote, 'I have to stage *Henry VIII* for Xmas and I intend putting Holbein on the stage.' Unfortunately, there seems to be little evidence of Holbein in the cloth on display, but the critic of the *Sketch* was convinced and on 6 January 1926 wrote: 'The Production of *Henry VIII* at the Empire is a very beautiful one in which the tragedy is played out in settings which suggest a series of Holbein pictures come to life.'

The figure in the suit on the right is Rex Whistler explaining to one of Alick Johnstone's Japanese assistants, Eko or Kono, the niceties of one of his scenes for Laurence Housman's *Victoria Regina*. This famous production, directed by Norman Marshall, opened at the Lyric Theatre on 21 June 1937 and ran for 337 performances with Pamela

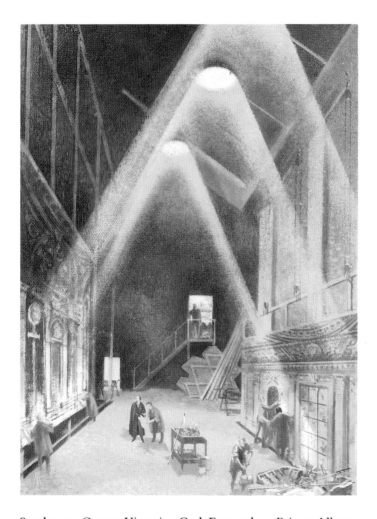

Stanley as Queen Victoria, Carl Esmond as Prince Albert, Allan Aynesworth as Lord Conyngham, and Ernest Milton as Disraeli. The play had been given at the Gate Theatre in May 1935 and then at the Broadhurst Theatre, New York where Whistler also designed the scenery and costumes. In New York the play opened on 26 December 1935 and ran for 203 performances. It was then revived almost immediately at the same theatre on 31 August 1936 and ran for a further 314 performances. It was directed by Gilbert Miller and the cast included Helen Hayes as Queen Victoria and Vincent Price as Prince Albert with Lewis Casson as Lord Melbourne, a part written out of the London production. The cloth on the frame is the back-drop to Act I scene i *1837 The Six O'Clock Call, Entrance Hall of Kensington Palace*. The alcove being measured by Whistler was later filled by a statue, painted in *trompe l'oeil*. The figure in the foreground stirring a bucket of size is John Bryan, who became Laurence Irving's assistant shortly after he had made his studies for the picture and then went on to become one of the most distinguished production designers of the British cinema.

121 Laurence Irving (1897–1988)

John Clements conducting a rehearsal of 'Pygmalion' by George Bernard Shaw

Oil on canvas 51 × 76.2 cm.

1972

Signed: *HI [?LI]* (in monogram) / *72* in brown and cream oil paint (bottom right)

Provenance: Given to the Theatre Museum by the artist, 1983

Condition: Sound.

Technique: Cream ground on tabby weave canvas.

Inscription on verso: *WINTON / Prepared by / WINSOR & NEWTON Ltd / LONDON ENGLAND* (stamp)

S.1116–1983 Neg: HF 4633

John Clements's production of *Pygmalion* opened at the St. James's Theatre on 19 November 1953. He presented and directed the play and appeared as Professor Henry Higgins to his wife, Kay Hammond's Eliza Doolittle. Athene Seyler played Mrs. Higgins, her husband Nicholas Hannen played Colonel Pickering, Charles Victor was Alfred Doolittle and amongst the minor parts was Peter Diamond as a Bystander. He was also A.S.M. on the production. The production was designed by Laurence Irving and the scene that is being set in his rehearsal picture is Professor Higgins's sitting room in Wimpole Street which appears in Acts one and four. The scenery was built by Brunskill and Loveday Ltd. and was painted by the Harkers. The gramophone was provided by H.M.V. and the furniture by A.V. Ketcher & Co. and The Old Times Furnishing Co.

Laurence Irving painted the picture almost thirty years after the event, using sketches made at the time. John Clements sits in the front row of the stalls with his secretary beside him. The artist stands behind in his painting overalls, and peering over the footlights into the auditorium is Harry Fine, the manager and stage director. The bust of Shaw was modelled in papier mâché and let into a false proscenium. The bookshelves contained Shaw's complete works with a gap indicating the missing volume of *Pygmalion*.

The white-haired female on the right was, according to the artist, 'the cleaner pushing her vacuum electric cleaner over the auditorium carpet regardless of our morning intrusions on her preserves.'

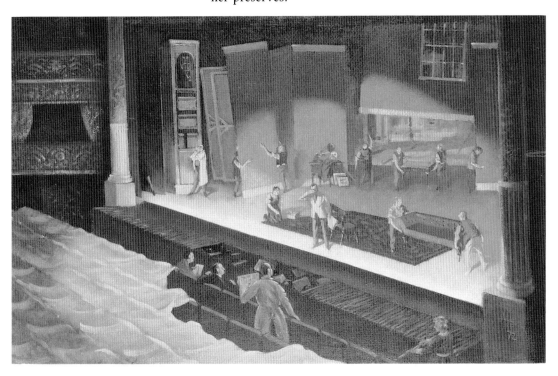

122 Derek Hill (b.1916)

Sir John Gielgud

Oil on canvas 46.5 × 46.5 cm.

1987

Provenance: Given by the artist, 1987

Condition: Sound

Technique: White ground on tabby weave canvas. Some thick impasto scraped over canvas

Label on frame: *Sir John Gielgud / Painted in September 1987 / By Derek Hill (B 1916) / Given by the Artist*

S.786–1987 Neg: HG 3514/CT 18532

123 Simon Redington (b.1958)

Sir John Gielgud as Sir Sydney Cockerell in 'The Best of Friends' by Hugh Whitemore

Hugh Whitemore's *The Best of Friends* opened at the Apollo on 10 February 1988 and ran until 23 April 1988. It was a conversational three-hander with Ray McAnally as George Bernard Shaw, Rosemary Harris as Dame Laurentia McLachlan, Abbess of Stanbrook Abbey, and the 83-year old Gielgud as Sir Sydney Cockerell, Director of the Fitzwilliam Museum. The director was James Roose-Evans and the set was designed by Julia Trevelyan Oman.

Oil on canvas 91 × 50.5 cm.

1988

Provenance: Commissioned by Michael Redington and given to the sitter; given by the sitter to the Theatre Museum, 1989

Condition: Sound. Canvas slightly loose on stretcher.

Technique: White ground on tabby weave or very fine twill weave canvas.

S.352–1989 Neg: HG 3514/CT 18532

THEATRICAL BIOGRAPHIES

Ira ALDRIDGE (1807–1867) **29; 37**

Aldridge was born in New York and probably acted for the first time in the African Theatre on Mercer Street in the early 1820s. He left for England in 1824/5 and played Othello at the Theatre Royal, Brighton, on 17 December 1825. He appeared in minor London theatres during the late 1820s and his performance in *The Death of Christophe* earned him an honorary commission in the Grenadier Guards of the President of Haiti in 1827. He spent the next few years touring the British provinces but finally gave his Othello at Covent Garden in the Spring of 1833. After provoking a somewhat unfavourable critical reaction he returned to the provinces, widening his repertory to include his own adaptation of *Titus Andronicus*, for which he re-wrote the role of Aaron. His popularity developed slowly amongst his British audiences but when, in July 1852, he left for a tour of the Continent he inspired immediate adulation and ecstasy wherever he went. He reappeared briefly in London in 1865 but he wisely spent the last fifteen years of his life touring Switzerland and all states East of the Rhine, and was knighted, awarded and honoured wherever he went. In March 1866 he was the first actor to play Shakespeare in English in Constantinople and he died in Lodz, Poland, where he was buried with full military and civil honours.

Sir George ALEXANDER (1858–1919) **46**

Born in Reading, George Alexander Gibb Samson left a career in drapery for the stage and made his professional debut at the Theatre Royal, Nottingham, on 7 September 1879. After two years of touring he joined Irving's company at the Lyceum on 26 December 1881 to play Caleb Deecie in *The Two Roses*. By the end of 1882 he was touring in such roles as Orlando, Romeo and Benedick with Miss Wallis and after various engagements at the Gaiety, Adelphi and St. James's returned to the Lyceum. Between 1884 and 1889 he played a variety of roles for Irving including Orsino, Faust, Macduff and Silvio in *The Amber Heart*. He was playing at the Adelphi when he went into management at the Avenue, presenting Fred Terry in *Dr Bill* on 1 February 1890. He performed in several plays at the Avenue before moving on to the St. James's, the theatre he managed for the rest of his professional life. He opened on 31 January 1891 with a double bill and produced and performed in over 80 plays there over the next 27 years. His greatest successes included Oscar Wilde's *Lady Windermere's Fan*, 20 February 1892, and *The Importance of Being Earnest*, 14 February 1895, in which played Lord Windermere and John Worthing. He also created the roles of Aubrey Tanqueray in Pinero's *The Second Mrs. Tanqueray*, 27 May 1893, and Thaddeus Mortimore in the same author's *The Thunderbolt*, 9 May 1908. His greatest popular success was undoubtedly the romantic double leading role in Anthony Hope's *The Prisoner of Zenda*, 7 January 1896, and *Rupert of Henzau,* 1 February 1900. As a manager Alexander kept a tight, efficient ship. As an actor and a gentleman he was immaculate and precise, uninspiring and reliable. He was knighted in 1911 for never putting a foot wrong.

Dame Peggy ASHCROFT (1907–1991) **103**

Born in Croydon, Peggy Ashcroft studied at the Central School under Elsie Fogerty. Her first appearance was at the Birmingham Rep. where she replaced Muriel Hewitt in *Dear Brutus* on 22 May 1926. Her West End debut, at Wyndham's in November 1927, was Betty in *The Way of the World* in which she also understudied Edith Evans's Millament, and her first major role was Naomi, Matheson Lang's daughter in *Jew Süss* at the Duke of York's, September 1929. Her first

Shakespearean role was Desdemona to Paul Robeson's Othello at the Savoy, May 1930 and this was followed, in 1932 at the Old Vic, by a whole series of Shakespeare heroines including Cleopatra, Portia, Rosalind, Perdita, Imogen and Juliet. Other work included Inken Peters in *Before Sunset*, Coliseum, February 1934 and Nina in *The Seagull*, New, October 1935, directed by her husband Komisarjevsky. A close professional relationship with John Gielgud developed with his 1937–8 season at the Queen's and his production of *The Importance of Being Earnest*, Globe, August 1939, in which she played Cecily Cardew to Edith Evans's Lady Bracknell and Gielgud's John Worthing. The war years included tours of *Rebecca*, and *Hamlet* with Gielgud and post-war successes included Evelyn Holt in Robert Morley's *Edward, My Son*, His Majesty's, May 1947 and Martin Beck Theatre, New York, September 1948, and Catherine Sloper in *The Heiress*, Haymarket, February 1949. She played Beatrice and Cordelia at Stratford in 1950 and Viola at the re-opening of the Old Vic in November 1951. The performances of the following thirty-five years have made her the most varied, distinguished and admired actress in the British theatre. She was created D.B.E. in 1956 and in 1968 was made a Director of the R.S.C., the company for whom she gave many of her finest interpretations, from the 1953 Portia to the 1981–2 Countess of Rossillion in *All's Well That Ends Well*. She appeared in films from 1933 and on television from 1959.

Tallulah BANKHEAD (1903–1968) **115**

The daughter of Senator William Brockman Bankhead, Tallulah was born in Huntsville, Alabama. In 1917 she won a *Pictureplay* photo contest and, as a consequence, was given the part of Mary Sinclair in *The Squab Farm* and opened in New York at the Bijou Theatre on 13 March 1918. She played a series of undemanding ingenue roles in New York before launching herself on London as Maxine in *The Dancers* at Wyndham's on 15 February 1923. She remained in London throughout the twenties playing a variety of parts and developing her reputation for glamour and eccentricity. A brief career in the movies was followed by her return to the New York stage as Mary Clay in *Forsaking All Others*, Times Square Theatre, 1 March 1933. Her 1937 Cleopatra was a disaster, but her reputation was saved by Regina Giddins in *The Little Foxes*, 1939, and Sabina in *The Skin of Our Teeth*, 1942–3. After the Second World War, during which she gave up whisky to help the British cause, Amanda in *Private Lives* became her staple part although she also succeeded in heavier roles such as Blanche Dubois in *A Streetcar Named Desire*. At least as entertaining off the stage as on, Tallulah cultivated an image that shocked and amused. Her last professional appearance was on television, as the villainess in *Batman*.

George Ann BELLAMY (1731?–1788) **8**

The daughter of an actress, Mrs. Bellamy, and a philandering lord, George Anne Bellamy appeared for the first time on stage at Covent Garden on 20 April 1741 as the servant to Columbine in *Harlequin Barber*. The following year, on 27 March 1742, she played Miss Prue in *Love for Love* at Covent Garden and in 1743 played opposite David Garrick in *The Distrest Mother* in a barn in Kingston. Her career as a regular professional actress began at Covent Garden on 22 November 1744 with Monimia in *The Orphan* and she played several other major roles during the season before moving to the Smock Alley Theatre in Dublin where she stayed until the Autumn of 1748. She then returned to Covent Garden for two years, an accomplished leading lady, widely admired for her fire and beauty both on and off the stage. The next three years were spent at Drury Lane, opening as Juliet to Garrick's Romeo on 28 September 1750 and continuing with an expanding repertory of tragic heroines. Returning to Covent Garden in November 1753 her efforts were divided between a vigorous stage career, a private life of incessant amorous intrigue and the production of illegitimate children. By 1757 she was attempting such heavy tragic roles as Lady Randolph in *Douglas*, Lady Macbeth and Constance but a mediocre technique and somewhat squawky voice did not compensate for her fast fading physical allure. After further seasons at Smock Alley and Covent Garden she moved to Edinburgh for two years. She returned to Covent Garden in December 1764 and remained there until the end of her last full season in London in

March 1770. The appearance of her *Apology* in 1785 was the most notable event of her later life. Its six volumes gush with the glory of her youth but did little to alleviate the illness and penury of George Anne Bellamy in her final years.

Sir Frank BENSON (1858–1939) **88**

Benson was educated at Winchester and New College, Oxford where he was a prominent member of the University Dramatic Company; his roles included Clytemnestra in an original language production of *Agamemnon*. His professional debut was as Paris in *Romeo and Juliet*, Lyceum 2 September 1882. He then toured with Miss Alleyne and Walter Bentley, whose company he took over in 1883. His original repertory included *Romeo and Juliet, Hamlet, The Lady of Lyons, Black-Eye'd Susan* and *The Merchant of Venice* and over the next twenty years he produced the entire Shakespeare canon. His first London season was at the Globe, opening on 19 December 1889 with *A Midsummer Night's Dream*. Benson's company also gave seasons at the Lyceum, Comedy and Adelphi and regular seasons at Stratford-upon-Avon from 1886. In 1913–14 he toured North America and returned to London to play *Henry V* at the Shaftesbury, 26 December 1914. At Drury Lane on 2 May 1916 he played the title role in *Julius Caesar* and was knighted by George V in the stage box after the performance. He retired for a time but returned to the stage early in 1920 to play the title roles in *Pompey the Great* and *Hamlet* at the St. Martin's. He toured in South Arica in 1921 and took his company on regular provincial tours from 1922 to 1929 when he began to tour under the management of Harold V. Neilson. Benson was a keen sportsman and regarded a good game of cricket as the best possible preparation for an evening performance.

Sarah BERNHARDT (1844–1923) **52**

Sarah Bernhardt was the illegitimate daughter of Eduard Bernhardt, a law student, and Julie Van Hard, a Dutch courtesan who had settled in Paris. Sarah was a sickly child and acquired her famous coffin, in which she slept, as a teenager. She planned to take orders but was inspired by visits to the theatre to apply to the Conservatoire. Her mother's lover, the Duc de Morny, assisted in her early career and she was taught by Provost and Samson before getting an engagement at the Comédie Française. She opened as Racine's *Iphigénie* and had an undistinguished career before moving to the Gymnase in 1864. She produced her only child, Maurice, by the Prince de Ligne then returned to the stage in 1865 at the Théâtre Porte Saint-Martin. In 1866 she moved to the Odéon where her roles included Cordelia. Her first great success was in 1869 as the pageboy Zanetto in *Le Passant* by Francois Coppée, the first of her many transvestite roles. She returned to the Comédie Française in Dumas's *Mlle. de Belle Isle* and was recognised as the successor to Rachel with her *Andromagus* and *Phèdre*. Important contemporary successes included Mrs. Clarkson in Dumas fils' *l'Etrangère* and Dona Sol in Victor Hugo's *Hernani*. In 1879 she made her first foreign tour, to London, and visited the United States for the first of nine tours in 1880. The time she spent away from Paris increased over the years as her expenses grew with her fabulously lavish life-style; Brazil was the most profitable venue. In 1882 she married Jacques Damala in London and unfortunately played opposite his mediocre talents until his death in 1889. In 1893 she entered into her first management with the Théâtre de la Renaissance. She relied on revivals to keep the theatre going but formed a good company with actors such as the young Lucien Guitry. In 1899 she took over the larger Théâtre des Nations which she re-named the Théâtre Sarah Bernhardt and remained in charge for the rest of her life. On 20 May 1899 she played *Hamlet* for the first time, a performance that impressed London audiences just as much as those in Paris and the following year produced Rostand's *L'Aiglon*, playing Napoleon's son, the duc de Reichstadt, her last great creation. She was the most spectacular performer of the late nineteenth century if not its greatest actress. Her undoubted dramatic presence and eccentric private life created a legend that remains as potent now as it was a hundred years ago.

Thomas BETTERTON (1635–1710) **3**

The eldest son of Matthew Betterton, under-cook to Charles I, by his second wife, Betterton was bound apprentice to the bookseller Thomas Holden, probably from 1649 to 1656. Betterton's first theatrical engagement was with John Rhodes's company at the Cockpit in Drury Lane in 1659–60. After the Restoration, he appeared briefly with Killigrew's King's Company in the same theatre but was performing with Davenant's Duke's Company by January 1661. He was given leading roles from the start, playing his first Hamlet, for instance, on 24 August 1661. In 1662 he was sent to France by Davenant to glean ideas from the French theatre and on his return married Mary Saunderson with whom he had been living for eighteen months. On Davenant's death in 1668 Betterton shouldered the principal responsibility for the Duke's company and by 1674 he was the principal shareholder with three and a quarter shares. He contributed towards the cost of the new Dorset Garden Theatre which his company opened on 9 November 1671 with Dryden's *Feigned Innocence* and, with William Smith, led the amalgamated company when the Duke's and King's Companies joined in 1682. His trips to France inspired the ambitious use of complex scenes and machines in such productions as Dryden's opera *Albion and Albanius*, Dorset Garden, 3 June 1685, and he also wrote his own plays and adapted others. However, he still performed frequently, creating such roles as Dorimant in *The Man of Mode*, 11 March 1676, Belville in *The Rover*, 22 March 1677, Castalio in *The Orphan*, February 1680, Lear in Nahum Tate's version of *King Lear*, March 1681 and Jaffier in *Venice Preserved* on 9 February 1682. Between 1690 and 1694 he devoted almost all his time to acting but led the actors' secession away from the joint company, now managed by Christopher Rich, back to the old theatre in Lincoln's Inn Fields. Although it seems that his management was chaotic his acting was at its most brilliant during his sixties and he created such roles as Sir John Brute in *The Provoked Wife*, April 1698, and Fainall in *The Way of the World*, 5 March 1701 before transferring his license to Vanbrugh and the Queen's Theatre in the Haymarket, which opened on 9 April 1705. Betterton performed the whole range of his parts there over the next two years and was also in charge of teaching the younger actors. The players moved to Drury Lane in January 1708, leaving the Queen's Theatre to the singers but Betterton was back in the Autumn of 1709, playing his great roles such as Othello, Hamlet, Macbeth and Lear before his last performance, Melantius in *The Maid's Tragedy*, on 13 April 1710. He was buried in the East Cloister of Westminster Abbey, leaving very little money and a demented wife.

Dorothy BLACK (1899–1985) **93**

Born in Johannesburg, Dorothy Black studied under Elsie Fogerty at the Central School. After various provincial engagements she replaced Evelyn Hope as Araminta in *The Farmer's Wife* at the Court Theatre in August 1925. After a long tour as Florence Churchill in *The Constant Nymph* she played the Step-daughter in *Six Characters in Search of an Author* at the Arts and Globe Theatres in May 1928. In September 1928 she appeared at the 'Q' theatre as Irene Shane in *The House of Women*, a play that she adapted in 1940 when she took the part of Lilian Shane. In April 1929 she appeared for the Stage Society at the Strand Theatre as Anna Alexandrovna Virabova in *Rasputin*. Her work over the next five years consisted of revivals such as *Dear Brutus* at the Playhouse, September 1929, *The Ghost Train* at the Comedy, December 1929, some modern plays, and costume pieces such as *The Rose Without a Thorn*, Duchess February 1932, in which she played Mary Lassells. The part of Emily Brontë in *The Brontës*, Royalty April 1933, was her most successful part and probably prompted the invitation to Stratford in 1934 to play Viola, Beatrice, Portia in *Julius Ceasar* and Rosaline in *Love's Labour's Lost*. She returned to Shakespeare in 1936 with a Rosalind in Regent's Park and on tour with Donald Wolfit in 1944 when she played Gertrude to his Dane and Lady Macbeth to his Scot. Her theatrical career was a mixture of the very serious and the very silly and despite the Wolfit tour and a Mrs. Linden in *A Doll's House* at the Arts in July 1945 she never really attracted the critical attention that perhaps she deserved. Her stage career ended in the early '50s but she continued to make film, television and radio appearances and wrote for radio and the stage.

Charles BLAKES (d.1763) **8**

Blakes's first London appearance seems to have been at the Haymarket on 27 May 1736 as Randal in *Guilt Its Own Punishment*. He was playing at the Haymarket the following Summer and by December 1740 was performing with the Goodman's Fields company. He played for a time at Covent Garden in early 1741 but returned to Goodman's fields later in the season. Blakes accompanied Giffard when he moved to Lincoln's Inn Fields. His first appearance at Drury Lane was as the Bailiff in *The Committee* on 9 October 1743 and he played every winter season at that theatre until his death. During the summer he tended to perform at the Jacob's Wells Theatre in Bristol. Blakes was a useful actor and could put his hand to a wide variety of parts although he was regarded as a better comedian than tragic actor. His tragic roles included Malcolm, Cassio, Cornwall, Norfolk in *Richard III* and Thessalus in *The Rival Queens*. His extensive comic repertory included Foigard and Sir Charles in *The Beaux' Stratagem*, Caius in *The Merry Wives of Windsor* and Scruple in *The Recruiting Officer*.

Hester BOOTH (c.1690–1773) **4**

As her billing changed from Miss to Mrs. Santlow in 1711, the unmarried Hester Santlow is assumed to have been born twenty-one years previously in 1690. In about 1704 she became a pupil of the French dancing master Cherrier and two years later the two drew up a contract dividing her income. Miss Santlow made her first stage appearance at Drury Lane on 28 February 1706, dancing with Cherrier in some of his own dances. She was successful enough to be given a solo benefit on 16 April. In January 1708 she moved to the Queen's Theatre as a dancer and stayed there until the end of the following season. She returned to Drury Lane after a benefit on 12 April 1709. At Drury Lane she began to develop her acting career, her debut was as Miss Prue in *Love for Love* on 3 December 1709. Her first Shakespeare role was Ophelia on 14 February 1710 although her first success was Dorcas in *The Fair Quaker of Deal* by Charles Shadwell, a part she created on 25 February 1710. She continued to dance but concentrated on the spoken word until September 1712 when she disappeared from the cast-lists for a year, probably to give birth to her daughter Harriet by her rakish lover James Craggs. Harriet's son Edward, one of nine children, was made Baron Eliot of St. German's in 1784. His descendants own most of the pictures collected by Hester, including three portraits of her by John Ellys. On her return to Drury Lane for the 1713–14 season Hester increased her repertoire to include such roles as Cordelia and Desdemona and various ingenue parts. She began to take her dancing more seriously and by 1718 her performances as an actress were becoming infrequent. In 1719 she married Barton Booth, one of the lessees of Drury Lane and one of the most distinguished actors in the generation between Betterton and Garrick. Hester brought her jewels to the marriage, the spoils of many liaisons, and the couple were blissfully happy until Booth died after a long illness in 1733. It was a working marriage and both of them were kept busy at Drury Lane with Hester spending two thirds of her time acting and the rest dancing; she often did a speciality dance between the acts of a play. Hester Booth was regarded as a limited actress, very charming as the innocent maid, but her dancing was clearly exceptional, graceful and sensual and full of sex-appeal.

James CAMPBELL GULLAN (d.1939) **98**

James Campbell Gullan first appeared as an amateur in his native Glasgow before making a professional appearance at the London Pavilion. He then won the George Edwardes Open Scholarship for Acting and Dancing and toured for several years before joining the Glasgow Repertory Theatre Company in 1909. Amongst his many parts with the company were an early Trigorin in *The Seagull* and Tammas in *Colin in Fairyland*. His first appearance on the legitimate London stage was as Chim Fang in *The Cat and the Cherub* at the Royalty on 31 May 1911 and his New York debut was at the Comedy on 10 October 1911 as Tammas Biggar in *Bunty Pulls the Strings*. Back in England he played John Rhead in *Milestones*, a play that he revived in October 1914 when he played Webster. In April 1914 he played Nicolas with Gladys Cooper in *My Lady's Dress*

at the Royalty and at the same theatre in December 1914 Corporal Atkins in the long-running *The Man Who Stayed at Home*. His single venture into Shakespeare seems to have been a Friar Lawrence at the Regent Theatre in May 1924 but his most distinguished role of the '20s was probably Gabriel Syme (Thursday) in *The Man Who Was Thursday* at the Everyman, January 1926. He appeared in a number of generally fairly light-weight plays both in London and New York throughout the '20s and '30s and from 1926 began to direct plays as well as appear in them. He also directed and appeared in a number of films.

Fanny CERRITO (1817–1909) **35**

Fanny Cerrito was one of the most distinguished ballerinas of the Romantic period. She studied with Jules Joseph Perrot, Carlo Blasis and Arthur Saint-Leon. She made her debut in Naples in 1832 and her erotic appeal and fiery temperament as well as phenomenal strength, speed and vivacity made her an immediate star wherever she danced, from Vienna in 1836 and London in 1840 to Paris in 1847 and St. Petersburg in 1855. She created the leading role in a number of ballets, including *Ondine*, 1843, and *Lalla Rookh*, 1846, and participated in the most celebrated event of Romantic ballet, the *Pas de quatre* performed at Her Majesty's on 12 July 1845 with Lucile Grahn, Carlotta Grisi and Marie Taglioni. She collaborated on some ballets as choreographer and retired in the late 1850s.

Boris CHRISTOFF (b.1918) **118**

Christoff was born in Ploviv, Bulgaria and began his career as a magistrate, becoming a tribunal judge after a period in the cavalry. He formed a regimental choir and joined the choir of the Alexander Nevsky Cathedral, Sofia. Christoff's singing so impressed Tsar Boris III at a mass on 19 January 1942 that he provided a scholarship that enabled Christoff to study in Rome with Riccardo Stracciari and then at the Salzburg Mozarteum. A professional debut in Rome in December 1945 was followed by his theatrical debut at the Teatro Argentina in March 1946 as Colline in *La Bohème*. In 1947 he sang Pimen in *Boris Godunov* at La Scala, Milan and two years later sang the title role for the first time at Covent Garden, returning several times to sing the role over the next thirty years. In London he has also sung Fiesco in *Simon Boccanegra* and, on several occasions, Philip II in *Don Carlos*. Elsewhere, his parts include the title role in Boito's *Mefistofele*, Gurnemanz in *Parsifal*, Hagen in *Götterdämerung*, Dosifei in *Khovanschina*, Ivan in Glinka's *A Life for the Tsar* and Galitzky and Konchak in Borodin's *Prince Igor*.

Sir John CLEMENTS (1910–1988) **121**

Born in London and educated at St. Paul's and St. John's, Cambridge, John Clements first appeared on stage at the Lyric, Hammersmith, as Lucas Carey in *Out of the Blue*, 1 April 1930. In the same year he also appeared in *She Stoops To Conquer* at the Lyric, Hammersmith, *The Beaux' Stratagem* at the Royalty and the revue *Caviare* at the Little Theatre. During 1931–2 he toured with Ben Greet's company playing juvenile leads in the broad Shakespearean repertory and then played a first quarto Laertes at the Arts Theatre in September 1933. His other parts before the War included Ragnar Brovik in *The Master Builder*, Westminster Theatre April 1934 and Lucien in *Napoleon* at the Embassy Theatre September 1935. In December 1935 he founded the Intimate Theatre, Palmer's Green, and directed forty-two plays there, appearing in leading roles in thirty-six of them. The Intimate was the first London theatre to reopen after the outbreak of war. Clements then went on to direct for ENSA and organised a special revue company for entertaining the troops. After the war he appeared at the St. James's under his own management as the Earl of Warwick in *The Kingmaker* and went on to direct and appear in other plays at the St. James's, including *Marriage à la Mode*, July 1946, and *Pygmalion*, November 1953. He appeared with the Old Vic company at the New Theatre 1947–8, playing Dunois in *St. Joan*, Petruchio and Coriolanus. He directed and played Archer in a long run of *The Beaux' Stratagem* at the Phoenix,

May 1949, and directed and played John Tanner in *Man and Superman* at the New, February 1951. In July 1955 he took over the management of the Saville Theatre and presented a series of distinguished revivals, including *The Way of the World* and *The Rivals* in which he also appeared. He then presented several plays at the Piccadilly before going to New York with the Old Vic company to play Macbeth and the Earl of Warwick in *St. Joan*. In December 1965 he was appointed director of the Chichester Festival Theatre and presented an annual Summer season until 1973. A number of the productions transferred to the West End, including *Heartbreak House*, Lyric, November 1967, *The Magistrate*, Cambridge September 1969 and *Vivat! Vivat! Regina*, Piccadilly October 1970. He returned to Chichester in 1977 and 1979. He was knighted in 1968.

Edward COMPTON (1854–1918) 43

Born in London, the son of Henry Compton, Edward Compton began his stage career in Bristol when he played Long Ned in *Old London*, Theatre Royal 22 September 1873. He toured with Francis Fairlie's company in 1876 and appeared in Glasgow and Kilmarnock before playing leading roles in Liverpool and Birmingham. His London debut was at Drury Lane on 1 March 1877 in a benefit for his father. He then toured with H.J. Byron as Cyril in *Cyril's Success* and with Mrs. Hermann Vezin and Miss Wallis. He returned to Drury Lane in 1878 to play a number of classical roles including Cassio, Malcolm, Posthumus and Romeo and in 1879 acted with Adelaide Neilson at the Adelphi. After an American tour with Miss Neilson, Edward Compton returned to London in 1880 to play a number of unexciting contemporary roles. In 1881 he founded the Compton Comedy Company which gave its first performance in Southport on 7 February with *Twelfth Night*, Compton playing Malvolio. Over 30 years he developed a repertory of 50 plays, mostly popular comedies of the eighteenth and nineteenth centuries, which he took all over the country. There were also London seasons at the Strand, Opera Comique, Toole's and St. James's. He managed a number of London and provincial theatres for short periods, including the Kennington Theatre with Robert Arthur in 1911. His last appearance seems to have been as Sir Roger in *Sir Roger de Coverley* at His Majesty's, in November 1914.

Mrs. Edward COMPTON (1853–1940) 97

The daughter of Col. Bateman, Virginia Frances Bateman married the popular actor-manager Edward Compton in 1882. She made her London stage debut at Her Majesty's on 22 December 1865 in the title role of *Little Daisy*. Other early roles were more demanding including Madelena in *Leah*, Haymarket 1868, and Glaucca in *Medea in Corinth*, Lyceum 1872. Her roles at the Lyceum also included Princess Elizabeth in *Queen Mary*, April 1876, Mrs. Racket in *The Belle's Stratagem*, June 1876, and Marie de Commines in *Louis XI*, April 1878. After her marriage she played leading roles in the Compton Comedy Company, throughout the provinces and at the Strand in 1883 and 1886. She took control of the company when Edward Compton died in 1918 and opened the Repertory Theatre, Nottingham, in September 1920. Four of her five children, including Fay Compton, took to the stage. The odd one out was the eldest, Compton Mackenzie. Mrs. Edward Compton was instrumental in founding the Soho Girls Theatre Club in 1915 and in later life she devoted most of her energies to the spiritual, moral and physical welfare of her Soho girls.

Fay COMPTON (1894–1978) 89

The daughter of Edward Compton and Virginia Bateman, Fay Compton made her stage debut with The Follies at the Apollo on 20 August 1911. Her first role was Denise in *Who's the Lady?*, Garrick, November 1913 and she spent the next twenty years of her career playing glamorous leading roles in mostly light-weight plays. There were exceptions such as Ophelia to John Barrymore's Hamlet at the Haymarket in February 1925 and Constance Middleton in *The Constant Wife*, Strand, April 1927. She first visited New York in 1914 and opened on 24 December as Victoria in *To-Night's the Night* at the Shubert Theatre. She returned in 1928 and toured Australia

and New Zealand in *Victoria Regina* in 1937–8. In December 1930 she took the part of Dick Whittington in the pantomime, Palace Manchester and repeated the role for the next two Christmas seasons at the Theatre Royal, Glasgow, and the London Hippodrome. With seasons in 1935 and 1937 at the Regent's Park Open Air Theatre she began to concentrate on more inspired roles such as Titania, Calpurnia and Paulina and in June 1939 she played Ophelia to Gielgud's *Hamlet* at the Lyceum. She went to Elsinore with the production and appeared as Regan with the Old Vic Company the following year. During World War II her notable successes were Ruth in *Blithe Spirit*, Piccadilly, July 1941 for fifteen months, and Martha Dacre in *No Medals*, Vaudeville, October 1944 until 1946. She joined the Old Vic Company in 1953 to play Gertrude, the Countess in *All's Well*, and Constance and returned in May 1957 to play Queen Margaret in *Richard III*. Her later appearances included Grausius in *The Broken Heart* and Marya in *Uncle Vanya* at the first Chichester Festival, 1963, and Anna in *A Month in the Country* at the opening of the Yvonne Arnaud Theatre, Guildford 1965. Her television career was extremely distinguished and included Aunt Ann in *The Forsyte Saga*.

Edward Henry Gordon CRAIG (1872–1966) 53

Craig was born in Stevenage, the illegitimate son of Ellen Terry and the architect Edward William Godwin. The surname Craig was inspired by Ailsa Craig, a rock off Scotland. Ellen Terry decided to return to the stage 1875 and she left Godwin, taking her children to London and a life in the theatre. Craig made his first appearance on the stage on 28 March 1878 when he walked on in *Olivia* at the Royal Court; his mother was playing the title role. In 1885 he toured America with his mother and the Lyceum company, playing the gardener's boy in *Eugene Aram*. He joined the Lyceum company as a full member in 1889. In 1893 Craig married and moved to Denham where, inspired by his neighbours William Nicholson and James Pryde, he discovered his considerable talents as a graphic artist. However, he continued to be a professional actor until 1899. His first theatrical designs were for de Musset's *On ne badine pas avec l'Amour* which he also produced at the Town Hall, Uxbridge, on 13 and 14 December 1893. In 1898 Craig met the composer Martin Shaw and they collaborated in a production of Purcell's *Dido and Aeneas* given at the Hampstead Conservatoire, later the Embassy Theatre, on 17 May 1900. This was the first time that Craig was able to carry out his theories, on a limited scale, of what his son Edward called '. . . a new kind of kinetic theatre – a synthesis of form, light, scene, figures and sound . . . movement.' Further minor productions followed and then in 1903 Ellen Terry took a lease of the Imperial Theatre so that Craig could produce Ibsen's *The Vikings* and *Much Ado About Nothing*. Craig's innovations were admired by Count Harry Kessler and he persuaded Otto Brahm to allow Craig to design for the Lessing Theatre in Berlin. In 1905 Craig began to work on *Elektra* for Eleanora Duse. This was abandoned but his designs for her production of *Rosmersholm* were seen at the Pergola, Florence, and they also worked together on *The Lady from the Sea*. Craig and Max Reinhardt sniffed around each other for some years and they collaborated on productions of *Oedipus* and the *Oresteia* before Craig left for Moscow and Stanislavsky. In Moscow Craig's famous screen designs for the 1911 *Hamlet* were the greatest triumph of his theatrical career. Thrilling and innovative, they were a great artistic success and with over 400 performances a commercial success as well. Very little theatre work was done after 1911 but Craig had an immense influence on the twentieth-century theatre with his seminal publications that included *On the Art of the Theatre*, 1911, *Towards a New Theatre*, 1913, and the fifteen volumes of *The Mask*, 1908–1929. Craig was a difficult man, beautiful when young and continually reminded of his genius wherever he went, but in the age of Irving and Tree he reached for an abstract concept of theatre that has marked theatre design and production ever since.

Vivien Van DAMM (1889–1960) 111

Vivien Van Damm was general manager of the Windmill Theatre under the direction of Laura Henderson from June 1931. On 3 February 1932 Van Damm initiated a policy of non-stop variety with *Revudeville* performances starting at 2.30 p.m. and running until 11.00 p.m. After teething

troubles the policy paid off and *Revudeville* ran in one form or another until 1964. It became the most famous theare in London during World War II and kept open all through the blitz. Laura Henderson died in 1944 but Van Damm continued to provide the same fare of comedy and innocent titilation until his own death in 1960, when he was succeeded by his daughter Sheila.

Maria Rebecca DAVISON (1783–1858) **26**

Born into a theatrical family, Maria Davison (née Duncan) began her stage life playing children's parts in major provincial theatre; she might have played Duke of York to George Frederick Cooke's Richard III at Dublin during the 1794–5 season. Her first regular engagement was with Tate Wilkinson on the York circuit and she made her London debut at Drury Lane on 8 October 1804 as Lady Teazle in *The School for Scandal* with Charles Mathews as Sir Peter. Her first Shakespearean role at Drury Lane was Rosalind, 18 October 1804, and on 31 January 1805 she created her most famous role, Juliana in *The Honeymoon*. She stayed at Drury Lane for fourteen years, as Mrs. Davison after her marriage in 1812. She played Lady Teazle to Macready's Joseph Surface on 8 September 1819, her Covent Garden debut. In 1825 she was playing at the Haymarket and in the same year returned to Drury Lane after a break; her last performance there was probably Mrs. Subtle in *Paul Pry*, 13 June 1829. Maria Davison's best known part was Juliana but she was widely admired in arch but sympathetic roles such as Lady Teazle and Beatrice.

Nina DE SILVA (Angelita Helena Margarita de Silva Ferro) (1868–1949) **105**

Nina De Silva made her debut as a Page in *Much Ado About Nothing* on 11 October 1882 at the Lyceum, where she met her husband John Martin-Harvey. Her other parts at the Lyceum included Marie in *The Corsican Brothers*, 1891, and Alice in *Faust*, 1894, and she remained there until 1897, only to return under her husband's management in February 1899 as Mimi in *The Only Way*. A pretty and prepossessing soubrette, Nina De Silva was an actress of limited range whose career owed everything to her husband's position in the British theatre. She supported him in his popular costume dramas such as *The Breed of the Treshams* and *The Last Heir* and *Boy O'Carroll*. She also played Ophelia to his Hamlet, Katherine to his Petruchio and Lady Anne to his Richard III. She accompanied his Canadian tours and endless peregrinations around the British Isles and her career ended with his farewell tour in 1939.

Winifred EMERY (1862–1924) **51**

Born in Manchester into a well-known theatrical family, Winifred Emery appeared at the Liverpool Amphitheatre in 1870 and in pantomime at the Princess's Theatre, London in 1874. Her first appearance as an adult was at the Imperial Theatre in *Man is Not Perfect*, 14 April 1879. She joined Wilson Barrett's company later in the year and in 1880 played opposite Mme. Modjeska at the Court in *Mary Stuart* and *Adrienne Lecouvreur*. In July 1881 she began a seven year connection with the Lyceum that included two trips to America in 1884–5 and 1887–8. Her parts included Olivia, Hero and Jessica as well as Julie in *The Lyons Mail* and Margaret in *Faust*. In 1890 she was playing an eighteenth-century repertory at the Vaudeville and later in the year rejoined Wilson Barrett at the New Olympic. In 1892 she played Lady Windermere in *Lady Windermere's Fan* at the St. James's and then joined Comyns Carr at the Comedy for *Sowing the Wind* and three other plays. In October 1896 she moved to the Haymarket with her husband Cyril Maude to play such parts as Renée in *Under the Red Robe* and Lady Babbie in *The Little Minister*. She retired from the stage in 1898 because of illness and apart from a brief return 1901–2 stayed away until January 1905 when she played Beatrice to Tree's Benedick. She took her own company on tour in 1906, playing the title role in *Olivia* and then producing *Her Son* in which she played Dorothy Fairfax. In April 1908 she appeared as Mistress Ford in a revival of Tree's *The Merry Wives of Windsor* at His Majesty's and had a success the following year as Queen Elizabeth in *Sir Walter Raleigh*, initially at

the Lyric and then on tour. Her career had faded away by the end of 1913 although she appeared in charity performances and on 8 January 1921 played the Fairy Berylune in *The Betrothal* at the Gaiety.

William FARREN (1786–1861) **22; 27 ?**

Son of the actor William Farren (1725–1796), William Farren II was born in London and educated at Dr. Barrow's school in Soho Square. He first appeared on stage in 1806, as Sir Archy McSarcasm in *Love à la Mode* at the Theatre Royal, Plymouth, which was managed by his brother Percy. He was then engaged in Dublin as 'first old man' for over a decade and eventually returned to London to perform Sir Peter Teazle in *The School for Scandal* at Covent Garden on 10 September 1818. He remained there until 1828, playing his widely admired gamut of comically eccentric old gentlemen such as Sir Anthony Absolute in *The Rivals* and Lord Ogleby in *The Clandestine Marriage*. He created a number of roles by contemporary authors such as Kenny, Planché and Morton at Covent Garden and during Summer seasons at the Haymarket. His first appearance at Drury Lane on 16 October 1828 was again as Sir Peter Teazle and he remained there until 1837, expanding his repertory to include such parts as Polonius in *Hamlet* and Kent in *King Lear*. He returned to Covent Garden in the late 1830s and then moved to the Haymarket as stage-manager for Benjamin Webster. An attack of paralysis added authenticity to many of his performances and after ten years at the Haymarket he went on to manage first the Strand and then the Olympic. He retired from management on 22 September 1853, gave his last performance at the Haymarket on 16 July 1855.

Dame Gwen FFRANGCON-DAVIES (1891–1992) **103**

Born in London, Gwen Ffrangcon-Davis was trained by Mrs. L. Manning Hicks and Agnes Platt. She walked on in *A Midsummer Night's Dream* at His Majesty's on 17 April 1911 and then toured for several years in a number of parts including Sambra in *The Arcadians*. She had a fine singing voice and from 1911–1922 she returned frequently to the part of Etain in *The Immortal Hour* (cf. No. *82*). She joined the Birmingham Rep. in July 1921, playing such roles as Juliet, Phoebe Throssel in *Quality Street* and Lady May in *The Admirable Crichton*. In October 1923 she played Eve and the Newly Born in *Back to Methuselah*. Another season in Birmingham was followed by Titania, Drury Lane, December 1924, and Cleopatra in *Caesar and Cleopatra*, Kingsway, April 1925. She was a popular Shavian and her other roles during the 1920s included Mrs. Dubedat in *The Doctor's Dilemma*, Eliza Doolittle and Ann Whitefield in *Man and Superman*, all Kingsway, 1926–7. In September 1930 she played Elizabeth Moulton-Barrett in *The Barretts of Wimpole Street* at the Queen's and in June 1932 joined John Gielgud to play Anne of Bohemia in *Richard of Bordeaux* at the New. They also played together in *The Importance of Being Earnest*, Globe, August 1939, and in *Macbeth*, Piccadilly, July 1942. Gwen Ffrangcon-Davies toured in South Africa 1943–6 and after her return appeared at Stratford for the 1950 season playing Queen Katherine, Regan, Portia in *Julius Caesar* and Beatrice. She joined the Old Vic as Queen Katherine in May 1953 and in April 1956 played Rose Pedley in *The Mulberry Bush*, the English Stage Company's first production at the Royal Court. During the 1950s important roles included Agatha in *The Family Reunion*, Phoenix June 1956, Mrs. Callifer in *The Potting Shed*, Globe, February 1958 and Mary Tyrone in *Long Day's Journey into Night*, Globe, September 1958. The next decade saw fewer productions but included Amanda Wingfield in *The Glass Managerie* at the Haymarket, December 1965 and her last stage appearance, as Mme. Voynitsky in *Uncle Vanya*, Royal Court, February 1970.

Beatrix FIELDEN-KAYE (fl.1910–1939) **104**

Beatrix was a member of the Benson company, although not for long as her only London appearance with them appears to have been as the Wife of Axel the Smith in *The Piper* by Josephine Preston Peabody. It opened at the St. James's on 22 December 1910 and ran for 33 performances.

The first performance had been in Stratford-upon-Avon on 26 July 1910 and the cast included Frank Benson as The Piper and Marion Terry as Veronika. Beatrix Fielden-Kaye then disappears from metropolitan theatrical records although she seems to have stood in for Edith Evans from time to time in the 1930s.

Sir Johnston FORBES-ROBERTSON (1853–1937) **54**

Johnston Forbes-Robertson came from a sophisticated artistic background and attended the Royal Academy Schools in 1870. He studied elocution under Samuel Phelps, whom he painted as Cardinal Wolsey, and made his stage debut at the Princess's on 5 March 1874 as Chastelard in *Mary Queen of Scots*. He appeared as Prince Hal in *Henry IV 2* with Charles Calvert in Manchester, September 1874, and then joined Phelps at the Gaiety as Fenton in *The Merry Wives*, December 1974, subsequently playing other parts such as Lysander and Hastings in *She Stoops to Conquer*. He appeared at the Olympic in 1875 and 1877 when his parts included Jeremy Diddler in *Raising the Wind* and George Tallboys in *Lady Audley's Secret*. He was engaged by the Bancrofts at the Prince of Wales's in August 1878 to play in *Diplomacy*, first Count Orloff and then Julian Beauclerc and, after a season with Genevieve Ward at the Lyceum, returned to the Bancrofts and accompanied them to the Haymarket in 1880, opening as Lord Glossmore in *Money* on 31 January. He was engaged by Wilson Barrett to support Mme. Modjeska's season at the Court and opened as Maurice de Saxe in *Adrienne Lecouvreur* on 11 December 1880. He joined Irving at the Lyceum in October 1882 to play Claudio in *Much Ado About Nothing* and then rejoined the Bancrofts from November 1883 until they left the Haymarket in July 1885. For the next two years his leading lady was Mary Anderson and they toured together in the provinces and North America where Forbes-Robertson made his New York debut as Orlando at the Star Theatre, 12 October 1885. Their production of *The Winter's Tale* at the Lyceum, September 1887, had costumes designed by Forbes-Robertson. The next few years included several distinguished seasons with John Hare at the Garrick, a tour with Kate Rorke, Lancelot in Irving's *King Arthur*, Lyceum, January 1895, and Lucas Clease in *The Notorious Mrs. Ebbsmith*, Garrick, March 1895. On 21 September 1895 he opened his first management at the Lyceum, playing Romeo to Mrs. Patrick Campbell's Juliet. He produced a wide variety of plays, both Shakespearean and contemporary. He played Othello for the first time on tour in 1897 and played Hamlet at the Lyceum in September 1897. He took his company to Berlin in 1898 and on his return played Golaud in *Pelléas and Mélisande*, Prince of Wales's, June 1898. Subsequent performances included Macbeth, Lyceum, September 1898, Mark Embury in *Mice and Men*, Lyric, January 1902 and Dick Helder in *The Light that Failed*, Lyric, February 1903. His production of *Caesar and Cleopatra* opened at the Savoy on 25 November 1907 after a North American and provincial tour. The great success of his later career, *The Passing of the Third Floor Back* in which he played the Third Floor Back, opened at the St. James's on 1 September 1908. He toured the play in North America in 1909–11 (along with other plays) and took it around the provinces as part of his farewell tour in 1912–13. His farewell season at Drury Lane, 22 March to 6 June 1913 opened and closed with *Hamlet* and he was knighted during the final week of performances. He again toured North America 1913–16 making a farewell performance as Hamlet at Harvard on 26 April 1916. In fact, *The Passing of the Third Floor Back* was revived several times for War Charities. According to his autobiography, *A Player Under Three Reigns*, Forbes-Robertson loathed every minute he stood on stage but he clearly had an extraordinary stage presence and recordings demonstrate that he was one of the most accomplished verse speakers of modern times, his voice the silvern inspiration for Gielgud and Robert Donat.

David GARRICK (1717–1779) **7; 8; 9**

Garrick was born in Hereford but grew up in Lichfield where his soldier father was stationed. In 1737 Garrick left Lichfield with Samuel Johnson, his former teacher, and the following year invested an inheritance of £1000 in the wine trade. By 1740 he was writing plays, *Lethe* was given at Drury lane on 15 April 1740, and the following year he started to act; he visited Ipswich with Henry Gifford's company in June 1741 calling himself Mr. Lyddall. On his return to London he

played Richard III on 19 October 1741 at Goodman's Fields Theatre. It was one of the great moments of British theatre history; the audience was ecstatic and the career of the greatest of all British actors was launched. He was billed as 'A Gentleman' for his first performances but began to use his own name on 28 November when he played Chamont in *The Orphan*. His success was the cause of the patent theatres demanding the closure of Goodman's Fields and Garrick had to move to Drury Lane on 26 May 1742 when he played Bayes in *The Rehearsal*. He gave his Lear the following night and his Richard III on 31 May. Garrick enjoyed four wildly successful seasons at Drury Lane but after considerable acrimony between him and the manager Charles Fleetwood he moved to Covent Garden for the 1746–7 season at a salary of 600 gns. This season included the first performance of his farce, *Miss in Her Teens,* 17 January 1747, and his debut as Ranger in *The Suspicious Husband*. Garrick returned to Drury Lane for the 1747–8 season, this time with a 50% share in the theatre for which he payed £8000. The season opened on 15 September with Charles Macklin's famous Shylock. Having to act and manage a large company left Garrick in a permanent state of exhaustion and to recoup he left for Paris on 19 May 1751. There he discovered that he was a European celebrity. Garrick had married in 1749 and in the same year bought the lease of 27, Southampton Street. In 1754 he bought his country house at Hampton and in 1758 built his Shakespeare temple with its statue of Shakespeare by Roubiliac. In November 1755 Garrick introduced Jean-Georges Noverre's *Les Fêtes Chinoises* to Drury Lane but anti-French feeling produced a riot and the theatre was wrecked. However, Garrick's management was usually efficient and delicately organised with just short of 200 performances each season. The plays included contemporary works and a high proportion of works by Shakespeare, many adapted by Garrick himself. From 1761 Garrick reduced the number of his own performances and on 15 September 1763 he left for a belated Grand Tour; he returned on 27 April 1765. The great event of Garrick's later career was the 1769 Stratford Shakespeare Jubilee which took place in farcical conditions from 6–8 September. Garrick recouped the money he lost at Stratford by reconstructing the event as it should have happened on the stage of Drury Lane. By 1771–2 Garrick was giving less than 20 performances a season but he moved to Adelphi Terrace on 28 February 1772 and his social life advanced in leaps and bounds, helped by his election in 1763 to The Club where he was able to join other luminaries of the age such as Dr. Johnson, Reynolds, Burke and Goldsmith. Garrick's final season, 1775–6, ended on 10 June 1776 with his performance of Don Felix in *The Wonder*; he gave his last Richard III on 3 June. Garrick dominated the eighteenth-century British stage; he was its greatest actor in both comedy and tragedy, its best manager, an extremely good business man and an important patron of the arts. He was also a good playwright, a marvellous letter writer and a worshipper of Shakespeare.

Sir John GIELGUD (b.1904) **94; 122; 123**

Gielgud was born in South Kensington, and inherited strong theatrical connections through both parents. He was educated at Westminster and at the age of 17 studied under Lady Benson, walking on at the Old Vic between terms. After a period at RADA he opened as Charles Wykeham in *Charley's Aunt*, Comedy, December 1923. In January 1924 he joined J.B. Fagan's repertory company at the Oxford Playhouse, leaving occasionally to play in London; for instance Romeo to Gwen Ffrangcon-Davies's Juliet at the Regent, May 1924, and following Noël Coward as Nicky Lancaster in *The Vortex*, Little, May 1925. After playing Trofimov in *The Cherry Orchard*, Lyric Hammersmith & Royalty transferred from Oxford, and Treplev in *The Seagull*, Little, October 1925, he played Baron Nikolai in Komisarjevsky's production of *The Three Sisters*, Barnes Theatre, February 1926. Gielgud made his New York debut as Grand Duke Alexander in *The Patriot*, Majestic Theater, 18 January 1928 but the play ran for only 12 performances. He joined the Old Vic company in September 1929 and his roles during this first season included Romeo, Richard II, Oberon, Mark Antony and Hamlet, which transferred to the Queen's, April 1930 and was, according to Gielgud, the best of his six Hamlets. In July 1930 he played John Worthing at the Lyric Hammersmith and then rejoined the Old Vic company. *Richard of Bordeaux*, New Theatre, February 1933, was Gielgud's first great commercial success and he played the title role for a year. He directed as well as starring in his second Hamlet, New, November 1934, and it ran for 155 performances. The following year he alternated Romeo and Mercutio with Olivier and directed

the play at the New, October 1935. It ran for 186 performances. In October 1936 Gielgud had his first American triumph with *Hamlet*, Empire, and on his return to London took over the management of the Queen's for nine months. Gielgud's next Hamlet closed the Lyceum in 1939 before being taken to Elsinore. He returned to the Old Vic on 15 April 1940 in a production of *King Lear* supervised by Harley Granville-Barker and followed it with his first Prospero. During the War he toured extensively with ENSA whilst keeping up an active West End career that included directing and playing Valentine in *Love for Love*, Phoenix, April 1943 for a year and a repertory season at the Haymarket. After an American tour in 1947 Gielgud directed a number of important new plays including *The Glass Menagerie*, Haymarket July 1948 and *The Lady's Not for Buring*, Globe May 1949 for 294 performances with Gielgud as Thomas Mendip. A memorable season at Stratford in 1950 included Angelo, Benedick, Cassius and a Japanese King Lear. An equally important season at the Lyric Hammersmith in 1952–3, directing with Peter Brook, included *The Way of the World* and *Venice Preserv'd*. Gielgud directed his first opera, *The Trojans* at Covent Garden in June 1957 and the following year saw the first tour of his one-man show, *Ages of Man*. His greatest success of the 1960s was his Headmaster in *Forty Years On*, Lyric, February 1970 and more recent triumphs have included Harry in *Home*, Royal Court, June 1970, Hirst in *No Man's Land*, Old Vic, April 1975, and Sir Noel Cunliffe in *Half Life*, Cottesloe, February 1978. Gielgud was knighted in 1953, slight reward for a very great actor and the most sublime speaker of verse of the twentieth century.

Sally GILMOUR (b.1921) 112

Sally Gilmour was born in Malaya. She studied with Karsavina and Marie Rambert in London and joined the Ballet Rambert. By 1939 she had become the company's leading dancer with such roles as Silvia in *Lady into Fox* by Andrée Howard. Other original roles included parts in *The Fugitive*, 1944, and *Sailor's Return*, 1947, both by Andrée Howard, *Peter and Wolf*, 1940 by Frank Staff, and Walter Gore's *Confessional*, 1941, and *Winter Night*, 1948. She left the stage in 1953.

Mary GLOVER (fl.1826–1860) 30 ?

Mary Glover was the third daughter of the actress Julia Glover and made her debut at Covent Garden on 25 September 1826 as Mary in *Charles the Second; or, The Merry Monarch* and followed this with her Ophelia on 16 October 1826. Later in the season, opening on 9 January 1827, she played Fanny Bloomly opposite her mother in *A School for Grown Children*. Her later career appears to have been less distinguished.

Phyllis Frances Agnes GLOVER (1801–1831) 27

Phyllis Glover's brief career was entirely lacking in distinction. She seems to have played tiresome young women for several years.

William Robert GROSSMITH (1818–1899) 25

William Robert Grossmith was born in Reading, the son of William Grossmith, a manufacturer of looking-glasses and picture-frames. By the time he was six the boy was a fine mimic and singer and added to his accomplishments by learning the part of Richard III by heart. He gave his first public performance in Reading on 9 November 1824 playing eight characters from melodrama, singing a selection of comic songs and performing scenes from *Richard III, Douglas* and *Macbeth*. Over the next two months his father took him on tour to Newbury, Marlowe, Maidenhead, Windsor, Egham, Chertsey, Kingston and Wokenham. The next tour went as far as Gloucester and Tewkesbury and performances in Birmingham began on 5 May 1825 with the additional role of *Rolla*. Over the next few years Master Grossmith travelled throughout England and Wales and

he was still performing as a rather mature child actor aged seventeen in 1835, when his seven year old brother, Master B. Grossmith was regarded as the greater attraction. A middle brother George, was the father of George and Weedon Grossmith, authors of *The Diary of a Nobody*. In his juvenescence Master Grossmith not only performed for at least two hours, probably in the afternoon, he was also on view to the inquisitive between the hours of ten and one. The Grossmith performances were popular and invariably highly praised in local press reports. The effect was helped by the lavish portable stage constructed to the specifications of Grossmith Senior. Apart from thirty changes of scenery and a diorama, the theatre boasted a stage supported by gold and bronze pillars and a proscenium flanked by two seven foot high bronzed statues of Thalia and Melpomene. It was free-standing, could be erected in two hours and weighed two hundred pounds.

Lucien GUITRY (1860–1925) **79**

Born in Paris, the youngest child of a stage-struck cutler from Normandy, Lucien Guitry attended the Conservatoire at the age of fifteen. He left early and signed a three year contract with the Théâtre de Gymnase where he played leading parts such as Armand in *La Dame aux camélias*. He was noticed by Sarah Bernhardt who took him on her 1882 tour to London and played opposite him in *Hernani, Adrienne Lecouvreur* and *La Dame aux camélias*. Guitry married Renée de Pont-Just in London on 10 June 1882. Between 1882 and 1891 Guitry spent his winters in St. Petersburg, playing at the Mikhailovsky Theatre. His fifty or so roles ranged from Shakespeare to Zola adaptations. When he returned to Paris in 1891 to work at the Odéon and Théâtre de la Renaissance with Réjane and Bernhardt he was regarded, Irving-like, as the head of his profession. He briefly joined the Comédie Française as a producer in 1901 but soon left to take over the management of the Théâtre de la Renaissance. He made highly successful visits to London in 1902 and 1909 and theatre-going Londoners returned the compliment by attending his new productions in Paris. His repertory was varied and often extravagant, the most extravagant being the 1911 production of *Kismet* at the Théâtre Sarah Bernhardt. His many plays included *Grandpère* and *L'Archeveque*, in both of which he appeared at the Théâtre Porte Saint-Martin in 1917 and 1918. During the last seven years of his life he appeared almost exclusively in plays written by his son Sacha, such as *Le Mari, Mon père avait raison* and, his greatest success, *Pasteur*.

Sir John Martin-HARVEY (1863–1944) **105**

John Martin-Harvey was born at Wivenhoe and was intended for his father's profession of naval architect, becoming an excellent draughtsman in the process. He decided, however, to take to the stage and was taught by John Ryder, formerly with Macready. He first appeared at the Court in 1881 playing a boy in *To Parents and Guardians* and then touring with *Betsy*. He joined Henry Irving at the Lyceum in 1882, at first walking on in *Romeo and Juliet* but eventually playing small but important parts rather well. He stayed at the Lyceum for fourteen years and his roles included Lorenzo in *The Merchant of Venice* and the Dauphin in *Louis XI*. He accompanied Irving on four American tours and regularly toured the provinces during the summer with William Haviland and Louis Calvert. He finally left Irving in 1896 and played a number of roles, the most impressive being Pélleas in *Pélleas and Mélisande* at the Prince of Wales's in 1898. The following year saw his great leap to stardom when he appeared as Sydney Carton in *The Only Way*, Freeman Crofts Wills and Frederick Langridge's weepy, self-indulgent but incredibly successful adaptation of *A Tale of Two Cities*. Nina De Silva, Martin-Harvey's wife, played Mimi and the production sailed through the next forty years and the whole of the English speaking world. More serious productions for his peripatetic company were *Hamlet* in 1904, *Richard III* in 1910 and *The Taming of the Shrew* in 1913. However, he had much more success with costume drama and to *The Only Way* he added *The Breed of the Treshams* in 1903, taking the part of Lieutenant Reresby, 'The Rat'. Perhaps the high point of his career was the massive production of *Oedipus Rex* at Covent Garden in 1912. John Martin-Harvey was perhaps the most approachable of the great Victorian actor-managers. There is no doubt that he had his moments as a tragic actor but he managed to retain his large provincial following with endless repetitions of pseudo-historic schmaltz.

John HENDERSON (1747–1785) **12**

Henderson took drawing lessons from Daniel Fournier before becoming stage-struck. He tried to get into the Drury Lane company and, although he was not successful, Garrick gave him a letter of recommendation to John Palmer, the manager of the Theatre Royal, Bath. Henderson made his debut there as Hamlet on 6 October 1772. He had to wait nearly five years for his first London appearance, at the Haymarket on 11 June 1777 as Shylock, but he soon became a favourite at both Drury Lane and Covent Garden. He was evidently a somewhat graceless performer who dressed rather messily but he was at his best in major character roles such as Shylock and Falstaff and was one of the leading tragic actors in the generation immediately following Garrick.

Ian HOLM (Ian Holm Cuthbert) (b.1931) **119**

Born in Ilford and trained at RADA, Ian Holm's career began as a spear carrier in the 1954 Stratford *Othello*. He remained with the company for two years, the highlight being Mutius to Olivier's Titus Andronicus in a production that toured Europe and was seen in London at the Stoll theatre in 1957. He returned to Stratford in 1958 and remained with the company, from 1961 a long-term contract artist, for ten years. His parts included Puck, the Fool to Charles Laughton's Lear, Troilus, Ariel, Richard III, Henry V, Malvolio and Romeo. His non-Shakespearean roles included Lenny in *The Homecoming* for which he won a Tony Award when he made his first New York appearance in the part in 1967. In 1970 he played Lord Nelson in *A Bequest to the Nation* at the Haymarket and more recent roles include Voinitsky in *Uncle Vanya* at Hampstead in 1979. On television perhaps his most remarkable role was James Barrie in *The Lost Boys* and, on film, whilst many remember his appearance as Napoleon in *Time Bandits* he was awarded an American Academy Award for his supporting role in *Events Whilst Guarding the Bofors Gun*.

Leslie HOWARD (1893–1943) **100**

Leslie Howard was born in London. He worked as a bank clerk and spent time in the army before taking to the stage. In 1917 he toured as Jerry in *Peg o'My Heart* and Charley Wykeham in *Charley's Aunt*. His London debut was as Ronald Herrick in *The Freaks*, New Theatre, February 1918. He achieved some success in bland contemporary drama before leaving for New York; his first appearance, at the Henry Miller Theatre on 1 November 1920, was as Sir Calverton Shipley in *Just Suppose*. He remained in New York until 1926, playing such roles as Gervase Mallory in *The Romantic Age*, Comedy, November 1922, and Pablo Moreira in *The Werewolf*, 49th Street Theatre, August 1924. After a brief stay in London he returned to New York to play Andre Sallicel in *Her Cardboard Lover*, Empire, March 1927, and Wrigley in hs own play *Murray Hill*, Bijou, September 1927. Another brief stay in London and then back to New York to play, amongst other things, Tom Collier in *The Animal Kingdom*, Broadhurst, January 1932. His last role in London was William Shakespeare in *This Side Indolatry*, Lyric, October 1933 and his last in New York, Hamlet in his own production, Imperial, November 1936. Latterly he spent most of his time in front of a camera and his films included *Of Human Bondage*, *The Scarlet Pimpernel*, *The Petrified Forest*, *Pygmalion* and *Gone With the Wind*.

Martita HUNT (1900–1969) **109**

Born in Argentina Martita Hunt was educated in England before being trained for the stage by Genevieve Ward and Lady Benson. She made her debut in 1921 for the Liverpool Repertory Company and appeared in London for the first time on 6 May 1923 when she played the Third Woman in *The Machine Wreckers* at the Kingsway Theatre. She went on to play a number of important parts including Olga in *The Three Sisters*, Mrs. Linden in *A Doll's House*, and strong character roles such as Lady Sylvia Cardington in *Potiphar's Wife* and the Tsarina in *Rasputin*. In September 1929 she joined the Old Vic company and played the gamut of Shakespeare roles,

including both Portias, the Queen in *Richard II*, Helena, Rosalind, Lady Macbeth and Gertrude. During the 1930s and 1940s she created many roles in the West End and returned occasionally to Shakespeare and his contemporaries. The success of *The Madwoman of Chaillot* in both New York and London marked the beginning of a later career as a popular player of eccentric Grand Duchesses. She made her first film in 1933 and perhaps her best-known role was Mrs. Haversham in David Lean's *Great Expectations*.

Ethel IRVING (1869–1963) **63**

Daughter of the actor Joseph Irving. Ethel Irving made her stage debut (as Birdy Irving) playing a peasant in *The Vicar of Wide-awakefield*, Gaiety, 8 August 1885. In 1887–8 she played a number of roles at the Prince of Wales's including Lady Betty in *Dorothy* and L'Arlésienne in *The Love that Kills*. She danced in *Ruy Blas, or the Blasé Roué*, Gaiety, 1889, and *The Red Hussar*, Lyric, 1889. Her New York debut was in the latter play, Palmer's Theatre 9 October 1890, and her success encouraged her to stay there for eight years. She returned to England in 1898 and had several major successes including Winnie Harborough in *The Girl from Kay's*, Apollo, November 1904, and Clarice in *Comedy and Tragedy* in May 1905. The greatest success of her career was probably the title role in *Lady Frederick*, at five different theatres after opening at the Court in October 1907. She began to produce plays in England and in May 1911 took her own company to Australia, playing Stella Ballantyne in *The Witness for the Defense* and Nina Jesson in *His House in Order*. In 1913 she managed the Globe Theatre and toured South Africa 1915–16. The rest of her career alternated between extended tours and London runs; popular parts included Floria Tosca in *La Tosca* and Julie in *The Three Daughters of M. Dupont*. In July 1920 she played Mme. Ranevsky in *The Cherry Orchard* at the St. Martin's. She seems to have retired in 1929, and the last ten years of her career were given over mostly to light-weight who-done-its and drawing room comedies.

Sir Henry IRVING (Henry Brodribb) (1838–1905) **44; 46; 55; 62**

Henry Irving was born in Somerset and was sent to the City at the age of eleven to train for a commercial career. Instead, he gradually trained himself for the theatre and made a professional debut at the Lyceum, Sunderland as the Duke of Orleans in *Richelieu* in September 1856. He made a brief appearance in London in 1859 but returned to the provinces until 1866 when he joined Mrs. Cawley at the St. James's. He acted with Ellen Terry for the first time at the Queen's in December 1867 in Garrick's *Catharine and Petruchio* and then moved from theatre to theatre until he had a long run playing Digby Grant in *Two Roses* at the Vaudeville in 1870. He then joined the Bateman management at the Lyceum and had the first great triumph of his career as Matthias in *The Bells*, opening on 25 November 1871. The following season he had a success in the title role in *Charles I* and in 1873 the title role in *Richelieu*. His first Shakespearean success in London was his Hamlet which opened in October 1874 and ran for over 200 performances. His Macbeth and Othello were not successful but his Richard III, January 1877, was seen as a direct descendant of Edmund Kean's intense and passionate hysteria. The Bateman family left the management of the Lyceum to Irving in 1878 and on 30 December he celebrated his elevation to actor-manager with a revival of *Hamlet* with Ellen Terry as Ophelia. His productions over the next five years included *The Merchant of Venice*, which ran for seven months from November 1879 and *Much Ado About Nothing*, eight months from October 1882, with Ellen Terry as Portia and Beatrice to Irving's Shylock and Benedick. Irving took the Lyceum company to North America in 1883, his New York debut was as Matthias at the Star on 29 October 1883, and 1884–5. In 1885 Irving followed his performance as Dr. Primrose in *The Vicar of Wakefield* with his very successful production of *Faust*. Another trip to North America in 1887 and another attempt at Macbeth before the lavish production of *Henry VIII*, January 1892 for six months, in which Irving played Wolsey and Ellen Terry Queen Katherine. His later notable parts included King Lear, November 1892, and Becket in Tennyson's play, February 1893. His lavish production of *King Arthur*, January 1895, was designed by Burne-Jones and had a cast that included Ellen Terry as Guinevere and Johnston Forbes-Robertson as Lancelot as well as Irving as Arthur. Other productions such as *Peter the Great* and *The Medicine*

Man lost money and in February 1898 the Lyceum scenery store was destroyed by fire. Irving recouped most of his losses with annual provincial tours and five more visits to North America but in 1899 he was obliged to give up the ownership of the Lyceum. His last production at his theatre was a 1902 revival of *The Merchant of Venice*. Irving was knighted in 1895, the first actor to receive the accolade, and died during his farewell tour at Bradford after a performance of *Becket* on 13 October 1905. His acting had a hypnotic quality that transported his audiences for short sharp periods. He had a prodigious and inventive energy and commitment that inspired the entire acting profession until well into the twentieth century.

Alick JOHNSTONE (fl. 1922–1970s) **120**

Alick Johnstone ran the most successful scenery painting workshop in the modern British theatre. He joined Walter Johnstone in 1921 and their first joint production was Weedon Grossmith's *The Night of the Party*, St. James's, 15 June 1921. His next production, *In Nelson's Day* by Mrs. Clifford Mills, Shaftesbury, 11 March 1922 only had three performances but Johnstone was working with Joseph Harker, veteran of Irving and Tree production, and must have learned a great deal from him about nineteenth-century methods of *trompe l'oeil* painting and producing extravagant space out of a flat wall of canvas. Walter and Alick Johnstone's last joint production was *Nuts in May*, Duke of York's, 9 May 1922. Alick went on to provide scenery for over 125 productions during the remainder of the 1920s, including some of the very grandest and most lavish such as *The Country Wife*, Regent, 17 February 1924 – not so lavish but designed by Norman Wilkinson – and the spectacular production of *Henry VIII*, Empire, 23 December 1925, with scenery designed by Charles Ricketts. Although Alick Johnstone's more recent career is difficult to follow, there is no doubt that he dominated the painting of scenery for West End productions for fifty years.

Walter JOHNSTONE DOUGLAS (1887–1972) **85**

Walter Johnstone Douglas studied voice with Jean de Reszke whose method he used when he became a successful singing teacher. He had a light and charming tenor voice and during the 1920s gave recitals accompanied by George Reeves. The great triumph of his performing career was Eochaidh in the Celtic twilight drama *The Immortal Hour*, first given in London at the Old Vic on 31 May 1920 and revived five times over the next twelve years. In 1920 he also appeared at the Old Vic as the Count in *The Marriage of Figaro* and in 1927 and 1928 produced *Cosi Fan Tutti* at the Kingsway and Court, playing Gugliemo under the baton of Adrian Boult. The 1928 production was part of a season at the Court that also included Johnstone Douglas's production of Schubert's *The Faithful Sentinel* and *The Secret Marriage* by Cimarosa. At the Court in 1926 he had directed a single performance of *The Song* by Adela Maddison with Laurence Olivier playing Lucio de Costanza. Johnstone Douglas tried to repeat the mystic success of *The Immortal Hour* with several musical verse plays including *Bethlehem* by Rutland Boughton and Laurence Housman in which he played Joseph to Gwen Ffrangcon-Davies's Virgin Mary, Regent, 19 December 1923 and *The Shepherds of the Delectable Mountains* based on *The Pilgrim's Progress* with music by Vaughan Williams. Johnstone Douglas directed and played the Pilgrim. His second career began when, with his friend Amherst Webber, he founded the Webber Douglas Academy of Dramatic Art.

Tamara KARSAVINA (1885–1978) **77; 78**

Born in St. Petersburg, the daughter of the Maryinsky Theatre director and teacher Platon Karsavin, Karsavina studied at the Imperial Ballet School with Gerdt, Cecchetti, Kosloff and Johansson. She made her debut at the Maryinsky in *Javotte* in 1902. She remained with the company until 1918, as ballerina from 1909, but she was also a member of the Diaghilev company from its formation in 1909. She was Diaghilev's outstanding ballerina, possibly the greatest of the twentieth century, and was unsurpassed in the traditional classics such as *Swan Lake* and *The Sleeping Beauty*. Perhaps more important to the history of ballet was the series of roles she created

for Diaghilev, including those in the majority of Michel Fokine's early and greatest ballets: *Les Sylphides* 1908, *Cléopâtre* 1909, *Carnaval* 1910, *Firebird* 1910, *Petrushka* 1911, *Le Spectre de la Rose* 1911, *Le Dieu bleu* 1912, *Daphnis and Chloe* 1912 and *Le Coq d'or* 1914. Her partnership with Nijinsky is generally regarded as the climax of twentieth-century ballet. In 1918 she moved from Russia to England with her British husband. She continued as a guest with Diaghilev's company and appeared with the Ballet Rambert 1930–31. She was instrumental in establishing the classical repertory in England and acted as adviser on many revivals. Her autobiography *Theatre Street*, 1930, is rather gushing and girlish but her articles on ballet technique are still highly regarded.

Charles John KEAN (1811–1868) **31; 32; 40**

Anxious to rid his son Charles of the stigma of having a father on the stage Edmund Kean sent him to Eton in 1824. He left three years later and made his first appearance on stage at Drury Lane on 1 October 1827 as Young Norval in *Douglas*. His acting talent was negligible but his name attracted large audiences. Father and son appeared together in Howard Payne's *Brutus* in Glasgow on 1 October 1828 and after solo visits to Holland and the United States in 1830, returning 11 February 1833, Charles played Iago to Edmund's Othello, his final performance, at Covent Garden on 25 March 1833. Charles spent the next few years in the provinces and then accepted an engagement with Alfred Bunn at Drury Lane, opening on 8 January 1838 at £50 with a repertory that included Hamlet, Richard III and Sir Giles Overreach. During the 1840s Kean alternated between the Haymarket, Drury Lane, the provinces and North America which he visited in 1840 and 1845–7. In 1842 he married his leading lady, Ellen Tree. With Robert Keeley, Kean entered into the management of the Princess's Theatre, opening on 28 September 1850 with *Twelfth Night* and appearing himself as Hamlet two nights later. After the first season Keeley retired from the management and Kean opened on his own with *The Merry Wives of Windsor* on 22 November 1851. The first of the famous 'historically accurate' Shakespeare revivals was *King John* on 9 February 1852 and the second was *Macbeth* on 14 February 1853. Kean's repertory also included contemporary favourites such as *The Corsican Brothers*, 24 February 1852, and an extravagant archaeological production of Byron's *Sardanapalus*, 13 June 1853, based on Layard's discoveries in the Middle East. A revival of *Richard III*, 20 February 1854, was not a success but on 9 October 1854 Kean produced *Louis XI* and in the title role created his greatest part. *Henry VIII* was revived on 16 May 1855 with Kean as Wolsey, *The Winter's Tale* on 28 April 1856 with Kean as Leontes and a celebrated production of *A Midsummer Night's Dream* on 15 October 1856. His last revival at the Princess's was *Henry V* on 28 March 1859 with Kean in the title role but financial problems meant that he had to leave the theatre on 29 July 1859. After provincial tours he appeared for two seasons at Drury Lane and then left for a round the world tour in 1863, returning to Liverpool in 1866. It was at Liverpool that Kean made his last appearance on stage, as Louis XI on 28 May 1867.

Edmund KEAN (1787–1833) **21; 23**

Kean was brought up by an actress called Miss Tidswell and he is supposed to have appeared on stage at Drury Lane and the King's Theatre as a small child during the 1790s. He joined Samuel Jerrold's company in Sheerness as a leading performer in 1804 but he was obliged to move to Mrs. Baker's company in Tunbridge Wells, where the roles were smaller but the salary greater. In 1810 he joined Andrew Cherry's company in the West Country and was able to return to his Sheerness roles such as Hamlet and Richard III. His belligerence, and problems with drink and marriage, caused a number of quick moves from company to company but in November 1813 he was spotted in Dorchester by Arnold, the manager of Drury Lane, and offered an engagement. Unfortunately, he had already accepted an engagement at the Olympic but Robert Elliston, the manager, waived his rights and Kean made his famous adult debut at Drury Lane on 26 January 1814. His Shylock was an immediate triumph and his acting was described by Hazlitt as '. . . more significant, more pregnant with meaning, more varied and alive in every part, than any we have almost ever witnessed'. Kean's Richard III on 12 February was an even greater triumph and Hamlet, Othello and Iago followed shortly afterwards. For several years he could do no wrong,

reviving the desperate finances of Drury Lane and becoming himself a rich man. His visits to Ireland and the provinces were now triumphant progresses with audiences thrown into hysterics. The cast too was reduced to a quiver on 12 January 1816 when Kean appeared as Sir Giles Overreach in *A New Way to Pay Old Debts*, his most celebrated non-Shakespearean role. Junius Brutus Booth, a potential rival, was acted off the stage when he foolishly accepted Kean's invitation to play Iago to his Othello on 20 February 1817. With the retirement of John Philip Kemble on 23 June 1817 Kean was left as the undisputed head of his profession and emphasised the fact with great performances as Lucius Junius Brutus in *Brutus*, 3 December 1818 and as King Lear, 24 April 1820. Other roles, such as Coriolanus, 24 January 1820, were less successful. His reputation preceeded him to North America and his performances were regularly mobbed; he opened in New York as Richard III on 29 November 1820 and proceeded to Boston, Philadelphia and Baltimore. He returned to Drury Lane as Richard III on 23 July 1821 and combined a successful career with a dangerously indulgent private life until his all too public affair with Mrs. Cox upset the delicate sensibilities of his adoring audience. He had a boisterous reception when he tried to play Richard III on 24 January 1825 but things gradually settled down and the provinces greeted him with their usual enthusiasm. Kean then made the mistake of returning to the United States where the self-righteous were determined to make an example of him. He received a much more friendly reception in Canada where he was made a Chief of the Huron Tribe. He was back at Drury Lane to play Shylock on 8 January 1827 but his fire and energy were gone and he was allowed to leave for Covent Garden the following season. There he played opposite his son Charles but the experiment was not a success, nor were his performances in Paris in May 1828. He made various farewell appearances in the early 1830s but his final performance was as Othello to his son's Iago at Covent Garden on 25 March 1833. He died a few weeks later, the most thrilling of all English actors.

Renée KELLY (1888–1965) **59**

Renée Kelly was born in London but made her stage debut in the United States, walking on in *The Genius* at Bridgeport, Conn., in November 1906. The next ten years were spent mostly in the United States, with her New York debut as Mamie Carter in *The Easterner* taking place on 2 March 1908 at the Garrick Theatre. She joined Maxine Elliott in October 1908 as Mamie in *Myself – Bettina* at Daly's, and stayed with her for two years. During 1911 she tried both Ibsen and Molière but did not repeat either experience, sticking largely to light-weight drama for the rest of her career. Her London debut, playing the title role in *Ann*, was at the Criterion on 18 June 1912. She soon returned to the United States where, in November 1912, she toured with Robert Loraine as Ann Whitefield in *Man and Superman*. She returned to England briefly in 1913 and then in 1916 brought her American success *Daddy Long-Legs*, in which she played Judy, to the Duke of York's for a run of 500 performances from May 1916. For the next 33 years, with a break of four years from 1939 to 1943, she appeared in a succession of minor comedies and dramas both on tour and in the West End.

John Philip KEMBLE (1757–1823) **13; 15; 16; 17; 18**

Kemble was born in Lancashire, the eldest son of Roger Kemble and Sarah Kemble and a younger brother of the future Sarah Siddons. As a child he acted with his parents' company but he was destined for the priesthood and was sent to the Catholic seminary at Sedgley Park and then, in 1771, to the English College, Douai. However he returned to England to become an actor and after various wanderings engaged himself to Joseph Younger's company in Liverpool in 1777. The following year he joined Tate Wilkinson's York circuit after sending a letter in which he claimed to have a repertory of 68 tragic and 58 comic roles. Whilst at York a number of his own plays were performed but most of his time was spent preparing roles and by the time he left Tate Wilkinson in 1781 he had played 102 roles in 99 plays. After a couple of years in Ireland Kemble fnally made it to London and appeared as Hamlet at Drury Lane on 30 September 1783. His considered and original interpretation was much admired although the same approach applied to *Richard III* on 6

November 1783 was not so successful. On 6 December 1783 he appeared with his sister Sarah in *The Gamester* and four days later they played together in *King John*. Kemble's calm grandeur was the ideal foil to Sarah's fireworks and he managed to stand up to her famous Lady Macbeth when he played the title role for his benefit on 31 March 1786. Kemble disappeared to Dublin for the summer season there but remained at Drury Lane through the winter, becoming acting manager for Sheridan on 23 September 1788. During this season he was seen in eighteen characters new to London including Cromwell and then Wolsey in *Henry VIII*, 25 November 1788 (Wolsey on 3 February 1789) in which Sarah played Queen Katherine; and *Coriolanus*, 7 February 1789, in which Sarah played Volumnia. With these two productions Kemble spent much time and effort providing what he considered were appropriate historical sets and costumes. Sarah Siddons retired temporarily from the stage at the beginning of the 1789–90 season but Kemble slogged on, appearing at the Haymarket for the first time during the 1793 Summer season. Sarah returned for *Macbeth* on 21 April 1794 in the newly built Drury Lane. By April 1796 Kemble was owed £1367 by Sheridan, the Drury Lane patent holder, and he reigned as manager although continued to act. The great financial success of the late 1790s was *Pizarro*, 24 May 1799, in which Kemble played Rolla. In 1800 Kemble was prepared to buy a quarter share in Drury Lane but, suspecting Sheridan's honesty, looked to Covent Garden and bought a sixth share in that theatre in April 1803. Kemble opened at Covent Garden as Hamlet on 24 September 1803 and brought the entire Siddons-Kemble clan with him. His management was successful and when the theatre burned down on 20 September 1808 he was able to finance a speedy rebuilding; Smirke's enormous theatre opened with *Macbeth* on 18 September 1809. Kemble had to cope with the Old Price riots until 14 December 1809 and his belligerent audience probably decided him to leave the stage as quickly as possible. His last new character was Brutus in *Julius Caesar* on 29 February 1812 and he tried, and failed, to sell his share in the Covent Garden patent for £25,000. Kemble then spent two yers in the provinces before returning as Coriolanus on 15 January 1814. He played the same part for his farewell on 23 June 1817 before giving his share in Covent Garden to his brother Charles and retiring to Lausanne. Kemble was thought lugubrious in comparison with firebrands such as Cooke and Kean but his considered approach to Shakespeare was an important step towards modern production methods.

Lindsay KEMP (b.1939) **116**

Born on the Isle of Lewis and educated at the Merchant Navy School, Lindsay Kemp later studied at the Bradford Art College and the Rambert Ballet School. He first performed in his peculiar brand of mime at the Edinburgh Festival in 1964 and went on to produce David Bowie's Ziggy Stardust concerts at the Rainbow in London. His position as one of the most original performers of the twentieth century was established with his production of *Flowers*, 1974, based on Genet's *Our Lady of the Flowers*. This production toured for several years but was eclipsed eventually by the spectacular *Salome*, given in London at the Round House in 1977. Other productions have included *The Parade's Gone*, 1975, *Cruel Garden*, 1977, *A Midsummer Night's Dream*, 1979 and *Alice*, 1988. Kemp's astonishing mime technique, and that of his company, in complemented by his ability to create the most startling visual images. Unfortunately, his images and irrepressible sexuality are too much for ninety per cent of the British public and he is obliged to develop his new productions in Italy and Spain, welcoming and warm.

Charles KILLIGREW (1655–1725) **2**

Born in Maestricht, Charles was the son of Thomas Killigrew, the original patent holder of the Theatre Royal, Drury Lane and head of the King's Players. He was gentleman of the privy chamber to Charles II (1670), James II (1685) and William and Mary (1689). He was appointed Master of Revels in 1680 and succeeded his father as patentee of Drury Lane in 1682. He became commissioner of prizes in 1707. He married Jemima, daughter of Paul Bokenham of Thornham, standard-bearer to the Duke of York, and lived in Somerset House and Thornham Hall, Suffolk.

Elsa LANCHESTER (1902–1986) **87**

Born in Lewisham, the daughter of James Sullivan and Edith Lanchester, Elsa Lanchester had an unusually free-spirited education which included a period as a pupil of Isadora Duncan in Paris and Berlin. She helped to start the Children's Theatre in Soho in 1918 and was later involved in the founding of the Cave of Harmony, Gower Street, where a number of interesting plays were produced including works by Pirandello, Housman and Anatole France. Her professional debut was at the Kingsway Theatre in April 1922 as the Second Shop Girl in *Thirty Minutes in a Street* and she followed this with her performance as Larva in *The Insect Play*, Regent, May 1923. For the rest of the 1920s she combined acting roles, such as Peggy in *The Way of the World*, Lyric Hammersmith, February 1924, with cabaret appearances and in 1927–8 was associated with Harold Scott in the management of the Cave of Harmony. In May 1931 she played Winnie Marble in *Payment Deferred* at the St. James's and then took the part to America for her New York debut on 24 September 1931 at the Lyceum. In October 1933 she joined the Old Vic company and enjoyed a number of unusual successes such as Ariel, Miss Prism and Miss Prue in *Love for Love*. She was a famous Peter Pan at the Palladium in December 1936 but did little subsequent stage work, preferring films and the exercise of her considerable wit as a diseuse in night clubs, mostly in the Los Angeles area. She chronicled in detail her marriage with Charles Laughton, firstly with *Charles Laughton and I* in 1938 and then with her biography of Laughton published after his death in 1983.

Vivien LEIGH (1913–1967) **108**

Born in India and educated all over Europe Vivien Leigh trained for the stage at the Comédie Française and at RADA. Her film career began in 1934 with stage work following in February 1935 when she appeared as Giusta in *The Green Sash* at the 'Q' Theatre. Her first Shakespearean role was the Queen in *Richard II* for OUDS in 1936 and the following year she joined the Old Vic Company to play Ophelia to Olivier's Hamlet at Elsinore. In London she also played Titania. After a period in Hollywood to film *Gone With the Wind*, *Lady Hamilton* and *Waterloo Bridge* she played Juliet opposite Olivier as Romeo on Broadway and on tour. They returned to England in 1940 and in 1942 she began a run of nearly 500 performances as Mrs. Dubedat in *The Doctor's Dilemma*. After entertaining the troops in the Middle East she joined the Old Vic tour of Australia and New Zealand and stayed with the company for the famous 1949 season at the New Theatre, playing Lady Teazle, Lady Anne and Antigone. After her success as Blanche Du Bois on stage and film she appeared as both Cleopatras in Olivier's productions of *Antony and Cleopatra* and *Caesar and Cleopatra* at the St. James's Theatre in 1951. The performances were repeated in New York. She joined the company at Stratford in 1955 to play Viola, Lady Macbeth and Lavinia. She toured Europe as Lavinia and brought the role to London in 1957. She toured the Antipodes again with the Old Vic Company 1961–2 in a repertory that included *Twelfth Night* and *The Lady of the Camelias*. She made her debut in a musical as Tatiana in *Tovarich* on Broadway in 1963.

Lucille LISLE (b.19--) **91**

Lucille Lisle made her stage debut in Melbourne, her home town, as a dancer in the 1916 production of *Dick Whittington*. She later toured in Australia for J.C. Williamson, appearing as Annie Hall in *Cradle Snatchers* for a year and as T'Mala in *The Silent House* for another year, 1928–9. She moved to New York in 1930 and opened on 6 October at the Empire as Bertina Farmer in *Stepdaughters of War*. She toured for six months with Jane Cowl as Sonia in *Art and Mrs. Bottle* and then took a number of parts including the Harkness Girl in *A Widow in Green*, Cort, November 1931, before moving to London at the end of 1932. In January 1933 she succeeded Edna Best as Stella Hallam in *Another Language* at the Lyric. The following May, at the St. James's, she played Susan Haggett in *The Late Christopher Bean* which ran for fifteen months and then went on tour. Other long runs in the 1930s included Silver Stream in *Lady Precious Stream*, which opened at the Little Theatre in December 1934 and ran for the whole of 1935, and Anna in *Anthony and Anna*

in which Lucille Lisle succeeded Jessica Tandy and which ran at the Whitehall from 1936 to 1938. In July–August 1939 she played a repertory of Shaw plays in Birmingham and Glasgow, and in October 1940 joined the B.B.C. repertory company. She stayed with them until 1949 with a brief interval in 1945. Her later career was restricted to broadcasting.

John LISTON (1776–1846) **20; 27**

Liston was born in London, the son of a cook's shopkeeper, and worked as an usher at William Pownall's school before taking to the stage. His first appearance was at the Haymarket on 15 August 1799 as Rawbold in *The Iron Chest*. At this point Liston saw himself as a tragic actor and as such appeared in places like Weymouth and Exeter, and with Stephen Kemble's company in Durham and Newcastle. After a year with Tate Wilkinson in York he returned to Newcastle in 1804 as principal comedian where his success attracted an offer from George Colman at the Haymarket. Liston's first appearance as a comedian in London was as Sheepface in *The Village Lawyer* on 10 June 1805 and his rustic performances earned him an engagement at Covent Garden; he opened there as Jacob Gawkey in *The Chapter of Accidents* on 15 October 1805. The following summer he returned to the Haymarket and began a life-long association with Charles Mathews, both on and off the stage. Another theatrical association was his marriage in 1807 to Sarah Tyrer. Her comforting plump figure was a favourite inspiration of Samuel De Wilde just as Liston's own physical bumps and bends were to become part of popular iconography in the 1820s. Liston's career at Covent Garden and the Haymarket progressed with a string of comic roles such as Lord Grizzle in *Tom Thumb*. He did not appear at the Haymarket in 1812 but Mathews joined him for the 1812–13 season at Covent Garden and Liston was hugely successful as Moll Flaggon in *The Lord of the Manor*, 24 October 1812, and Lubin Log in *Love, Law and Physic*, 20 November 1812. Liston played Shakespearean clowns very infrequently but he was an excellent Bottom in a musical version of *The Dream*, 17 January 1816, and he also played Pompey, Launcelot Gobbo, Cloten and a transvestite Ophelia on 17 June 1813. At the end of the 1821–2 season Liston left Covent Garden and moved over to Drury Lane, waiting until 28 January 1823 to make his debut as Tony Lumpkin in *She Stoops to Conquer*. His salary was an enormous £50 per week and the transfer was a complete success. Liston had returned to the Haymarket for summer seasons in 1818 and on 13 September 1825 he achieved the greatest success of his career at that theatre. *Paul Pry* was an immediate success with nightly receipts up from £150 to £270. The following summer Liston's salary was increased from £60 per week to £60 per night and with his image as Paul Pry on all manner of household goods he became the best-known figure in the land. During the 1827–8 season Mathews and Liston renewed their partnership with great success. However, drink, injury and fatigue persuaded him to give up Drury Lane for a more intimate theatre and he spent the last years of his career working for Mme. Vestris at the Olympic. He retired in 1837, giving farewell performances at the Olympic, Covent Garden and, on 10 June, at the Lyceum. Liston was the greatest comic actor of the early nineteenth century. Apart from the great comedian's gift of timing he was also able to establish an extraordinary rapport with his audiences. He also looked extremely funny and the audience was usually on the floor before he opened his mouth.

Joan Maud LITTLEWOOD (b.1914) **92**

Born in London and studied at RADA. Founded the Theatre of Action in Manchester in 1933 and the Theatre Union in the same city the following year. She was the co-founder, with Gerry Raffles, of the Theatre Workshop which toured in the British Isles and on the Continent from 1945 to 1953, when the company moved to the Theatre Royal, Stratford East. For the next eleven years the company was renowned for exciting and enterprising productions of great commitment. Joan Littlewood acted and adapted but devoted most of her energies to directing plays. Many of the productions transferred to the West End, including *The Quare Fellow* (1956), *A Taste of Honey* (1958), *The Hostage* (1958), *Fings Ain't Wot They Used T'Be* (1959) and *Oh, What a Lovely War* (1963). She took *The Hostage* to Broadway in 1960 and *Oh, What a Lovely War* in 1964. A period in

Tunisia was followed by a revival of the Theatre Workshop in 1967 with *Macbird, Mrs. Wilson's Diary* and *The Marie Lloyd Story* and again in the early 1970s. In 1975 she left England to work in France.

Herbert LOM (b.1917) **113**

Born in Prague, Herbert Lom studied at the Prague School of Acting and then in London at the Vic-Wells School and the Embassy School. He toured and appeared in provincial repertory companies for a number of years and made his first West End appearance as Dr. Larsen in *The Seventh Veil* at the Prince's Theatre on 14 March 1951. He played Pless in *The Trap* at the Duke of York's in July 1952 and scored his greatest stage success with *The King and I* at Drury Lane. Since then he has cornered the market in mysterious middle-European parts in both the cinema and television.

Lillah McCARTHY (1875–1960) **69**

Lillah McCarthy appeared on stage for the first time in 1895 with A.E. Drinkwater's company and moved on to join Ben Greet's company later in the year with roles such as Desdemona, Juliet and Beatrice. She joined Wilson Barrett in 1896 to play Berenice and then Mercia in *The Sign of the Cross*. She toured America and Australia and then appeared in a number of West End productions before rejoining Wilson Barrett in 1900 as his leading lady, staying with him for four years. In 1905 she appeared at the Court Theate as Nora in *John Bull's Other Island* and Ann Whitefield in *Man and Superman* and in 1906 as Gloria in *You Never Can Tell* and Jennifer in *The Doctor's Dilemma*. She continued a Shavian but also played a wide variety of roles from Dionysus in *The Bacchae* to Madge Thomas in *Strife*. In 1911 she took over the management of the Little Theatre, producing Schnitzler's *Anatol* plays and *The Master Builder*. After engagements with Tree and the Martin Harvey *Oedipus Rex*, Lillah McCarthy and her husband Harley Granville-Barker took over the management of the Savoy in September 1912 where she appeared as Hermione and Viola in Barker's famous productions of *The Winter's Tale* and *Twelfth Night*. They then ran the St. James's Theatre for a short period before returning to the Savoy in 1914 to produce *A Midsummer Night's Dream* in which she played Helena. In 1914 she went to America with a repertory that included Shaw and Shakespeare and made a number of spectacular appearances playing Euripides in places like the Yale Bowl and the Adolph Lewisohn Stadium. She and Barker were divorced in 1918 and she virtually retired from the stage in 1921.

William Charles MACREADY (1793–1873) **24; 38**

Macready was born in London into a theatrical family. He was educated at Rugby and left in 1809 to help manage the family stock company, his father having been imprisoned for debt. He made his stage debut as Romeo with the family company in Birmingham and toured the provinces for several years, playing opposite Sarah Siddons in Newcastle in 1812. In 1816 he signed a five year contract with Covent Garden and made his debut as Orestes in *The Distrest Mother* on 16 September. An early experience was alternating Iago and Othello with Charles Mayne Young and the following season he played Romeo to Eliza O'Neill's Juliet. During 1819–20 season he had considerable success with his Richard III and was seen as a realistic rival to Kean, although more in the considered mould of J.P. Kemble with little fire. After Charles Kemble took over Covent Garden in 1822 Macready played Wolsey, Shylock, Macbeth and the title role in the celebrated 'historic' production of *King John*. He moved to Drury Lane for the 1823–4 season and stayed there until he left, in September 1826, for his first American tour. He returned to Drury Lane in November 1827 and the following year enjoyed, unlike Kean, a huge success during the English season in Paris. There were then two years in the provinces sorting out the Bristol company after the death of his father and a return to Drury Lane with his most popular non-Shakespearean part, the title role in Sheridan Knowles's *Virginius*. In 1832 he finally played opposite Kean, the usual

battle of Othello and Iago, and then, showing considerable Keanean passion, fell out with Alfred Bunn, the manager of both Drury Lane and Covent Garden, and returned to Bristol. He remained there until 1835 when he was forced back to Drury Lane; he had to pay Bunn damages after hitting him. In July 1837 he took over Covent Garden and with a series of very distinguished productions, attempted to restore and improve the quality of the current Shakespeare acting texts; *Macbeth, King Lear* and *Coriolanus* were perhaps the most successful. His most popular modern part was the title-role in *Richelieu*. In 1841 he took over Drury Lane and in September 1843 left for a long tour of North America. On his return to England he spent most of his time earning tons of money in the provinces and then tried to make even more with a farewell American tour in 1848–9. This tour was marred in New York by riots fermented by a rival, Edwin Forrest. Macready's final performance was at Drury Lane on 26 February 1851 when he played Macbeth. He enjoyed a long retirement away from the stage that he had never done any more than put up with. He had a noble demeanour and a splendid voice and a talent for organising large groups of people. He was impressive rather than inspiring.

Cecil MADDEN (1902–1987) **117**

Born in the British Consulate in Mogador, Morocco, Cecil Madden was educated in French and Spanish before being sent to an English prep school. He joined the B.B.C. Talks Department, becoming senior producer to the Empire Service and then first producer for television at Alexandra Palace in August 1936. In 1940 he became Head of Overseas Entertainments Unit, in charge of all radio programmes to British forces serving abroad. In 1946 he returned to television as Programmes Organiser, in 1950 he became Head of Children's Programmes and from 1951 to 1964 Assistant to the Controller of Television Programmes. He wrote a number of plays including *Through the Veil* (1930 with X.Y. Stone), *Chelsea Reach* (1950 with Vincent McConnor) and *Silent Witness* (1952 with Macgregor Urquhart) as well as reviews in Spanish, French and English. After he retired in 1964 Cecil Madden founded BAFTA, the British Film and Television Academy, and in 1966 became President of the British Puppet and Model Theatre Guild, whose collection now forms part of the Theatre Museum.

Leonide Fedorovich MASSINE (1895–1979) **86**

Born in Moscow into a dancing family Massine was educated at the Moscow Imperial School of Ballet, a pupil of Domashoff, Nicholas Legat, Cecchetti and, later, Michel Fokine. His first professional appearance was in 1912; for Diaghilev his first role was in *Petrushka* and his first leading role was in *La Légende de Joseph* at the Paris Opéra on 23 May 1914. He made his London debut in the same role, Drury Lane 23 June 1914, and his New York debut in 1916, at the Century Theatre. In 1915 he succeeded Fokine as chief choreographer to the Diaghilev company and his first production was *Soleil de Nuit*, quickly followed by *Boutique Fantasque, The Three Cornered Hat, Le Coq d'or, The Good Humoured Ladies* and *Pulcinella*. He left Diaghilev in 1921 but returned in 1924 to produce a number of ballets including *Les Matelots* and *Le Pas d'Acier*. He toured his own company in South America and founded a ballet school in London, associating himself with C.B. Cochran's reviews in 1925–6. In the late 1920s he spent three years producing ballets at the Roxy, New York and then worked at the Paris Opéra and La Scala, Milan. In April 1932 he choreographed *The Miracle* at the Lyceum in London, taking the part of Spielmann. At the end of 1932 he joned Colonel de Basil's company in Monte Carlo and produced over forty ballets during the next ten years. He also appeared with the company in their visits to London, and New York. In the mid-1940s he became director of the Ballet Theatre, New York and in 1946 toured the U.K with *A Bullet in the Ballet*. After 1947 he worked principally in Europe; Milan, Perugia, Paris, Monte Carlo and London when he produced several ballets for Sadler's Wells Ballet. In 1960 he founded Ballet Europeo for the Nervi Festival. His film choreography included *The Red Shoes*, 1946, and *The Tales of Hoffman*, 1951.

Cyril MAUDE (1862–1951) **51**

Born and educated in England, but obliged to go to North America for his health, Cyril Maude made his stage debut in *East Lynne* in Denver, Colorado, April 1884. He played in New York later in the year, returned to England in 1885 and made his London debut at the Criterion on 18 February 1886 as Mr. Pilkie in *The Great Divorce Case*. He acquired a reputation as a confident juvenile lead and after some wandering settled at the Vaudeville for over two years in March 1888; his parts were mostly contemporary flotsam but also included Joseph Surface in *The School for Scandal*. In November 1890 he joined Charles Wyndham at the Criterion, in January 1892 Henry Arthur Jones at the Avenue Theatre, and in September 1892 Mrs. Langtry at the Haymarket. On 27 May 1893 he appeared at the St. James's as Cayly Drummle in *The Second Mrs. Tanqueray* and in September 1893 he joined Comyns Carr at the Comedy, staying there until 1896. In partnership with Frederick Harrison he managed the Haymarket from October 1896 until July 1905. The repertory included Sheridan and Goldsmith as well as contemporary works; his last role there was Joseph Lebanon in *The Cabinet Minister*. He bought the Avenue Theatre in 1905 but Charing Cross Station fell on top of it and Maude took over the Waldorf Theatre (Strand) whilst his theatre was rebuilt. It finally opened on 28 January 1907, as the Playhouse, with *Toddles* which had previously run at the Duke of York's and Wyndhams. Maude toured America evey year from 1913 to 1916 and, having terminated his lease of the Playhouse in 1915, visited Australia 1917–18. His career continued in London and New York for a further ten years and he had a number of successes in unmemorable plays.

Robert MICHAELIS (1884–1965) **80**

Robert Michaelis was born in Paris and studied voice in Vienna and London. His stage debut was in pantomime in Cork in December 1898 and his London debut was as a singer at the Palace Theatre on 12 January 1903. He toured in a number of operettas before playing Harry Gordon in *The Girl from Kay's*, Comedy, December 1903. His New York debut, at the Casino Theatre, February 1907, was as Paul in *The White Man*. His distinguished roles in operettas included Prince Danilo in *The Merry Widow*, Daly's, 10 August 1908, Lieutenant Niki in *A Waltz Dream*, Daly's, January 1911 and Count Rene in *The Count of Luxembourg*, Prince's Manchester, December 1911. He served with the British Expeditionary Force 1915–19 and returned to the stage as James in *Who's Hooper*, Adelphi, September 1919. His parts during the early 1920s included J.P. Beaudon in *Irene,* Empire, April 1920, Field-Marshall Menshikoff in *Catherine*, Gaiety, September 1923 and Tan Miles in *Our Nell*, Gaiety, April 1924. His last stage role seems to have been Baron Fretigny in *Up With the Lark*, Adelphi, August 1927.

Alma MURRAY (1854–1945) **47; 48**

Born in London, the daughter of actor Leigh Murray, Alma Murray made her debut as Saccharissa in *The Princess*, Olympic, 8 January 1870 and then appeared in a number of productions at the Royalty including *As You Like It*. During the 1870s she divided her time between London, mostly the Princess's, and provincial tours. In June 1879 she appeared with Irving at the Lyceum as Julie de Mortemar in *Richelieu* and went on to play Jessica and Portia in *The Merchant of Venice*, Annette in *The Bells*, Julie in *The Lyons Mail* and other parts. From 1881–3 she appeared at the Vaudeville and then began to make a speciality of poetic drama, appearing in Browning's *In a Balcony*, Prince's Hall 1884, and the same author's *Colombe's Birthday*, St. George's Hall, November 1885. Her greatest triumph in this line was the single performance as Beatrice in Shelley's *The Cenci* at the Grand, Islington 1886. She also appeared as Mildred in Browning's *A Blot on the 'Scutcheon*, in 1888. Over the next twenty years her roles varied between classical and contemporary and included Clarissa in *The Sequel*, Vaudeville July 1891 and Criterion 1902, Mrs. Maylie in *Oliver Twist*, His Majesty's July 1905, June 1912 and April 1915, and Jane Bennett in *Fanny and the Servant Problem*, Aldwych, October 1908. She retired from the stage in 1915.

Julia NEILSON (1868–1957) **81; 82**

Born in London, Julia Neilson was educated in Wiesbaden before going to the Royal Academy of Music where she developed into a fine mezzo-soprano. W.S. Gilbert saw her potential as an actress and gave her the part of Cynisca in his comedy *Pygmalion and Galatea* in a charity matinee at the Lyceum on 21 March 1888. The following May she played Galatea to Lewis Waller's Pygmalion at the Savoy and was launched on a successful stage career that lasted for nearly fifty years. She was engaged by Rutland Barrington for a season at the St. James's and then joined Herbert Beerbohm Tree at the Haymarket where she stayed for five years playing such parts as Olga in *The Red Lamp*, Drusilla Ives in *The Dancing Girl*, Hester Worsley in *A Woman of No Importance* and the title role in *Hypatia*. After seasons with other actor-managers such as Charles Wyndham, John Hare and George Alexander she rejoined Tree at Her Majesty's, playing Constance in *King John* and Oberon in *A Midsummer Night's Dream*. She was a famous Rosalind in *As You Like It* in 1900 and started in management with her husband Fred Terry in the same year. They toured for thirty years with a series of historic costume dramas, notably *Sweet Nell of Old Drury* and *The Scarlet Pimpernel*, which they adapted to their own dramatic needs. Julia Neilson's statuesque appearance and booming voice made her the dramatic equivalent of Clara Butt.

Marie NEY (1895–1982) **96**

Born in Chelsea and educated in New Zealand, Marie Ney made her stage debut with Allan Wilkie's Shakespearean Company at the Princess's Theatre, Melbourne, on 4 November 1916 as the Widow in *The Taming of the Shrew*. She subsequently played a series of Shakespearean roles with the same company. In 1919 she was taking leading parts in Perth before acting for J.N. Tait's management and being taken up by Marie Tempest in August 1921 to play Dinah in *Mr. Pim Passes By*. She made her English debut with Marie Tempest as Rosalie in *The Marriage of Kitty*, Brixton Theatre, 27 August 1923. In October 1924 she began a distinguished season at the Old Vic, playing major roles such as Helena, Viola, Hermione, Ophelia and Lady Macbeth. Over the next thirty years she followed a remarkably busy stage career from Kate and Millicent Gregory in *The Constant Nymph*, New, September 1926, to Mrs. Coleridge in *The Burning Boat*, Royal Court, March 1955. During the late 1920s she made a number of appearances at the Lyric, Hammersmith including Kate Hardcastle in *She Stoops to Conquer*, October 1928. Her Old Vic roles included Olga in *The Three Sisters*, November 1935, Isabella in *Measure for Measure*, October 1937, and the Nurse in *Romeo and Juliet*, on tour August to October 1939. During World War II she toured Australia, South Africa and the Middle East. She also took her one-woman show *Shakespeare's Women* to Holland and the Channel Islands. She returned to London as Hecuba in *The Trojan Women*, Lyric Hammersmith, November 1945. Marie Ney's career did not perhaps live up to the promise of the early 1920s and she clearly missed the greatness of a Peggy Ashcroft or Edith Evans. However, she was one of the ever-present leading ladies of the British stage from 1922 until the early 1950s.

Vaslav NIJINSKY (1889–1950) **65**

The son of Polish dancers, Nijinsky was accepted into the Imperial Ballet School in St Petersburg in 1898. He remained at the school for nine years graduating in April 1907. Nijinsky was introduced to Serge Diaghilev in 1908 by his first patron, Prince Pavel Dmitriovitch Lvov, and accompanied the impresario to Paris in 1909 to take part in the first Russian Ballet season. The season opened at the Théâtre du Châtelet on 18 May 1909 when Nijinsky danced in *Le Pavillon d'Armide*. Nijinsky returned to St Petersburg for the winter season of the Imperial Ballet while Diaghilev tried to organise a season of Russian Ballet in London but this fell through because of the death of Edward VII. In 1910, after a short season in Berlin, Diaghilev and his company returned to Paris for their second season. This time the performances were given at the Opéra and included *Carnaval*, *Schéhérazade*, and Karsavina and Nijinsky in *Giselle*. In January 1911 the two great artists danced *Giselle* at the Maryinsky Theatre but exception was taken to the scantiness of Nijinsky's

costume. He was told to apologise or resign, chose the latter and returned to Paris for the third season of Russian Ballet which included *Le Spectre de la Rose* and *Petrushka*.

Diaghilev then took his company to London where they gave sixteen performances at Covent Garden, opening on 21 June 1911. Six of the performances were shared with opera but the season was such a success that a second season was speedily arranged and opened at Covent Garden on 16 October 1911. The following spring season in Paris included *Le Dieu Bleu* and Nijinsky's choreographic debut, *L'Après-midi d'un Faune* the erotic ending of which caused a scandal. The climax of Nijinsky's career with Diaghilev's company came in March 1913 when his ballet *Le Sacre de Printemps* caused a riot at the Théâtre des Champs-Elysées and 'marked the turning point in the history of the Dance'.

After the London season the Ballets Russes went to South America without Diaghilev. In Buenos Aires Nijinsky married Romola de Pulsky and was dismissed by Diaghilev. Nijinsky tried to form his own company and was offered a two week season at the Palace Theatre, London, by Alfred Butt, opening on 2 March 1914. The season was not a success; Nijinsky fell ill and only half the planned performances were given. *Les Orientales* was included in the repertory, but Nijinsky's original solo, to music by Sinding, was performed by his brother-in-law, Kotchetovsky.

During the war Nijinsky and his wife were trapped in Vienna but some sort of reconciliation was patched together and Nijinsky joined Diaghilev's company in New York in April 1916. He toured with the company in the United States and later danced for Diaghilev in Spain but the perpetual feeling of acrimony was too much for Nijinsky. He succumbed to chronic schizophrenia from which he suffered until his death in England in 1950.

Laurence Kerr OLIVIER (1907–1989) **114**

Laurence Olivier was born in Dorking, son of Reverend Gerard Kerr Olivier and his wife Agnes (née Crookenden). After attending various preparatory schools, he joined All Saints Church Choir School where he acted in Geoffrey Heald's productions of Shakespeare, and then went on to St Edward's, Oxford. In 1924 he won a scholarship and bursary to Central School of Speech Training and Dramatic Art, and while studying there under Elsie Fogerty he found his first professional work on stage in Letchworth as Lennox in *Macbeth* and as an assistant stage manager. After a short spell with the Lena Ashwell Players, Barry Jackson took him on at the Birmingham Repertory Theatre in 1926. His roles included Tony Lumpkin, Uncle Vanya, and Parolles in *All's Well That Ends Well*, and in 1928 at the Court Theatre Malcolm in *Macbeth* and Martellus in *Back to Methuselah*. He created Stanhope in *Journey's End* (1928) but declined a West-End transfer, which proved a great hit, to play the lead in *Beau Geste*, which flopped. In 1930 he gained his first West-End success as Victor Prynne in Noël Coward's *Private Lives* at the Phoenix, and also married Jill Esmond, who had distinguished theatre parents in H.V. Esmond and Eva Moore.

After an indifferent debut in Hollywood films, Olivier alternated the roles of Romeo and Mercutio with John Gielgud in the latter's production of *Romeo and Juliet*, at the New, 1935. Following Tyrone Guthrie's invitation to join the Old Vic in 1937–38 he played major Shakespearean roles there including Hamlet, Henry V, Macbeth, Iago, and Coriolanus during 1937–38. In 1939 he won international acclaim as Heathcliff in the film of *Wuthering Heights*. In 1940 he married Vivien Leigh and co-starred with her in their production of *Romeo and Juliet* which failed on Broadway. Returning to England and to service in the Fleet Air Arm in 1941, he contributed to the war effort by directing and starring in his great film of *Henry V* (1944). From 1944 he ran the (now legendary) Old Vic Company season at the New Theatre with Ralph Richardson and John Burrell, playing *Richard III*, Astrov in *Uncle Vanya*, Hotspur and Shallow, Oedipus, Mr Puff in *The Critic*, and King Lear. He then led the company on tour with Vivien Leigh to Australia and New Zealand in 1948. After the Old Vic governors declined to renew his contract Olivier went into West End management starring in *Venus Observed*, *Antony and Cleopatra*, *Caesar and Cleopatra* and *The Sleeping Prince*, and making films including *Richard III* (1954). With his marriage in difficulties he reaffirmed his mastery as a classical actor playing Macbeth and Titus at Stratford-upon-Avon in 1955. He revitalised his career in 1957 and endorsed 'new wave' drama by appearing as Archie Rice in *The Entertainer* at the Royal Court – a daring experiment which eventually led to his marriage with Joan Plowright. He directed the first

Chichester Festival in 1962, from which he organised the repertoire and formation of The National Theatre at the Old Vic. As its first director until 1973, he led the company very much from the front, battling for the completion of the new South Bank premises, acting in thirteen plays, including Othello, Tattle in *Love for Love*, Edgar in *The Dance of Death*, Chebutikin in *The Three Sisters*, Shylock and James Tyrone in *Long Day's Journey into Night*, and also directing (e.g. *Love's Labour's Lost* and *The Three Sisters*). After retiring from the National and the stage in 1973 he fought off illness by appearing in many films and television dramas including *A Voyage Round My Father* (1982) and *King Lear* (1983). Olivier was knighted in 1947, became the first theatrical peer in 1970 and gained the Order of Merit in 1981 – a fitting honour for a very great classical actor, distinguished film maker and stage director, and founder-director of Britain's National Theatre.

Anna PAVLOVA (1881–1931) **67**

Born in St Petersburg, Anna Pavlova was accepted into the Imperial Ballet School in 1891. She graduated in 1899 and joined the Imperial Ballet at the Maryinsky Theatre where she was made a *coryphée* immediately. By 1906 Pavlova was ranked prima ballerina and had various ballets choreographed for her by Petipa, Fokine and others. She began to tour outside Russia in 1907 and the following year joined Diaghilev's company for his first season in Paris. She made her London debut at the Palace Theatre in 1910. This season, the first of three at this theatre with some brief American appearances earlier in the year, really marked the beginning of Pavlova's extraordinary series of peregrinations with her own company all over the world. In 1912, having decided to settle in London, she bought Ivy House on Hampstead Heath and visited Russia for the last time in 1914. From then until her death in 1931 she toured all over the world, introducing classical ballet to an immense new audience. Her programmes were made up of short ballets, divertissements and solos, by far the best known of which was *The Dying Swan*. It was created in 1907 for Pavlova by Fokine who, using Saint-Saëns' musical description of *The Swan* from *The Carnival of the Animals*, said 'It was like a proof that the dance could and should satisfy not only the eye but through the medium of the eye should penetrate into the soul'.

W.S. PENLEY (1851–1912) **49**

Penley was born in Margate and educated at Westminster where he was a chorister at the Abbey and the Chapel Royal, Savoy. He made his stage debut at the Court Theatre in 1871 as Tim in *My Wife's Second Floor*. He made a number of successful appearances in musical plays including *Trial by Jury* and *La Périchole* at the Royalty in 1875. In 1876 he played Zapeter in *Princess Toto* at the Strand and appeared in several productions at the same theatre before his success as Grinder in *The Zoo* in April 1879 at the Royalty. After several tours in musical plays he had two great successes in London, as Lay Brother Pelican in *Falka*, Comedy, 1883, and as the Rev. Robert Spalding in *The Private Secretary*, Globe, 1884. His production of *Charley's Aunt* at Bury St. Edmunds on 29 February 1892 was by far his greatest success although he must have yearned for more demanding stimulation as the play ran relentlessly in London at the Globe from December 1892 to December 1896. He also revived the play several times before his virtual retirement in 1901. His last revival was at the Great Queen Street Theatre which he had rebuilt on the site of the Novelty Theatre in 1900.

Sir Arthur Wing PINERO (1855–1934) **50**

Born in Islington of Portuguese Jewish descent, Pinero entered his father's office in Gray's Inn at the age of ten. He remained on the fringes of the legal profession until he was nineteen when he plunged into the theatre as a gentleman utility in Mr. and Mrs. R.H. Wyndham's company in Edinburgh. He was spotted by Wilkie Collins in Liverpool and this connection led to work for Irving at the Lyceum and Bancroft at the Haymarket. His first play, *£200 a Year*, was produced at the Globe on 6 September 1877 and Irving produced *Daisy's Escape* at the Lyceum the following

year. Pinero's first success was *The Moneyspinner*, which was seen in Manchester before opening at the St. James's on 8 January 1881 but fame and fortune came with the series of farces produced at the Court theatre. The first, *The Magistrate*, opened on 21 March 1885, and was quickly followed by others such as *The Schoolmistress*, 27 March 1886, and *Dandy Dick*, 27 January 1887. They are extremely witty and beautifully constructed but did not prepare Pinero's public for the serious later work in which he argued for a society with men and women on an equal footing. *The Profligate*, Garrick 24 April 1889, was followed by *The Second Mrs. Tanqueray*, St. James's, 27 May 1893, the best known of Pinero's hard-hitting plays. *The Notorious Mrs. Ebbsmith*, Garrick, 13 March 1895, was a better play than the earlier work but not so successful at the box office. Pinero continued to write successful farces such as *The Times*, Terry's, 24 October 1891, and *The Gay Lord Quex*, Globe, 8 April 1899, as well as less demanding serious dramas such as *Iris*, Garrick, 21 September 1901, and *Letty*, Duke of York's, 8 October 1903, and some plays that fit into no single category; *Trelawny of the 'Wells'*, Court, 20 January 1898, was the best of these and it is now Pinero's most popular play. Pinero's later work is a curious mixture of fantasy and confused assertion of what he saw as basic moral truths. Many were one act pieces but *The Enchanted Cottage*, Duke of York's, 1 March 1922, discussed a confused ideology at full length. Pinero was a public spirited man and spent much time working for good causes, theatrical and otherwise. He was knighted in 1909.

Nancy PRICE (1880–1970) **60**

Nancy Price was born in Worcestershire and made her first stage appearance with the Benson company in September 1899. She played minor parts for the company during a season at the Lyceum in early 1900 and also played Olivia in *Twelfth Night*. She was first noticed when she replaced Mrs. Brown-Potter as Calypso in Tree's production of *Ulysses* at His Majesty's in February 1902. For Tree she also played Olivia, Princess Bellini in *The Eternal City* and, in 1905, Mrs. Ford and Calpurnia. Her more interesting early roles included Hilda Gunning in *Letty*, Duke of York's, 8 October 1903, and Sophie Fullgarney in Sir John Hare's farewell performances of *The Gay Lord Quex*, Garrick, April 1906. She played Portia in *The Merchant of Venice* at Stratford-upon-Avon in April 1911 and in 1916 Hermione and Lady Macbeth. After the War, in 1920, she went on tour with *Chu-Chin-Chow* and spent the 1920s playing a series of heroic roles such as the Marchioness Matilda in Pirandello's *Henry IV*, Everyman, July 1925, and the Hon. Honoria Tankerdown in *None But the Brave*, Garrick, July 1926. In 1928 she appeared in *John Gabriel Borkman* at the 'Q' Theatre and as the Rat-Wife in *Little Eyolf* at the Everyman. In November 1930 she founded the People's National Theatre with a revival of *The Man from Blankley's* and went on to produce over 80 plays at the Fortune, Duchess, Little, Duke of York's, Savoy and Playhouse theatres. Her parts included Herodias in *Salome*, Savoy October 1931, Mrs. Jones in *The Silver Box*, Little, October 1932, Edith Cavell in *Nurse Cavell*, Vaudeville, March 1934, and Mrs. Alving in *Ghosts*, Little, July 1935. The most popular role in her later career was Adeline in *Whiteoaks* which opened at the Little in April 1936 and ran for two years. During World War II she appeared on tour with the Old Vic Company. She was a prolific writer and her popular adaptations of the Alice books were produced in 1932 and 1935. In 1950 she received a C.B.E.

John Langford PRITCHARD (1799–1850) **28**

Pritchard was the son of a captain in the navy and spent some time as a midshipman before taking to the stage in 1820. His first appearance was in Bath, playing Captain Absolute in *The Rivals*. In 1821 he joined the York circuit as a leading juvenile and played parts such as Romeo, Iago, Edmund and Richmond. Early in 1823 he joined Murray's company in Edinburgh and remained with it until 1832; he gained a reputation for his romantic Scottish heros such as George Douglas in *Mary Stuart* and the Young Pretender in *Charles Edward; or, The Last of the Stuarts*. He appeared in Dublin for two seasons, starting 5 October 1833 and made his London debut at Covent Garden on 16 November 1835 as Alonzo in *Pizarro*. Under Macready's management of Covent Garden Pritchard found himself being pushed out of his best parts, such as Don Felix in *The Wonder*, and eventually he returned to York where he became manager of the circuit.

Frederick ROBSON (Thomas Browbill) (1821–1864) **41**

Robson was born in Margate and apprenticed to a copperplate engraver near the Strand in 1836. He set up on his own in 1840. After an appearance at the Little Theatre, Catherine Street, in May 1842 Robson gave up his business and began to give turns at the Bower Saloon, Lambeth, calling himself Robson for the first time. After several years as a strolling player Robson was employed in 1846 by Mr. Rouse at the Grecian as a general utility. His parts included 'a bustling old lady' in *The Maid and the Magpie* and his first big success, on 13 May 1847, Jenny Lind in *More Ethiopians, or Jenny Lind in New York* which combined the two ruling passions of the day – Jenny Lind and nigger mistrels. In April 1848 Robson gave his first one-man show, *Robson's Academy*, and after success on the mainland moved to Dublin from October 1850 to March 1853. His next move, the most important of his career, saw him back in London replacing Henry Compton as William Farren's leading man at the Olympic. He opened on 18 March 1853 as Bomba Becatelli in *Salvatori* and Tom Twig in *Catching an Heiress*. His first great success was Jem Bags in *The Wandering Minstrel* which opened on 23 May. A burlesque Shylock followed a burlesque Macbeth and Robson was able to further widen his repertory when Alfred Wigan took over the management of the Olympic at the beginning of the 1853–4 season. His first serious role was Desmarets in Tom Taylor's *Plot and Passion*, 17 October 1853, and he was immediately recognised, somewhat surprisingly, as the most dynamic actor since Edmund Kean. On 16 October 1854 Robson played another straight role, Job Wart in *A Blighted Being*, but the success of the 1854–5 season was his Gam-Bogie in *The Yellow Dwarf*. The following year Robson created his most celebrated *travestie* role when he sent up Adelaide Ristori's performance of *Medea* at the Lyceum and his last important new part for Wigan was the title-role in F. Palgrave Simpson's adaptation from the French of *Daddy Hardacre*, like Desmarets and Gam-Bogie a stunning evocation of nastiness and despair. The 1857–8 season opened on 10 August with Robson and W.S. Emden as joint lessees of the Olympic, Emden taking care of the business side. Robson continued to perform with an ever-changing repertory but his liver caused great problems and his last appearance at the Olympic was on 4 April 1863 in *Ticklish Times*. His last year and a half were a rather desperate trek through the provinces. All but forgotten now, Robson was recognised by many, Henry James, Charles Dickens and Henry Irving for instance, as by far the greatest actor of his generation.

Milton ROSMER (1882–1971) **101**

Born in Southport and educated at Manchester Grammar School, Milton Rosmer appeared in burlesque in 1899 before joining Osmond Tearle in December 1900 to tour in *Virginius* and other plays. In June 1902 he played Hamlet, Orlando and Mark Antony under Walter Melville and made his London debut of 7 December 1903 at the Kennington Theatre with John Martin-Harvey as Cornet Tresham in *The Breed of the Treshams*. He toured a classical repertory in North America in 1904 and after a number of London successes joined the company at the Royalty, Glasgow, in 1909 and Miss Horniman's Manchester Gaiety company in 1910, staying there until 1915. He directed the company on its tour of North America in 1913 and had other short periods of management before joining the army in 1916. His first role after the War was Austin in *His Royal Happiness*, Holborn Empire, February 1919, and his first classical role Cassius in *Julius Caesar*, St. James's, January 1920. He played a number of interesting roles during the early 1920s, mostly at the Little and Everyman Theatres and in March 1924 appeared as Gilles de Rais in the famous production of *St. Joan* at the New. In June 1927, with Malcolm Morley, he became manager of the Everyman Theatre. As well as directing and appearing at this theatre he found time for many more commercial West End appearances and in November 1936 played Touchstone at the Old Vic. He was director at Stratford-upon-Avon for the 1943 season and continued with an active and enterprising stage career until 1956.

Sarah SIDDONS (1755–1831) **10; 11**

Sarah Siddons was born in Brecon, the daughter of Roger and Sarah Kemble, and was acting with the family company as early as 1767. She married William Siddons in 1773 and together they played with various provincial companies. After being spotted in Bath Sarah Siddons was given an engagement by David Garrick at Drury Lane. At her debut on 29 December 1775 she played Portia to Thomas King's Shylock. She played half a dozen parts but none with much success and she was allowed to return to the country at the end of the season. She was, however, a great success in Manchester and Liverpool and made a famous debut with Tate Wilkinson's company at York on 15 April 1777 as Euphrasia in *The Grecian Daughter*. On 24 October 1777 she appeared as Lady Townly in *The Provoked Husband* for Palmer's company at Bath and remained there as leading lady for five years, playing over 100 parts. Her triumphant return to Drury Lane took place on 10 October 1782 when she played the title role in *Isabella*. Her voice, her stage presence, her expressive features, her gestures and, above all, her passion swept the audience off its feet. She followed Isabella with Euphrasia on 30 October and Jane Shore on 8 November, all dramatic roles of an unbearably tragic nature. She did not try Shakespeare until 3 November 1783 when she played Isabella in *Measure for Measure*. Constance followed and then, on 2 February 1785, she played Lady Macbeth in London for the first time. Her other monumental Shakespearean roles were Queen Katherine and Volumnia, given for the first time at Drury Lane during the 1788–9 season, after her brother John Philip Kemble became manager of the theatre. She remained the greatest attraction of the London theatre through the 1790s despite frequent illness, mixing her classical repertory with new roles such as Mrs. Haller in *The Stranger*, 24 March 1798, and Elvira in *Pizarro*, 24 May 1799. She moved to Covent Garden with John Philip Kemble at the beginning of the 1803–4 season and took a share in the profits of the well-run theatre. There she remained until her farewell performance as Lady Macbeth on 29 June 1812. In fact, she returned for the occasional performance until 9 June 1819 when she appeared as Lady Randolph in *Douglas*. In retirement she sculpted and read at respectable gatherings. Sarah Siddons was undoubtedly the greatest actress of her era and possibly of any other. She combined the intelligence and noble aspect of her brother John Philip Kemble with the passion, fire and total commitment of Edmund Kean.

William SQUIRE (1920–1989) **107**

William Squire studied at RADA and made his stage debut with the Old Vic Company at the New Theatre, September 1945. He remained with the company until 1947, visiting New York with them in 1946. He joined the Stratford Memorial Theatre Company at Stratford-upon-Avon in April 1948 to play Laertes, Ulysses and the Duke in *Othello* amongst other parts. The following season his parts included Oberon and Cloten. In 1950 he appeared with the Birmingham Rep. and returned to Stratford the following year. In 1952 he joined the Bristol Old Vic to play Banquo and The Wicked Fairy in *The Love of Four Colonels* amongst other parts. He then rejoined the Old Vic Company for a two year stint; parts included Casca, Cranmer, Horatio, Lafeu, Menenius and Sir Andrew Aguecheek. During the later 1950s his roles included Captain Cat in *Under Milk Wood* at the New, September 1956 and Federico Gomez in *The Elder Statesman* at the Edinburgh Festival, August 1958. He took over the part of Arthur in *Camelot* at the Majestic Theatre, New York in 1961. In 1964 he returned again to Stratford to take part in *The Wars of the Roses*. He was back at the Old Vic with the National Theatre Company in 1974 and in 1976 helped to launch the Shakespeare Company at St. George's Islington with his Sir Toby Belch.

Marie GUY-STEPHAN (1818–1873) **36**

Mme. Guy-Stephan acquired a special talent for Spanish dancing during her lengthy stay in Madrid during the 1840s. She was the first Giselle in Madrid and was the major Romantic ballerina to spend time in Iberia. During the 1840s she also appeared in London for several seasons. She was engaged at the Paris Opera during the 1850s and played the leading role in *Aelia and Mysis*.

Richard SUETT (1755–1805) **14**

Born in Chelsea, Suett became a choirboy at Westminster Abbey at the age of ten. He later sang in the London Pleasure Gardens and at the Haymarket for Samuel Foote in 1770. The following year he joined Tate Wilkinson on the York Circuit as a singer and second low comedian. He stayed with the company for nine years as its highest paid member. Suett returned to London in October 1780, playing Ralph in Bickerstaffe's *The Maid of the Mill* at Drury Lane and creating the role of Moll Flagon in Burgoyne's *The Lord of the Manor*. Suett remained a Drury Lane player until his death although he also played Summer seasons at the Haymarket from 1793 to 1803. His parts consisted of Shakespearean clowns and low comedy roles in contemporary plays, along with a few serious parts such as Samson in George Colman the Younger's *The Iron Chest*, Drury Lane, 9 June 1795. The parts he created included Wenzel in Cumberland's *The Wheel of Fortune*, Drury Lane, 28 February 1795, Fustian in Colman the Younger's *New Hay at the Old Market*, Haymarket, 9 June 1795 and Dominique in Holcroft's *Deaf and Dumb*, Drury Lane, 10 June 1805, his last new part. Suett followed William Parsons as principal low comedian at Drury Lane and was widely praised for his natural acting. He could project great charm, had a famous laugh and, according to Charles Lamb, 'a loose and shambling gait (and) a slippery tongue'.

Fred TERRY (1863–1933) **76; 83**

Fred Terry was the youngest brother of actresses Kate, Ellen, Marion and Florence Terry. He walked on in the revival of *Money* with which Squire and Marie Bancroft opened their management of the Haymarket on 31 January 1880. He then toured with Mr. & Mrs. Chippendale after a season at the Crystal Palace. From 1881 to 1884 he toured with Charles Kelly, Marie de Grey and Ben Greet and on 8 July 1884 he appeared as Sebastian in *Twelfth Night* at the Lyceum opposite Ellen Terry's Viola and Irving's Malvolio. The next three years included several North American tours. In 1888 he joined Tree at the Haymarket for a single production but returned in 1890 for a four year stint when his parts included Laertes, Ivan Zazzulie in *The Red Lamp* and Philammon in *Hypatia*. He appeared with a number of distinguished managements during the 1890s including Comyns Carr, John Hare, Johnston Forbes-Robertson, George Alexander and Henry Irving at the Lyceum where he appeared again with his sister Ellen as Squire Thornhill in *Olivia*, 19 June 1900. With his wife Julia Neilson, Fred Terry began his own career as an actor-manager at the Haymarket on 30 August 1900 when he opened as Charles II in *Sweet Nell of Old Drury*. He and the part became inseparable over the next thirty years and in 1903 he added Sir Percy Blakeney in *The Scarlet Pimpernel*, his other perennially popular role. Most of the year was spent in the provinces but from 1905 to 1913 there was an annual London season when the repertory included the usual favourites and other similar costume dramas such as *Dorothy o'the Hall* and *Henry of Navarre*. His most popular Shakespearean role was Benedick but Fred Terry squandered his considerable physical and orational powers on minor matters, giving great pleasure to a wide public but profound consolation to very few.

Ernest THESIGER (1879–1961) **99**

Thesiger was born in London, the son of Sir Edward Pierson Thesiger. During his twenties he followed a career as a painter and then, after some amateur experience, made his professional stage debut on 23 April 1909 at the St. James's as James Raleigh in *Colonel Smith*. He played a variety of roles, both comic and light tragic, including Charles Dumby in *Lady Windermere's Fan*, St. James's, October 1911, and Roderigo in *Othello*, His Majesty's, April 1912. In October 1915 he began a run of nearly 1250 performances at the Criterion as Bertram Tully in *A Little Bit of Fluff*. After the war he continued in a series of contemporary plays, including Somerset Maugham's *The Circle*, as Arnold Champion-Chaney M.P., Haymarket, April 1920, and revivals such as Pinero's *The Second Mrs. Tanqueray*, as Sir George Orreyd, Playhouse, June 1922. Classical roles included Ithamore in *The Jew of Malta*, Daly's, November 1922, Piers Gaveston in *Edward II*, Regent, November 1923, and Mr. Sparkish in *The Country Wife*, Regent, February 1924, all for the

Phoenix Society. In March 1924 he played the Dauphin in *Saint Joan* at the New and appeared in the revivals the following year and in 1931. During the late 1920s his roles included Master Crummles in *When Crummles Played* Lyric Hammersmith, June 1927, and Henry Spofford in *Gentlemen Prefer Blondes*, Prince of Wales's, April 1928, and in 1930 he played Osric to Gielgud's Hamlet at the Haymarket. During the 1930s he made regular appearances at the Malvern Festival bringing some of his parts into the West End; for instance Lord Foppington in *A Trip to Scarborough*, St. James's, September 1931, the Monster in *Too True to be Good*, New, September 1932 and Dr. Marshall in *A Sleeping Clergyman*, Piccadilly, September 1933. He made his first New York appearance at the Selwyn Theatre on 4 January 1932 as Cosmo Penny in *The Devil Passes* and returned regularly during the 1930s. After World War II he returned to both Malvern and New York but spent most of his time in the West End playing both Shakespearean and contemporary roles. His last stage role was Baron Santa Clara in *The Last Joke*, Phoenix, September 1960, the year he was awarded the C.B.E.

Brandon THOMAS (1856–1914) **51**

Born in Liverpool, Brandon Thomas studied to become a civil engineer. However, he took to the stage and made his debut as Sandy McPibroch in *The Queen's Shilling* under John Hare at the Court on 19 April 1879. He followed Hare to the St. James's in October 1879 and played a number of juvenile parts over the next six years. In 1885 he toured America and returned to London to play Col. Tressider in *Harvest*, Princess's, September 1886. In June 1891 he appeared at Terry's in a popular triple bill, his own *A Lancashire Sailor* as well as *A Commission* and *A Pantomime Rehearsal*. His best-known play, *Charley's Aunt*, opened in Bury St. Edmunds on 29 February 1892 and Thomas played Colonel Chesney for the first part of its run in London. His parts over the next ten years included Thomas Whamond in *The Little Minister*, Haymarket, 1897, Captain Hawtree in *Caste*, Haymarket, 1902, and the Pope in *The Eternal City*, His Majesty's, 1902. He played John of Gaunt in Tree's production of *Richard II* and in 1903 toured as Dr. Primrose in *Olivia* with Winifred Emery in 1906. Apart from *Charley's Aunt* Thomas wrote a number of more or less successful comedies as well as several songs.

Sir Herbert Beerbohm TREE (1853–1917) **56; 58; 61; 64; 72; 73; 74; 75**

Born Herbert Beerbohm in London, Tree joined his father's grain business but spent more time with amateur theatricals. The first of several public performances as an amateur was on 24 June 1876 at the Duke's Theatre, Holborn, as Achille Talma Dufard in *The First Night*. He was offered and accepted a professional tour, changed his name to Beerbohm Tree and played Lord Ingleborough in *Engineering* on his return to London, Old Park Theatre, 24 June 1878. He was then taken on by Henry Neville at the Olympic to play character roles for a year before branching out on tour in *Madame Favart*. He played opposite Genevieve Ward in *Forget-me-Not*, Prince of Wales, April 1880, and was then engaged by Charles Wyndham at the Criterion, having a great success as Lambert Skeyke in *The Colonel*, July 1881. Over the next few years he had a number of successes at various theatres, the most considerable being Rev. Robert Spalding in *The Private Secretary* and Pablo Macari in *Called Back*, both Prince of Wales, March and May 1884. In April 1887 Tree went into management at the Comedy. He played Paul Demetrius in *The Red Lamp* and transferred the play to the Haymarket on 15 September 1887. He ran this theatre for the next ten years. His first Shakespeare production was *The Merry Wives of Windsor* which opened on 2 January 1889 with Tree as a wonderfully leering Falstaff. He played Hamlet for the first time on tour in Manchester, 9 September 1891, and brought his performance to London on 21 January 1892. Important modern parts included Lord Illingworth in *A Woman of No Importance*, 19 April 1893 and Dr. Thomas Stockmer in *An Enemy of the People*, 14 June 1893. Tree made his New York debut on 28 January 1895 at the Abbey Theatre with his Demetrius in *The Red Lamp* and whilst in Philadelphia was inspired to commission a dramatised version of George Du Maurier's *Trilby*. He produced it for the first time at the Theatre Royal, Manchester on 7 September 1895 and then brought it to London on 30 October. It was a huge success and with the profits Tree felt confident

enough to build himself a very grand theatre indeed. Her Majesty's opened on 28 April 1897 with an extravagant production of *The Seats of the Mighty* in which Tree played Tinoir Doltaire. It was not a success but Tree quickly discovered that Shakespeare usually was and *Julius Caesar* with Tree as Mark Antony opened on 22 January 1898 and made lots of money. Popular costume parts included D'Artagnan in *The Musketeers*, 3 November 1898, and the title role in *Rip Van Winkle*, 30 May 1899, but with his production of *King John*, 20 September 1899, Tree saw himself taking over the leadership of the British theatre from the destitute Irving. His Bottom, 10 January 1900, and Malvolio, 5 February 1901, were extremely popular and the great theatrical coup of Coronation year was his success in getting both Ellen Terry and Madge Kendal to act together as the Merry Wives to his Falstaff. There were rumblings about his preposterously literal approach to scenery, real rabbits in *The Dream* and real water in *The Tempest* for instance, but audiences loved it and it was the real reason that the productions ran and ran, and were able to pay for themselves. He also did his bit for modern poetic drama and Stephen Phillips's turgid *Ulysses*, 1 February 1902, and *Nero*, 25 January 1906, were great successes because of the money Tree put into them. Tree continued to run His Majesty's until his death with a strong Shakespearean repertory, popular adaptations such as *Oliver Twist*, 10 July 1905, and some surprises such as *Pygmalion* in which Tree played Henry Higgins to Mrs. Patrick Campbell's Eliza, 11 April 1914. He gave Shakespeare Festivals in 1912 and 1913. He founded RADA in 1904 and was knighted in 1909.

Madame VESTRIS (Lucia Elizabetta Bartolozzi) (1797–1856) **27**

Lucia Bartolozzi was born in London and married Armand Vestris, the ballet master at the King's Theatre, in 1813. Because of huge debts he decided to put her on the stage and when she appeared at the King's Theatre on 20 July 1815 in *Il Ratto di Proserpina* she was a great success, with a beguiling stage presence and a beautiful contralto voice. The following season her parts included the title role in *Zaire* but she was unable to save her husband from bankruptcy and they left for Paris. Vestris soon moved on to Italy leaving his wife to perform on her own. She returned to London in 1820 and was engaged by Robert Elliston at Drury Lane, opening in February as Lilla in *The Siege of Belgrade*. She also played the title role in *Artaxerxes* and a number of musically less taxing roles. During the summer season at the Haymarket Mme. Vestris played Captain Macheath in *The Beggar's Opera* to great acclaim and, like Peg Woffington and Dorothea Jordan, began to make a speciality of breeches roles. Her next great success in the genre was as Don Giovanni in a burlesque of Mozart's opera called *Don Giovanni in London* which ran at Drury Lane from 30 May to 8 July 1821. As well as acting at Drury Lane Mme. Vestris made operatic appearances at the King's Theatre where her parts included Lucia in *La Gazza Ladra* in 1821 and Rosina in *Il Barbiere di Siviglia* in 1824. Her parts at Drury Lane included Mrs. Ford, Oberon, Nell in *The Devil to Pay* and Lydia Languish in *The Rivals*. She left to run the Tottenham Street Theatre at the end of the 1820s and in 1831 took over the management of the Olympic Theatre. She opened on 3 January with *The Olympic Revels* and enjoyed nine expensive but generally successful seasons. She married Charles James Mathews, her leading juvenile, in 1838 and they left for an American tour in an attempt to avoid bankruptcy. Deciding to go for all or nothing they took over Covent Garden and opened on 30 September 1839 with a production of *Love's Labour's Lost* which was brave but a financial disaster. The repertory included *A Midsummer Night's Dream* and *The Merry Wives of Windsor* and the occasional contemporary success such as *London Assurance* in 1841 but the theatre was too expensive to run with a company of over 600 and the last night of the Vestris-Mathews management was 30 April 1842. After a very brief period under Macready at Drury Lane they moved to Ben Webster at the Haymarket. Then to the Princess's and another attempt at management at the Lyceum, opening on 18 October 1847. They managed to hold onto the theatre until March 1855, Mme. Vestris having given her last performance on 26 July 1854. She died on 8 August 1856, one of the most remarkable women of the British stage. Not only was she one of the finest singers and light comediennes of the early nineteenth century, she was one of its best managers. Her seasons at the Olympic marked a new era in careful production and good theatrical planning and a revolutionary break from the lurching productons at the patent houses of Covent Garden and Drury Lane.

Geoffrey Arundel WHITWORTH (1883–1951) **95**

Born the youngest of five children, Geoffrey Whitworth was the son of a barrister who lived in Kensington and at Sharnbrook, near Bedford. In childhood he suffered from a spinal infection which prevented him from attending boarding school. After reading modern history at Oxford he worked for the *Burlington Magazine* before joining the publishers Chatto and Windus. Inspired by an amateur rendering of a one-act play in Crayford in 1918, he founded the British Drama League to 'assist the development of the art of the Theatre and to promote a right relationship between Drama and the life of the community'. With the support of Harley Granville-Barker and other leading theatre practitioners, the League resolved in 1919 to gain proper recognition for Drama in Education and to lobby for a National Theatre. As the first director of the British Drama League Geoffrey Whitworth also urged the formation of a great dramatic library. This soon found a nucleus in the collection of prompt books which Miss Horniman of the Gaiety Theatre, Manchester and pioneer of the Repertory Movement donated in 1921. The League greatly stimulated amateur theatre by launching the annual national One-Act Play Festival of Community Drama in 1927. He was awarded the C.B.E. in 1947 and relinquished the directorship the following year to become Chairman of the British Drama League's Council. As Hon. Secretary of the Shakespeare Memorial National Theatre Committee from 1930–51 Geoffrey Whitworth fought tirelessly for National Theatre, living just long enough to see the first laying of the foundation stone by the Queen in 1951.

Mr. WILLIAMS (fl.1827) **27 ?**

Mr. Williams was a character actor of legendary obscurity who flashed in the Haymarket pan in the late 1820s.

Margaret (Peg) WOFFINGTON (1718–1760) **6**

Born in Dublin, the daughter of an itinerant bricklayer, Peg Woffington joined Mme. Volante's Lilliputians at the age of twelve. Her first part was Polly Peachum in *The Beggar's Opera* and when the company went to London in 1732 for a season at the Haymarket her roles included Captain Macheath in the same piece. She was a member of the company at the opening of the new Dublin Theatre Royal in March 1734 and she gradually extended her repertory to include roles such as Phyllis in *Conscious Lovers* and the title role in *The Female Officer*. In November she went to Paris as a dancer and on her return to Dublin had a great success as Silvia in *The Recruiting Officer* and Harry Wildair in *The Constant Couple*. She went to London in May 1740 and opened at Covent Garden on 6 November as Silvia. However, it was her breeches roles such as Harry Wildair that made her immediately popular with the London public. The following season she moved to Drury Lane where her roles included Helen in *All's Well that Ends Well* and, on 27 May 1742, Cordelia to David Garrick's King Lear. At the end of the season Peg Woffington and Garrick left for Dublin and spent the summer at the Smock Alley Theatre. Tradition gives them a passionate affair at this point and they probably shared a house on their return to London. Garrick moved to Covent Garden for the 1746–7 season whilst she stayed at Drury Lane. He returned to Drury Lane as a partner in 1747 and after a year Woffington left for Covent Garden. Her roles included Lady Macbeth to Quin's Macbeth and the title role in *Lady Jane Grey* but she had an increasing number of younger actresses to contend with and returned to Dublin and the Smock Alley Theatre in 1751. She opened in *The Provok'd Wife* and over the next six years she dominated the Irish stage with roles such as Portia, Ophelia, Rosalind, Calista in *The Fair Penitent* and Hermione in *The Distrest Mother* as well as perennial favourites like Silvia and Harry Wildair. She gave her last performance, as Rosalind, on 17 May 1757 and after a long illness died on 26 March 1760.

Sir Henry WOOD (1869–1944) **84**

The son of a model railway engine manufacturer, Henry Wood was born in London and at the age of ten was deputy organist at St. Mary's, Aldermanbury. He studied composition at the Royal Academy of Music but he soon discovered a talent for conducting and was engaged by Sullivan and D'Oyle Carte to take the rehearsals of *Ivanhoe* in 1890. This led to a position as assistant conductor at the Savoy and was followed by engagements at the Crystal Palace and Olympic Theatre. In 1894 he was appointed musical adviser for a series of Wagner concerts at the new Queen's Hall and was engaged by Robert Newman the following year to give a series of Promenade Concerts there. Wood's connection with the Queen's Hall and the proms lasted for the rest of his life. He conducted most of the concerts himself but invited many British and continental composers to give their own works and the proms became the main forum for contemporary music in Britain. Wood also conducted for festivals in Wolverhampton, Sheffield, Cardiff, Birmingham, Manchester and Liverpool and, in 1926, conducted a three day Handel Festival at the Crystal Palace having re-scored all the music for an immense orchestra and choir. He taught at the Royal Academy of Music and gave them his important musical library in 1938. Wood was knighted in 1911 and given the Royal Philharmonic Society's gold medal in 1921. He acquired innumerable international honours during the 1920s and in 1944 was made a Companion of Honour.

Charles Mayne YOUNG (1777–1856) **30**

Born in London, the son of an eminent surgeon of violent propensities, Young was educated at Eton and Merchant Taylor's. He began a job in the city but began to appear as an amateur in the provinces, variously called Mr. Green and Mr. Douglas. He eventually raised enough courage to use his own name and appeared successfully in Edinburgh on 23 January 1802 as Doricourt in *The Belle's Stratagem*. After some managerial experience in the provinces Young made his professional London debut for George Colman at the Haymarket, playing Hamlet on 22 June 1807. He also played juvenile favourites such as Octavian in *The Mountaineers*, Don Felix in *The Wonder* and Hotspur as well as stronger character parts such as Sir Edward Mortimer in *The Iron Chest* and Rolla in *Pizarro*. On 10 November 1808 he made his debut with the Covent Garden company, creating the role of Daran in *The Exile*. He played a number of leading roles with the company whilst it was in exile at the King's Theatre and often stood in for John Philip Kemble. As Kemble faded from sight, and before Kean sprang to prominence, Young was accepted as the leading English tragedian. He had a fairly complete repertory of juicy roles including Prospero, Iachimo, Richard III, Iago, Cassius, Mark Antony and Coriolanus as well as lighter parts such as Barford in *Who Wants a Guinea?* and Macheath in *The Beggar's Opera*. He made his Drury Lane debut on 17 October 1822 as Hamlet and later shared Iago and Othello with Kean. This was not a great success for Young and he returned to Covent Garden the following season and remained there, on and off, until he reappeared at Drury Lane, again as Hamlet, on 1 October 1828. His last performance, on 31 January 1832, was also as Hamlet with Macready as the Ghost and Charles Mathews as Polonius. Young had a good voice and stage presence; the last survivor, bar Macready perhaps, of the John Philip Kemble school of acting.

INDEX OF ARTISTS

INDEX OF PLAYS

INDEX OF PREVIOUS OWNERS